THE MUSÉE D'ORSAY

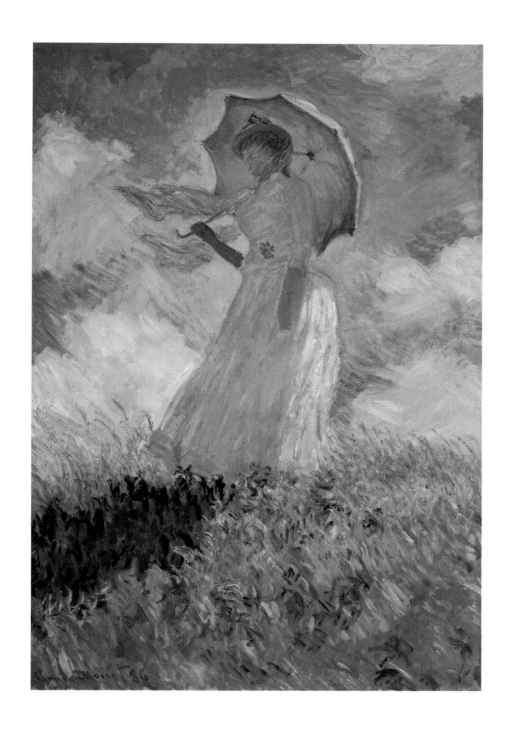

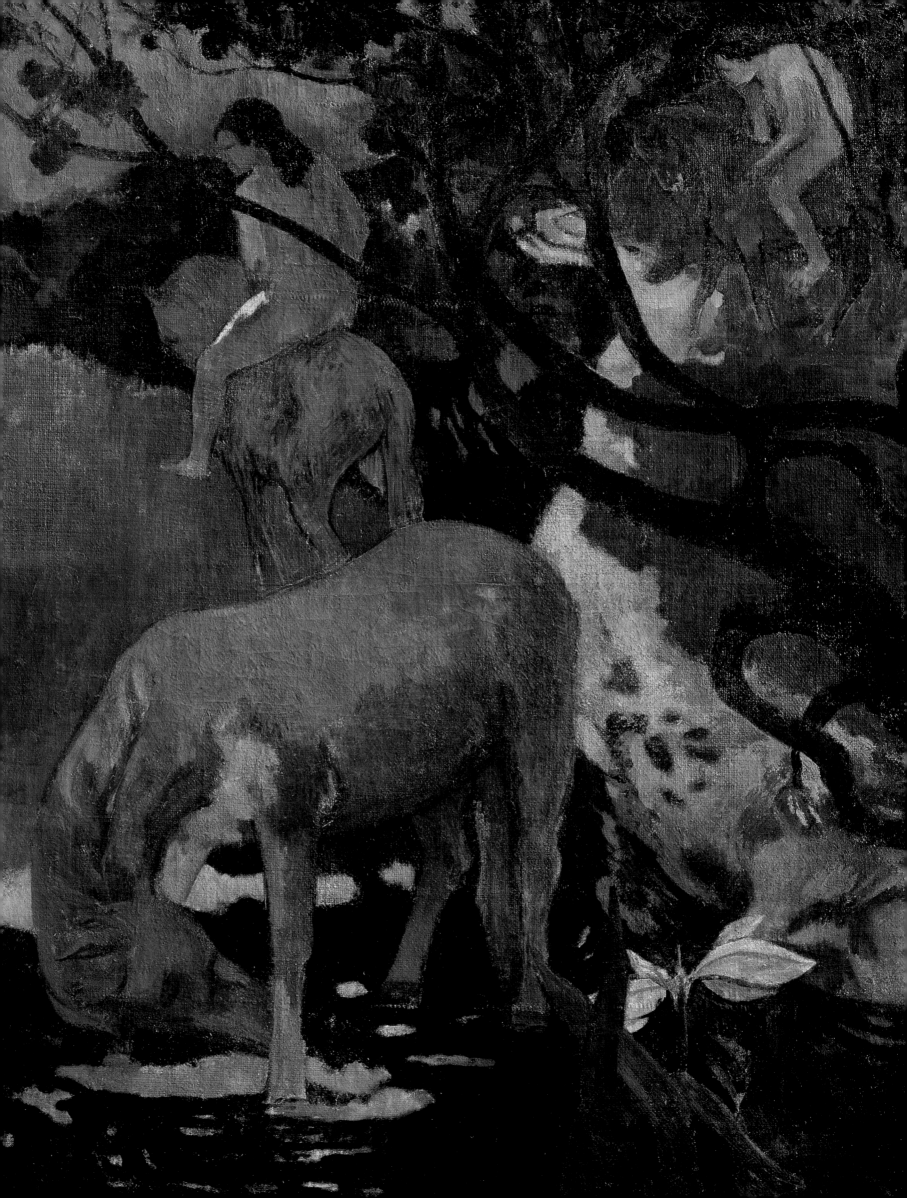

THE
MUSÉE D'ORSAY

Alexandra Bonfante-Warren

HUGH LAUTER LEVIN ASSOCIATES, INC.

Copyright © 2000 Hugh Lauter Levin Associates, Inc.
Distributed by Publishers Group West

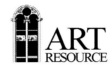 All photos of artworks courtesy of Art Resource, New York.

Design by: Charles J. Ziga, Ziga Design

Printed in China
ISBN: 0-88363-502-x

All works by Jean Beraud, Émile Bernard, Giovanni Boldini, Pierre Bonnard, Maurice Denis, André Derain, André Devambez, Maximilien Luce, Aristide Maillol, Paul Signac, Maurice de Vlaminck, and Édouard Vuillard © 2000 Artists Rights Society (ARS), N.Y./ADAGP, Paris.

All works by Max Lieberman © 2000 Artists Rights Society (ARS), New York/VG Bild-Kunst, Bonn.

All works by Henri Matisse © 2000 Succession H. Matisse, Paris/ Artists Rights Society (ARS), N.Y.

All works by Piet Mondrian © 2000 Artists Rights Society (ARS), New York/Beeldrecht, Amsterdam.

CONTENTS

ACKNOWLEDGMENTS

I would like to thank, first, Hugh Lauter Levin for thinking of me for this thrilling project, which has allowed me to time-travel in the company of great artists, writers, saints, queens, kings, and politicians, but also with unnamed children, peasants, revolutionaries, and reactionaries.

In the present, I wish to thank Jeanne-Marie P. Hudson of Hugh Lauter Levin Associates, a writer's dream of an editor, a tactful shepherdess with a gift for flexible organization, a great eye, and, it would seem, unfailing good humor. I am grateful, too, to Debbie Zindell, also of Hugh Lauter Levin Associates, for her discerning and trustworthy eye. Charles Ziga's handsome design would make any text read well. At Art Resource, Gerhard Gruitrooy, Director of Research, at times understood what I was trying to do better than I did. I appreciate his taste, imagination, and enthusiasm. Also at Art Resource, I am grateful to Jenny McComas for her ready assistance. Thanks also to Stéphane Houy-Towner of the Irene Lewisohn Resource Center of the Costume Institute of the Metropolitan Museum of Art, New York, for generously giving of his time and expertise.

In Paris, my thanks to M. Dominique Lobstein, of the Musée d'Orsay's Research Office for replying to my questions so promptly. I am also grateful to the heroes at the d'Orsay's Information Desk, who field thousands of questions a day, some of them mine.

This is for my friends and family, in particular for *mon général*, who first showed me Paris.

The
Musée d'Orsay

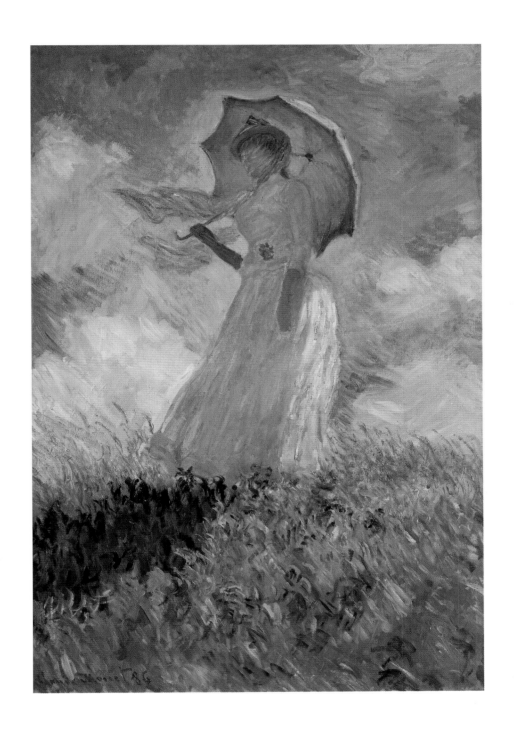

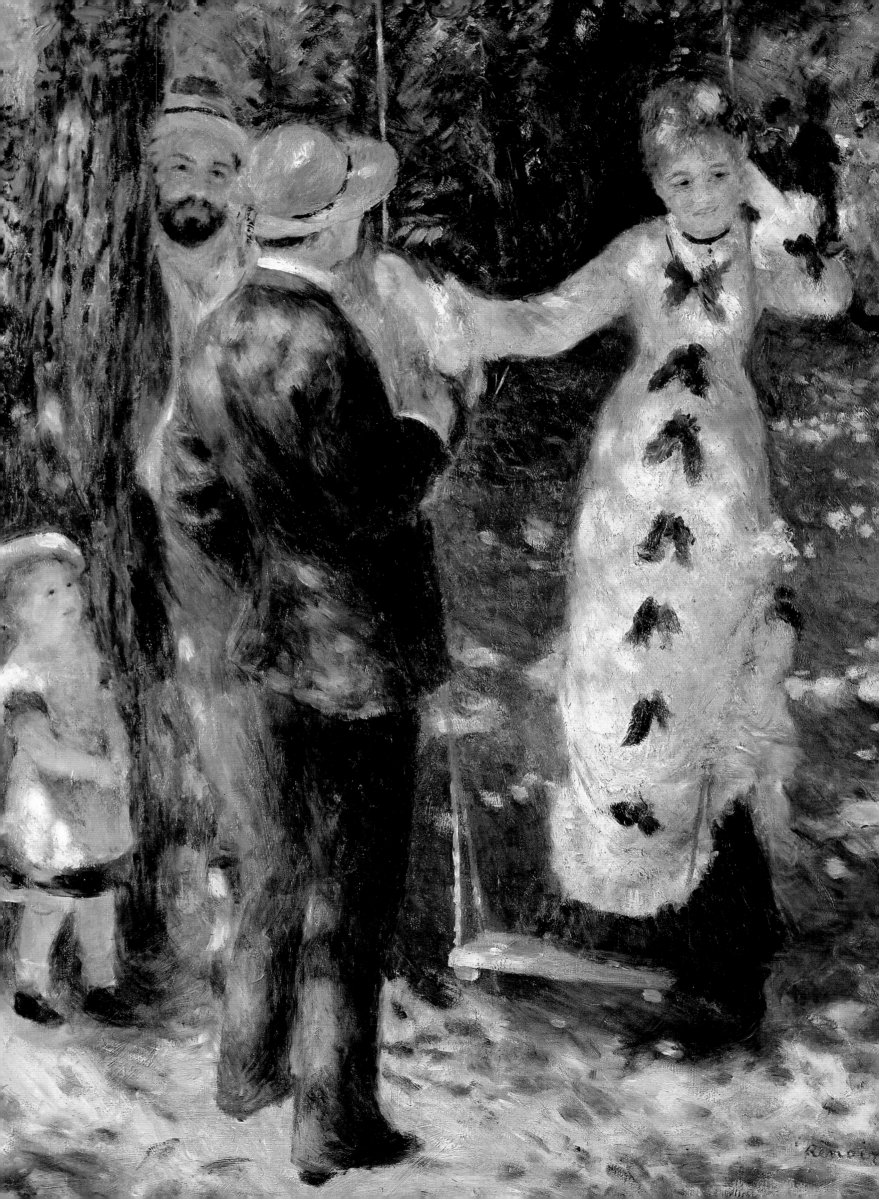

THE MUSÉE D'ORSAY

The two clocks of the Musée d'Orsay rise above the chestnut trees that line the Seine; contrasting with the ageless Paris cityscape, they remind the viewer of the reality of time passing. They are survivors of a brave new world of timetables and timeclocks, of schoolbells, workdays, and factory whistles. These twin clocks of the former Gare d'Orsay, a train station built in record time and completed in July 1900, created a community of gazers at a time when private watches—pin watches and pocket watches—were badges of the bourgeoisie.

By 1900, when the Gare d'Orsay was inaugurated, the secular age had been in force in France for a century; fewer and fewer folks lived by the rise and set of the sun, and more and more people passed their days by a mechanical dial. Appropriately, both time and timing would prove crucial to the birth of the Musée d'Orsay. Broadly, the museum's collection, largely works from the nineteenth-century Musée du Luxembourg, fits chronologically between those of the Louvre and the Musée d'Art Moderne, although the collection is best known—and much loved—for its works by the Impressionists and Post-Impressionists. Roughly, the museum's collection of photography, drawings, architectural plans and models, paintings, sculpture, and decorative and industrial art is bracketed by the years 1848 and 1914. Yet human imagination is too fluid to be contained within arbitrary dates, the artists and designers who created these works claiming their place within the continuum that draws from the past and reaches into the future. For this reason, the Musée d'Orsay exhibits precursors and descendents, as well as the Academy art that represents the period's official taste. Often, but by no means always rightly, maligned, the works of the members of the Académie and École des Beaux-Arts manifested the prevailing expressions of their time, and just as often stimulated much creative reaction. No exhibition covering the period between the birth of the short-lived Second Republic and World War I would be complete without these artworks.

In the curious way of history, the story of the Musée d'Orsay begins as the tale of two queens. In 1599, Pope Clement VIII dissolved the marriage between the ambitious Protestant prince Henry of Navarre and the spoiled, charming, and Roman Catholic Margaret of Valois, known to history as Queen Margot. Henry married Marie de Médicis the following year. In 1606, the forsaken Queen Margaret retired to her land by the Seine, across the river from the royal palace of the Louvre, and there began to construct a hôtel amid a park of some forty acres. In 1612, two years after the two queens' husband died, Marie began construction of the Luxembourg Palace, her own, far more splendid retreat, just south of her predecessor's.

In 1615, the learned, festive, and scandalous Margaret died, her home unfinished, her estate burdened with debts. The land was sold off in lots, but the memory of her park survives in the grid of streets around today's museum where her decorous allées once were. The area was still open country, and over the next century and a half it gradually attracted members of the nobility who sought to be near the court, then at the Tuileries. They built townhouses—the handsome Parisian *hôtels particuliers*. One of the finest examples of these is the Hôtel de Salm, which today is home to the Musée de la Légion d'Honneur. Erected in 1782–88, it served as a model for several structures, including San Francisco's California Palace of the Legion of Honor.

At the time, the riverbank by the former queen's house was a patchwork of vacant lots and piers. The longest-lived of these was La Grenouillère, a bathing dock among the stockpiles of wood that were floated into the city down the Seine. The constant risk of fire moved the provost of the Paris merchants, Charles Boucher d'Orsay, to order a proper *quai* to be built, beginning in 1708. In 1795, on Queen Margot's lot, a cavalry barracks was installed in the buildings of the Ferme, where the royal coaches were once kept. In 1810, the finest art of Italy, trophies of the emperor Napoleon's victories, was flooding into the Louvre, selected by Baron Dominique-Vivant Denon—"Napoleon's Eye." The emperor, as part of his architectural program, commissioned a building on the same lot as the Ferme for the State Department; with his highly developed instinct for political spectacle, he intended the new edifice to stand for France's imperial radiance. By the time construction was completed, however, in 1838 under Louis-Philippe, the Palais d'Orsay was an outsize hulk of Roman-style Neoclassicism, ill-suited to serve the Audit Office, which it now housed. The adornment of the interiors, however, was entrusted to some of the most famous painters of the day, darlings of the Salon like Théodore Chassériau, whose imposing *Tepidarium* holds pride of place in the Musée d'Orsay.

<div align="center">❧ ❧ ❧</div>

The quarter century between the emperor's commission of the Palais d'Orsay and its completion by the Citizen-King witnessed profound social and technological shifts. In the arts, as in politics, the world was becoming modern. In 1792, the Revolution had decreed a new age, including a new calendar by which to live. In 1795, the Académie des Beaux-Arts—the Academy of Fine Arts—replaced both the Académie Royale de Peinture et Sculpture and the Académie Royale d'Architecture, both of which had been

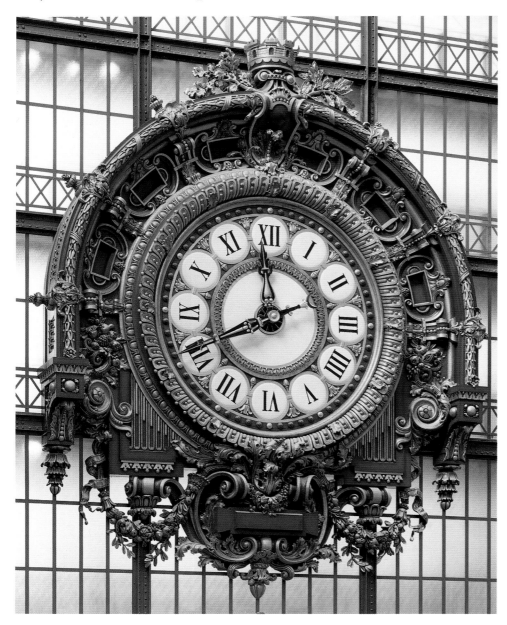

P. 8
Pierre-Auguste Renoir. *The Swing*. 1876. Oil on canvas. 34 ¼ x 28 ¾ in. (92 x 73 cm).

LEFT
Exterior view of the museum's signature timepiece.

OPPOSITE
Exterior view of the Gare d'Orsay.

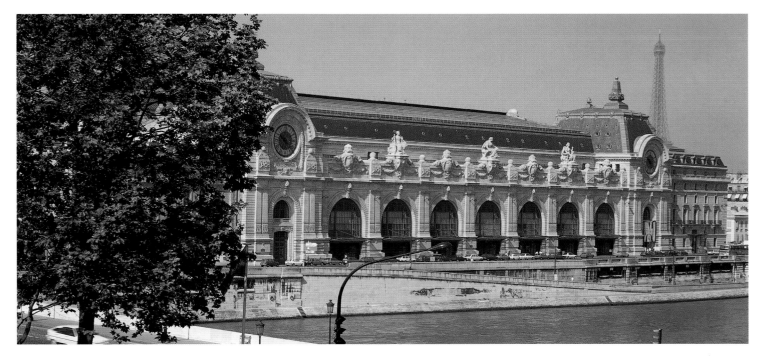

abolished two years earlier. During the Restoration of 1814–15, the Academy acquired the institutional shape it would maintain for most of the rest of the century: it counted forty members, comprising painters, sculptors, architects, engravers, and musicians. The new institution took up many of its predecessors' functions, including awarding the Prix de Rome, a fellowship that allowed promising students to attend the Académie Française in the papal capital, where they would study directly from ancient and Renaissance models.

The most significant change in the post-Revolutionary Salon system was that all artists—not just members of the Academy—could submit work to the annual Salon. The Academy still fielded the jurors, however, and also perpetuated the Classical style and subjects through its awards and the Prix de Rome. The hope that French artists would take the torch from the now-stagnant art of Italy had inspired the founding of the Muséum Central des Arts in the Louvre. By the Restoration, the museum was indeed proving essential to the education of young artists.

An artist's appearance in the Salon meant important commissions—money and fame—and a chance to have his or her work hang in the Louvre posthumously. The exhibition took its name from its venue— the Salon Carrée of the Louvre—and at one time it was suggested that works bought at the Salon be moved into the Grande Galerie directly next door. Works were presented chronologically in the Grande Galerie, the room just before the Salon Carrée, so it was natural to think of simply adding contemporary works at the end of the French galleries. The idea was abandoned, however, because it seemed fitting that there should be some kind of discreet waiting period before works entered the Louvre permanently, perhaps to see how the work looked when it was no longer of its time. Likewise, a variable interval would be mandated between the death of an artist represented in the Musée du Luxembourg and the transferral of that artist's work into the Louvre.

It is no less true today that viewers see contemporary art one way in its time, and another way when it is no longer "contemporary," that is, when it can be evaluated independently of the temporal context in which it was produced. This belief contributes to the idea of a museum as a realm outside of time, a place of ageless quality. In fact, no sooner were museums invented, in the mid-eighteenth century, than artists began to want their work—extensions of themselves—to be accepted into those solemn precincts, among acknowledged masterpieces of all time. Museums offer the closest thing to the transcendence of eternity in the here and now, so much so that an artwork's significance in its own place and time is easily lost.

There was nothing transcendent about the gouty, sedentary Louis XVIII, brother of the executed Louis XVI. Louis ascended the throne in 1815, after Napoleon's Hundred Days, and founded the Musée du Luxembourg three years later in the palace erected by his ancestor Marie de Médicis. The Luxembourg was

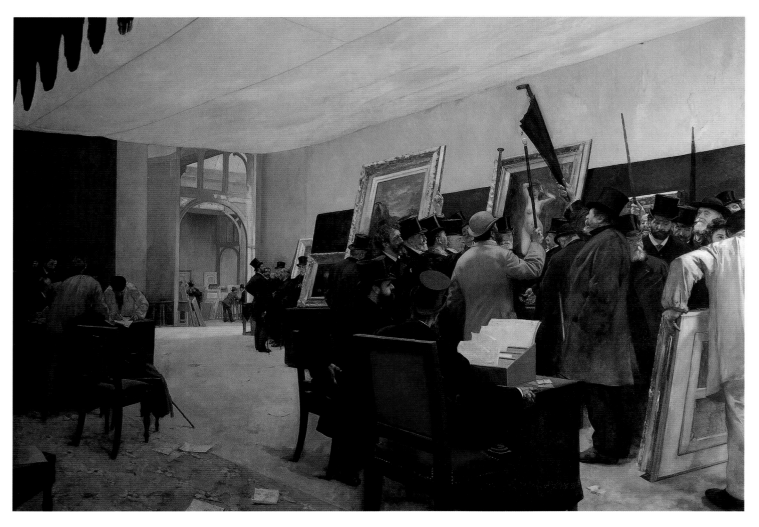

Henri Gervex. *A Painting Jury*. 1885. Oil on canvas. 117 ⅝ x 164 ⅜ in. (299 x 419 cm).

intended to display the art that the State purchased at the Salon, thereby solving one of the problems that the Ancien, Revolutionary, and imperial regimes had faced in devising the idea of the museum—how and where to exhibit works by living artists. The art that entered the new museum was doubly conservative, because it had been filtered through the Academic Salon jury, then through the museum's government-appointed administration. The tensions between the public, the Academy, the art establishment, and the government would determine the direction of the museum's collection for the rest of the century.

By the time the Musée du Luxembourg opened, Neoclassicism, the expression of the Age of Reason's selective rationality, was waning. While the art establishment was beginning to place less emphasis on art's potential to uplift, and the public continued to enjoy still lifes and genre painting, the Academy maintained the preeminence of history painting. (The primacy of history painting, the depiction of "great deeds of great men, worthy of memory," went back to the Renaissance: the phrase is from Leon Battista Alberti's 1486 work, *Ten Books on Architecture*.) The Academy deprecated still lifes and landscapes because of the absence of human figures, and portraits of ordinary people and genre paintings because they could not inspire to high public virtue.

An entirely new artistic expression had emerged at the end of the eighteenth century. Romanticism—its name referred to the medieval "romances," or tales of chivalry—represented a reaction to both the stoic, cerebral style of the Enlightenment and the stifling social conventions of the Ancien Régime. The movement exploded in literature, philosophy, and the visual arts, especially in England and Germany, but France was not far behind. The Romantics exalted emotion and the picturesque: the Middle Ages became the standard of passion and color, influencing form and content in all the arts. Dante's *Divine Comedy*, in which the poet toured Hell, Purgatory, and Paradise, would provide material for works in every medium, including Jean-Baptiste Carpeaux's *Ugolino* and August Rodin's *La Porte de l'Enfer*, both represented in the

Musée d'Orsay. The French Romantic school was influenced in part by the artistic choices of Baron Denon, the director of the Louvre museum during the First Empire, who had rediscovered the pre-Renaissance painters of Italy and legitimized them by bringing them into the imperial museum.

The writer and cultural philosopher Baroness Anne-Louise-Germaine de Staël, the daughter of Louis XVI's chief minister, left Paris during the Revolution, and came back in 1794. A liberal strongly opposed to both Napoleon and the empire, she was exiled by Bonaparte in 1803, and returned after his final defeat in 1815. Beginning in 1794, Madame de Staël became one of the great salonnières—a gift she inherited from her mother—at the center of some of Paris's most intellectual circles. In 1800, in her philosophical work *On Literature*, she argued against the doctrine of classicism, maintaining that there was no single, absolute ideal of beauty. Rather, she argued, beauty can take on different aspects in different countries, depending upon the climate, the character of the inhabitants, their form of government, and their religion. Therefore, criticism had to be relative, and based upon a thorough knowledge of history. This was especially meaningful to a public that was seeing the fabulous artifacts of ancient Egypt at the Louvre—artworks that Denon had revealed to be the source of the previously ultimate Greek and Roman cultures.

In *On Germany*, published in 1810, de Staël claimed that the classical literature of the South—by which she meant Italy—was, in France, a foreign, unnatural transplant. She argued that it was the Romantic literature of the North that was native to the country. (Nevertheless, Italian authors such as Dante and Torquato Tasso were all the rage, a vogue that only intensified as the century unfolded.) In the same work, the baroness expressed the hope for a new literature, based on emotion and enthusiasm, on religious sentiment and national—not just Greek and Roman—history.

Where Neoclassicism had portrayed a high morality that placed the good of society above all, Romanticism was centered in the subjective consciousness, the individual in isolation. The Revolution had been stilled, but its radical innovation—that an individual has rights, not just duties—could not be unlearned. This truth was held to be self-evident, or "natural," in the vocabulary of the Enlightenment, whose visual vocabulary was Neoclassicism. Philosophically and stylistically, Romanticism and Classicism overlapped. The republicans, for example, pointed to the democracies of antiquity to justify the overthrow of tyranny, while introducing the Romantic notion of the rights of the individual. On the other hand, it took a gentleman's education to understand Classicism's sometimes arcane references to ancient Greek and Roman history and literature. It would not be unusual to find Romantic aristocrats such as George, Lord Byron supporting national liberation movements, or like Victor Hugo, the son of a count, who wrote *Les Misérables*.

In theory, Romanticism was democratic, not only because it emphasized (common) nature—where Classicism praised common sense—but because feeling in art makes it accessible to everyone, regardless of level of education. In practice, Romanticism as a philosophy had elitist overtones, because sensitivity was still usually considered an aristocratic attribute: Madame de Staël disliked Napoleon because he was an upstart, as much as because he betrayed the Revolution. Furthermore, the expression of the self is often made easier by an independent income.

The writer, statesman, and viscount François-Auguste-René de Chateaubriand, a royalist to the bone, was, with the Baroness, one of the earliest proponents of Romanticism in France. The Ancien Régime had regarded the depiction of Christian narrative as disrespectful; such episodes continued to be banished during the adamantly anticlerical years of the Revolution as well. Now, Chateaubriand proposed, in *The Genius of Christianity*, that Christianity could and should be a source of artistic inspiration. It would be some time before convention caught up with theory, but in the second half of the nineteenth century, Christian themes would give rise to works such as Cormon's *Cain* and Théodule Ribot's grisly *Saint Sebastian, Martyr*. The viscount's travels in the United States in 1791–92 went far in introducing American Indians—"noble savages"—into the artistic vocabulary. In addition, Chateaubriand's world-weary melancholy set the style for a generation.

A generation later, in 1846, Charles Baudelaire, one of the century's preeminent poets and an important art critic, would describe Romanticism as "the most recent, the most current expression of the

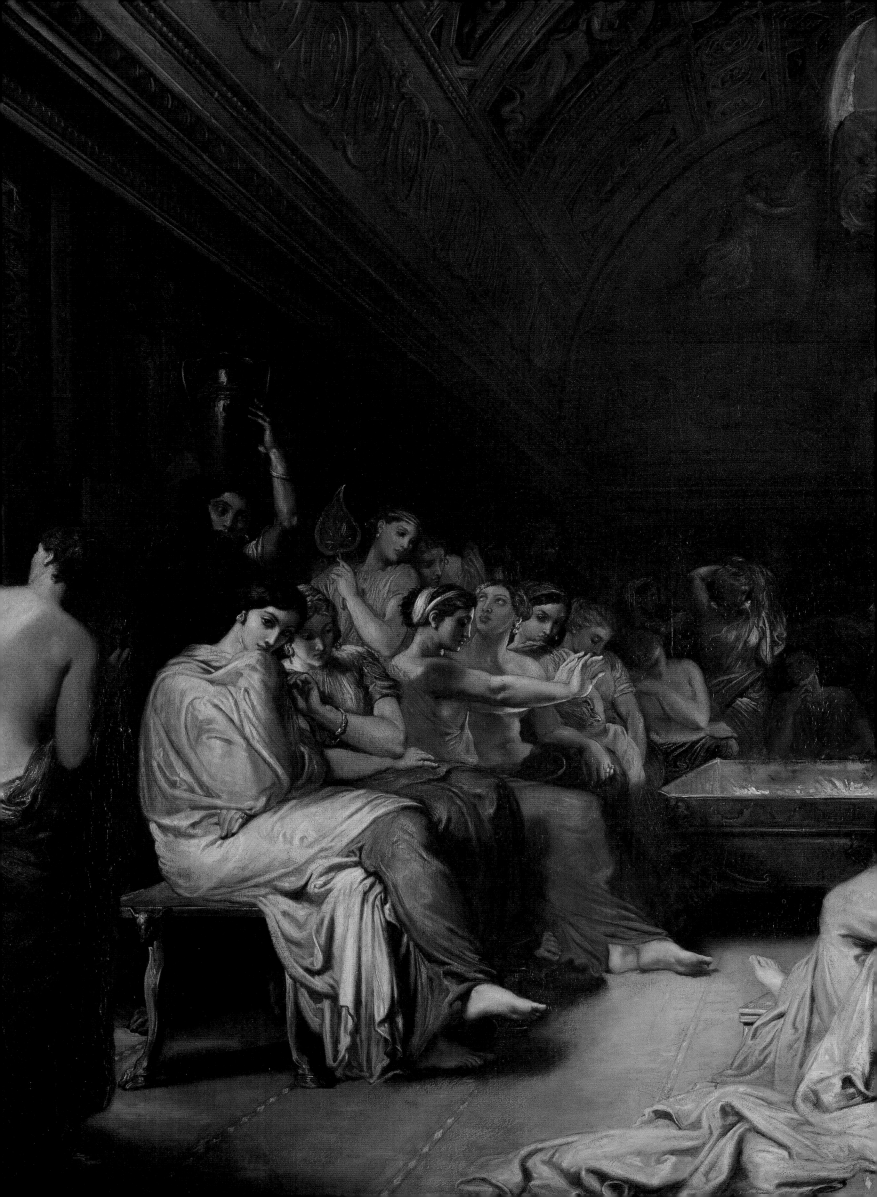

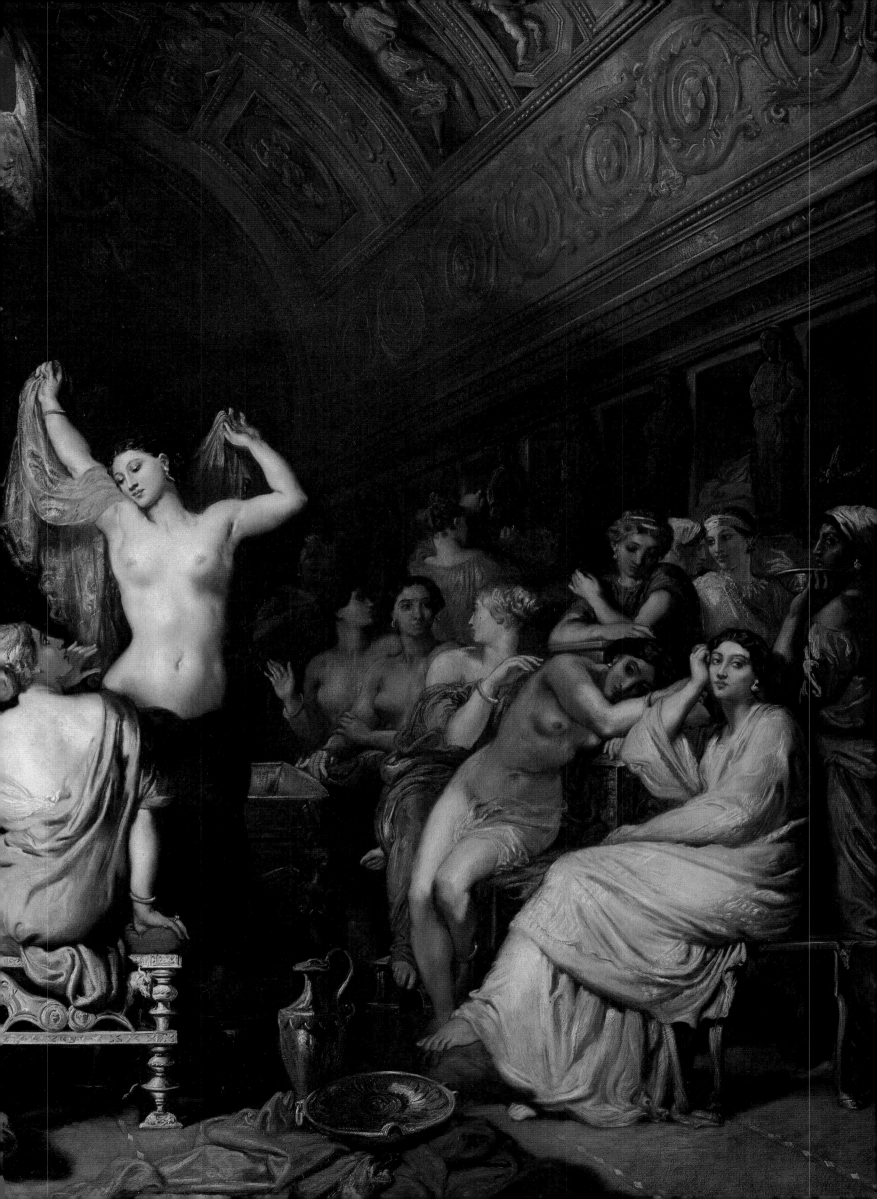

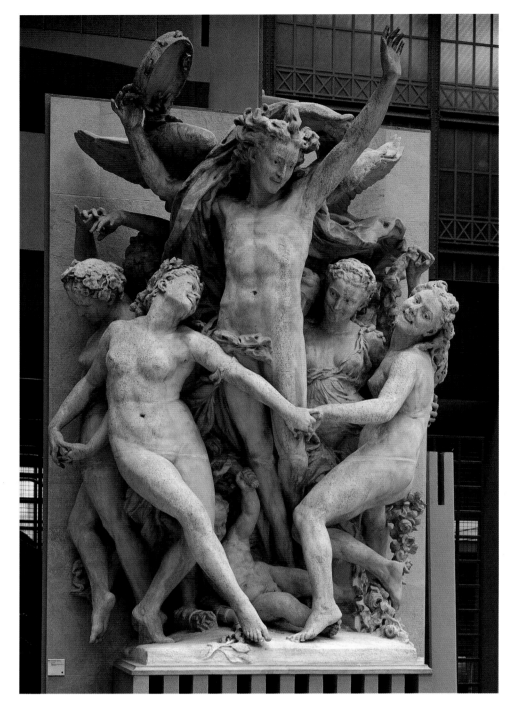

PP. 14-15
Théodore Chassériau.
The Tepidarium. 1853. Oil on canvas.
67 ¼ x 95 ½ in. (171 x 258 cm).

LEFT
Jean-Baptiste Carpeaux.
The Dance. c. 1895. Marble. 27 ¼ x
16 ⅛ x 11 ⅜ in. (69 x 41 x 29 cm).

beautiful." Its modernity he defined as "the transitory, the fugitive, the contingent, half-art, the other half of which is the eternal and the immutable."

Visually, Romanticism and Classicism were complementary and very compatible strains of idealism, although their proponents could be ferociously partisan—there were fistfights between Romantics and Classicists for more than three months outside the theater where Hugo's play *Hernani* was being performed in 1841. The two expressions often merged, producing hybrid works such as Théodore Chassériau's *Tepidarium.* During the nineteenth century and beyond, they would absorb and beget, together and separately, innumerable currents. These would range from Orientalism, inspired first by the withdrawal of the Ottomans from central Europe, then by France's colonialist expansion in North Africa, to the morbid excesses of Decadentism, to personal expressions independent of categories.

Jean-Auguste-Dominique Ingres was one painter who followed his own course, or, rather, courses. One of the most popular painters of the century, he is academically categorized as a Classical painter, but his philosophy was primarily the pursuit of the beautiful. His most famous—but not his best—paintings are brilliantly drawn, masterfully tinted, impeccably finished, vapid Italianate pin-ups that show the influence of the artist's years in Rome, first as a winner of the Prix de Rome, and then as director of the Académie

Française. Although Ingres's riveting portraits best display his great skill and insight, they received less attention in his day because the Académie placed so little value on such subjects.

Eugène Delacroix was the most successful artist in the Romantic manner in the first half of the nineteenth century. He often borrowed classical themes or models, for example, for his 1850 ceiling in the Louvre's Galerie d'Apollon. Other works, such as *The Lion*, are powerful, almost expressionistic whirlwinds of energy and color. As different as they are, works by Ingres hung side by side with paintings by Delacroix in the Luxembourg from 1824, and at the Paris World's Fair of 1855.

Unblended Classicism continued longest in architecture and sculpture. Sculpture, often commissioned for architectural embellishment or other public art, reprised ancient artistic and historical subjects, such as the Greek poet Sappho, or the Roman reformers, the Gracchi. At the same time, Romantic emotion and movement—the first stirrings of Realism—offered an intriguing challenge to artists and audiences alike. During Napoleon's decade of glory, for example, the young François Rude was steeped in the Neoclassical style at the École des Beaux-Arts. Although he won the Prix de Rome in 1812, there was not enough public money to send him abroad to complete his classicizing. Too Romantic to be elected to the Academy, Rude was the most popular French sculptor of the first half of the nineteenth century. He is best known for his furious *Marseillaise*, completed in 1836, which crowns Napoleon's Arc de Triomphe.

Like most successful artists, Rude had a school: one of his students was Jean-Baptiste Carpeaux, the favorite sculptor of the Second Empire. Carpeaux, like Rude, studied at the École des Beaux-Arts; like his teacher, Carpeaux won the Prix de Rome, but unlike Rude, he was able to go. He spent almost ten years in Rome, and his work shows an Italian influence in a sinuous Classicism approaching Realism that shocked the official public.

Louis XVIII was stolidly anti-republican. Very conservative at the beginning of his reign, he managed to move even further right by the time he died, in 1824. He was succeeded by his younger brother, Charles X. Handsome and elegant, with beautiful manners, Charles made for a striking change, but his attributes were merely skin deep. After leaving France on July 15, 1789, Charles had lived mostly in England and Scotland until 1815 and the Restoration, and so was completely out of touch with the moods of the French nation. Even more ultraroyalist than Louis XVIII, he boasted that he had not changed since 1789. France had, however, and the king's repressive regime was unacceptable to a generation that had grown up with rights, such as freedom of the press, that he now withdrew. The king's attempt to reestablish absolutism was an anachronism by this time, and it was not long before his obstinate intransigence provoked the people of Paris to the point of rebellion.

In 1829, an economic crisis struck the country, hitting the capital the hardest. Unemployment was high, prices rose almost daily, violence and crime were epidemic, the tension between a nostalgic, resentful, and regressive administration and a hungry and desperate population had to snap. The once peaceful daily demonstrations turned into riots. In 1830, in an attempt to bring the city to a standstill, overthrow the government, and restore the republic—with the Marquis de Lafayette as president—the radicals of Paris erected barricades throughout the city. The bourgeoisie, once again rising to the defense of the monarchy, brokered a compromise. Charles X abdicated in favor of Louis-Philippe, a nobleman who was also a former lieutenant in the Revolutionary army. The Citizen-King Louis-Philippe ascended the throne.

The violence of those years was exacerbated by the terror brought on by an epidemic of cholera, the first of its kind, that swept through Paris in the early 1830s. To escape the chaos and dangers of the city, a handful of artists went to join colleagues who had founded an informal artists' colony at Barbizon, a village near the Forest of Fontainebleau—the castle where, three hundred years earlier, Francis I had founded a school of easel painting. These artists worked outside the Academy system, preferring the inspiration of the French countryside to the pilgrimage to Rome. Their models were the works of the English painter John Constable.

In 1824, Constable's rustic but unsentimentalized countrysides, controversial in his native country, had won him a place in the Salon. Perhaps they resonated with the émigrés who were having their ancestral lands restored, thanks to the king's measures, or they may have meant something to the wealthy *hauts*

bourgeois who were buying land in emulation of the nobility. Certainly, Romanticism had rehabilitated landscapes—nature *par excellence*. Many viewers were charmed and intrigued by their realism, while others were disconcerted by the abstract white flecks that rendered the quality of light so aptly. In any case, Constable's paintings were something quite new.

Earlier landscape artists had painted ideal—illusionistic, but imaginary—scenes. To do this, they would invent details, or combine elements of places, and locate them in a suggestive, but otherworldly light. They never made portraits of actual places. The outdoor painters in the Fontainebleau forest, on the other hand, strove to replicate specific effects of light; this turned out to be the door through which Realism, the century's most transforming expression, would enter the history of art.

Over the more than forty years of its existence, the members of the so-called Barbizon school would include Théodore Rousseau, Narcisse Diaz de la Peña, Jean-François Millet, Camille Corot, Charles Daubigny, and others. The Barbizon school would influence very diverse painters in a number of ways, directly and indirectly. Although their attention to nature was fully in the Romantic groove, they favored the realistic, humble themes of genre painting, not at all the heroic, historical mode. In the scientific spirit of the age, they experimented with ways to achieve their ends. Technically, they tended to use visible brushstrokes, often broad, rough touches, as if to accentuate their sober depictions of peasants' lives, and left their surfaces unvarnished.

The framing of some of these works is particularly interesting. Since the Renaissance, important, panoramic paintings had presented the total picture, so to speak. While personages frequently looked out at the viewer, convention held the painter to be absent, an omniscient narrator. As early as 1830, some Barbizon paintings presented only a portion of a view, a compositional ploy that photography has taught us to take for granted. The fact of selection might be emphasized by a strongly asymmetrical composition, by a cropped element at the edge of the picture, or by an abruptly foregrounded object that calls attention to the point of view, and so by implication, to the individual painter.

The Barbizon painters were initially successful at the Salon, but Rousseau—whom the critics considered the head of the "school"—was rejected in 1836. It would be forty years before the Luxembourg hung works by Millet, Diaz, and Daubigny, by which time the innovators were comfortably old hat, the mild predecessors of the unsettling Impressionists.

Even though Romanticism brought movement, emotion, and drama into the picture, and even though artists were sketching those pictures outside, most painters and sculptors were producing art as they had always done. The studio was where artists made art, not least because they could control the lighting, preferring cool, white northern exposures to warm, yellow-tinted southern light. Classical paintings and the eclectic school, which combined styles, required costumes and set designs, not to mention nude or scantily clad models who had to be kept inside and warm. Like the Old Master paintings, the surfaces had to display a flawless finish: artists routinely varnished a painting to give it more gloss (thus creating headaches for conservators and restorers of later generations). Sculptors, of course, also worked from models; in their studios they created the casts that would be used for metal, usually bronze, statues, or else sculpted pure white marble. Their use of this stone harked back to a sixteenth-century error. The Renaissance, unearthing the statuary of ancient Rome, had discovered marble works of pristine white, perfectly attuned to the era's high-minded image of the classical age. Michelangelo and others either did not notice, or disregarded, the traces of color that suggested the historical fact: that these works, once as richly polychromed as the wood statues of the disdained Middle Ages, had been bleached by time, not Platonic aesthetics.

Psychologically and politically, the time was right for Realism. Side by side with the convulsive, progressive disintegration of the absolute monarchy, which had been taking place for more than a quarter of a century, a new painting style was slowly taking shape. Art was coming out of the studio, and artists like the Barbizon group were beginning to look publicly at the world as it was, and report it. From the country, the artists would soon move their observing gaze to villages, cities, and factories. The Enlightenment philosophers and the Revolution they engendered, by devising rights of the individual, had effectively created that individual. Now, artists—painters and novelists especially—were bringing the

individual, as artist and as subject, literally into the foreground. Furthermore, they were endowing these hitherto unreported aspects of life with the importance once given only to the past and to "great men." Just as the ideal historic was giving way to the specific present, so too the smooth, two-dimensional surface was being replaced by the evident, physical material of which the pictorial illusion was made.

This shift was taking place on several fronts at once. In 1832, Honoré Daumier leveled broad, but shrewd barbs at the ruling middle class—the *juste milieu*—in a series of satirical sculptures. That same year, the twenty-four-year-old humorist spent six months in prison for his caricature of Louis-Philippe as Gargantua battening on the money of the have-nots, and spitting it back to the privileged classes. In 1835, the critic, author, and newspaper editor Théophile Gautier had proposed a Romantic injunction, "art for art's sake," in the introduction to his novel *Mademoiselle de Maupin*. In the same text, he harshly attacked the unimaginative conservatism of "bourgeois philistinism."

In 1829, a mob had destroyed one of the first sewing machines, fearing—rightly, as it turned out— that the invention would rob tailors and seamstresses of their livelihoods. That same year, the first French railway line opened; within a decade, the daily life of vast numbers of people would alter radically and irreversibly. During those years, manufacturing developed as well, with its clock hours and piecework, where once agriculture had run on natural light and seasonal rhythms. The nature of time itself would change, or at least the way millions of people experienced it.

The Paris railway was inaugurated in 1836. The writer Delphine Girardin commented on the occasion with mixed feelings, and tongue delicately in cheek, in one of her *Lettres parisiennes*. Foreshadowing the psychological effect of today's airplane travel, she remarked of one of the inaugural voyagers: "Upon arriving in Saint-Germain [some eleven miles outside Paris; twenty-six minutes by train], his soul became sorrowful, as he reflected that it had taken so few moments to be so far from his family and friends."

The first train stations in Paris and in the great terminus cities of France were built that year. Despite the absence of train stations in antiquity, architects adhered to classical architectural models—complete with columns, pilasters, and statuary—to manifest the institutional importance of the new buildings.

Film still from Louis Lumière's
*Arrivée d'un Train en Gare de
La Ciotat.*

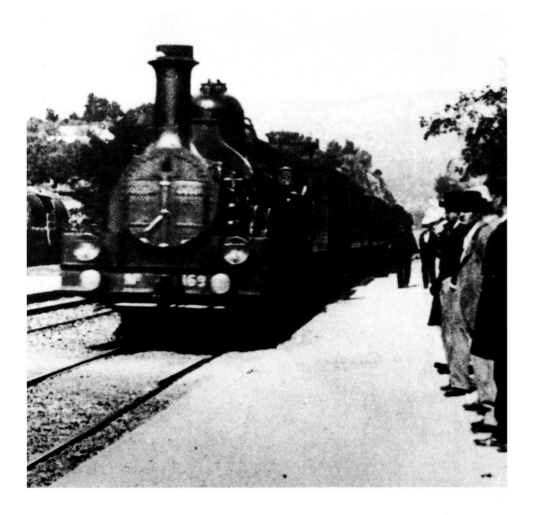

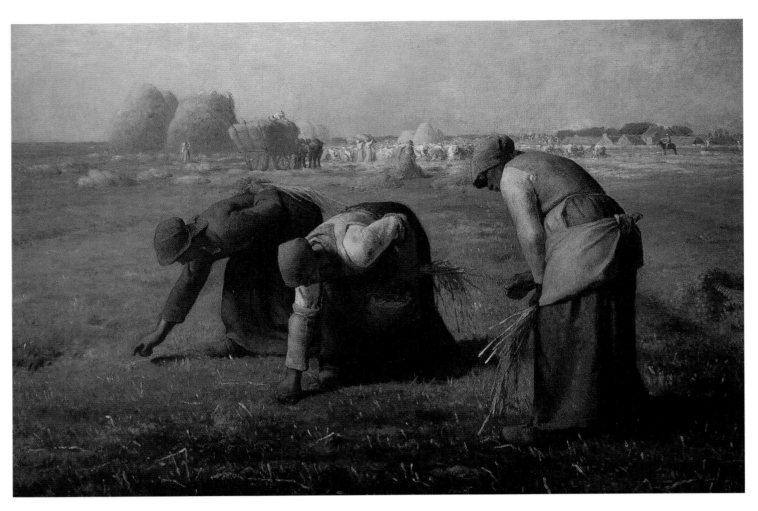

Jean-François Millet. *The Gleaners*. 1857. Oil on canvas. 32 ¾ x 43 ¾ in. (83.5 x 111 cm).

The novelty of the function required architectural innovation, for example, the stations had to reveal their identity in their façades. Great semicircular windows revealed the high, vaulted sheds that were necessary to disperse the billows of foul smoke and vapor emitted by coal-burning, steam-driven locomotives. The French railways and the number of passengers multiplied so rapidly that a second generation of train stations was necessary by midcentury. By then, architects were enchanted with the technical and aesthetic possibilities afforded by improvements in the manufacture of iron. The airy metal-and-glass structures that survive today still display the requisite classical elements, translated into the new medium.

More people were more prosperous; however "philistine," the larger bourgeoisie had more leisure time, and some of it they dedicated to the arts. The Salons were increasingly important social events: in 1801, 268 artists had exhibited 485 works; in 1831, 1,180 artists had shown 3,000 works. In 1841, the magazine *L'Artiste* would declare that one million people had seen that year's exhibition. The École des Beaux-Arts, with six hundred students registered per year, was more influential than ever.

<div align="center">∾ ∾ ∾</div>

At midcentury, Realism was finding a mixed reception. A number of artists, painters such as Courbet, Corot, and Millet, were excited by the explorations suggested by the new expression. The Académie by and large rejected Realism on several counts, but chiefly because their philosophical hierarchy still placed landscapes, genre, and portraiture—the very subjects the Realists were bringing to life—low on the scale. The art establishment on the whole found the literalism of the Realist style earthbound, banal, and just plain ugly.

Some critics differed from the prevailing tastes of the art establishment: in 1857, the art writer and theoretician Jules Castagnary would enthuse: "Nature and man, portraiture and genre painting—in these lie the whole future of art." In addition, the expanding bourgeoisie was an art-buying public that often looked for something more accessible, interesting, or pleasing than what a rarefied circle of academics felt was acceptable. The Barbizon painters sold well.

With significant exceptions, most artists were born into the broadening middle class; at least their early studies and perhaps a sojourn in Italy to study the greats were paid for by families resigned to seeing their sons forsake the more secure professions. Their daughters might properly study at home, but a public life meant notoriety, which only the nobility could afford to ignore. As adults, some of the artists who worked outside the establishment paid a financial price; their financial constraints, along with their gregarious artistic exchanges, occasionally gave their lives a decidedly unbourgeois appearance. Furthermore, because some of these painters and sculptors could not afford to marry, they were considered by right-thinking people to be living "irregular" lives. They became known as Bohemians, at the time a synonym for Gypsies.

"I have just embarked on the great wandering and independent life of the bohemian. . . . Don't think that this is a whim, I have thought about it for a long time. Moreover, it is a serious duty, not only to give an example of freedom and character in art, but also to publicize the art that I undertake." These words, written in 1850, say much about one of the great exponents of Realism, who was also one of the era's most emblematic—and deliberately provocative—figures: Gustave Courbet. In many ways, Courbet's life was a crossroads of the various social, artistic, and political currents of the mid-1800s, and illuminates the art establishment of his time. He also virtually created the stereotype of the hypermasculine, sexually promiscuous bohemian artist.

Jean-Désiré-Gustave Courbet was born in 1819 into a family of rich landowners in eastern France. In 1841, he moved to Paris; ambitious and self-confident, he began submitting paintings to the Salon that same year. At first, he attempted to overcome his provincial accent and manners, and to paint to please the Académie jurors. For the 1844 Salon, for example, he submitted *Lot and His Daughters*, a conventionally prurient biblical subject, which was refused. Interestingly, his more original *Self-Portrait with Black Dog* was accepted that year. In 1848, the Salon jury accepted *Walpurgisnight*, the epitome of a Romantic subject.

It was not long, however, before the young painter—his sculptures were few and somewhat later—decided to turn his unsophisticated, or at least un-Parisian background to his advantage. His letters of the 1840s already reveal his perception that self-promotion was vitally necessary in an increasingly crowded art world. Courbet, who early on formed a friendship with Baudelaire, also frequented Castagnary and another art theorist, Champfleury, author of *Le Réalisme*, inspired by the recently invented daguerreotype, one of the first cameras. In terms of artistic mission, Courbet wanted to do what Millet was doing: to bring the reality of life in his part of the world into the consciousness of a wider audience.

Courbet was a strong and original artist, but history gave him a lucky break as well. In 1848, from Liberia to Seneca Falls to Costa Rica, and throughout Europe, revolutionary insurrectionists took to the streets, many inspired by *The Communist Manifesto*, first published in that year. Also in that year, France was again in upheaval. In Paris, students and workers took the city, declared the Second Republic, and elected Louis Napoléon Bonaparte—nephew of the former emperor—president.

The victory of the Second Republic brought with it a three-year window of liberalism in the arts. In 1848, the Salon jury was suppressed; it would soon be reinstated, but its members would be elected. Over the next three years, paintings by Corot and Théodore Rousseau entered the Musée du Luxembourg, as did the painter-sculptor Rosa Bonheur's near-photographic *Plowing in the Nivernais*. At the Salon of 1849, Courbet won his only gold medal, for *After Dinner in Ornans*; an honor in itself, the medal also exempted him from having to submit his paintings to the Salon jury in the future. *After Dinner in Ornans* was bought by the State for the Musée des Beaux-Arts in Lille, but the ultra-conservative Luxembourg would never exhibit Courbet's work in his lifetime.

To some critics, Courbet's art epitomized everything that was repellent about Realism, yet he showed his work frequently, not only as a regular in the Salon in many years between 1845 and 1870, but at the Paris World's Fairs of 1855 and 1867 and numerous other venues. Eleven paintings by him were accepted for the World's Fair of 1855, but not his large and confusing *Painter's Studio*. In a grand gesture, Courbet set up a Pavilion of Realism for this and other works.

Exposure in the Salons did not guarantee sales, and his enormous real-life-as-history paintings were unsuitable for private homes, so Courbet held his own exhibitions, with paid admission. In addition, he

was a successful portrait and landscape painter and in the 1860s sold many explicit nudes in the Realist manner to Khalil Bey, the Ottoman ambassador in Paris in the 1860s. Caricatured in the bourgeois press, the painter was hugely respected and influential in the avant-garde sector of the art establishment. In the end, it would be the Louvre that recognized Courbet after his death, with the purchase of several works at auction; *Burial in Ornans,* a bequest by one of the painter's sisters, joined the Louvre's collection as well.

<center>∾ ∾ ∾</center>

Paris was one of nineteenth-century Europe's modern cities. Innumerable scientific, mechanical, commercial, and social shifts were taking place in every area of life, and the art world was no exception. For example, artists had long made their own paints, grinding pigments and preparing the medium that would give the desired textures and finishes. Some painters purchased their paints from color merchants, when they could afford it, or customized a prepared mixture with other ingredients. A small metallurgical miracle changed the face of painting when in 1841 the collapsible paint tube, made of tin but later of aluminum, was invented. This meant that a painting could be not only sketched but completed out of doors—*en plein air.*

Mixed to keep pigment and oil in suspension, and to have as long a shelf life as possible, the new mass-produced tube paints had a stiff consistency that was not to every painter's liking. The art they permitted, however, was a leap forward in Realism. After all, as quietly revolutionary as his Realist landscapes were, Constable's painting methods were necessarily absolutely conventional. Like his artist forebears for centuries, he made sketches on site, then returned to finish his paintings in his studio. Now, the process of representation could be seamless: a specific scene in a particular light. Time, literally, entered the picture.

Beginning in the eighteenth century, chemists had discovered a series of elements that brought brilliant colors to the painters' palettes, as would the synthetic pigments at the end of the nineteenth century. Two of these elements had been used for centuries in pottery: cobalt, prized for its deep, bright blue, and zinc, for white. Now, they were processed commercially, as was chromium, which gave a rich orange red, and cadmium, with its blazing sunflower yellow, beloved of Vincent van Gogh. Another tiny improvement—a new kind of paintbrush—would contribute to major art movements. For centuries, brushes had been made of bristles held in a section of quill; now, a soft metal ferrule held the bristles. The metal could be pressed to array the bristles in any shape the painter preferred, to shape the paint as well as spread it. Palette knives, too, were turned to the expanding practice of using paint to raise a third dimension on the support.

Another instrument gave rise to a new art form altogether. Painters had been using something like a camera since the Renaissance, as a tool to aid them in achieving correct proportions in their works. Developed independently and in stages in England and France since the turn of the nineteenth century, the camera that we know combined several mechanical and chemical processes. By the mid-1800s, photography was a widely accepted medium for portraiture: the writer, caricaturist, and photographer Gaspard-Félix Tournachon, better known as Nadar, opened his portrait studio in Paris in 1853; his sitters included celebrities such as the ubiquitous Baudelaire. In England, Julia Cameron was interpreting Romanticism photographically with allegories and illustrations of literary works such as Alfred, Lord Tennyson's *Idylls of the King.* By 1859, the Salon exhibition included photographs.

Photography had the appeal of novelty, and photographic portraits were very popular—not least because they were economically accessible to more people than painted portraits—but the long exposure times tended to make sitters look stilted, if not stuffed. There was, of course, greater status in having one's portrait painted, but many also felt that the painter's eye allowed for more insightful—certainly more flattering—representation of character. Nevertheless, the arrival of photography was a watershed. Realism in art prepared contemporary sensibilities for the art of photography, while photographic realism left the field of three-dimensional physicality to the art of painting. Bringing the physical matter of art to the viewer's attention, while achieving a new kind of illusionism was more than just painterly bravado—it was a materialism as revolutionary in artistic terms as Marx's was in political philosophy.

A key art-world figure emerged at midcentury: the art dealer. In Paris, these dealers were often paint merchants, or their offspring, who, their original trade changed forever by technological advances, now displayed art for sale and held exhibitions. Dealers such as the Bernheims and Paul Durand-Ruel would

encourage artists working outside the Salon system. Though some stretched their own financial resources to support these painters, especially in the early years, others found their galleries to be very profitable. Over the second half of the nineteenth century, and even more in the twentieth, the new art expressions were taken up by the connoisseurs who frequented the galleries. Reviewed by the press and embraced by the liberal art establishment, the independent artists became fashionable, and finally mainstream.

<div align="center">∾ ∾ ∾</div>

Idealism in art was philosophically allied to the monarchy; after all, the king—sovereign by divine right—was the greatest of great men. The bygone Three Estates, the categories that theoretically took in every free person in the kingdom, had been established by Providence. The election of Louis Napoléon Bonaparte in 1848 reflected a widespread ambivalence about abandoning the old order entirely, but it was also an attempt to achieve an equilibrium between republicans and royalists. In the end, repression once more followed upon revolution. Bonaparte, elected president by the will of the people in 1848, three years later staged a successful coup d'état, which was peculiar in that he put his takeover to a vote. The Second Empire was duly endorsed by a majority of the electorate.

In 1853, Napoléon III, as he styled himself, married Eugénie de Montijo, a Spanish countess who established herself as a leader of society, despite what the royalists considered a penchant for vulgar display. The imperial couple's princely tastes in the decorative arts were indeed opulent and plush, a regal continental version of the Victorian style. Eclecticism in furniture design often took the form of elaborate confections that contrasted with the clean, classical references of the First Empire.

The emperor exerted his absolutism in administration: sponsoring extensive and often effective public works in the countryside and the cities. In Paris, Baron Georges-Eugène Haussmann, Prefect of the Seine, supervised the razing of entire *quartiers*, creating today's Paris of monuments and *grands boulevards*. These broad avenues linked areas of the city together and provided handsome vistas, but they also served an explicit military purpose. In a city where the right to assembly was compromised, the boulevards made it possible for the police to observe crowds of any size, and, if those crowds failed to disperse—thus becoming mobs—to fire cannon at them. Some five hundred miles (800 km) of sewers were installed: cholera would never devastate Paris again.

Napoléon III's censorship of public discourse was crushing. Plays were prohibited or mangled, the secret police were everywhere, people could be jailed for private conversations. Perhaps displacing its political frustrations, the public became increasingly vocal in its criticism of the Academy. Suspicion particularly targeted the selection process for the Salon—the Academy accepted on average about half of all submissions, according to criteria that were not always explicit. In 1863, three-fifths of submissions were turned down. The public was irate.

In order to silence the critics of an institution closely associated, though not always allied, with the government, Napoléon permitted a Salon des Refusés, where the public could see works rejected by the Academy. The emperor's intention was to prove the august institution right, and, in fact, the public acknowledged that many of the works in the Salon des Refusés (as in the normal Salons) were mediocre. Among those exhibiting, however, were Eugène Boudin, Paul Cézanne, Henri Fantin-Latour, James McNeill Whistler, and Édouard Manet.

One of Manet's submissions was *Le Bain* (Bathing); four years later, he would change the title to *Déjeuner sur l'herbe*. Under any name, the painting created a scandal. It was far from the first art-world uproar: Géricault's *Raft of the Medusa* and Courbet's *Burial at Ornans* had outraged the public and the conservative critics alike. Here, however, the reaction was of another order. The painting's references are impeccably classical: Titian's *Concert*, which young artists knew from the Louvre, and a print after Raphael's *Judgment of Paris*. This is what offended so many: on one level, the painting is an art-student's joke, a Realist—even Surrealist—joke at the expense of classicism.

This is no nude, but a naked woman, no nymph or allegory, but the model Victorine Meurent. She is unashamedly unclothed, glowing fish-white as if spotlit by a pitiless artificial moon. She boldly, if distractedly, looks out at the viewer (or the painter?), as if turning her attention from her companions'

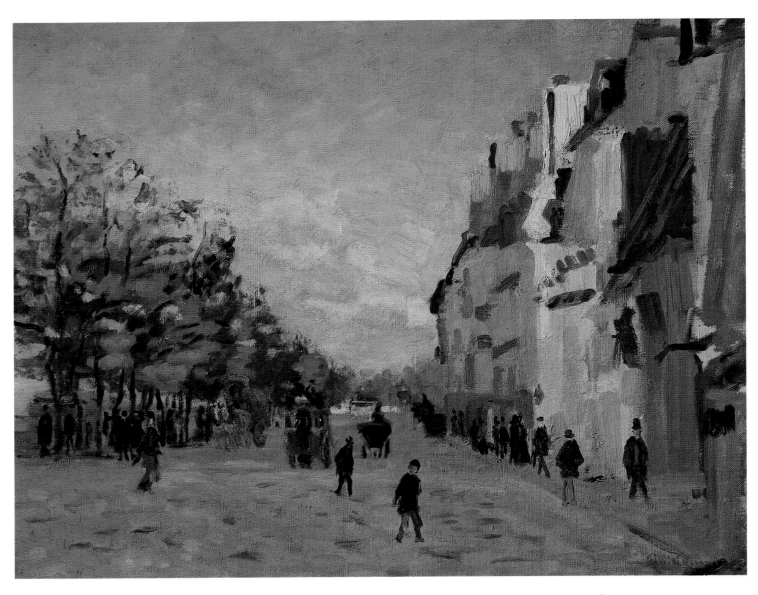

Armand Guillaumin. *Quai de la Gare, Snow.* 1880. Oil on canvas. 19 ⅞ x 24 in. (50.5 x 61.2 cm).

rather sententious discourse for a moment. Her attitude is reflected in the casual modeling and loose, almost indifferent brushwork that describes her male companions and the surrounding nature. By an instant alchemy, this one work, this art-world practical joke, transformed all the myriad dryads and goddesses of classical art, all of Ingres's ideal unclad beauties, into naked women being looked at (painted, sculpted, drawn) by clothed men (artists). This was particularly true of nineteenth-century classical art, which in effect excluded women, forbidden as they were to attend the life classes where they could have worked from nude models—male as well as female.

The tumults of the century had brought the questions of women's rights front and center. Immediately following the Revolution of 1793, the women who had hauled cannon and survived the street-fighting were denied the rights they had struggled and died for, and were barred from all direct political activity. Their male peers declared that women's natures, irrational and vacillating, made them unfit to take part in government, including as voters. Fewer women exhibited in the Salons, even though stereotype attributed to them qualities of elevated morals and empathy, the very qualities that the Academy favored. The aristocratic salonniéres, who presumed to consider themselves the intellectual equals of their male associates (and lovers: the novelist Benjamin Constant was Madame de Staël's companion for more than a decade), were either savagely ridiculed as pretentious and tiresome "bluestockings," condemned as libertines, or—as in the case of Madame de Staël—both.

The increased nakedness of nineteenth-century nudes may have been at times a more or less unconscious response to the dilemma posed by the notion of women's equality: its self-evidence, on the

one hand, versus an array of emotional arguments against it. Realism and, later, Impressionism, both of which had their fair share of nudes, were also the doors through which women re-entered the public art world. One eminent example was Rosa Bonheur, who was appointed director of the Imperial drawing school, and in 1865 became the first woman to receive the Cross of the Legion of Honor—only recently extended to artists at all.

Art inspired by the ancients continued to find favor with the Academy, however, and to hold its place as the official expression in public, governmental, and other institutional buildings, but nowhere more than in the Luxembourg. At the same time, especially by comparison with the attractions of the range of Realist art, Academic art was becoming less and less relevant to more and more people. The cosmopolitan urban artistic and literary circles—not just the Bohemians—ridiculed what they viewed as cumbersome classical compositions, like those of Jean-Paul Laurens, as *art pompier*, "fireman's art." The dismissive term was suggested by the resemblance between the classical helmets of gods and heroes and the more modern headgear of Paris's firefighters.

The Luxembourg's brief, like that of the Louvre, was to show "serious" art that would set an example to other (French) artists and so support a national preeminence. The Luxembourg and other State institutions were still hanging these high-minded but often lifeless depictions, but the world outside their palatial doors was continuing to change. As society became increasingly industrialized, it also became more fluid: the industrious and/or fortunate could amass considerable material rewards and some degree of class mobility. The revolutions of midcentury and the trade unions had shortened the days of many workers; during the brief Second Republic, for example, laundresses successfully demanded a shorter workday. As the result of their efforts the workday was reduced to ten hours, and it may be that the paintings of these women that recur during the second half of the century are tributes to their organizing.

The victories of organized labor improved life for many, but just the same only a few *sous* stood between many more and destitution, and these grim subjects would claim the attention of the naturalist artists and writers. The poor tend to be drab, however, and the heirs to the Barbizon painters were concerned with representing the effects of light and color.

Nature continued to exert its appeal, and few aspects of nature provide more challenges to the students of light than the sea. Boudin, who worked principally on the Normandy coast, was one painter who specialized in the inflections of sunlight on water; Courbet knew him from his own excursions to the area. Another painter who frequented the Normandy coast, especially Honfleur and Le Havre, was Claude Monet, who would become a follower of Boudin and a protegé of Courbet. In the early 1860s, Monet studied briefly with Charles Gleyre, who ran a respected studio in the École des Beaux-Arts, although Gleyre's own work can look pedantic to modern eyes. After showing locally, Monet exhibited at the Salon of 1865, which was Edgar Degas's first as well.

At Gleyre's studio, the twenty-two-year-old Monet had met Pierre-Auguste Renoir, Frédéric Bazille, and Alfred Sisley. The four would form the core group of the "Impressionists," a name coined by a waggish critic in 1874. The Impressionists became a loose association of increasingly individualistic painters pursuing analogous goals through very different techniques. The group would eventually include, among others, Monet, the systematic purist; the good-natured Renoir, an exuberant colorist; the ladylike subversive Berthe Morisot; the boulevardier Degas, a masterly versatile draftsman, painter, and sculptor; the eloquent American aristocrat Mary Cassatt; Bazille, fascinated by the effects of direct light; and Sisley, a transplanted Englishman whose land- and cityscapes display a tenderly modulated palette.

The younger artists were pursuing individual avenues, but they shared a commitment to using their physical materials in such a way as to oblige the viewer to participate in their engagement. The stages in an artwork, a Renaissance convention, were breaking down: the distinction between the immediacy of the sketch and the finished appearance of the completed work was dissolving. Their realism was extending to the surface of the paintings, which was becoming ever more three-dimensional, with visible brushstrokes and sometimes impasto carved with a palette knife. The Impressionists were taking apart and reassembling not only light and color, but perspective and the relationship between figures

and background. Unlike Renaissance paintings, as the viewer approached an Impressionist painting, the illusion crumbled—only to reappear at a given distance.

Because light and color were their priority, rather than any specific subjects per se, the number of possible motifs suddenly proliferated, to include the great variety of daily life. One theme that manifests the group's approach to temporality is clothing, especially women's and children's dresses—a time-honored challenge to an artist's skill. (Edgar Degas's multimedia *Young Dancer of Fourteen* is a particularly complex example.) Besides being occasions for studies of color, textures, and shadows, dresses were indicators of social status that could give artworks an understated subtext, without taking them into the excesses of genre. In the new age of consumer capitalism, fashions changed rapidly and mattered: critics in 1866 admired Monet's greens in the gown of Camille Doncieux, the future Madame Monet. A critic described Manet admiringly as a *couturier*, as well as a painter, for the elegance of his models' costumes. Nothing could have been further from the would-be classical drapery of conservative works.

These were no art-world bad girls and boys. Berthe Morisot and her sister, Edma, were granddaughters of Jean-Honoré Fragonard, the rococo painter ruined by the Revolution. The sisters had studied with Corot, made their copies in the Louvre, and exhibited at the Salon. It was a sign of Edma's professional attitude toward her painting that she abandoned it when she married. (Berthe would not do the same when she married Édouard Manet's brother, nor did her husband expect her to.) In 1864, Morisot, Renoir, and Pissarro exhibited at the Salon; over the next ten years, she and others of the group would be regulars there. Yet, as their experimentation became bolder, the more conservative public became more disconcerted. In 1867, Monet's submissions to the Salon were rejected, and in 1868, only one of two was accepted.

∾ ∾ ∾

The foreign policy of Napoléon III was going from inept to dangerous. His tragically absurd attempt to create a Franco-Mexican empire ended with the puppet-emperor, Maximilian, facing a firing squad in 1867—Manet's painting of the execution, apparently taken from a photograph, was a risky public statement. In 1870, the war with Prussia and Napoléon's surrender at Sedan were the last straw, igniting an uprising in Paris. On September 4, 1870, the Second Empire came to an end, and the Third Republic was proclaimed.

The war, followed by the blood and flames of the Commune, hit the Paris art world hard. At the onset of the troubles in Paris, Courbet had been made head of an artist's committee charged with safeguarding the city's monuments; the postwar government held him responsible for the 1871 destruction of the column of the Place Vendôme. Unable to pay the staggering fine, Courbet fled to Switzerland, where he died in 1877. Bazille was killed in action. Renoir, Degas, and Manet joined the army, although they were never under fire. Pissarro and Monet left France for London for a year, during which they studied the works of Constable and Joseph Mallord William Turner, masters of landscape and light. In London, Monet met James Abbott McNeill Whistler, a veteran of the Salon des Réfusés, and the dealer Paul Durand-Ruel, another French refugee from the war, who would be a faithful supporter of the group.

Postwar France was rife with political tensions, not least because of the German presence, but it was soon a stable republic. The city life that had burgeoned in the previous decade was blossoming. In the 1860s, under Baron Haussmann, Paris had gradually annexed the surrounding suburbs. Woodlands were transformed into the Bois de Vincennes and the Bois de Boulogne, among other masterpieces of contained nature inspired by London's parks. These became places where the bourgeoisie repaired to enjoy their newfound or -won leisure. In town, men and women of the middle classes sought public pleasures in restaurants. With the Paris World's Fair of 1867, government censorship relaxed, and music halls, theaters, and cafés-chantants multiplied.

The avant-garde painters were making domestic art. They were looking around themselves and at each other, examining the faces, postures, and gestures of family, friends, and leisure in the new urban surroundings—including the parks. Their paintings are remarkably often *about* looking: people at the theater, the ballet, the opera. These were places where people went to appear as much as to enjoy, that is, to be objects of gazes, as much as subjects of experience. Morisot's famous *Cradle* shows Edma looking at her baby; it is a quietly radical work because the new mother's expression is not one of mindless rapture, but

of thoughtfulness. Cassatt's paintings of maternal joy display not thought but plenitude and transcendence. Renoir, one of the few working-class artists in the group, affectionately depicted less chic, even provincial subjects—hints of ways of life that were passing away.

The friends' first collective exhibition was in 1874, at Nadar's former photography studio. (The column of the place Vendôme was re-erected that year.) The press picked up a critic's joke, and thenceforth called the group "Impressionists," but they themselves would only adopt the name for their third exhibition, in 1877. At the first officially Impressionist exhibition, Monet exhibited seven of a series of twelve canvases titled *La Gare Saint-Lazare*, showing, in billows of smoke, the station's shed and beyond it, Haussmann's brand new Paris. Monet knew this particular *gare* very well: it was the station from which trains left for the Normandy coast, where he had been painting for more than a decade, and near which he had taken a studio the previous January. The scumbled brushstrokes effectively reinforce the feeling of energy and power suggested by the subject, while the open sky gives a sense of expansive possibility. Émile Zola, best known for his Naturalist novels, was also a critic who defended the painters of the avant-garde. In an article about Monet's Gare Saint-Lazare paintings he wrote: "This is what painting today is all about . . . our artists must find the poetry of the railway station, just as their fathers found that of the woods and rivers."

In all, the Impressionists, in various configurations, would hold eight shows; the last in 1886. Not all the group exhibited at all the shows—Morisot and Renoir abstained more than once. Manet never showed with them, but continued to assail and court the Academy Salon; his last Salon was in 1882, the year before his death.

The 1880s were a crucial decade, one in which artistic currents reached new visual junctures, and a variety of expressions emerged, often antithetical to one another. The Luxembourg continued to resist the avant-garde that was massing at the gates of the establishment, although the museum allowed in a trickle of the

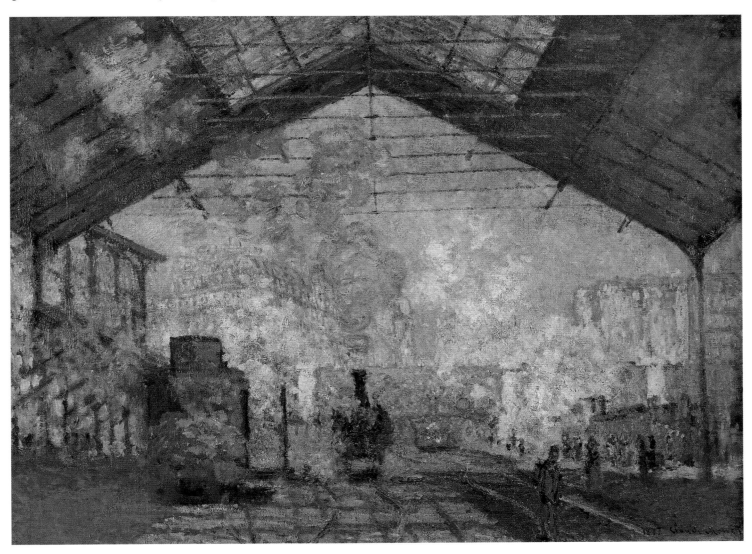

Claude Monet. *Gare Saint-Lazare.* 1877. Oil on canvas. 29 ¾ x 41 in. (75.5 x 104 cm).

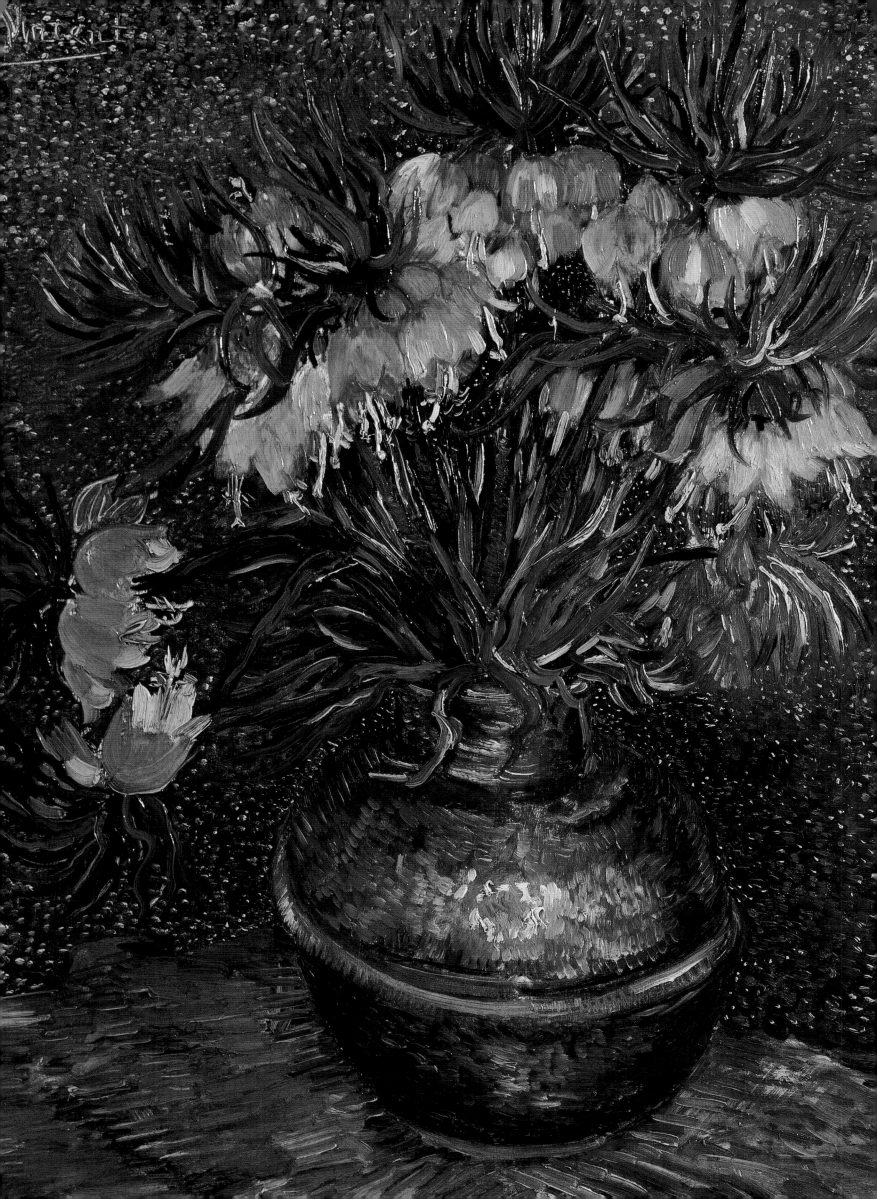

more anodyne works of the less confrontational artists. Nevertheless, the Luxembourg's collection grew so large that in 1886 it required more room than the building—by then the seat of government—could provide, even with an additional museum created within the palace that year. The government looked to the two Second Empire jewels that signaled the western end of the Tuileries terrace: the Jeu de Paume, which housed the imperial tennis court, and the Orangerie, a conservatory. The latter was selected to house the Luxembourg's prestigious overflow, although the Jeu de Paume would be similarly requisitioned later on.

One Impressionist direction led to a darkening of the palette, a quality often appearing in Realist and Romantic paintings of the age as well. Monet's series became more systematic: he would set up canvases for each of several times of day and paint them in sequence, as the light changed. These projects sometimes involved Monet, then in his mid-forties, hiking to remote areas, hauling several canvases on his back, as well as an easel and other paraphernalia. His seascapes of the cliffs at Étretat show a treatment of the surface of the sea made up of discrete dabs of juxtaposed paint. Other artists elaborated from Manet's outlines and broad, flat areas of color. Vincent van Gogh would push both techniques.

The museums of the Louvre and the Luxembourg had both been established to train artists who would bring renown to French painting and sculpture. And indeed, hundreds of painters copied some of the world's greatest art from the walls of the Louvre, while others were spiritual descendants of the solemn Luxembourg collections. Ironically, however, those who made Paris the Mecca for artists that it was, were precisely those whom the Luxembourg would largely ignore. Van Gogh was only one of many who came to the French capital because he was drawn by the imaginative and collegial ferment. He had begun painting in 1881; his palette and subjects lightened considerably after 1886, when he came to Paris to join his brother Théo, who worked for an art dealer. Vincent was drawn to the Impressionists, taking from them a preoccupation with surface texture and the limits of color. His palette, however, reached pure, straight-from-the-tubes colors; as violent in their brilliance and juxtaposition as his brushwork, they represented an explicit emotional lexicon that Van Gogh had constructed.

A self-portrait from 1889—one of the last before his suicide the following year—used wavy vertical lines of blue as a kind of projection of emotion or spirit, one expression of the Symbolism that was increasingly coming to the fore. Even though schools continued to form, and "isms" to proliferate, the individuality of the 1870s was, in a way, a movement in itself. A Symbolist manifesto stating the style's philosophy was published in 1886, but the manner was often combined with other strains. Romanticism, for example, took on Symbolist overtones, becoming dramatic, even melodramatic, with storm-lit crags, scary woods, and decayed ruins standing in for the chiaroscuro heights and depths of human sensibility.

In 1866, Gustave Moreau had a hit at the Salon with his *Orpheus*. Critics and Symbolist artists admired the poetry that they discerned in the refinement of the painter's tints—a souvenir of his Italian sojourn—and the delicacy of his allusion to the immortality of art. They found poetry, too, in the medieval overtones of the Thracian girl's costume, which recalls the Pre-Raphaelite aesthetic across the Channel. Ten years later, Moreau's watercolor series *The Apparition* iterated the severed head theme in a flashy, over-the-top manifesto of Orientalist Romanticism. Another vein of Symbolism appeared in the work of Pierre Puvis de Chavannes, who brought a brooding never-neverland lyricism and fin-de-siècle, slightly weary pastel shades to Ingres's classicism. Photography, with its silver and rich gray-black tints, particularly lent itself to evocative, even eerie Symbolist images.

Paul Cézanne was another Post-Impressionist artist who blazed new paths. His deconstructions were less of light than of the geometry of reality—of shapes and colors. Unlike Cézanne's former associates, who sought to transfer a specific moment in time onto canvas, his works reveal an almost Platonic absence of temporality. Cézanne would take his experiments to the very edge of abstraction, a platform from which a future generation would take off. Gauguin's explorations were not so much analytical as synthetic; this was, in fact, the term employed to describe his paintings and those of the other artists who met, between 1886 and 1888, in Pont-Aven, a village on the coast of Brittany. Gauguin, Émile Bernard, and others abandoned conventional perspective in favor of edged areas of saturated colors. Gauguin would take this technique into his Tahitian paintings and sculpture.

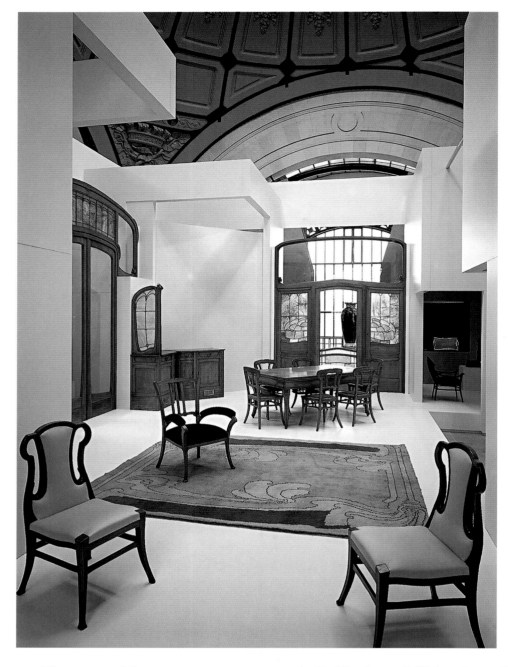

P. 28
Vincent van Gogh. *Imperial Crown Fritillaries in a Copper Vase.* 1887. Oil on canvas. 28 ¾ x 23 ¾ in. (73 x 60.5 cm).

LEFT
Interior view of an Art Deco furniture gallery.

OPPOSITE
Interior view of a painting gallery.

The art world was ever more open to individual sensibilities, from Odilon Redon's evocative manifestations of mystical states, to Henri de Toulouse-Lautrec's insightful and energetic sketches of the Impressionists' lively world—a few classes down. One of the most original in subject matter and treatment was the late-nineteenth-century exponent of outsider art, Henri Rousseau, who was both admired by his fellow artists and patronized by them. They nicknamed him *le Douanier*, "the customs officer," because that was his lifetime job; he only began painting full time after he retired in 1893.

The Impressionist concerns were far from forsaken, however. Georges Seurat is perhaps the best-known of the artists, later called Neo-Impressionists, who were dedicated to pointillism, or divisionism, a breakdown of color inspired by contemporary scientific treatises. Seurat's tour-de-force was to create scenes, often of traditional Impressionist subjects, that evince movement, light, and feeling—and then disintegrate before the viewer's eye. Henri Matisse, whose protean versatility would embrace a number of techniques and expressions over his long career, was inspired to do his own pointillist experiment after the turn of the century: the enchanting *Luxe, Calme, et Volupté*, its wistful title borrowed from a poem by Baudelaire. In the years before World War I, critics would label Matisse and others *fauves*, wild beasts, for applying what Matisse, in writing about *Luxe, Calme, et Volupté*, described as the "pure colors of the rainbow."

The nabi group, which emerged in 1888, was an association of friends dedicated to a new art—*nabi* means prophet in Hebrew. The group included, among others, the painters Pierre Bonnard, Édouard

Vuillard, and Maurice Denis, and the painter-turned-sculptor Aristide Maillol. They moved away from easel art toward a decorative expression that combined Gauguin's broad areas of color and the Japanese ornamentality that had influenced Cassatt, Van Gogh, and many others. Denis's sinuous lines of the early 1890s in particular foreshadowed the serpentine forms of Art Nouveau.

Naturalism, an inheritor of genre paintings, tended toward dark shades and narrative content that could tip into narrative and morbidity. Narrative and fantasy soon characterized the century's latecomer, the cinema, which emerged in the 1890s. Generally considered the first film, a short documentary by the Lumière brothers featured the arrival of a train into the La Ciotat station, in southern France. In no time, however, films were movies, traveling into space in works such as the antic *Journey to the Moon*, by the former magician Georges Méliès.

The decorative arts at the end of the century were evolving toward a more spare silhouette. This was not only due to a reaction against the fussy, elaborate constructions of the Second Empire, but to a taste acquired over two generations of the simpler lines of industrially manufactured furniture. Another response to the industrial age was produced by William Morris in England and other designers throughout Europe, who were reintroducing natural materials and shapes and evident handcrafting. Artisans working in glass, porcelain, metal, and wood turned out one-of-a-kind pieces for those who could afford them.

Sculpture was shaking off its classical strictures, albeit slowly—allegorical nudes still held pride of place in public art. Jean-Léon Gérôme reinterpreted classicism with *Tanagra*, which shocked the more conservative viewers at the 1890 Salon, because some parts, now lost, were polychrome, in imitation of ancient art as it really was. Exoticism found restrained expression in the use of stones of mixed colors, less boldly, in the end, than in Charles Cordier's *Negro of the Sudan* of 1857, a stunning portrait bust in bronze and onyx.

A universe away from the lithe architectural whimsy of Carpeaux's *Dance* was the undisputed star of late-nineteenth-century sculpture. Far from renouncing the Realism for which he was reviled at the Salon

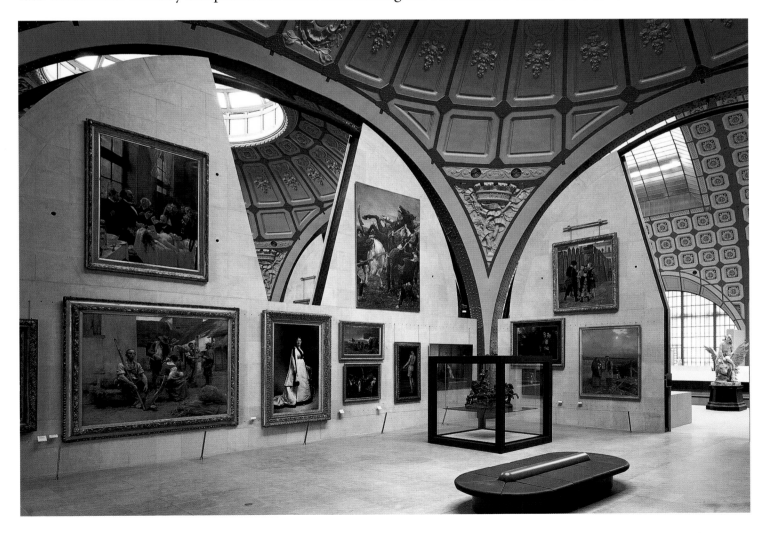

of 1877, Auguste Rodin only further condensed its fierce effects. Beside his society portraits and busts of Victor Hugo, George Bernard Shaw, and others, is his almost stylized *Balzac*, clothed at the demand of the association that had commissioned it.

∾ ∾ ∾

The end of the century swept away many of the artists who had made it great; their works began to arrive at the museums of Paris—still causing raging controversy. In 1896, Gustave Caillebotte, the wealthy painter and faithful supporter of the Impressionists, left an invaluable legacy of Impressionist paintings and drawings to the Luxembourg. Although the national committee of museum curators accepted his bequest of sixty-seven works by Degas, Manet, Cézanne, Monet, Renoir, Sisley, and Pissarro, it aroused bitter contention; in the end, only thirty-eight were accepted. It is hard to believe that the gentlemanly but maybe mischievous Caillebotte did not foresee the dissension his generosity would arouse, or was perhaps intended to arouse. When Impressionist paintings and drawings from the Caillebotte bequest were given a room in the Orangerie, the Académie des Beaux-Arts lodged an official protest, objecting to the fact that paintings that were "flawed to the point of extravagance" would be displayed side by side with "the finest examples of contemporary French art."

From the turn of the century to the years following World War I, so many works by foreign artists were entering the Luxembourg that another annex opened, this one in the Jeu de Paume. The Louvre was also receiving modern works, notably a collection of the 1830 school. With a major bequest of 1911, the Impressionists were accepted by the official art establishment. In 1927, Monet's *Waterlilies*, originally painted to decorate a friend's dining room, had gone to the Orangerie, which would also exhibit contemporary art until 1978. The Luxembourg's Impressionist collection went to the Louvre in 1929, while over the next several years many of the Academic paintings and sculptures of the nineteenth century were distributed to public institutions throughout France, or simply put into storage.

In 1937, the Musée du Luxembourg closed its doors for good, replaced by the Musée d'Art Moderne, housed in the Palais de Tokyo, which had been built for the World's Fair of that year. It was not until 1946, after the war, however, that the museum would finally display its unparalleled holding of art since 1890—but without some of the nineteenth century's great artists, such as Seurat and Gauguin. In the same year, the Jeu de Paume opened with the Louvre's Impressionist collection, the light-filled portrayals of Parisian life and leisure shining in a newly liberated Paris.

Over the following two and a half decades, bequests, gifts, and the arrival of works from Japanese collectors, following the peace treaty with Japan, poured into the Jeu de Paume. At the same time, the popularity of Impressionism was exploding, as were the numbers of national and international travellers, beginning in the 1960s. The Jeu de Paume was no longer adequate to either the size of its holdings or the size of the public that came to see them.

In 1976, the Musée d'Art Moderne, its collections redefined, moved to the Centre Georges Pompidou. The new museum's program excluded paintings of the Pont-Aven group, the Neo-Impressionists, and the nabi group, as well as turn-of-the-century works that changes in taste had long relegated to provincial museums—or even storage. The question arose: Where would the exiled works go?

∾ ∾ ∾

On May 23, 1871, during the fiercest days of the uprisings, the Communards had set fire to the Tuileries, reducing the royal palace to ruins; the following day, flames consumed the Palais d'Orsay. The Tuileries were left in ruins for more than ten years, the Palais d'Orsay for almost thirty. The cost of restoring the Palais to its original function was prohibitive. A less radical renovation would render the building habitable by the planned Musée des Arts Décoratifs, and the project proceeded accordingly. In 1880, August Rodin was commissioned to sculpt *La Porte de l'Enfer*, the cast of which, by coincidence, is exhibited today in the Musée d'Orsay. The plan was abandoned.

As was the site. An overgrown urban forest primeval, it became a popular destination for late-nineteenth-century Romantics, like the friend of an unnamed reporter for *La Revue Illustrée*:

Auguste Rodin. *The Gates of Hell*, detail *The Thinker*. 1880–1917. Bronze. *Gates*, 267 ¾ x 157 ½ x 33 ½ in. (680 x 400 x 85 cm).

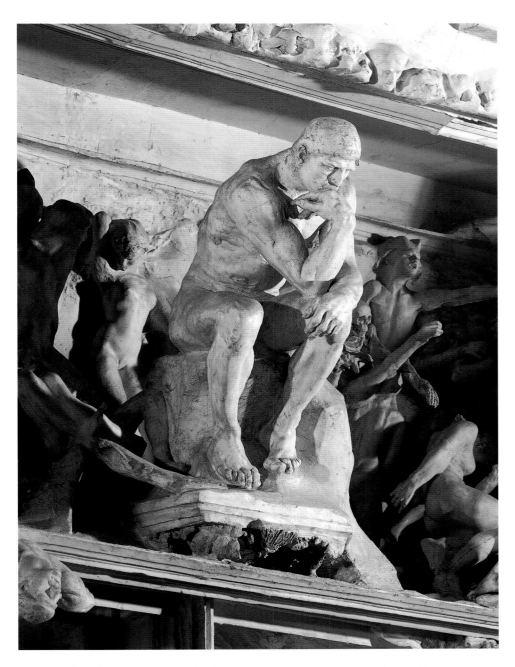

He marvels at the astonishing vegetation that has sprung up in less than seventeen years: brambles barring the windows, mosses clinging to the pilasters, grass growing thickly in the cracks; a virgin forest . . . all endowing this very recent rubble with the appearance of the most beautiful of ancient ruins.

With the World's Fair of 1900 looming, the government was particularly anxious to see something built on so eminent and visible a site. Such an eyesore, directly across the Seine from the Tuileries gardens and the Palais du Louvre, could not be tolerated.

The Compagnie des Chemins de Fer d'Orléans was equally anxious to build a railway terminus in the center of Paris, as the other railroad companies had been doing. The CCFO's Gare d'Austerlitz, most recently rebuilt in 1865–69, was inconveniently located in the then-remote southeastern part of the city. The lot on the Quai d'Orsay offered both location and prestige, and the deal was made.

In 1898, the CCFO selected their architect: Victor Laloux, a professor of architecture at the École des Beaux-Arts who had won the 1878 Grand Prix de Rome. His proposal, which had come in just under the deadline, was the most ambitious of those submitted, calling for a station with a major hotel attached on the side of the rue de Bellechasse. No sooner was Laloux's proposal accepted than the ruins of the Revolutionary barracks and Napoleon's government office building were cleared. Painful reminders of the ravages and reprisals of the Commune, the architectural salvage—columns, candelabras, balconies, and statuary—was sold at auction.

Laloux had two years to complete a monumental undertaking. Like all train stations, the Gare d'Orléans would be a vast complex, serving a number of purposes and recognizing several social distinctions. It would require at least the usual three waiting rooms, one for each class of compartment; ticket windows; shipping offices; baggage checks; and a lobby. Because the adjoining hotel would have its own restaurant, however, the station would dispense with having one of its own.

Time was tight, and the stakes were high. Because of the aristocratic surroundings of the *gare*, the building could not display externally the still-radical iron architecture in use for half a century in projects from train stations to churches to the bustling market of Les Halles. The architectural fashion of the moment was the thermal bath of antiquity, the vast, vaulted halls of the Roman baths of Caracalla or Diocletian. Laloux's originality lay in combining the style with another classical expression, the basilica, and applying the hybrid design to a train station. Train stations typically had high roofs, to allow the smoke and vapor to disperse; at the Gare d'Orléans, the high shed was not, strictly speaking, necessary, because the trains would be hauled from the new station to the Gare d'Austerlitz by the electric locomotives that the Parisians fondly called "salt boxes." At the Gare d'Austerlitz, the trains would be coupled onto conventional coal-burning, steam-driven engines. The vaulted roof was, however, a much more aristocratic treatment, and the noble example of the Palais de la Légion d'Honneur—the former Hôtel de Salm—across the rue de Bellechasse, was never far from the architect's mind. The monumental volumes and "thermal" design would be borrowed in the United States especially for several of the nation's most impressive termini—New York's Grand Central and much-lamented Pennsylvania stations and Washington, D.C.'s Union Station. Inside, the ceiling was decorated with elegant, painted floral stucco coffers. Today's striking juxtapositions of metal and stucco at the junctions of the supports and the ceiling create a felicitous surrounding for the Musée d'Orsay's galleries of decorative arts.

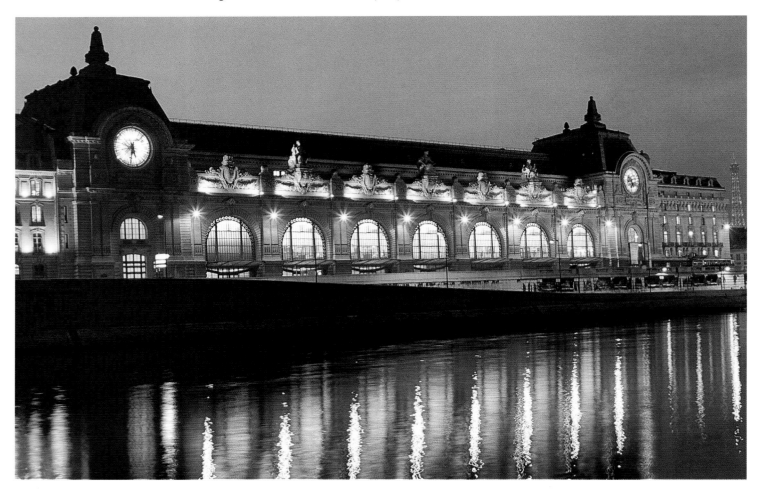

ABOVE Exterior view of the d'Orsay at night, reflecting off the Seine.
OPPOSITE Édouard Vuillard. *Chapel in Versailles*. 1917–19, reworked 1928. Oil on paper on canvas. 37 ⅞ x 26 in. (96 x 66 cm).

The interior of the station fulfilled its purposes gracefully and rationally. On the outside, however, its functionality was too evident in its extended horizontality. Laloux applied a solution from his own design for the Tours train station, by breaking up the Seine-side façade with seven glassed-in arcades. He accentuated the vertical with another railway architecture convention: allegorical sculptures representing the principal cities served by the Compagnie de Chemin de Fer d'Orléans—Madame Laloux was the model for the face of the statue depicting Nantes. Silhouetted against the sky, they lighten the building's mass.

On the hotel side, on the rue de Bellechasse, Laloux placed two pavilions whose architecture referred directly to those of the Louvre, just across the river. The Hôtel du Palais d'Orsay was intended to be the grand hotel for the 1900 World's Fair, and grand it was. It had 370 rooms, nearly all with bathrooms—an unusual luxury for the time—as well as the restaurant, a reception hall, a reading room, and a smoking room. Thomas Mann in 1926 provided a snob's-eye view of the hotel's amenities:

> It is . . . where the Parisian middle class comes to celebrate—the scene of wedding dinners, association balls, and other exciting ceremonies. At least one such takes place here every day. On the various landings, dress-coated servants, gold chains at their necks, greet and direct you. Young people flirt on the stairs, and the music is deplorable.

Mann was no doubt appalled by what he considered the déclassé opulence of the interiors, a confectionary mix of Louis XIV, XV, and XVI, a symphony of chandeliers, ornate woodwork, gilt stuccoes, and decorative paintings by Academy artists such as Fernand Cormon. Today, the museum's restaurant, which occupies the same site as the hotel's, retains many of the swags and grandeur of the original, providing a nostalgic contrast with the sleek lines of the concourse.

Construction went on around the clock: three hundred workers laboring during the day took turns with a crew of eighty at night. These unnamed workers broke all records, and the Gare d'Orsay was inaugurated on July 14, 1900. Another architectural marvel built for the World's Fair of that year was the Grand Palais, a breathtaking glass-roofed exhibition hall dedicated to French art. The painter Édouard Détaille—today represented in the Musée d'Orsay—commented humorously of the two edifices: "The train station is splendid; it looks like a Palace of the Fine Arts. Since the [Grand Palais] looks like a train station, I suggest that Laloux switch their purposes while there's still time."

For almost forty years, nearly two hundred trains a day pulled out of the Gare d'Orsay. The times were leaving it behind, however. As electric locomotives phased out their coal-burning predecessors, the trains became longer—too long for the gare's platforms. As early as 1929, the now-nationalized French railroad system planned to close the station down, and turn the physical plant to other uses: in 1935, a modern arena was proposed. In 1939, all long-distance train travel in and out of the terminus ceased; it now served only the Parisian suburbs. The great space was all but abandoned.

Over the following decades, the station would serve as a wartime and postwar clearing station; a film set; a theater; and an auction house. In 1958, General de Gaulle announced his return to politics in the hotel's reception hall. Nevertheless, since the 1960s, plans had been afoot to demolish the complex and replace it with a luxury hotel. In 1970, the government gave its permission to tear down the gare.

A twist of fate saved this unique monument—this time, a peaceable uprising on the part of the Parisians. Spurred by the demolition of their beloved Halles in 1972, the people refused to allow another architectural prize to disappear. In 1973, the hotel closed, but the ensemble of buildings was entered in the supplemental register of historic monuments; in 1978, they received landmark status.

Détaille's jest came true: the Gare d'Orsay was assigned to house the State's orphaned artworks from the mid-nineteenth century to the early twentieth. The winner of the design competition was ACT Architecture, a French firm whose overall vision gave its shape to today's museum. Much of the team's work consisted of conservation: Laloux's metal columns and beams and stucco coffers were stripped and restored, and the coffers integrated into the massive ventilation and acoustical systems. The hotel's former lobby today welcomes more than two million visitors a year.

The Italian designer Gae Aulenti, a master of architectural reuse, was commissioned to organize the interiors, in consultation with the curatorial staff of the new museum. Aulenti's plan works seamlessly with ACT's—the designer's postmodern slabs are as classic in their way as the station itself. The most important part of the interior architecture, however, is the management of light by means of a combination of natural and artificial illumination and a system of shades and baffles that protects the artworks from direct sunlight.

The Musée d'Orsay, begun under the administration of Valéry Giscard d'Estaing, was opened in 1986 by his successor, François Mittérand, inventor of the Grand Louvre. The great bronze station clock in its wall of glass brick has looked over the colossal nave for a century; where once the "salt boxes" busily pulled trains in and out, the bright sculpture promenade rises to Carpeaux's lithe figures dancing to their eternal melody. The museum fulfills the station's turn-of-the-century grandeur, its high vaults literally shedding light on the collection of which it is a part. Itself a work of the imagination, the museum offers a unique portrait of the rich and complex period when art—and the world—became modern.

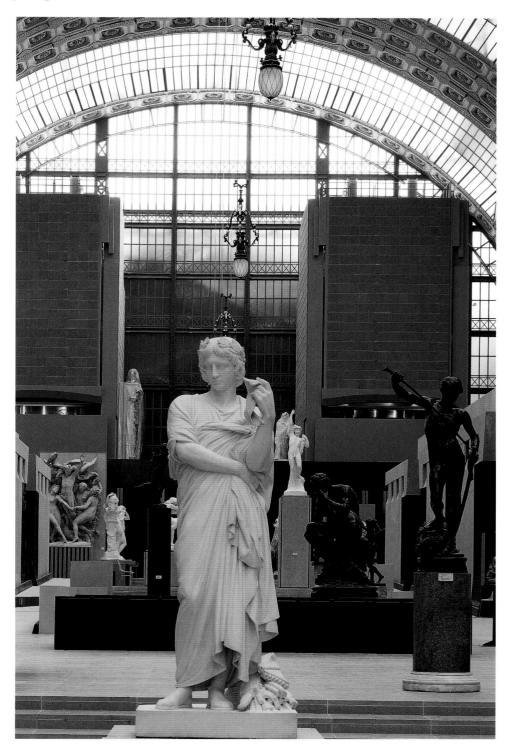

Interior view of an upper concourse sculpture gallery, featuring Gabriel-Jules Thomas's *Virgil* in the foreground, commissioned for the Cour Carrée of the Louvre in 1859, and set there from 1865 until 1874.

~ Paintings

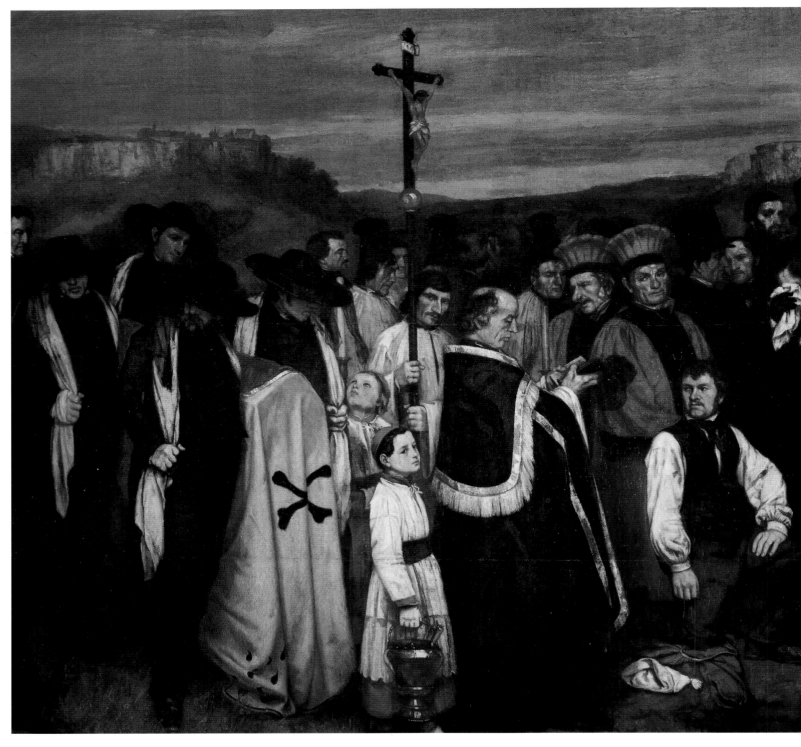

Gustave Courbet. *Burial at Ornans.* 1849–50. Oil on canvas. 243 ½ x 513 in. (314 x 663 cm).

The work, which shocked the public and critics alike, demonstrates Courbet's mastery of color. Delacroix, among others, was appalled by the painting's vulgarity, while admiring certain "superb details; the priests, the choirboys, the jug of holy water and the weeping women."

P. 38
Claude Monet. *La Rue Montorgueil, Decked out with Flags, 30 June 1878.* (detail) 1878. Oil on canvas. 32 x 20 in. (81 x 50.5 cm).

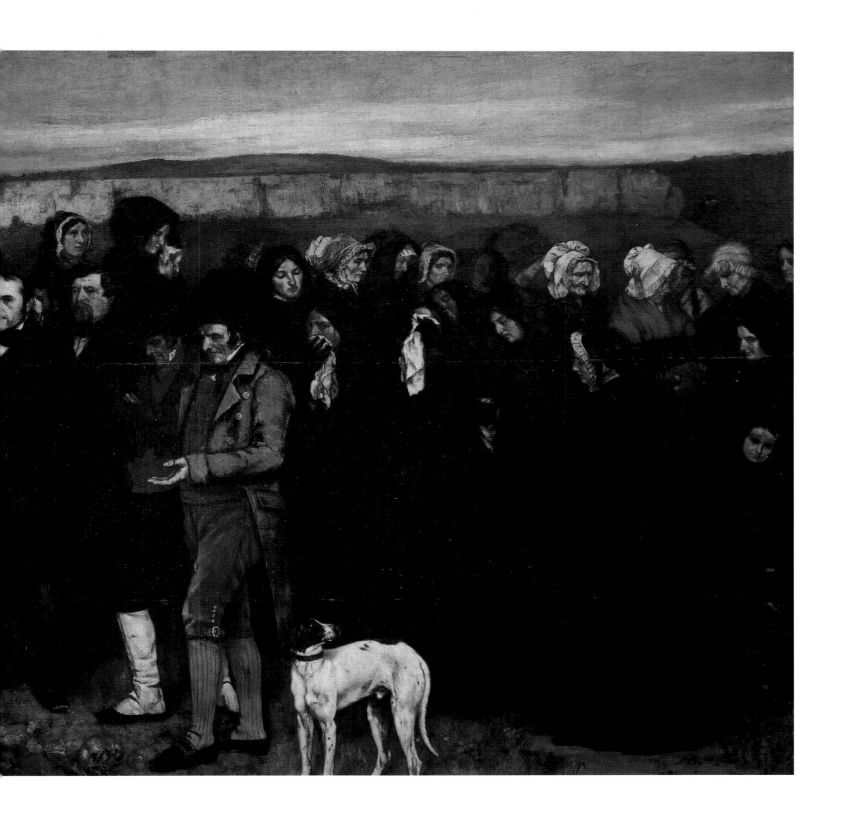

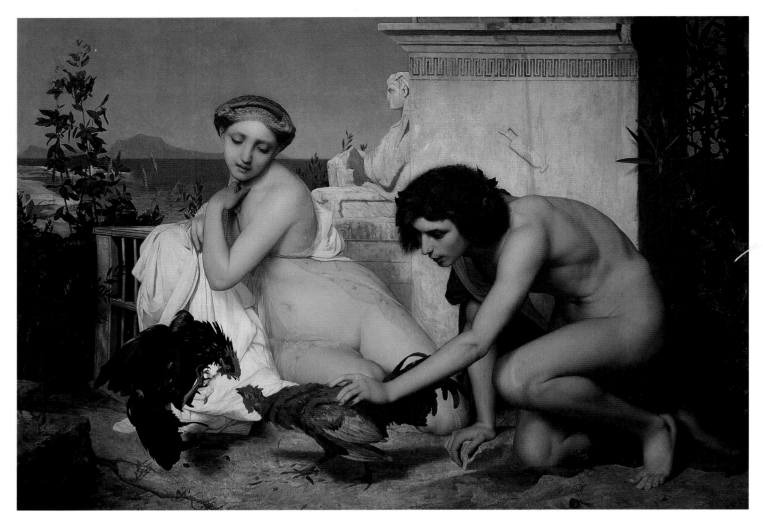

Jean-Léon Gérôme. *Young Greeks at a Cockfight*. 1846. Oil on canvas. 56 ¼ x 80 ¼ in. (142.9 x 203.8 cm).

Gérôme, one of Ingres's great admirers, was twenty when this painting achieved success at the 1847 Salon. The artist was famous for his classically inspired genre and fantasy scenes, although the critic Champfleury criticized the work for combining "marble figures" and animals "of flesh and blood."

Thomas Couture. *The Romans of the Decadence*. 1847. Oil on canvas. 185 ¾ x 304 in. (472 x 772 cm).

Commissioned by the government in 1846, this work, a paragon of eclecticism, was exhibited in the 1847 Salon, and later hung in the Musée du Luxembourg. Despite its ostensible moralizing and its classical references, the painting's prurient intent is obvious, and a number of viewers found it trivial. Manet was a regular visitor to Couture's studio, and the elder artist's treatment of some faces, for example, may be seen in the younger painter's work.

Rosa Bonheur. *Plowing in the Nivernais*. 1849. Oil on canvas. 69 x 104 in. (175.3 x 264.2 cm).

Bonheur, an internationally celebrated painter and sculptor, specialized in the portrayal of animals. The cattle are, in fact, the stars of this work, commissioned by the State in 1848. Although she was the daughter of a feminist Socialist, Bonheur's sunny photographic realism is free of social commentary.

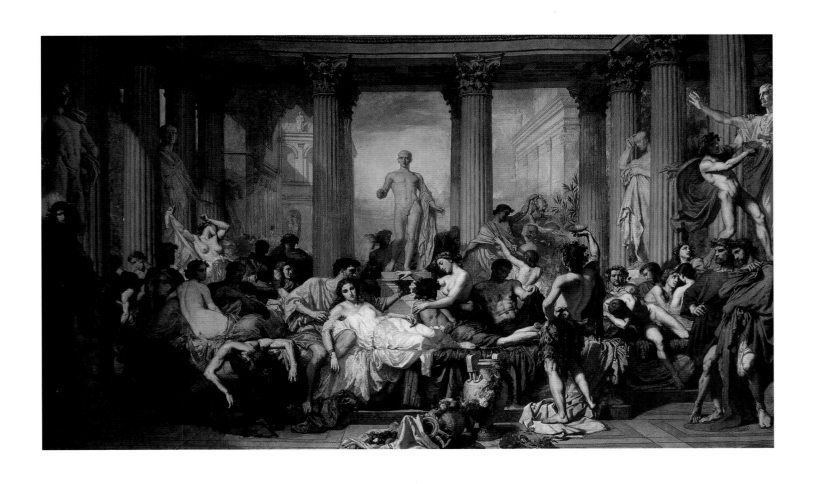

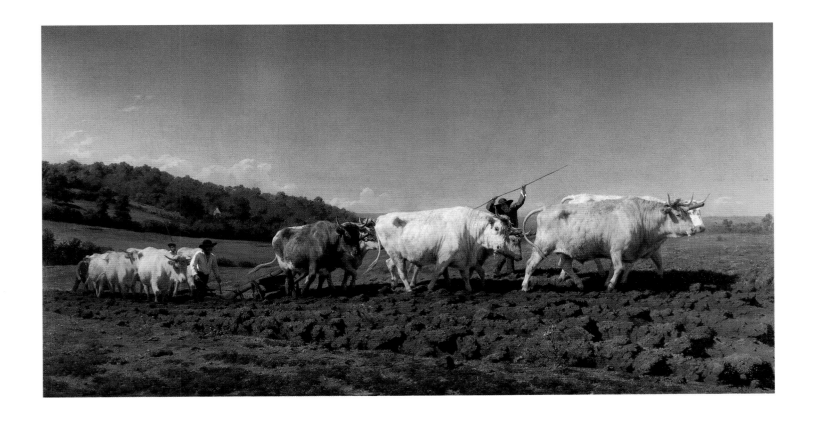

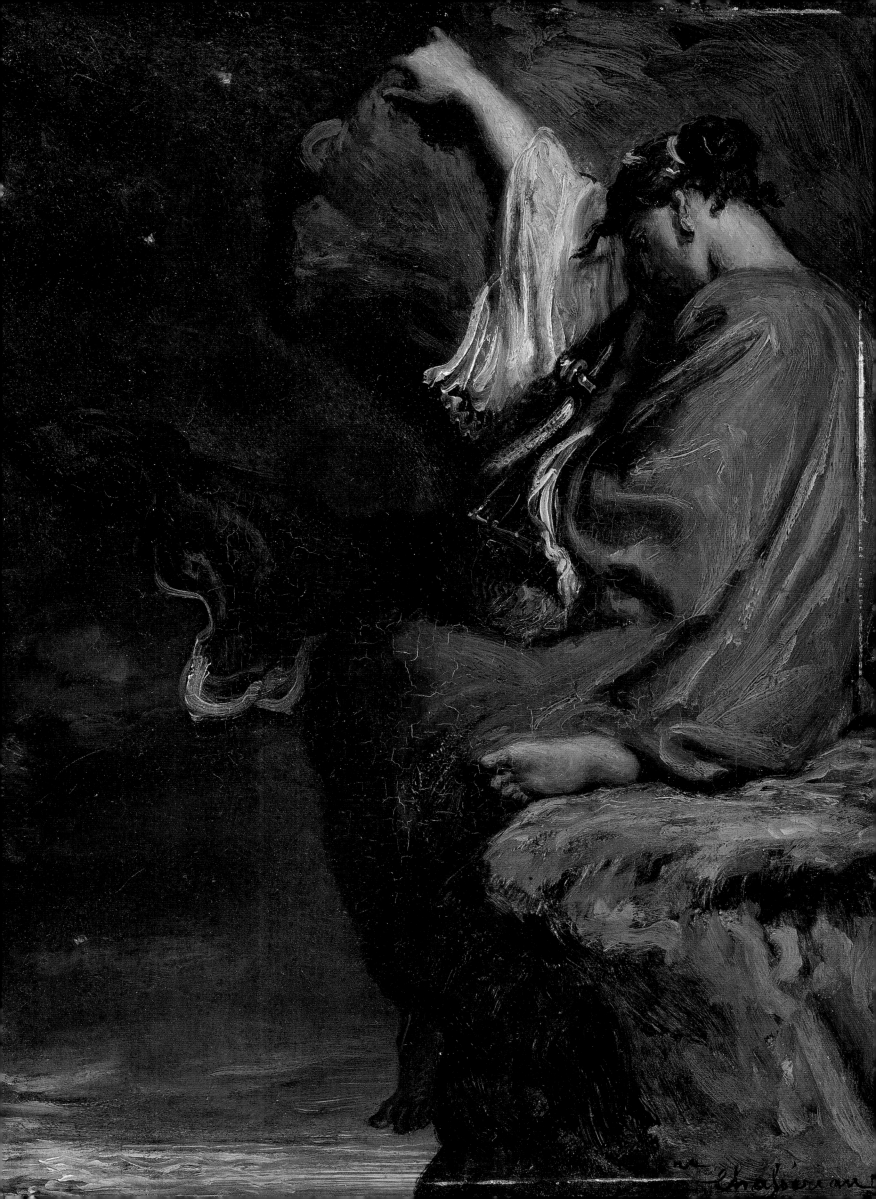

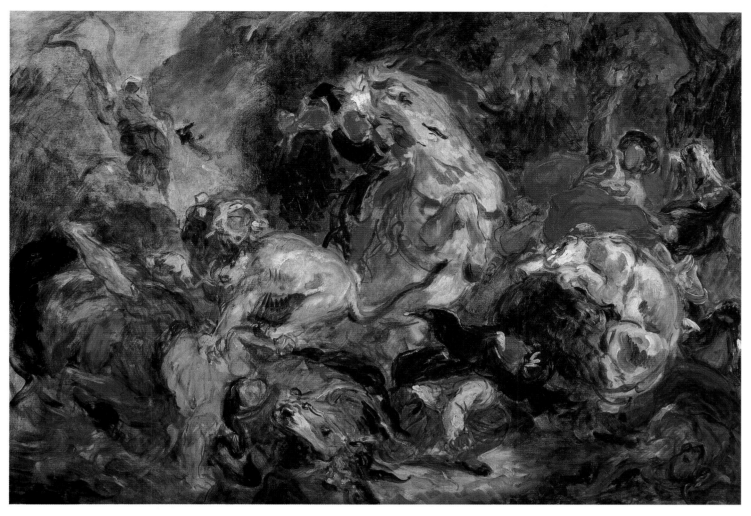

Eugène Delacroix. *The Lion Hunt.* 1854. Oil on canvas. 33 ⅞ x 45 ¼ in. (86 x 115 cm).

This preparatory oil sketch was made for a painting, shown at the 1855 Paris World's Fair, that inspired Baudelaire to exclaim in his review: "Never have lovelier, more intense colors penetrated to the human soul by way of human eyes." Action becomes color in a work inspired by the artist's travels in North Africa.

Théodore Chassériau. *Sapho* [sic]. 1848. Oil on canvas. 10 ¾ x 8 ½ in. (27.5 x 21.5 cm).

The ancient Greeks considered her poetry the equal of Homer's; Plato called her "the tenth Muse." Chassériau's Sappho combines a Neoclassical subject with a touch of exoticism in her coloring, features, and majestic robes, her introspection standing for the artist's creative interior life.

Isidore Pils. *Deathbed of a Sister of Charity*. 1850. Oil on canvas. 95 x 120 in. (241 x 305 cm).

Pils's religious genre scene and the large dimensions dedicated to it were something new. The artist's realism manages to accommodate the lividity of the dying nun's hands, the unromantic poverty of those who attend her, and the mysterious glow of grace illuminating the middle of the painting.

Jean-Léon Gérôme. *Night*. 1850–55. Oil on canvas. 30 x 18 in. (76.5 x 46 cm).

The flying figure with its billowing drapery is rendered in a perspective that recalls some of the virtuoso allegorical compositions of the Italian Baroque. At the same time, the Neo-Greek young artist's clear colors and high finish bear witness to his admiration for Ingres's ideal nudes.

Charles Daubigny. *The Harvest*. 1851. Oil on canvas. 53 ¼ x 77 ¼ in. (135 x 196 cm).

Daubigny, who worked in Barbizon after 1843, was one of the first French artists to seek to paint the ephemeral. In this, as in his light, clear tones and bold couplings of colors, he would influence the Impressionists. Elected a juror of the Salon in 1864, he actively supported Manet and his Realist circle.

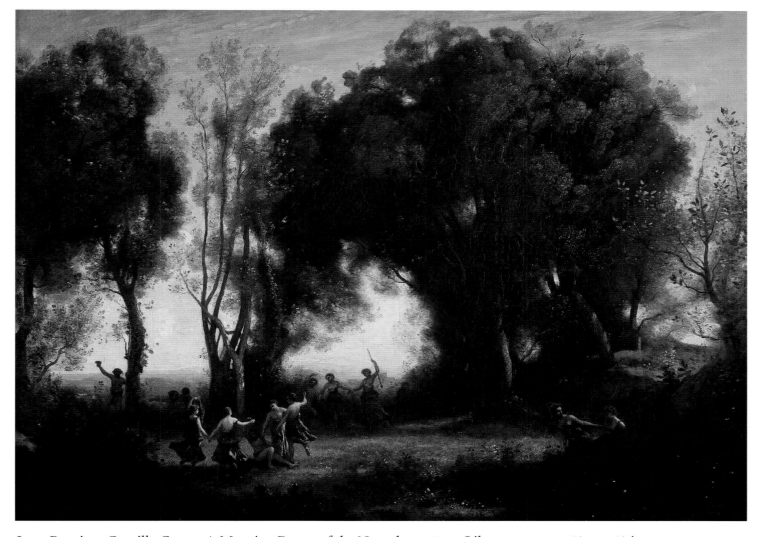

Jean-Baptiste-Camille Corot. *A Morning Dance of the Nymphs.* c. 1850. Oil on canvas. 38 ½ x 51 ½ in. (97.8 x 130.8 cm).

Corot prudently inserted classical nymphs into his lyrical, Barbizon-style landscape, which allowed critics to perceive it as poetic and classically inspired. In fact, Corot spent time in Italy, and over time would infuse his paintings with an enigmatic quality.

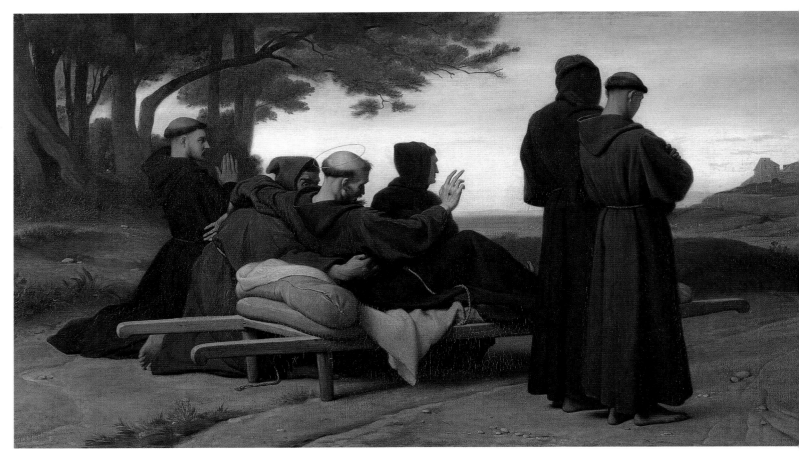

Léon Benouville. *Saint Francis of Assisi, Carried Dying to Santa Maria degli Angeli, Blesses the City (1226).* 1853. Oil on canvas. 36 ½ x 94 ½ in. (92.7 x 240 cm).

With the secularism of the Revolution over, and under the influence of Romanticism, Christian themes returned to European art. Benouville's approach, however, is an entirely modern take, beginning with the blunt foregrounding of the saint and his disciples.

Alfred Stevens. *What Is Called Vagrancy.* 1855. Oil on canvas. 52 x 63 ¼ in. (132 x 160.6 cm).

The ladies of the Second Empire flocked to have their portraits painted by the Brussels-born Stevens, who here depicts the cruelty of laws condemning the homeless poor to prison. The variety of emotional expressions are set off by blunt, unmodulated areas of color.

Gustave Courbet. *The Studio of the Painter: A Real Allegory Summing Up Seven Years of My Life.* 1854–55. Oil on canvas. 142 x 236 in. (360.7 x 599 cm).

This was the centerpiece of Courbet's *Pavilion of Realism,* a virtuoso autobiographical panel given the importance of a history painting. Not all the figures are portraits, but among the people depicted are Charles Baudelaire, seen at the extreme right.

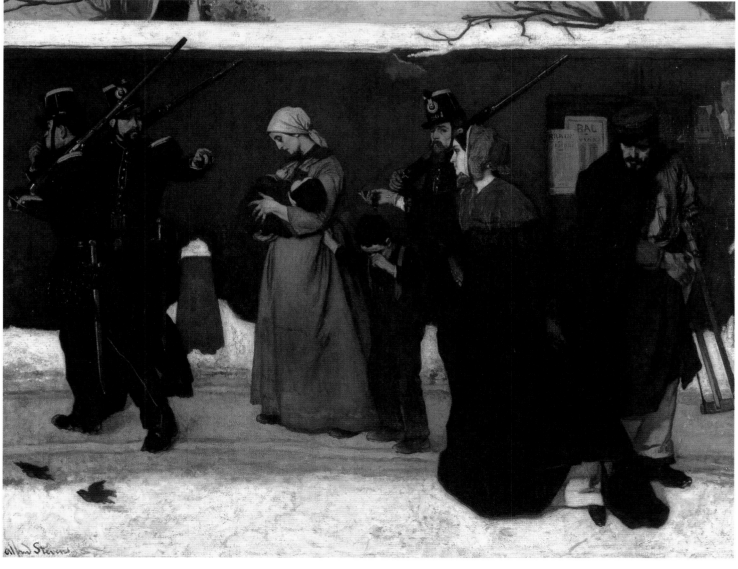

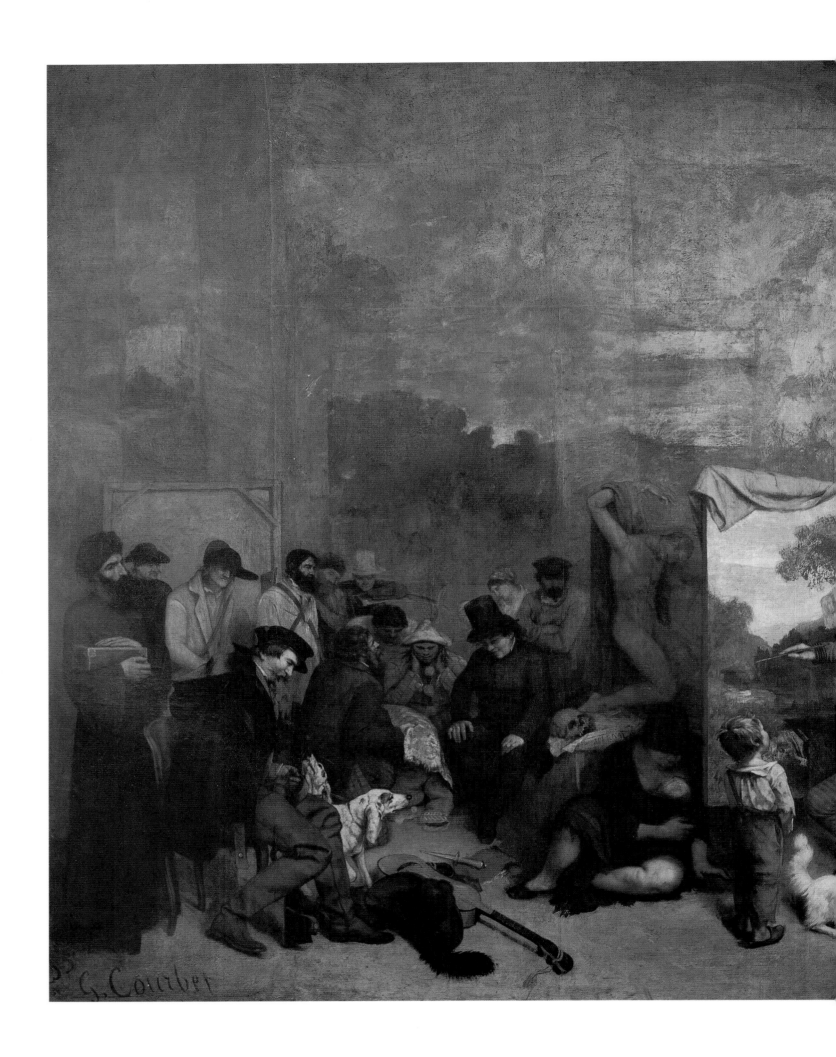

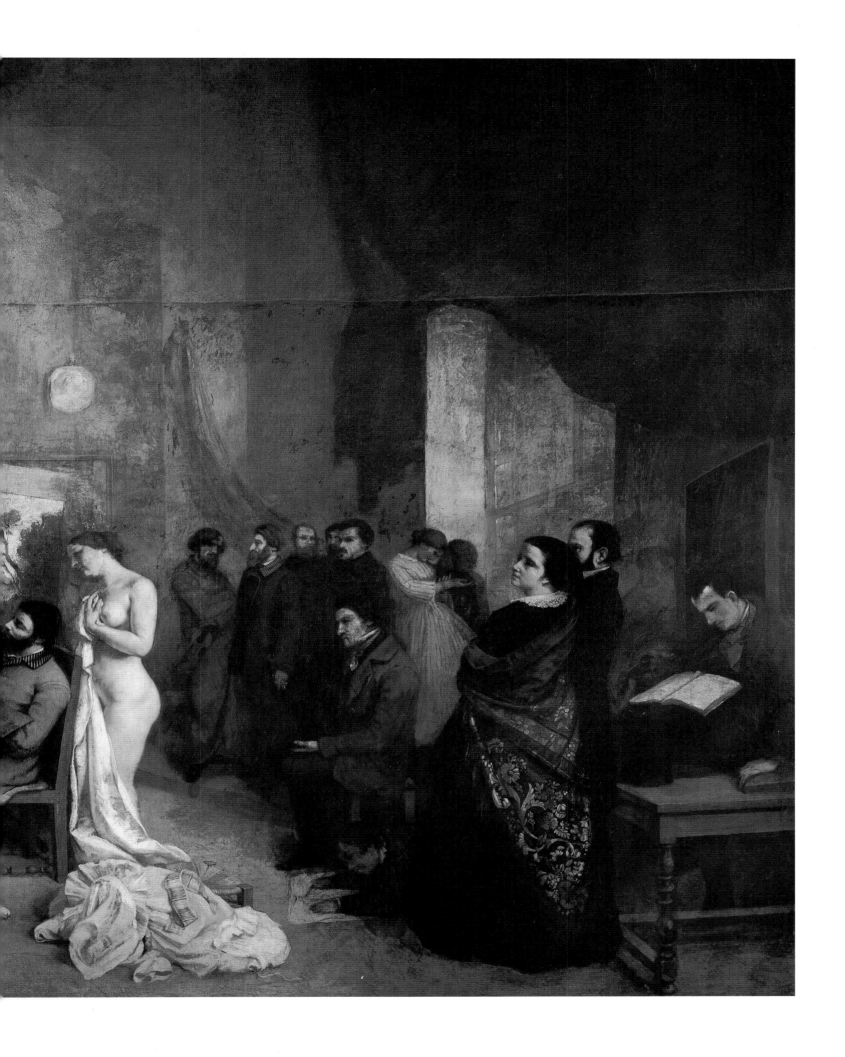

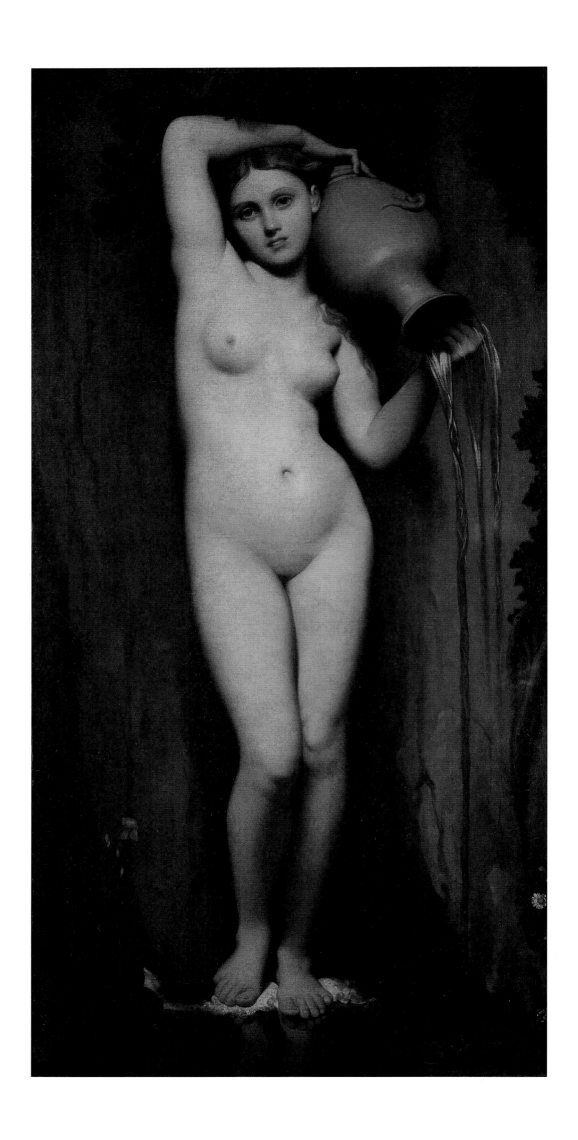

Jean-Auguste-Dominique Ingres. *The Virgin of the Host*. 1854. Oil on canvas. 44 ½ x 44 ½ in. (113 x 113 cm).

Ingres's women are almost preternaturally round, a visual essentialism that removes them from the earthly realm. This painting, which represents her whom the prayer describes as "blessed amongst women," uses circles as a motif linking the Virgin and Host.

Jean-Auguste-Dominique Ingres. *The Source*. 1856. Oil on canvas. 64 ¼ x 31 ½ in. (163 x 80 cm).

Ingres began this painting in 1820 in Florence and finished it, with the assistance of two other painters, in Paris in 1856. This naiad, both a personification and deity of the stream's source, displays a virtuoso idealism perfectly appropriate to the subject.

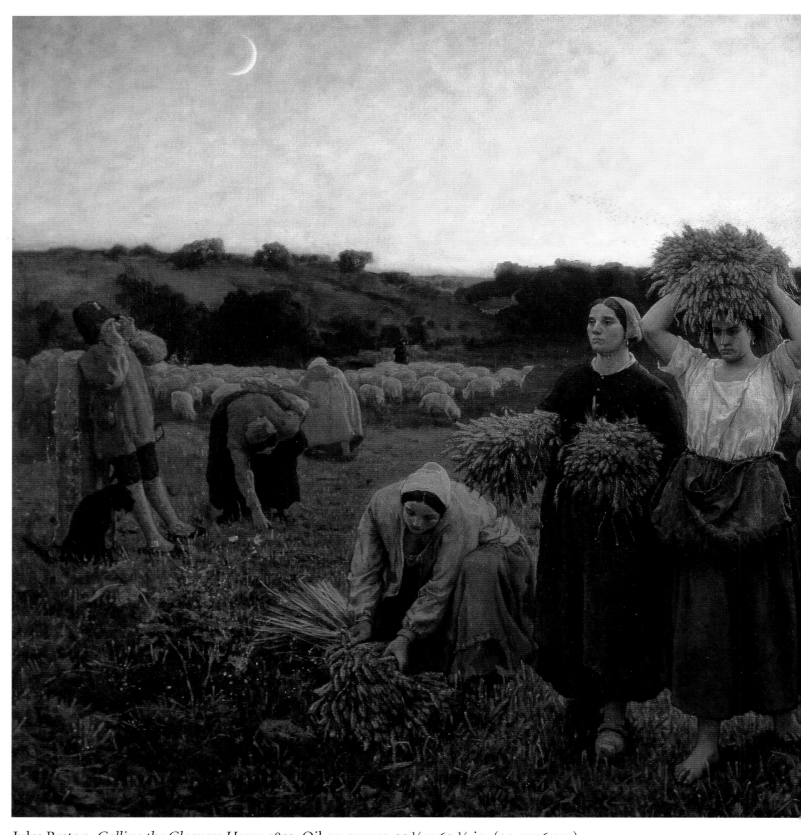

Jules Breton. *Calling the Gleaners Home.* 1859. Oil on canvas. 35 ½ x 69 ¼ in. (90 x 176 cm).

The conservative critics who had damned Millet's gleaners as ugly, praised Breton's "beautiful rustic caryatids." The painting—whose sublunar figures look more like fecund harvest goddesses than worn-out peasants— won a First Class medal at the 1859 Salon.

Charles Carolus-Duran. *The Convalescent (The Wounded Man)*. c. 1860. Oil on canvas. 39 x 49 ½ in. (99 x 125.7 cm).

Generally a slicker, more bourgeois portrait painter, in this work Carolus-Duran attempted a rougher Realism, more in the manner of Courbet. At the same time, the feverish white of the pillow and the emphatic angularity of the convalescent's face recall the Spanish drama of El Greco.

Édouard Manet. *Monsieur and Madame Auguste Manet: The Artist's Parents.* c. 1860. Oil on canvas. 43 ¼ x 35 ½ in. (110 x 90 cm).

This was one of two paintings accepted to the Salon of 1861, at which Manet won an honorable mention. Some of the more avant-garde artists praised the work, which shows the couple dressed informally as they would be at home, but the general public found its Realism excessive and ugly.

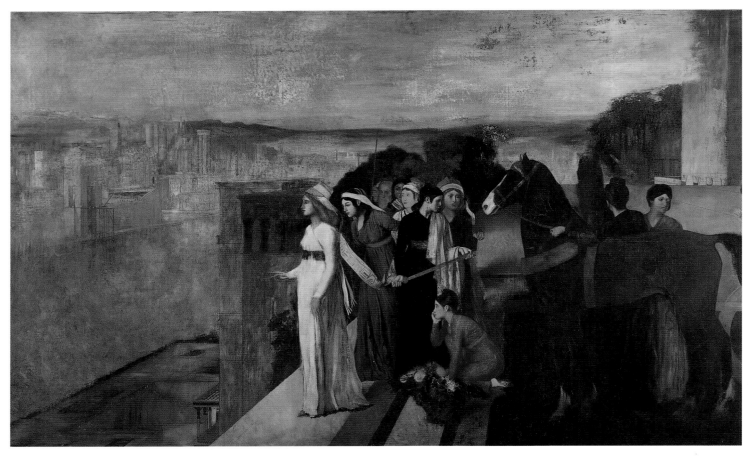

Edgar Degas. *Semiramis Overseeing the Construction of Babylon.* 1861. Oil on canvas. 59 ½ x 101 ½ in. (151 x 258 cm).

This dreamy, unfinished, fresco-like painting, with strong references to the Italian Renaissance, looks like history painting (a genre Degas disdained), but it isn't. In fact, Degas, an opera fan since his youth, was inspired by a revival of Rossini's 1823 opera *Semiramide.*

Edgar Degas. *The Bellelli Family.* c. 1858–60. Oil on canvas. 78 ¾ x 98 ⅓ in. (200 x 250 cm).

This group portrait of a family in an interior looks familiar because of the references to Dutch painting, but it is an original, scrupulously composed network of tensions strung between gazes. The artist began it in his mid-twenties, when he stayed with his mother's sister, Baroness Laura Bellelli, in Florence.

ABOVE

Ernest Meissonier. *Campaign in France, 1814.* 1864. Oil on canvas. 20 ¼ x 30 in. (51.5 x 76.5 cm).

This painter of small-format works influenced by the detail and finish of seventeenth-century Dutch masters was hugely popular. His paintings were very expensive genre and historical scenes. This work was one in a series dedicated to Napoleon's military exploits.

OPPOSITE, ABOVE

Johan-Barthold Jongkind. *Ruins of the Château of Rosemont.* 1861. Oil on canvas. 13 ½ x 22 ¼ in. (34 x 56.5 cm).

Jongkind's low-keyed, realist execution of a quintessential Romantic subject—time's erosion of greatness—is an achievement in itself. The painting almost illustrates the ancient couplet,

> *When Adam delved and Eve span*
> *Who was then a gentleman?*

OPPOSITE, BELOW

Paul Huet. *The Abyss, Landscape.* 1861. Oil on canvas. 49 ¼ x 83 ½ in. (125 x 212 cm).

The Musée d'Orsay purchased this large, late-Romantic painting by a close friend and follower of Delacroix as part of its program to increase its holdings of Old Masters from the Louvre. The intense emotions of the man who stares down into the title abyss are projected onto the livid sky, imminent storm, and rearing horse.

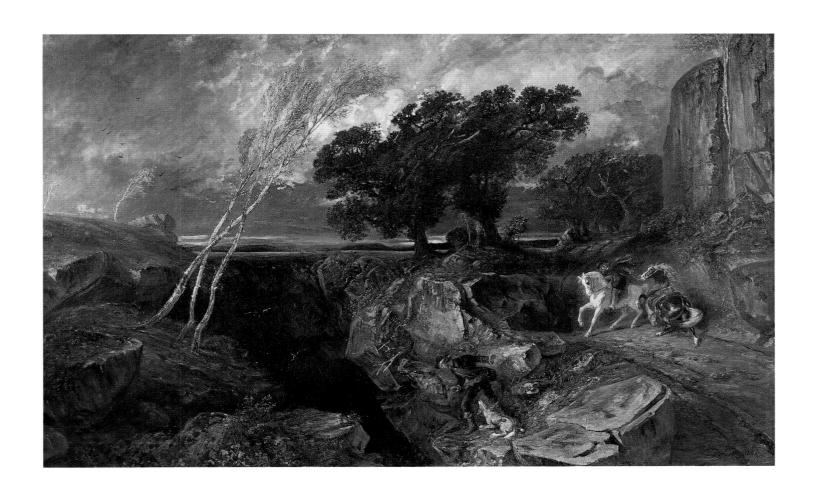

ABOVE

Théodule Ribot. *Saint Sébastien, Martyr.* 1865. Oil on canvas. 38 ¼ x 51 ¼ in. (97 x 130 cm).

The atmospheric contrasts of light and dark—and the realistically rendered sole of the dying saint's foot—
are adapted from seventeenth-century Spanish painting, especially that of Jusepe de Ribera. Three centuries later
the intense chiaroscuro and religious theme were squarely in the Romantic mode.

OPPOSITE

Eugéne Fromentin. *Falcon Hunting in Algeria; The Quarry.* 1862. Oil on canvas. 64 x 46 ½ in. (162.5 x 118 cm).

Fromentin knew Algeria, and his painting style lent a degree of naturalism to picturesque reconstructions, as here.
It may have been its fantasy-Orientalist quality that made this work acceptable for the 1863 Salon—the exhibition
was so conservative that it inspired a revolt on the part of the public.

OVERLEAF

Édouard Manet. *Olympia.* 1863. Oil on canvas. 51 ⅜ x 74 ¾ in. (130.5 x 190 cm).

One of the several aspects of this painting that raised eyebrows was that the art-world public recognized—here as
in *Déjeuner sur l'herbe*—Victorine Meurent, Manet's favorite model. She would appear in eight of his paintings,
and was besides a painter herself, who showed her work in three Salons.

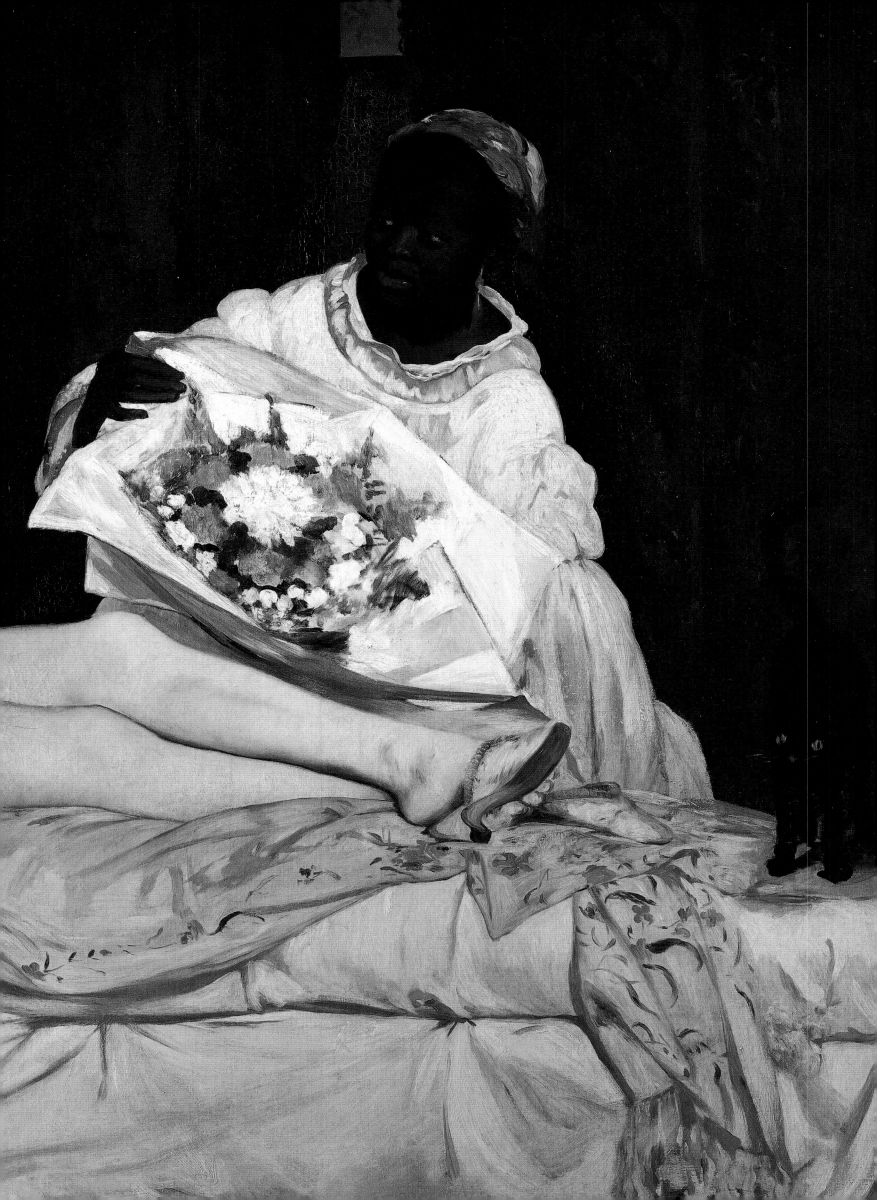

Eugène Boudin. *The Beach at Trouville*. 1864. Oil on canvas. 10 ¼ x 19 in. (26 x 48 cm).

Courbet told Boudin that he was "the only one of us who knows the sky." In the early 1860s, Boudin expanded his subject matter to include social observation on the activities of the leisure classes on the fashionable beaches of the Normandy coast.

Johan-Barthold Jongkind. *The Seine and Notre-Dame de Paris*. 1864. Oil on canvas. 16 ½ x 22 in. (42 x 56 cm).

Jongkind found the play of light and shadow on the Paris cityscape as various and compelling as any "natural" view of land or sea, although he also worked in the countryside. Haussmann's renovation of the city was well underway; the artist may have been aware that this scene would soon be no more.

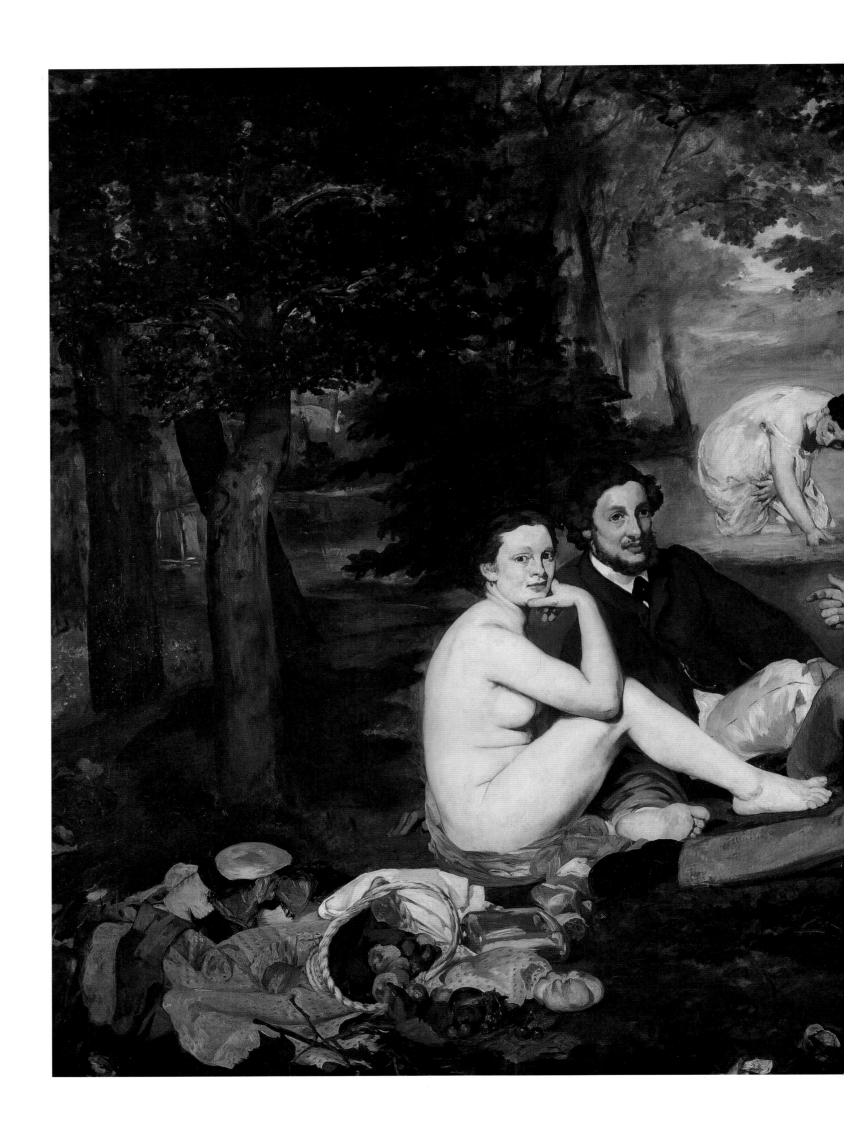

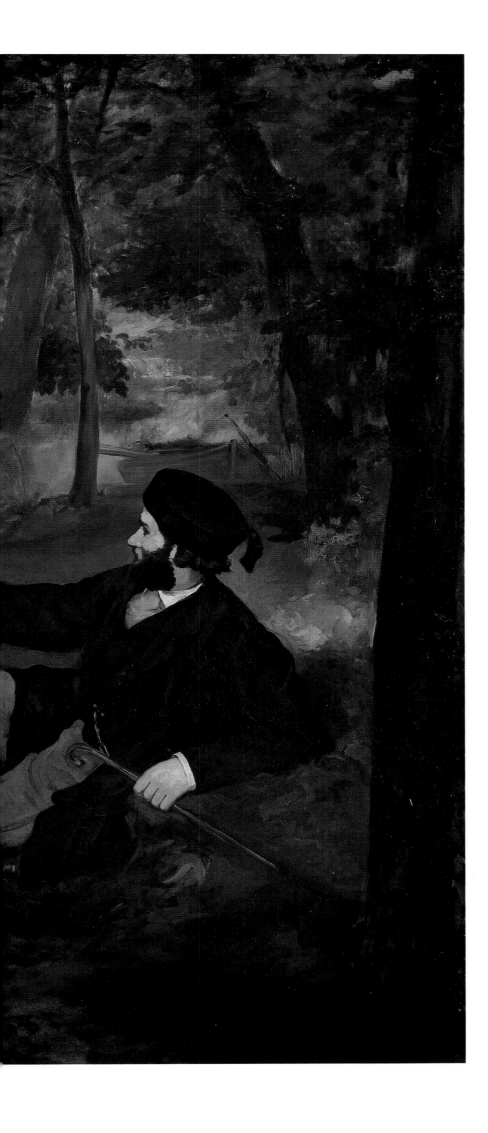

Édouard Manet. *Le Déjeuner sur L'Herbe (Luncheon on the Grass)*. 1863. Oil on canvas. 82 x 104 in. (207 x 264.5 cm).

Manet's sketchy technique and "obsession for seeing things in patches" were highly controversial, as was the painting's subject, which the artist described as a "foursome." The painting's sexual in-jokes are constructed in part by the figures' hands and feet.

Claude Monet. *The Chailly Highway*. c. 1865. Oil on canvas. 17 ⅛ x 23 ¼ in. (43.5 x 59 cm).

In 1863, Monet went to paint in Chailly-en-Briére, a village in the Fontainebleau forest. Lacking human presence — in the Barbizon tradition — this realist work, with its cast shadows and intrusive tree in the right foreground, has an almost photographic quality.

ABOVE

Narcisse Diaz de la Pena. *The Heights of Le Jean de Paris, Fontainebleau Forest.* 1867. Oil on canvas. 33 x 41 ¾ in. (84 x 106 cm).

Diaz de la Pena was one of the first artists to settle in Barbizon, and he was known for his skill at rendering the effect of light on foliage. As Romantic as this stormy landscape may appear, it is a radically realistic rendering of a specific meteorological moment in a specific place.

P. 74

Honoré Daumier. *The Laundress.* c. 1863. Oil on canvas. 19 ¼ x 13 ¼ in. (48.9 x 33.6 cm).

Daumier was a painter's painter, admired by colleagues such as Delacroix, Degas, and Toulouse-Lautrec. He began his career as a sculptor, and paintings such as this one retain a monumental, three-dimensional quality, and marvelous draftsmanship.

P. 75

Franz-Xaver [sic] Winterhalter. *Mme Rimsky-Korsakov.* 1864. Oil on canvas. 46 x 35 ½ in. (117 x 90 cm).

Trained in the French manner, the German Winterhalter executed state portraits of the Belgian, British, and French royal families, as well as society portraits. (This lady is the aunt of the composer.) Winterhalter was said to be so able a draughtsman that he painted directly on canvas, with no preliminary studies.

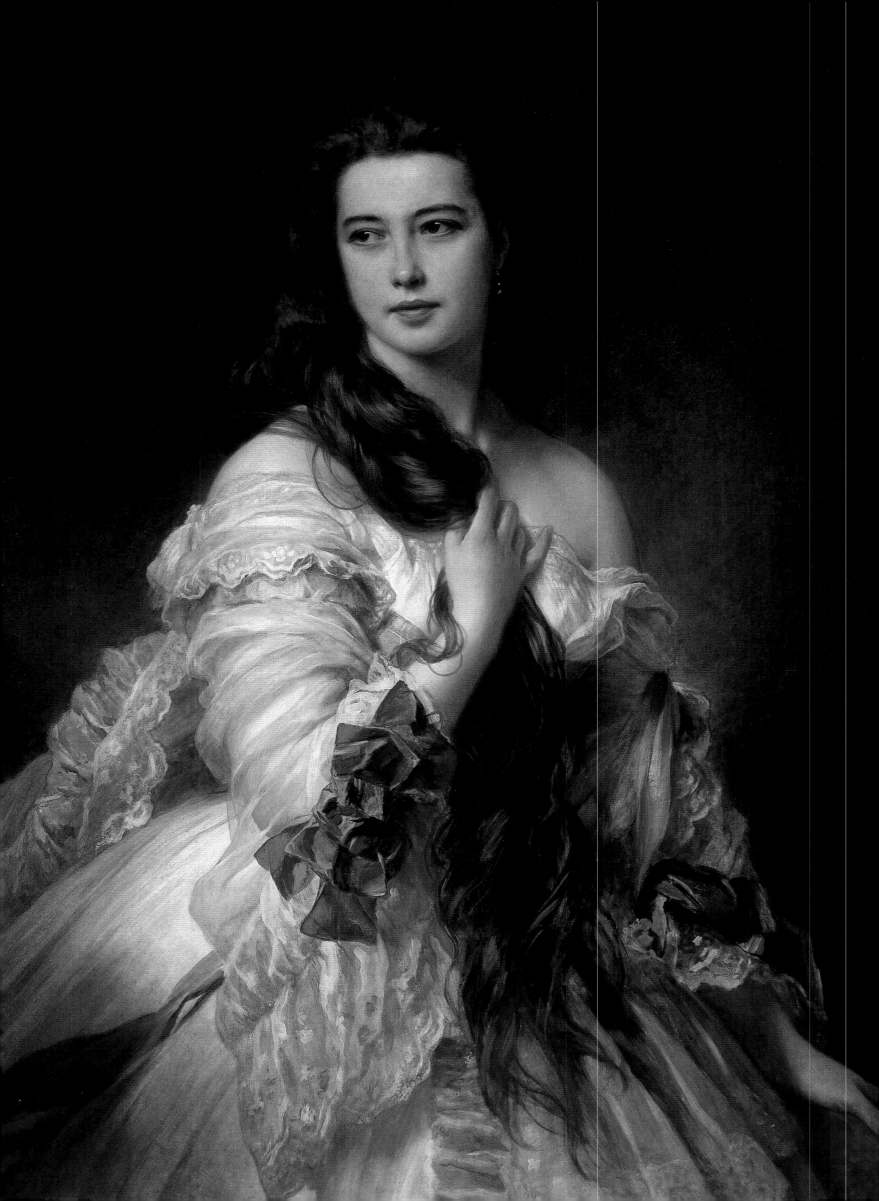

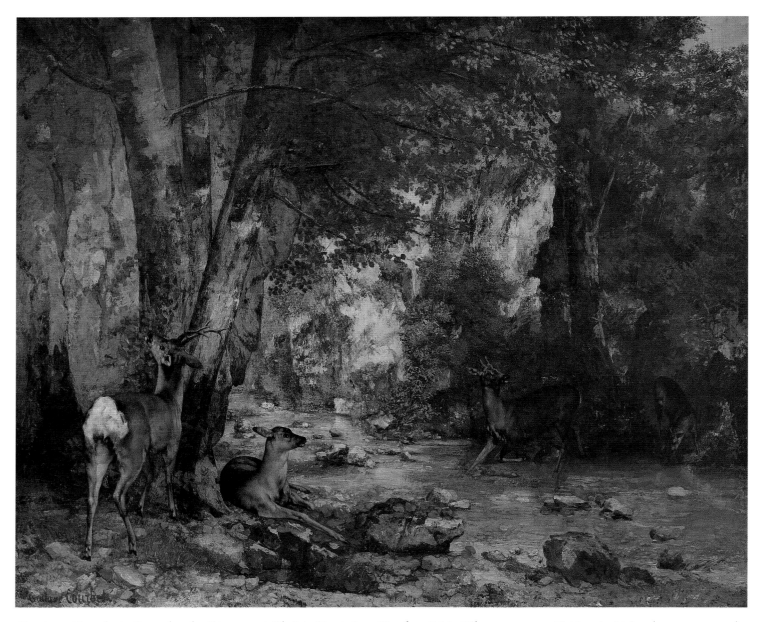

Gustave Courbet. *Stags by the Stream at Plaisir-Fontaine, Doubs.* 1866. Oil on canvas. 68 ½ x 82 ¼ in. (174 x 209 cm).

This silent, carefully composed scene acquires movement from the attitudes of the stags, and from the acute diagonal of the stream. The scene is suffused with a mysterious, almost Romantic light characteristic of a number of Courbet's works.

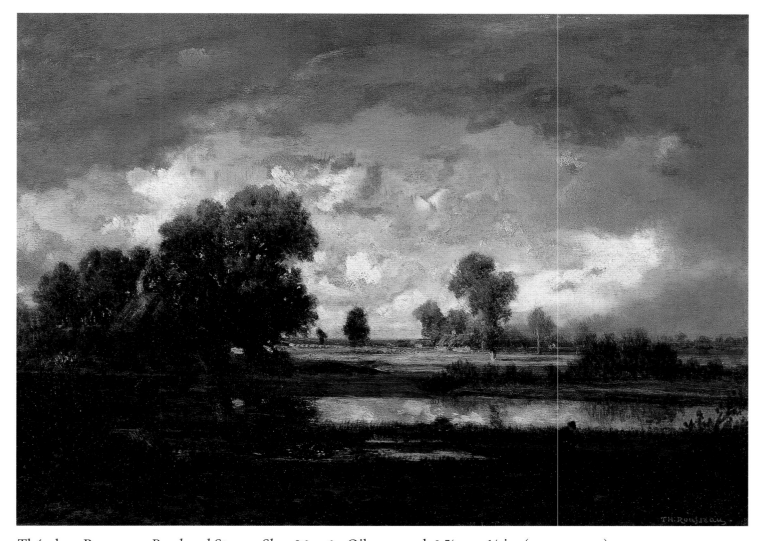

Théodore Rousseau. *Pond and Stormy Sky.* 1865–67. Oil on wood. 8 ⅞ x 12 ¼ in. (22.5 x 31 cm).

Diaz de la Pena, Rousseau, and Millet were the elders of the Barbizon group, but Rousseau was perhaps the most influential, in his pursuit of the singular light as it appears at a certain time of day, in a given season. Nothing could have been further from the classical ideal of timelessness.

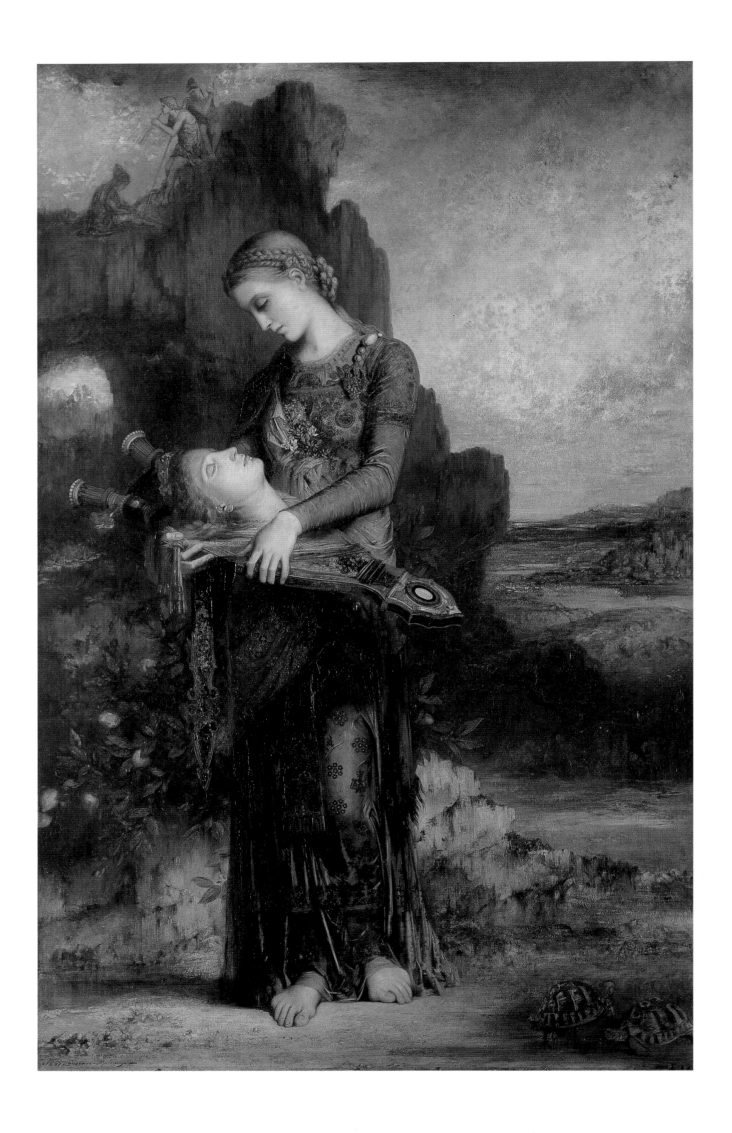

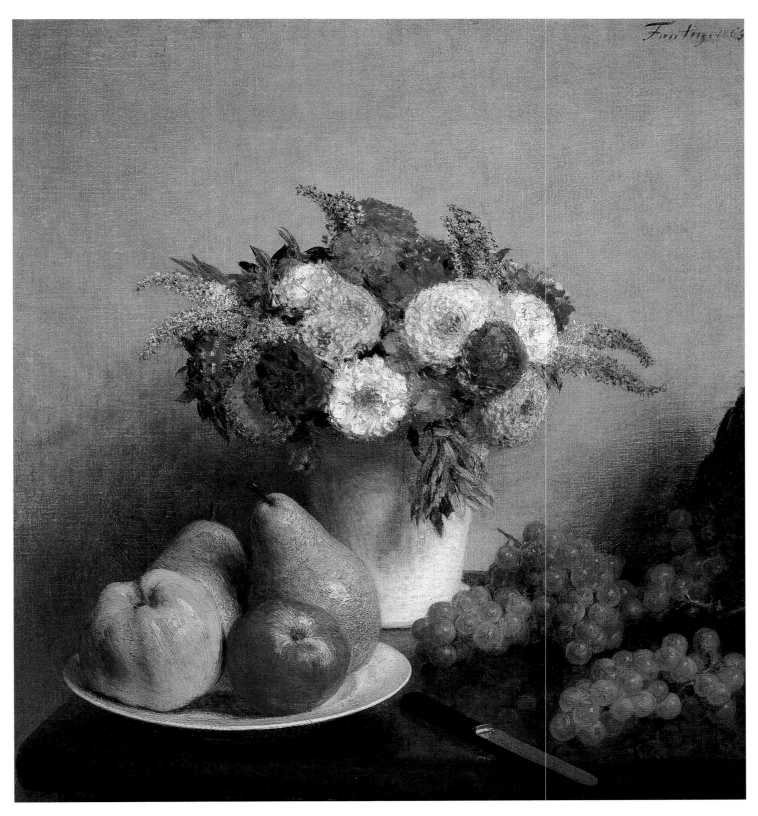

Henri Fantin-Latour. *Flowers and Fruit.* 1865. Oil on canvas. 25 ¼ x 22 ½ in. (64.1 x 57.1 cm).

The influence of the Dutch masters is present in the illumination and modeling in this work. At the same time the painting is quietly radical in the thick impasto of the flower petals and the explicit reference to the canvas background.

Gustave Moreau. *Orpheus.* 1865. Oil on canvas. 60 ¾ x 39 ¼ in. (154.3 x 99.7 cm).

Orpheus was a poet and musician whose art bewitched not only wild animals, but even the rocks and trees. Dionysus' maenads tore the young man limb from limb — his head, still singing, washed out to sea. Moreau's elegant, elaborate treatment proposes the immortality of art.

Gustave Courbet. *Madame Proudhon.* 1865. Oil on canvas. 28 ¾ x 23 ¼ in. (73 x 59 cm).

Courbet painted the radical social philosopher Pierre-Joseph Proudhon with his family in 1865, and exhibited the portrait in that year's Salon. Dissatisfied with the figure of Mme Proudhon, Courbet eliminated it from the group portrait, but made her the subject of a separate picture.

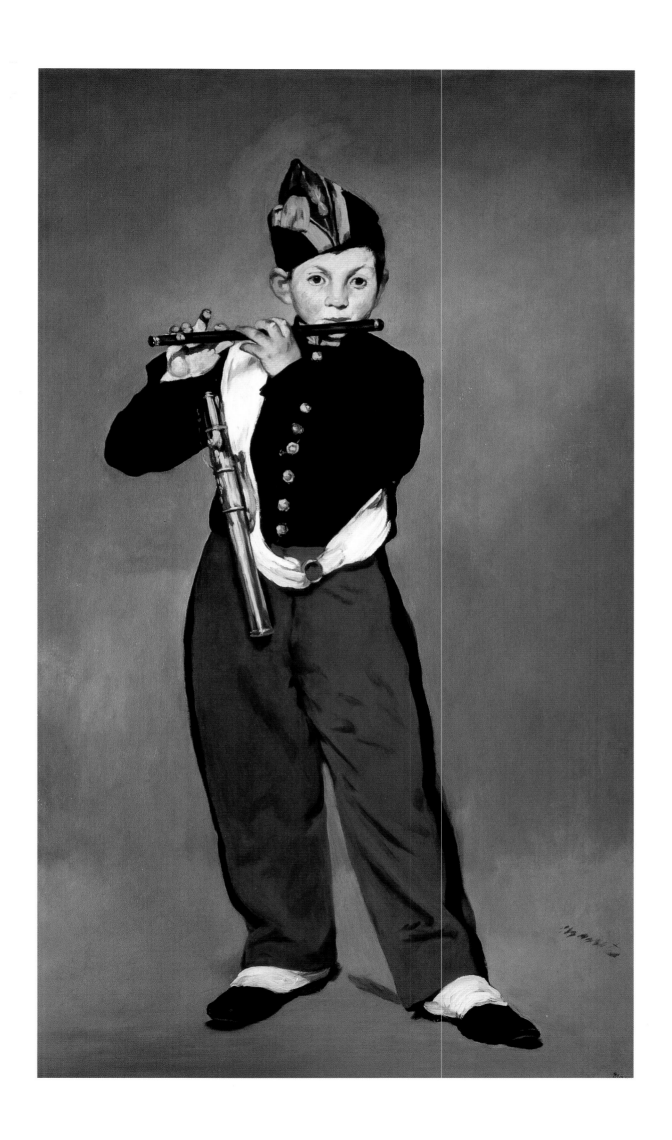

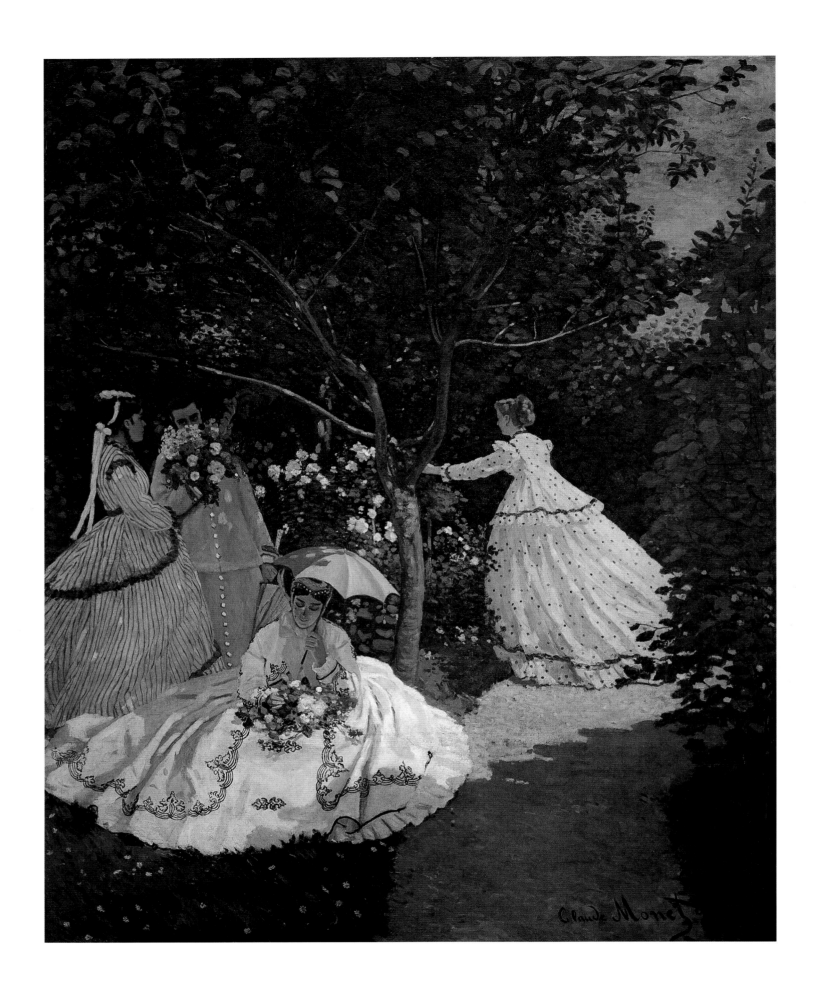

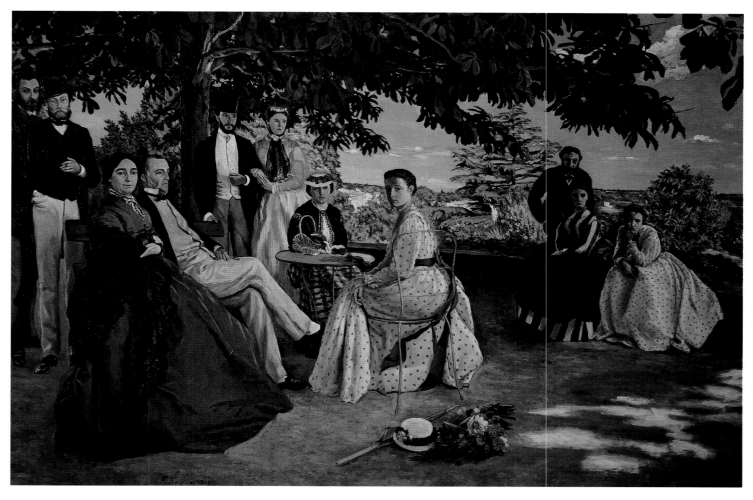

ABOVE

Frédéric Bazille. *Family Reunion.* 1867. Oil on canvas. 59 ¾ x 90 ½ in. (152 x 230 cm).

Bazille was from Montpellier, in the Midi, and this portrait explores the effect of the blunt southern light. The subject resembles Monet's *Women in the Garden,* and the younger artist also adopted Monet's treatment of the effect of light filtering through leaves onto clothes and ground.

OPPOSITE

Claude Monet. *Women in a Garden.* 1867. Oil on canvas. 100 ½ x 80 ¾ in. (255 x 205 cm).

One of relatively few figure paintings by the artist, this was his first painting to be rejected by a Salon jury, some of whose members considered the treatment of light and shadow crude. Émile Zola defended the work, calling it a "tour de force."

P. 81

Édouard Manet. *The Fifer.* c. 1866. Oil on canvas. 63 x 38 ½ in. (160 x 98 cm).

This painting was rejected for the Salon of 1866: its admirers and detractors alike found the contrasts of colors "brusque." The radical near-dissolution of the background was Manet's tribute to the seventeenth-century Spanish court painter Diego Rodriguéz de Silva y Velázquez.

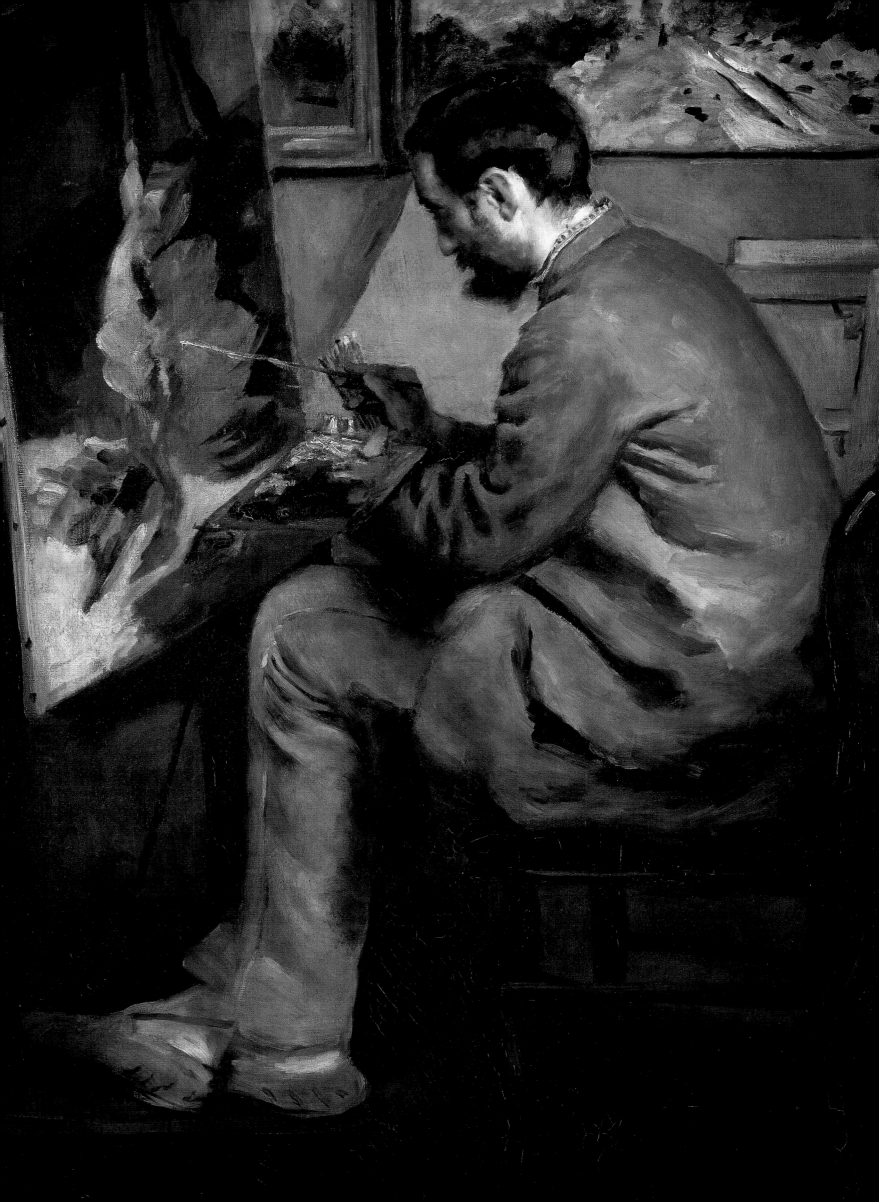

ABOVE

Jean-Baptiste Carpeaux. *The Attempted Murder of Czar Alexander II by Berezowski, (6 June, 1867).* 1867. Oil on canvas. 51 ½ x 76 ¾ in. (131 x 195 cm).

On June 6, 1867, in the Bois de Boulogne, Antoine Berezowski, a young Polish patriot, attempted to assassinate Napoleon III and Tsar Alexander II, then on a state visit to Paris. Berezowski was sentenced to twenty years' hard labor and shipped off to Cayenne Island, in French Guiana. The Tsar was outraged that the would-be assassin was not executed.

OPPOSITE

Pierre-Auguste Renoir. *Frédéric Bazille Painting at His Easel.* 1867. Oil on canvas. 41 ¼ x 57 ¾ in. (105 x 75.5 cm).

Bazille and Renoir were especially close friends: this same year, Bazille did a portrait of Renoir, which Renoir kept all his life. Renoir's portrait of Bazille appeared in the second Impressionist exhibition in 1876 — six years after Bazille died in the War of 1870.

Charles de Tournemine. *African Elephants.* 1867. Oil on canvas. 34 ¾ x 70 in. (88 x 178 cm).

An enthusiast for the exotic, Tournemine found his inspiration chiefly in the travel stories emerging from the extension of empire and the exploits of explorers. His Africa is far from Guillaumet's sere, austere deserts: here, the title beasts trumpet beneath a vast and brilliant sky.

BELOW

Gustave Guillaumet. *The Desert* or *The Sahara.* 1867. Oil on canvas. 43 ½ x 77 in. (110 x 200 cm).

Castagnary championed "the free inspiration of the individual" in art, and Guillaumet, whose works are sometimes categorized as naturalist Orientalism, took up the challenge, becoming very successful in the process. This painting was in the 1868 Salon.

ABOVE

Alfred Stevens. *The Bath*. c. 1867. Oil on canvas. 29 ¼ x 37 in. (74 x 93 cm).

The Belgian Stevens ceased painting political themes after 1855, becoming a very successful painter of bourgeois genre scenes. Here, the watch in the soap dish may mean that this respite is stolen from domestic responsibilities and social rounds. The roses may be a trace of another, also stolen, private moment.

OPPOSITE

Gustave Courbet. *The Spring*. 1868. Oil on canvas. 50 ½ x 38 ¼ in. (128 x 97 cm).

The French title, *La source*—which can also be translated as "The Source"—offers a broad play on words when applied to this creamy nude. The artist's treatment is only partially successful: the figure's luminous skin and awkward posture, not to mention the fact of a naked woman in a woods, make this far from Courbet's usual Realism.

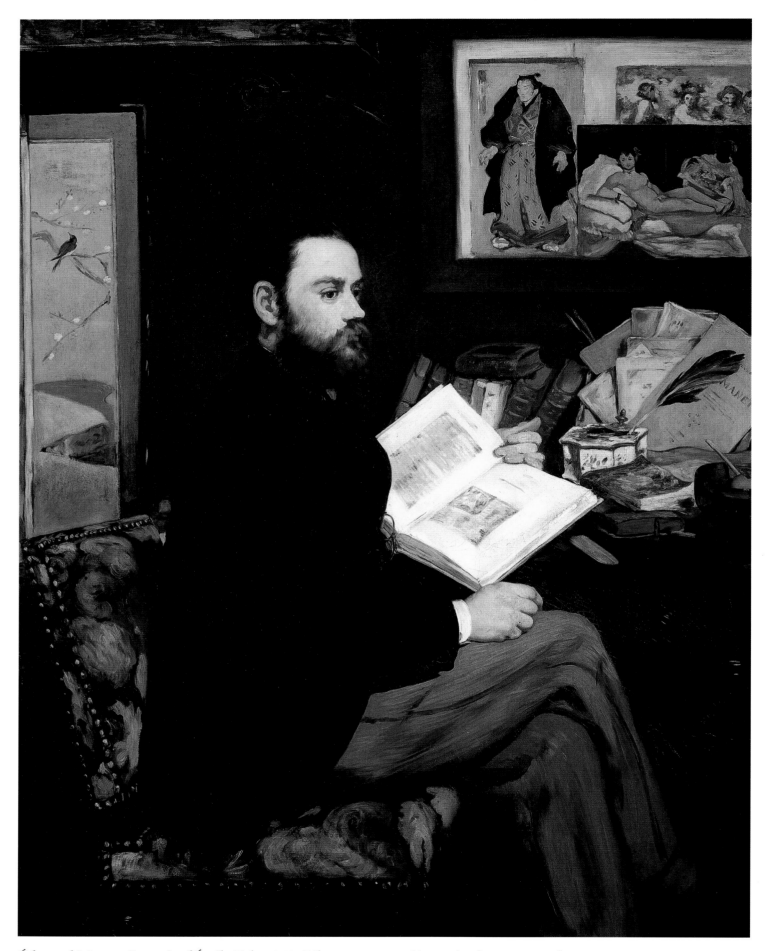

Édouard Manet. *Portrait of Émile Zola.* 1868. Oil on canvas. 57 ½ x 45 in. (146 x 114 cm).

The artist's thank-you to his friend and supporter relies on the inclusion of attributes, a device of classical painting. Here, beside one of the popular Ukiyo-e prints, an engraving—or a photograph of an engraving—of Manet's *Olympia* recalls Émile Zola's defense of the painting.

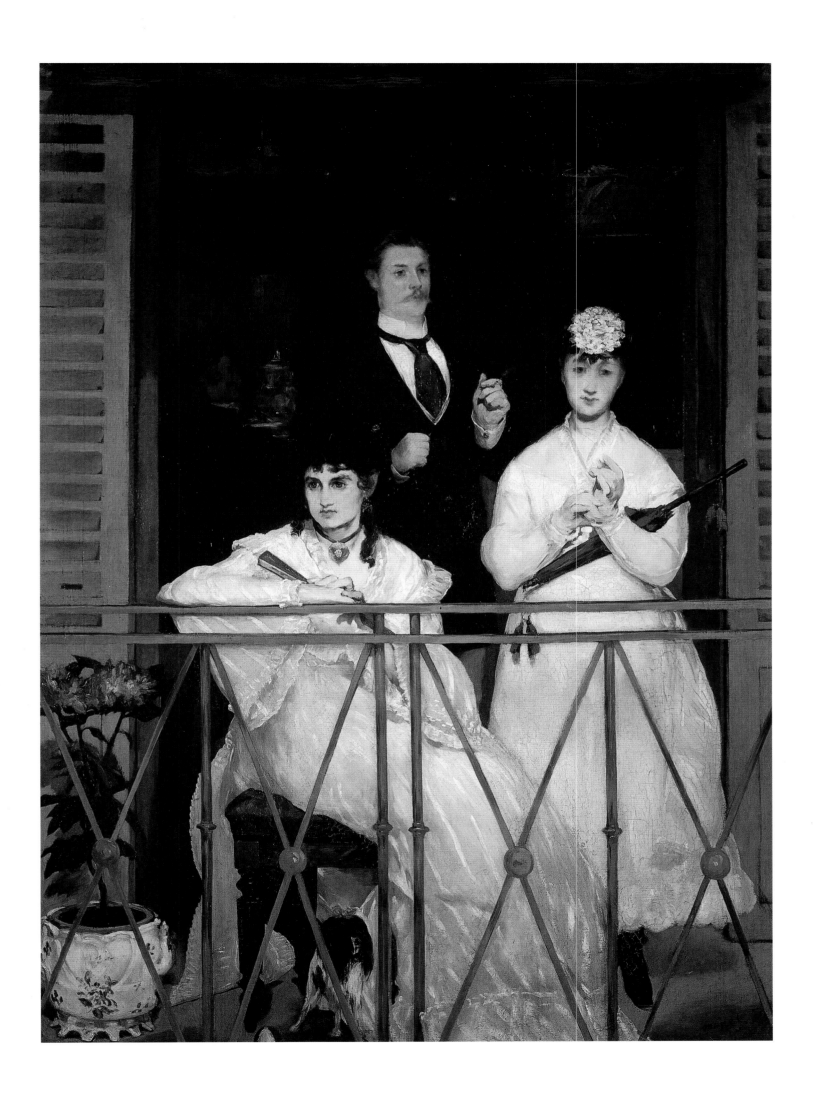

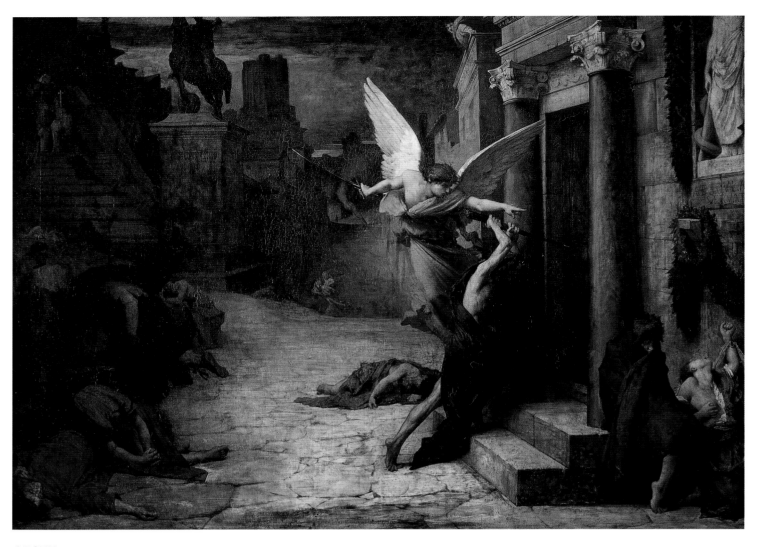

Jules-Élie Delaunay. *The Plague in Rome.* 1869. Oil on canvas. 51 ½ x 69 ¼ in. (130.8 x 175.9 cm).

This large painting relates an episode from the fourteenth-century *Golden Legend,* concerning an outbreak of the plague in the title city. Delaunay, the very model of an Academy artist, skillfully sculpted his areas of light and dark.

P. 91

Édouard Manet. *The Balcony.* 1868. Oil on canvas. 66 ½ x 49 ¼ in. (169 x 125 cm).

Manet borrowed frankly from his sources: this is a direct reference to *Majas on a Balcony*, by Francisco José de Goya y Lucientes. Here, however, the figures—Berthe Morisot, seated; the violinist Fanny Claus; and the landscape painter Antoine Guillemet—are utterly, and disturbingly, unconnected.

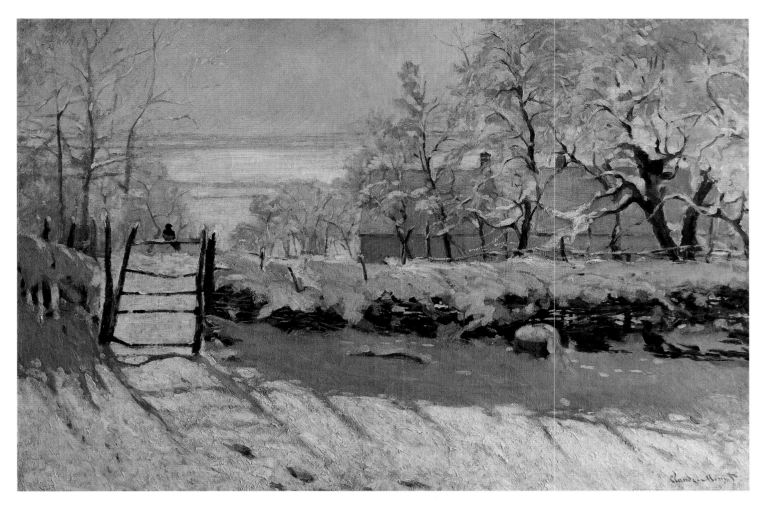

ABOVE

Claude Monet. *The Magpie.* 1869. Oil on canvas. 35 x 51 ¼ in. (89 x 130 cm).

Monet's ability to show the magic moments of everyday life without sentimentalizing them is even greater than his technical ability to convey true gradations of color—incuding white. He was spotted painting this on a freezing cold day, with a heater beside him.

P. 94

Jean-François Millet. *The Spinner, an Aubergne Goatherd.* 1868–69. Oil on canvas. 36 ½ x 29 in. (92.5 x 73.5 cm).

By this time, the public liked Millet's peasants, who were already haloed with nostalgia, given the rapid industrialization of much of the country. The official stance of the administration of the Second Empire, however, was still firmly against such humble, unpoetic works, portraying nameless rural folk.

P. 95

Pierre-Auguste Renoir. *Young Boy with a Cat.* 1868–69. Oil on canvas. 43 ¾ x 26 ¼ in. (124 x 67 cm).

The high, almost cold contrast—a world away from Renoir's jolly, blowsy babes—accentuates the eroticism of this very unusual picture. The cat both allows the boy to be a child, and establishes a sensuous parallel with him. A later *Girl with a Cat* portrays a dressed, but disheveled teenager.

Paul Cézanne. *Pastoral* or *Idyll*. 1870. Oil on canvas. 25 ½ x 32 in. (65 x 81 cm).

The Italian Baroque painters are thematically, if not aesthetically or emotionally, present in this heavy, almost tortured nature scene, in Cézanne's signature palette of green and blue versus pink and tan. There is a tip of the hat to Manet's *Déjeuner sur l'herbe*, and a foreshadowing of Cézanne's Bathers series.

Paul Cézanne. *Mary Magdalene*. c. 1869. Oil on canvas. 65 x 37 ½ in. (165 x 125.5 cm).

Cézanne, aware early of his artistic vocation, was soon haunting the Louvre. The strong emotional content, chiaroscuro, and robust modeling are lessons he learned from the Italians, especially the Venetians and Caravaggio. Medieval legends associated Mary Magdalene with Provence, the artist's native region.

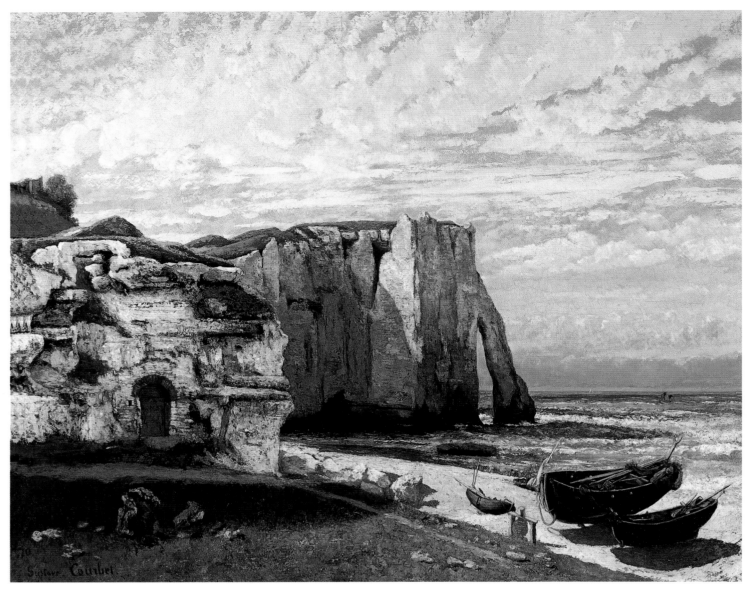

ABOVE

Gustave Courbet. *The Cliff at Etretat after the Storm.* 1869. Oil on canvas. 52 ⅜ x 63 ¾ in. (133 x 162 cm).

Courbet's landscapes were well received, providing realism in a much more palatable form than his more consciously radical works of the mid-1850s. The Impressionists thought highly of Courbet's limpid treatment of light in works such as this.

OPPOSITE

Claude Monet. *Hôtel des Roches-Noires Trouville.* 1870. Oil on canvas. 32 x 23 in. (81 x 58.5 cm).

The strong breeze blowing off the Channel, and the warm summer sun are almost palpable in this portrait of an instant in time. On July 19 of this year, France declared war on Prussia. Within months, the carefree quality that Monet captured would be no more.

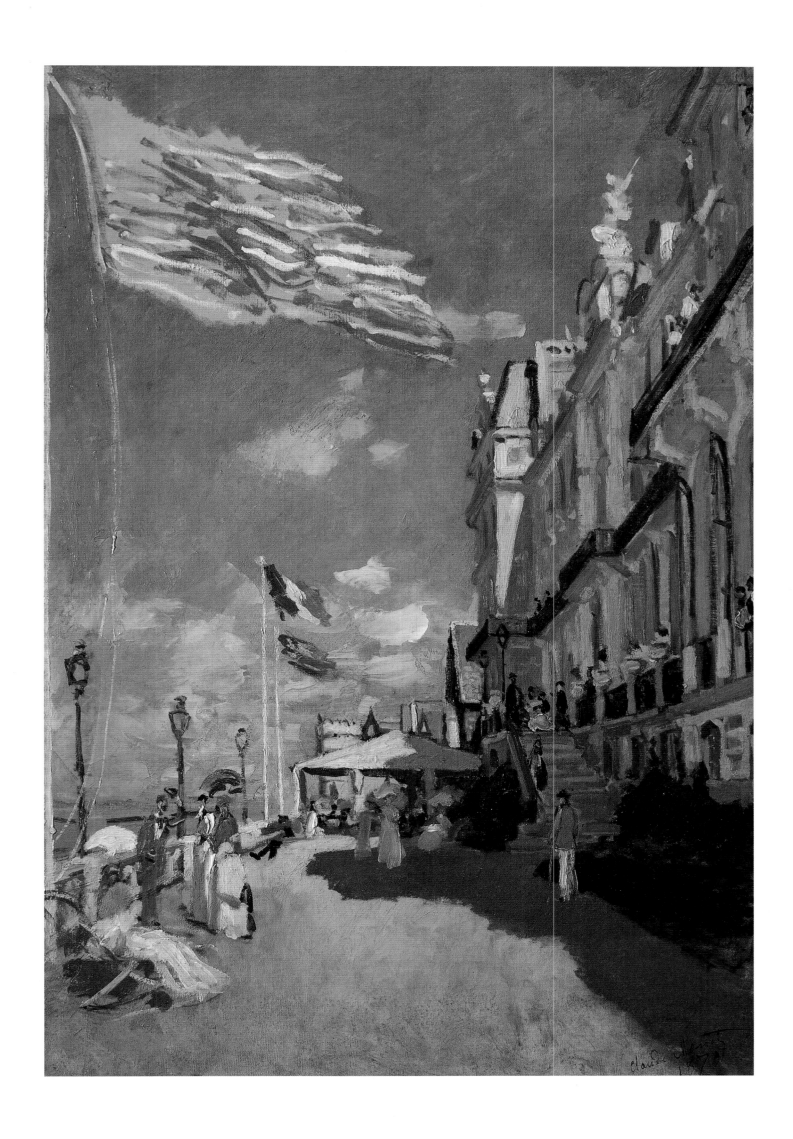

Edgar Degas. *The Orchestra of the Opéra*. c. 1870. Oil on canvas. 22 ¼ x 18 in. (56.5 x 46 cm).

Désiré Dihau, the orchestra bassoonist, the center of a marked triangle, surrounded by other identifiable figures, asked Degas to paint his portrait, and this was the result. Another acquaintance of Degas is the severed head in the upper left corner—a motif that recurs in Degas's work.

Jean-Baptiste-Camille Corot. *The Artist's Studio, Young Woman with Mandolin.* c. 1865. Oil on canvas.
25 x 18 in. (64 x 48 cm).

In the tradition of artists reflecting on the making of art, this is a portrait of a young woman who is a musician, not a model—except that, of course, she *is* a model. The implication—that everything is worthy subject matter—is emphasized by the darkness behind the young woman.

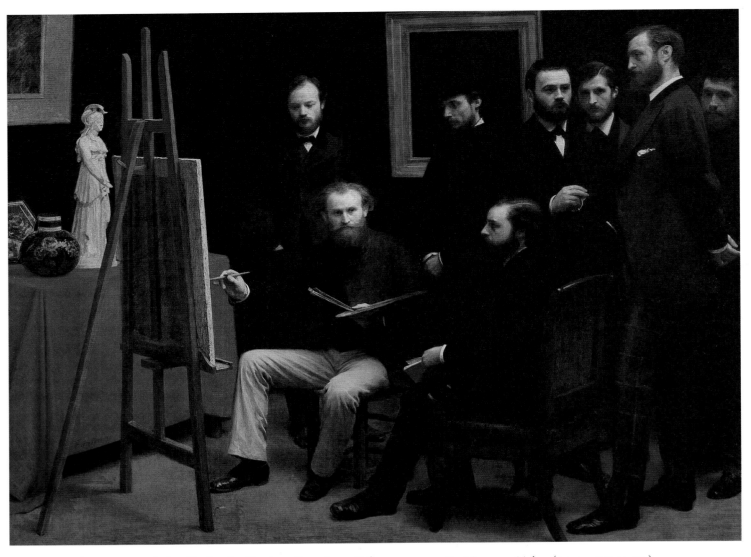

Henri Fantin-Latour. *A Studio in the Batignolles*. 1870. Oil on canvas. 80 ¼ x 107 ¾ in. (204 x 273.5 cm).

Fantin-Latour, a friend of the Impressionists, pursued his own realist path, usually in somber tones. This painting is an homage to Manet, shown painting, and includes the artist's friends: Renoir, his head framed, stands behind Manet, while Zola, next to him, looks away. The tall red-haired man is Bazille, who would die that year, and Monet is at the far right, looking out at the viewer.

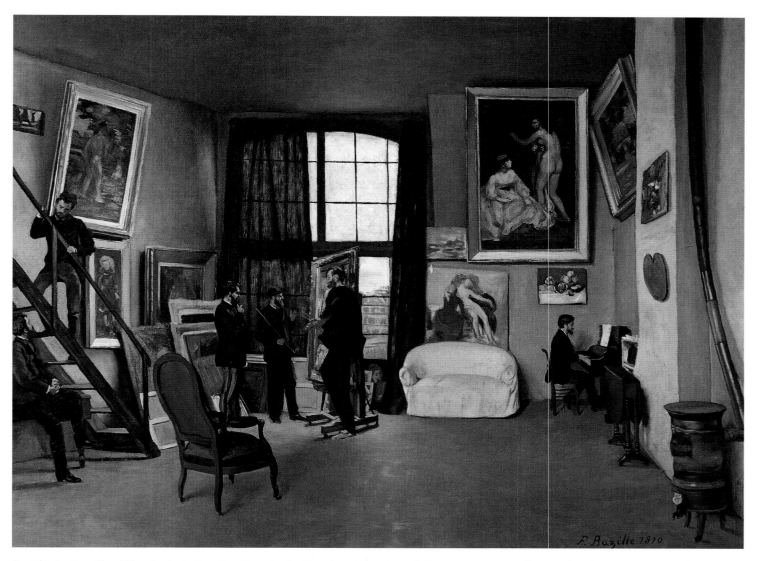

Frédéric Bazille. *The Artist's Studio, Rue de la Condamine.* 1870. Oil on canvas. 38 ⅞ x 47 in. (98.7 x 119.4 cm).

This tribute to friendship and a shared artistic endeavor depicts several of Bazille's works in progress, and a still life by Monet, who may or may not be the man behind Manet, the hatted man who comments on the painting on the easel—and who painted the figure of Bazille, the tall man to his right.

Henri Regnault. *Execution without Trial*. 1870. Oil on canvas. 119 x 57 ½ in. (302 x 146 cm).

The French military involvement in North Africa inspired writers such as Gustave Flaubert and painters such as Regnault to depict the sumptuous cruelties and barbaric splendor many vaguely associated with the Islamic past. Orientalism was very popular with both the public and the art establishment.

Alexandre Cabanel. *The Death of Francesca da Rimini and Paolo Malatesta.* 1870. Oil on canvas. 72 ⅜ x 100 ¾ in. (184 x 255 cm).

Dante's *Divine Comedy* was a seemingly inexhaustible source for Romantic painters, and Cabanel, a member of the Institute and a favorite of the Emperor, rose to the occasion. The tale, in Canto 5 of the *Inferno*, recounts the tragic unfolding of a passionate, adulterous, and doomed love affair.

Ernest Meissonier. *The Siege of Paris.* 1870. Oil on canvas. 21 x 27 ¾ in. (53.3 x 70.5 cm).

This painting "was my vengeance," the artist later wrote, for France's defeat. (Meissonier's own home in Paris had been requisitioned.) The lion-skinned figure in the center represents the city of Paris; the figure to the right of her is the painter Henri Regnault, who was killed in action the following year.

Gustave Doré. *The Enigma*. 1871. Oil on canvas. 51 ¼ x 77 in. (130 x 195.5 cm).

Doré, who remained in Paris during the brutal years of 1870 and 1871, expressed his vision of those devastating events in allegory. As direct as only poetry can be, this painting shows the weeping, winged figure of France desperately asking an inscrutable Sphinx the meaning of such horror.

Edgar Degas. *Racehorses in front of the Grandstand.* c. 1879; also dated 1866–68. Oil on canvas. 18 x 24 in. (46 x 61 cm).

Degas constructed the excitement of the race that is about to start with an acute central wedge that forces the eye to the center of the painting, where one of the jittery thoroughbreds is prancing. The horse on the left is borrowed from a work by Ernest Meissonier.

Claude Monet. *Boating at Argenteuil*. c. 1872. Oil on canvas. 17 ¾ x 29 in. (48 x 75 cm).

In 1872, Monet, followed by other future Impressionists, went to live in Argenteuil, some five miles from Paris. Renoir, Sisley, Caillebotte, and Monet—the latter already considered by outsiders the group's leader—shared their discoveries, while each pursued his own direction.

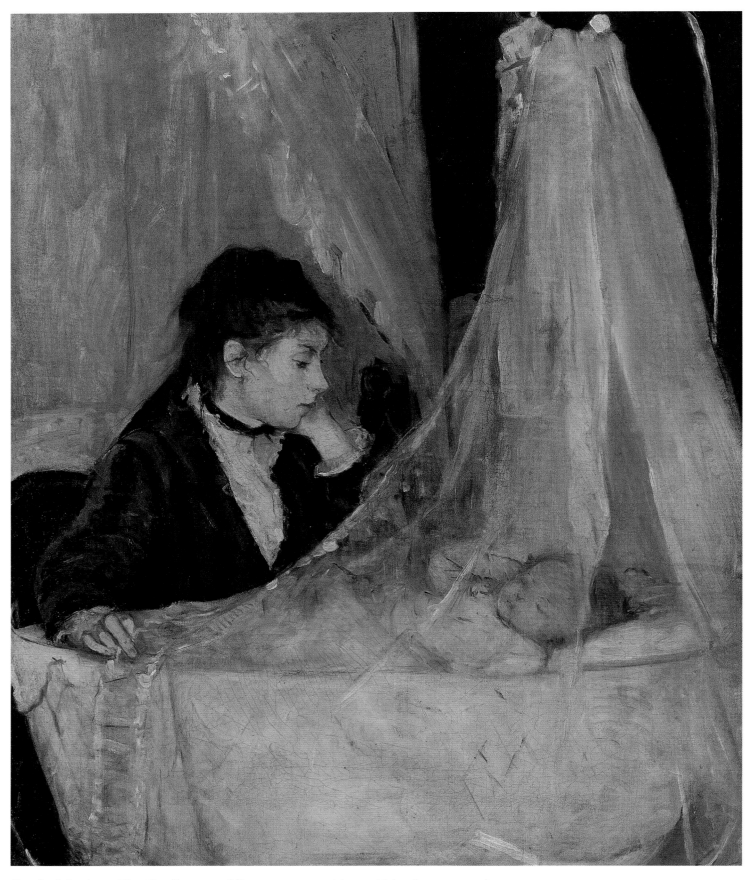

Berthe Morisot. *The Cradle*. 1872. Oil on canvas. 21 ¼ x 18 ⅛ in. (54 x 46 cm).

Scholars have noted that Morisot's fathers and mothers—here, her sister, Edma—are thoughtful and often in some way distanced, psychically or physically, from their children. This is in keeping with the nature of Impressionist realism, but especially striking given her subject matter.

James Abbot McNeill Whistler. *Arrangement in Grey and Black, No. 1: Portrait of the Artist's Mother.* 1871. Oil on canvas. 56 ⅝ x 63 ¾ in. (144 x 162 cm).

With this title, the artist insisted upon how he wished this painting—shown in the Salon of 1883—to be viewed: not as a portrait but as a composition. The delicate tonalities and patterns refer to the Japanese style that was hugely influential not only in the European capitals, but in the United States as well.

ABOVE

Édouard Manet. *On the Beach*. 1873. Oil on canvas. 23 ½ x 28 ¾ in. (59.6 x 73.2 cm).

Grains of sand in the paint testify to the spontaneity of this family double portrait: the woman reading is Manet's wife, Suzanne Leenhoff; the man looking out to sea is the artist's brother Eugène, who would marry Berthe Morisot the following year.

OPPOSITE

Édouard Manet. *Berthe Morisot with a Fan*. 1872. Oil on canvas. 23 ½ x 17 ¾ in. (60 x 45 cm).

Between 1868 and 1874, when Morisot married his brother Eugène, Édouard Manet painted her eleven times, more often than either his wife, Suzanne Leenhoff, or Victorine Meurent. It has been argued that several of these works reveal Manet's complex erotic feelings, which included hostility and professional jealousy.

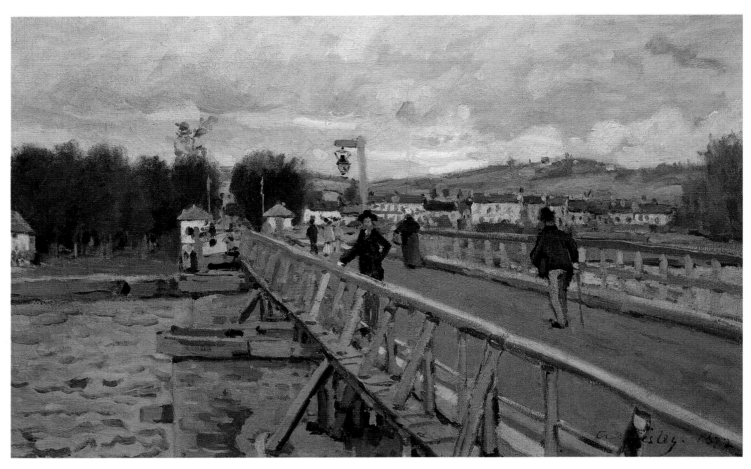

Alfred Sisley. *Footbridge at Argenteuil.* 1872. Oil on canvas. 15 ¼ x 23 ½ in. (39 x 60 cm).

Though the Impressionists' artistic concerns at Argenteuil were similar—the look of light on water, for example—their execution remained individual. Sisley's short, abrupt, stylized brushstrokes contrast with his meticulous treatment of other elements in his painting.

ABOVE

Camille Pissarro. *Hoar Frost*. 1873. Oil on canvas. 25 ½ x 36 ½ in. (65 x 93 cm).

The artist showed this work—a study of reflected light—in 1874, at the first Impressionist exhibition. Some critics received it with outrage, because it failed to be a genre painting: "The picture has no head, no tail, no up, no down, no front, and no back."

OVERLEAF

Claude Monet. *Field of Poppies*. 1873. Oil on canvas. 19 ¾ x 25 ½ in. (50 x 65 cm).

Poppies are the flowers of high summer, the season of deep blue skies, and the child in the foreground, reveling in these ephemeral blossoms, provides a way in for the viewer. The energetic diagonal sweep of the red swath contrasts with the figures' lazy leisure.

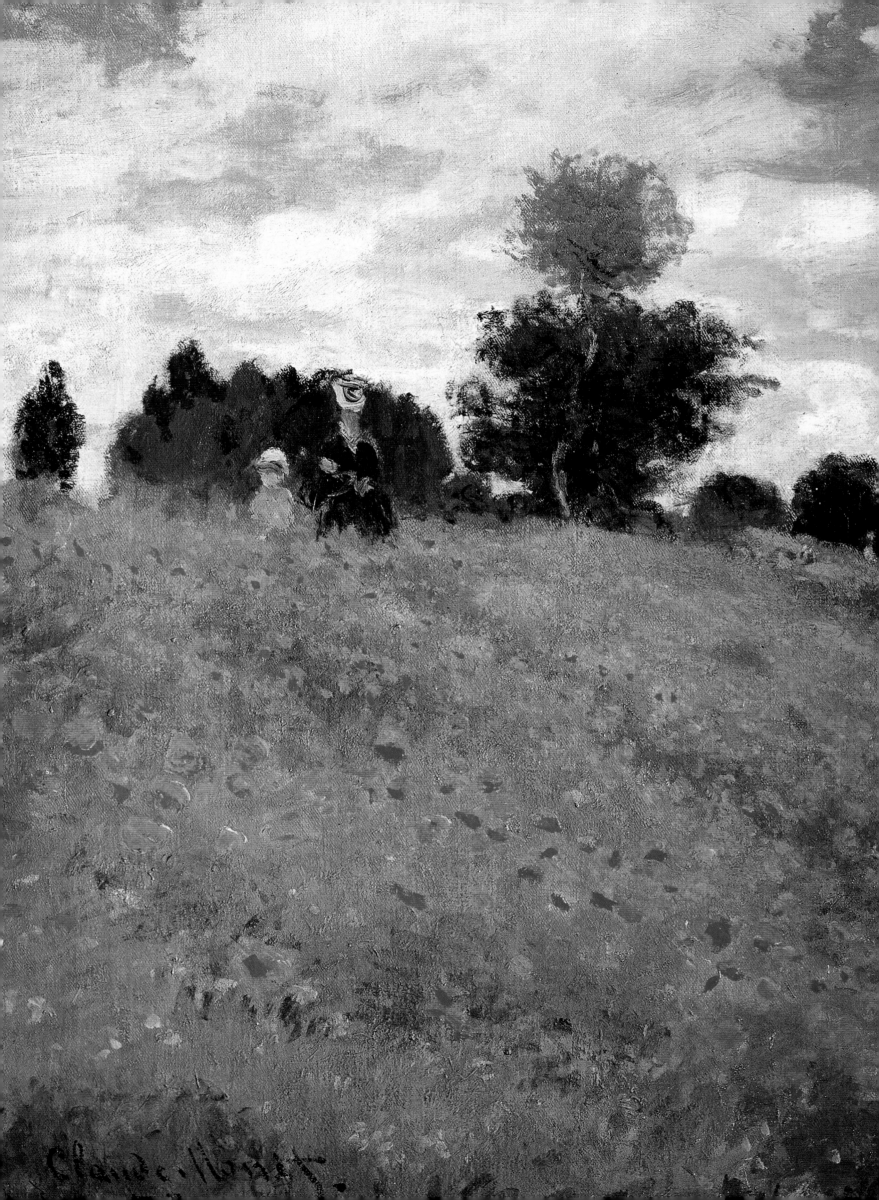

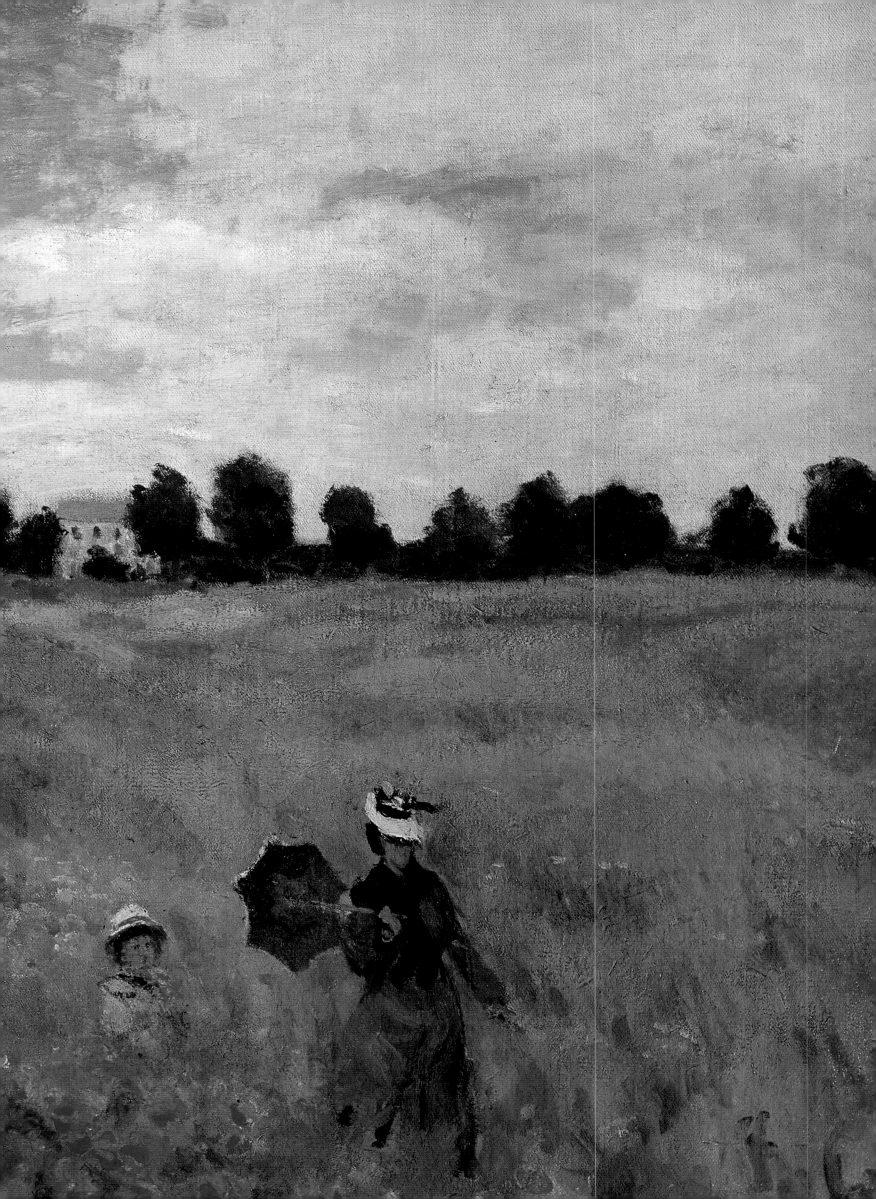

Jean-François Millet. *Spring*. 1868–73. Oil on canvas. 33 ¾ x 43 ¾ in. (86 x 111 cm).

Millet's planned series of paintings on the seasons remained unfinished at his death. In his last phase, his paintings became increasingly poetic, though no less scrupulously realistic. The drama of light and shadow refers in part to the landscapes of Jacob van Ruisdael and John Constable.

Paul Cézanne. *A Modern Olympia.* c. 1873–74. Oil on canvas. 18 x 22 ¾ in. (46 x 55.5 cm).

Cézanne's was not usually a lighthearted temperament, but his frothy second version of this subject, after Manet's complex realist fiction of 1865, is as dashingly frivolous as anything by Fragonard. Olympia's black cat—or is it a dog?—is front and center, while the viewer has entered the picture frame.

Edgar Degas. *Dance Class.* Begun 1873; completed 1876. Oil on canvas. 33 ½ x 29 ½ in. (85 x 75 cm).

A gifted, largely self-taught draftsman, Degas tended to choose subjects that allowed him to study gesture and movement. In addition, born into the well-to-do élite, he enjoyed entrée to the scenes behind the scenes, such as a dance rehearsal.

Edgar Degas. *The Dance Foyer at the Opéra on the rue Le Peletier.* 1872. Oil on canvas. 13 x 18 in. (32 x 46 cm).

A priviledged backstage observer, Degas depicted environments usually closed to the public. François Mérante, standing and holding a cane, was a famous dancer and teacher, who also choreographed some of the society ballets, in which the aristocracy performed. Although there were female teachers and male dancers, Degas did not portray them.

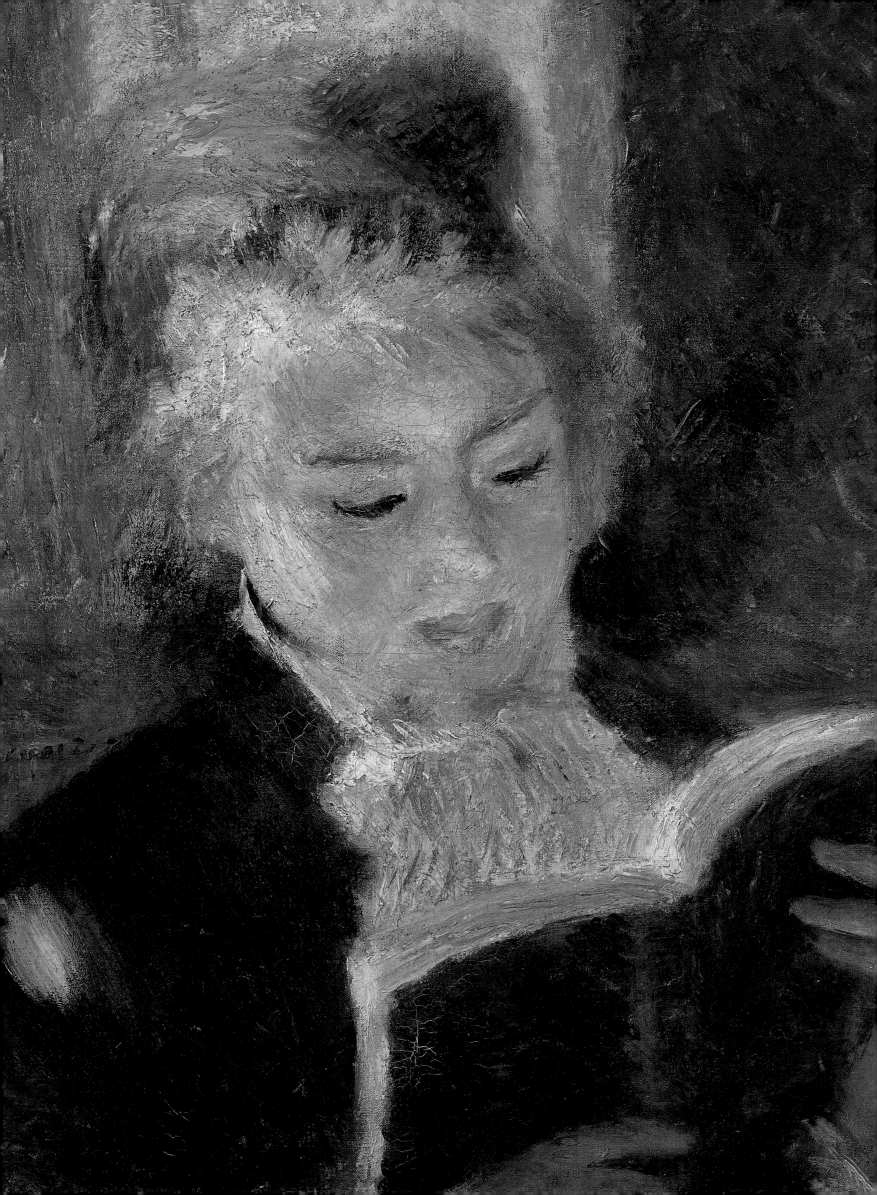

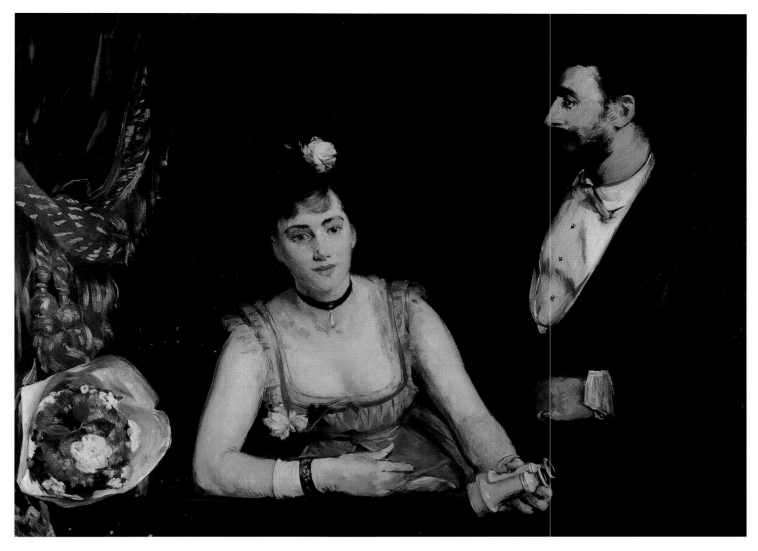

Eva Gonzalés. *The Loge at the Italian Theater*. c. 1874. Oil on canvas. 38 ½ x 51 in. (98 x 130 cm).

The vivid female figure relates visually more directly to the bouquet of flowers—either presented to her, or intended for the star performer—than to her escort. The artist, Manet's only pupil, like her teacher showed at the official Salons rather than with the Impressionists.

Pierre-Auguste Renoir. *Woman Reading (The Reader)*. 1874. Oil on canvas. 17 ¾ x 14 ½ in. (45 x 37 cm).

Renoir's small, intimate portrait is a full-blooded picture of a woman's interior life, exteriorized in a cascade of warm light—warmer than the natural light by which the unnamed woman reads. This is no pale, well-groomed bourgeoise, but a pink-cheeked woman of the people.

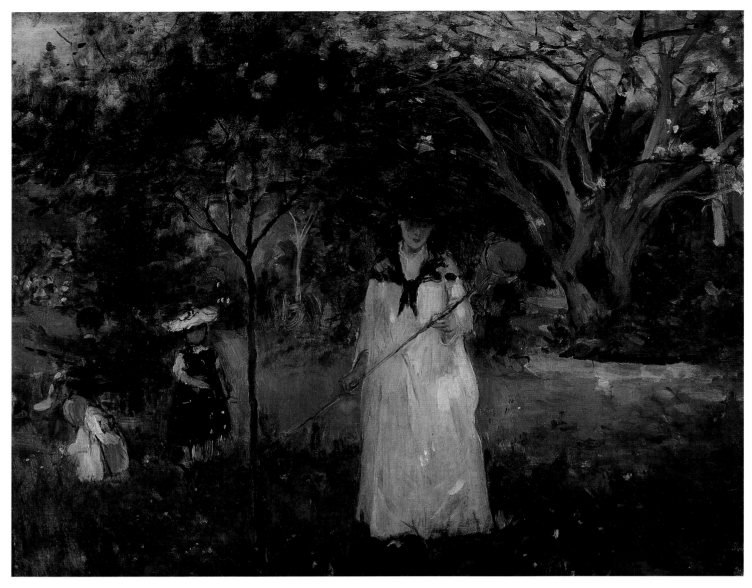

Berthe Morisot. *The Butterfly Hunt.* 1874. Oil on canvas. 18 x 22 in. (46 x 56 cm).

Morisot subverts a conventionally charming subject: a mother and her little girls (Edma and her daughters) in leisurely pursuit of beautiful, fluttering creatures. Here, the girls seem rather to be pursuing their elusive parent, separated from them visually by the abrupt vertical of the sapling.

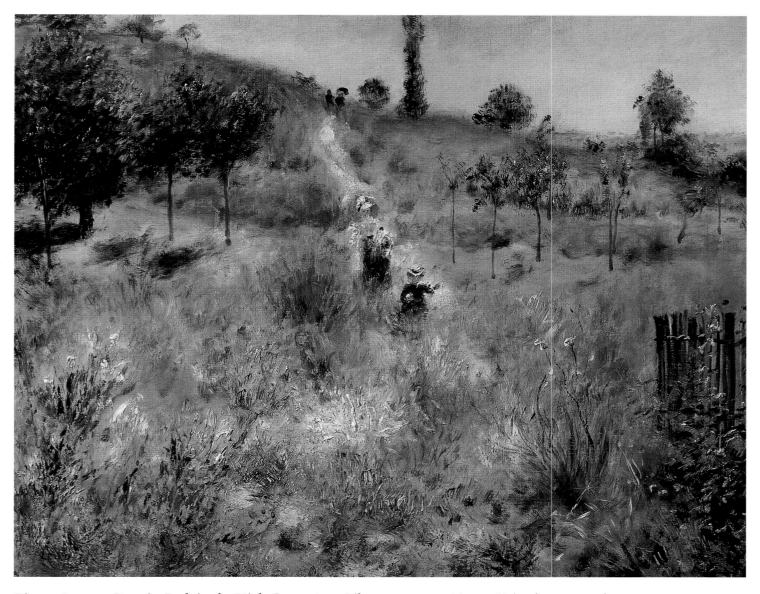

Pierre-Auguste Renoir. *Path in the High Grass*. 1874. Oil on canvas. 23 ¼ x 29 ⅛ in. (59 x 74 cm).

Close in spirit to Monet's *Field of Poppies* and probably also painted near Argenteuil, Renoir's work is more playful, both in the central red patch of a parasol, echoing the surrounding poppies, and in the variety of textures on the painting's surface.

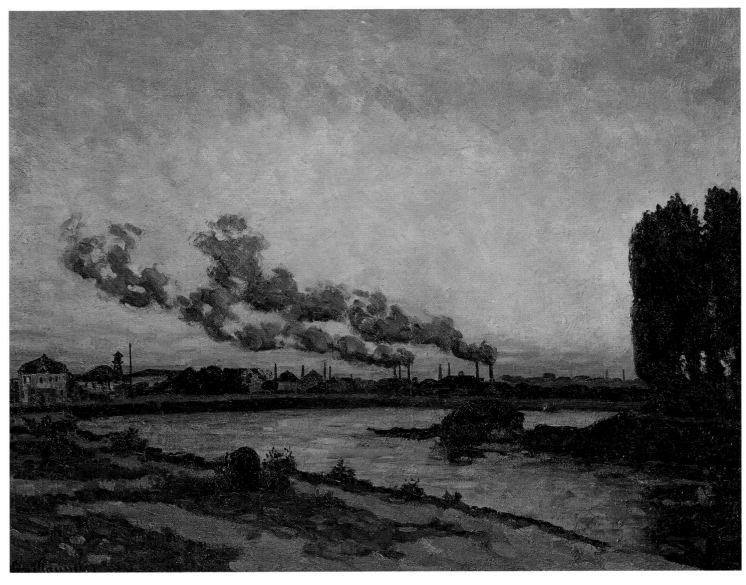

Armand Guillaumin. *Sunset at Ivry.* 1874. Oil on canvas. 25 ½ x 31 ⅞ in. (65 x 81 cm).

In place of history painting and grand subjects, the Impressionists celebrated the specific present. Here, the wind-blown smoke of the factories in the Paris suburb continues the angle of the river, emphasizing the economic energy that the chimneys represent.

Berthe Morisot. *In the Wheatfields at Gennevilliers*. 1875. Oil on canvas. 18 ¼ x 27 ¼ in. (46.5 x 69 cm).

The Manet family, Morisot's in-laws, had a property at Gennevilliers, near Argenteuil. The face of the country figure is barely sketched, a technique that Morisot was severely criticized for, but the subject may be rather the progression of the area from open country to suburbs and industry.

Gustave Caillebotte. *The Floor-Scrapers*. 1875. Oil on canvas. 40 ¼ x 57 ¾ in. (102 x 146.5 cm).

The lighting in Caillebotte's scrupulously and handsomely realist work, shown at the 1876 Impressionist exhibition, both accentuates and honors the workers' physical labor. The prominent bottle of wine, just broached, suggests the numbing, mechanical nature of that labor, typical of the new urban age.

Edgar Degas. *Madame Jeantaud at the Mirror.* c. 1875. Oil on canvas. 27 ½ x 33 in. (70 x 84 cm).

Degas's summary of his approach to his art could describe that of his Impressionist colleagues as well: "What I do is the result of contemplation and the study of the old masters." This painting, which inspired later artists, such as Picasso, is itself a representation of several contemplations: Degas, imagining a lady of the bourgeoisie looking within herself.

Jean-Paul Laurens. *The Excommunication of Robert the Pious in 998*. 1875.

LEFT

Jean-Paul Laurens. *The Excommunication of Robert the Pious in 998*. 1875. Oil on canvas. 51 ¼ x 85 ¾ in. (130 x 218 cm).

Robert II married Bertha of Burgundy, a cousin, and was godfather to one of her children by a former marriage. The Church considered the marriage incestuous, and when Robert refused to repudiate Bertha, Pope Gregory V excommunicated him. Laurens, a confirmed atheist, created this image for the new secular state.

P. 132

Edgar Degas. *L'Absinthe*. 1876. Oil on canvas. 36 x 26 ¾ in. (92 x 68 cm).

The harsh, timeless light suggests the state of mind of the absinthe drinker and her companion, both portrayed by popular models and fellow-denizens of Impressionist circles. The pair, pushed up into the right-hand corner of the frame, are both separated from and connected to the viewer by the café's tables.

P. 133

Antonio Mancini. *The Poor Schoolboy*. 1876. Oil on canvas. 51 ¼ x 38 ¼ in. (130 x 97 cm).

The schoolchild is not the only poor one: he is evidently in his teacher's home, where books, the most prized possessions, are stacked high and the prominent *brazier* is cruelly empty. This genre scene, with its sentimental evocation of childhood and parental ambition, was exhibited at the 1876 Salon.

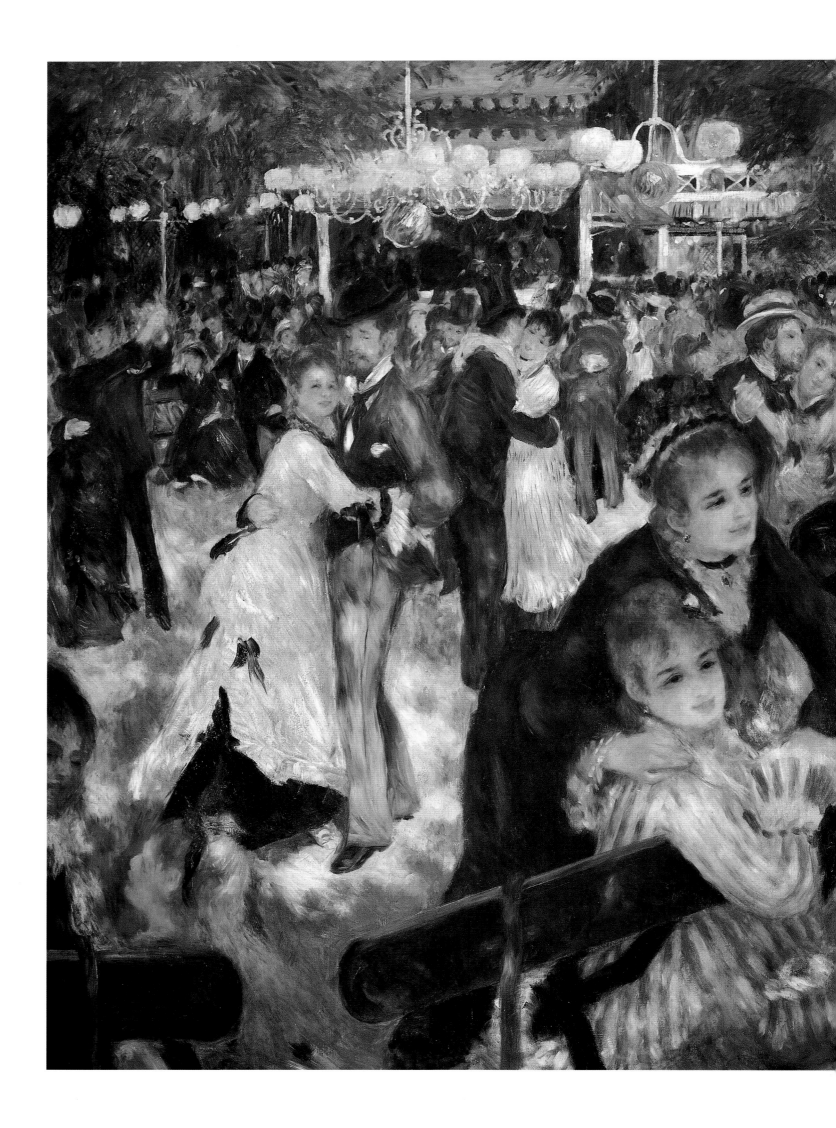

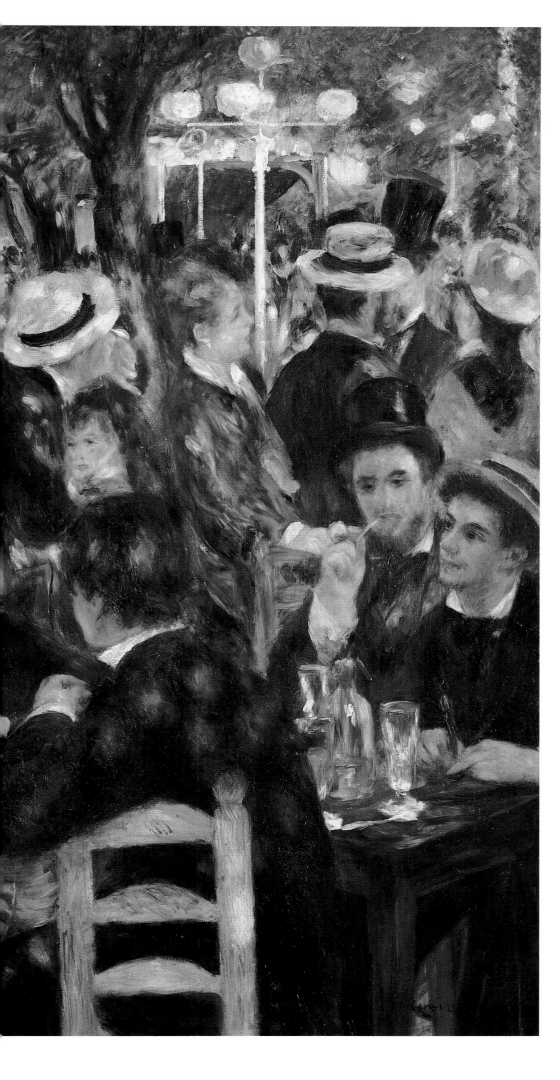

Pierre-Auguste Renoir. *Ball at the Moulin de la Galette.* 1876. Oil on canvas. 51 ½ x 68 ⅞ in. (131 x 175 cm).

This open-air café in the Paris suburb of Montmartre (not yet the bohemian art capital it would soon become) held dances on Sundays. Some of those portrayed are working-class locals, but this insightful study of light and human nature is populated by a collection of Renoir's male friends and female models.

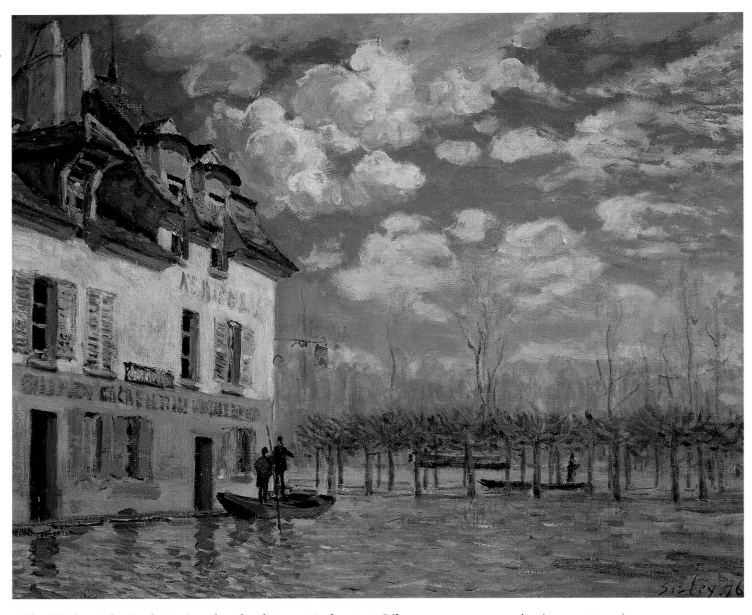

Alfred Sisley. *The Bark During the Flood, Port Marly.* 1876. Oil on canvas. 20 x 24 in. (50.5 x 61 cm).

In the mid-1870s, Sisley lived at Marly-le-Roi, near Versailles. In a group of six pictures, he recorded the aftermath of the great flood of 1876, which inundated Port Marly, a village on the Seine. The soft palette and generally low-keyed treatment are typical of Sisley's take on Impressionist sincerity.

Camille Pissarro. *Red Roofs, a Corner of the Village in Winter.* 1877. Oil on canvas. 23 ½ x 25 ¾ in. (54.8 x 65.5 cm).

The branches on the left give this painting, shown in the Impressionist group's exhibitions of both 1874 and 1877, a found, photographic quality. This was one of the seven paintings by this artist that were originally accepted into the Luxembourg from Gustave Caillebotte's bequest.

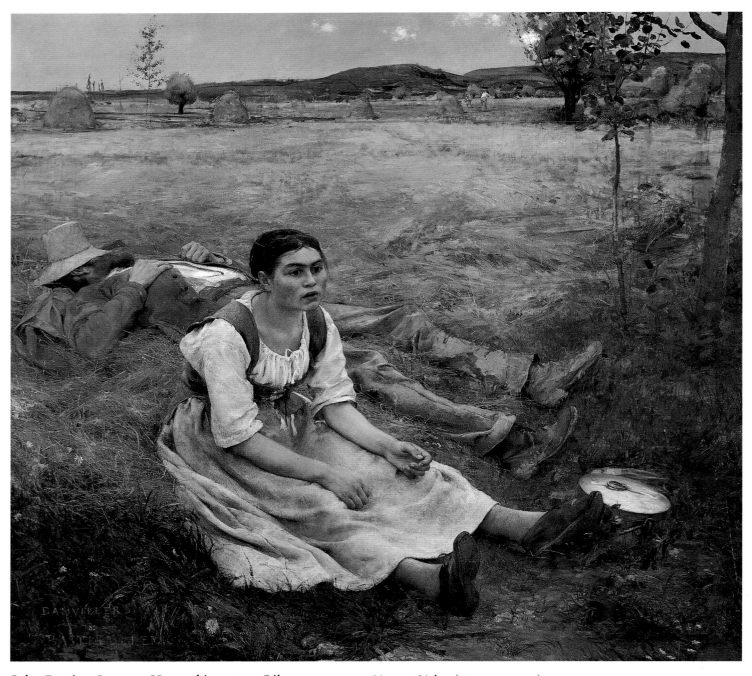

Jules Bastien-Lepage. *Haymaking.* 1877. Oil on canvas. 70 ¾ x 76 ¾ in. (180 x 195 cm).

After narrowly losing the Prix de Rome, Bastien-Lepage began painting the peasants in his native Lorraine. This life-size naturalist work, whose title adds a sexual subtext, was well received at the 1878 Salon, perhaps because the woman's expression introduced a spiritual element. The State purchased the work within months of the artist's death.

Berthe Morisot. *Young Woman Powdering Herself.* 1877. Oil on canvas. 18 x 15 ¼ in. (46 x 39 cm).

Morisot's admirers found her work delicate and subtle. Here, she has captured a private, but virtually universal bourgeois rite of passage of her time. The young woman herself understands the weight of her gesture: she hesitates before the act that will transform her into a public, marriageable woman.

Paul Cézanne. *The Bridge at Maincy*. 1879. Oil on canvas. 23 x 28 ½ in. (58.5 x 72.5 cm).

A contemporary of Monet, Cézanne was close to the Impressionist group, but came to pursue a course at variance with their dissolution of forms in color and light. Here, blunt dabs of paint, strong outlines, and reliance on color to create shadow and shape point to the artist's future direction.

Paul Cézanne. *L'Estaque.* c. 1882–85. Oil on canvas. 23 ½ x 28 ¾ in. (59.5 x 73 cm).

This view of the coast near Marseilles where Cézanne's mother owned a house is one of the first expressions of the painter's own vision, a synthetic assembly of graded thicknesses of paint and flat, distinct areas of color. The artist wrote Pissarro that the effect of the southern sunlight was "the antithesis of modeling."

P. 142

Jules-Élie Delaunay. *Madame Georges Bizet.* 1878. Oil on canvas. 41 x 29 ½ in. (104 x 75 cm).

The composer had died three years before Delaunay painted this somber portrait of mourning; the light on the widow's face, hands, and single piece of jewelry adds poignancy to her soulful features and the unmodulated black of her widow's weeds.

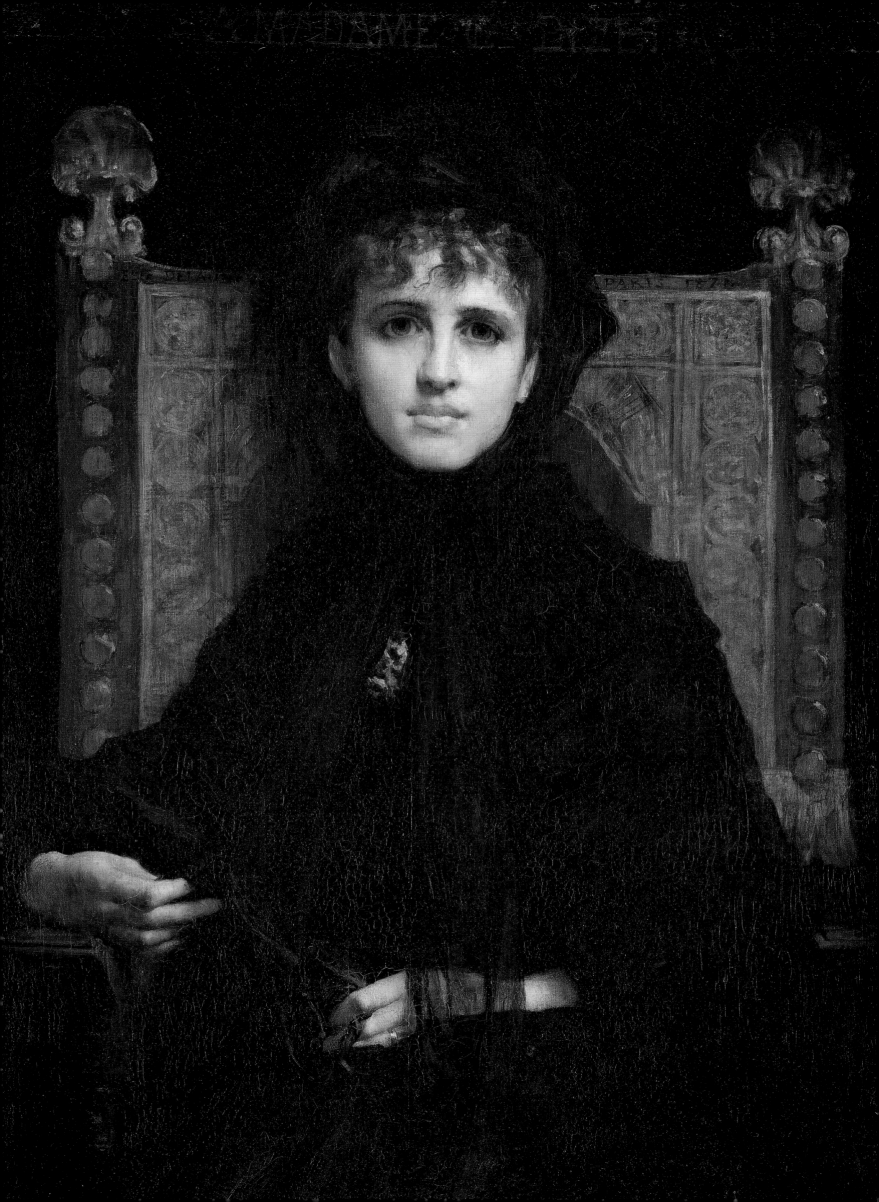

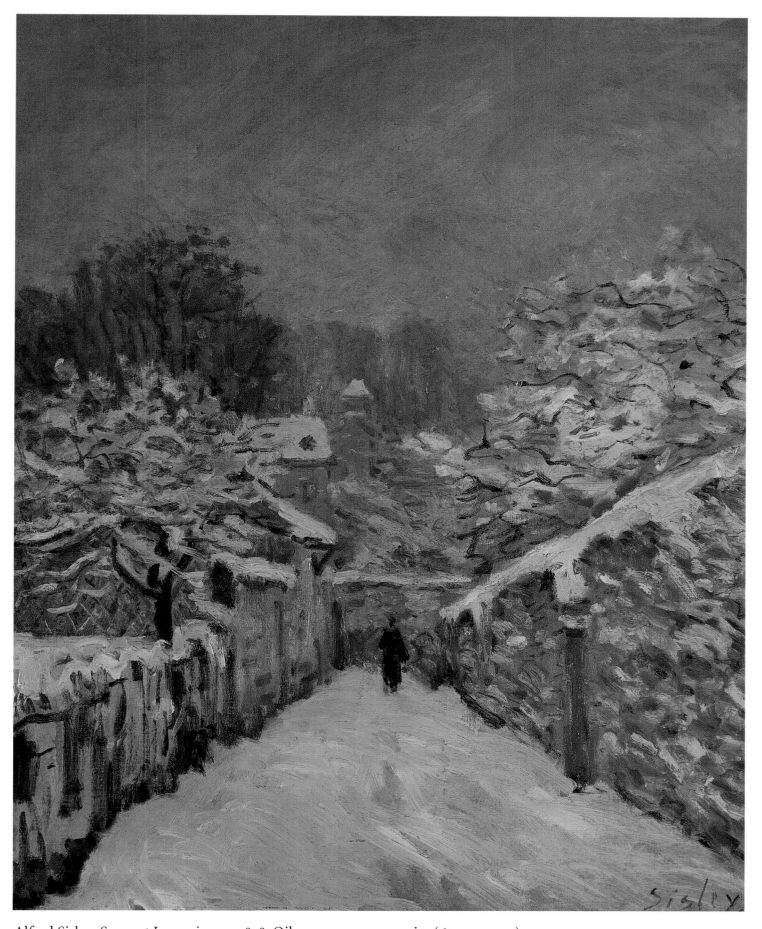

Alfred Sisley. *Snow at Louveciennes.* 1878. Oil on canvas. 24 x 20 in. (61 x 50.5 cm).

Sisley's thick brushstrokes convey the weight and silence of snow in the countryside, its fleeting and changeable shades of white. Sisley's was a reserved, even solitary nature, and these qualities appear in his subdued compositions, peopled by isolated figures.

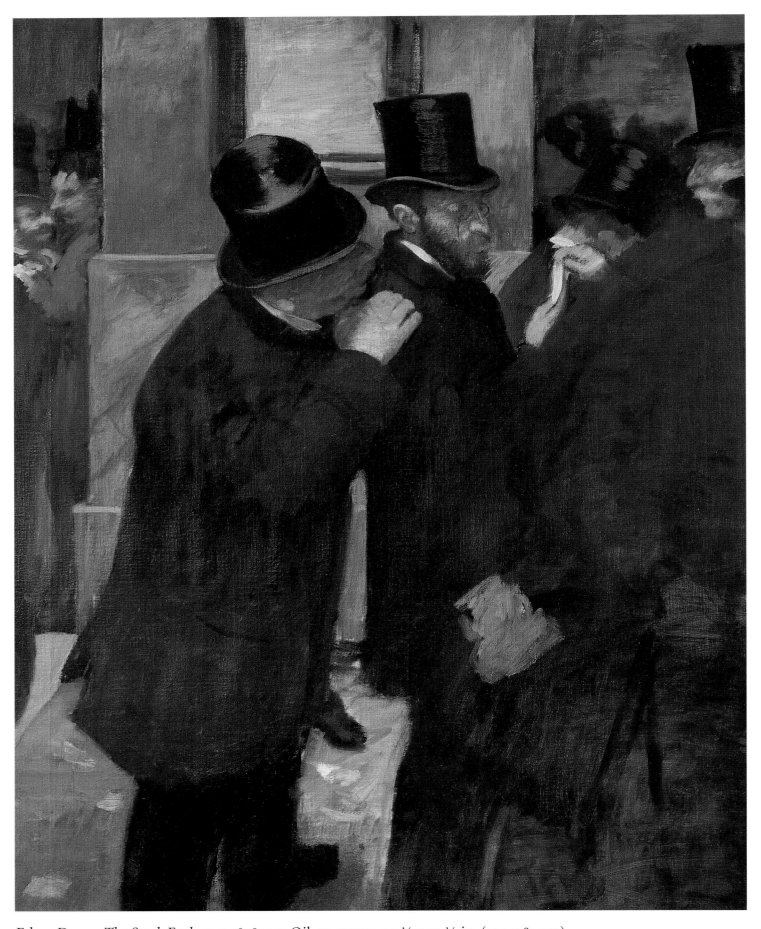

Edgar Degas. *The Stock Exchange.* 1878–79. Oil on canvas. 39 ¼ x 32 ¼ in. (100 x 82 cm).

Jockeys ride, laundry women iron, dancers pose, and the bourgeoisie makes money. Degas's own family's banking business failed in 1874, and much of the "well-born" artist's mixed feelings are apparent in this group portrait with, at its center, one of Degas's patrons.

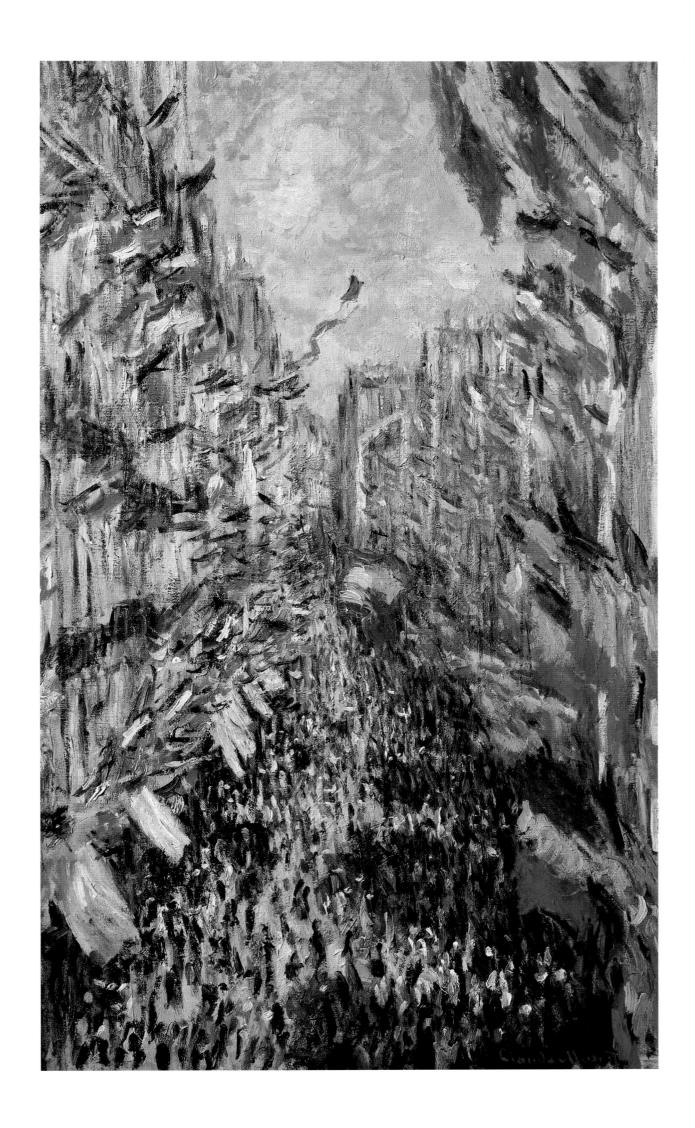

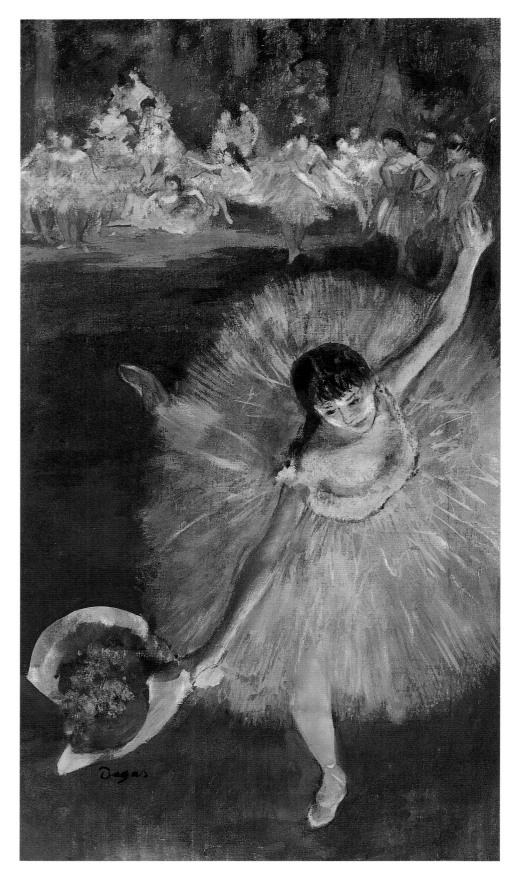

LEFT

Edgar Degas. *Fin d'arabesque.* c. 1877. Pastel, essence, and oil on paper. 25 ½ x 14 in. (65 x 36 cm).

Degas's fascination with ambiguity—the public and the private, the unself-conscious and the artificial—finds rich expression in this image. The harsh shadows cast by the footlights and the dancer's graceful but unnatural stance are in contrast with the postures of her colleagues backstage, presented in a decorative frieze.

P. 145

Claude Monet. *La Rue Montorgueil, Decked out with Flags, 30 June 1878.* 1878. Oil on canvas. 32 x 20 in. (81 x 50.5 cm).

In an interview of 1920, Monet recalled that, having identified the best vantage point, he had asked for and received permission to paint from a private balcony. The painting's composition, with flagpoles on either side, was considered very daring in its day.

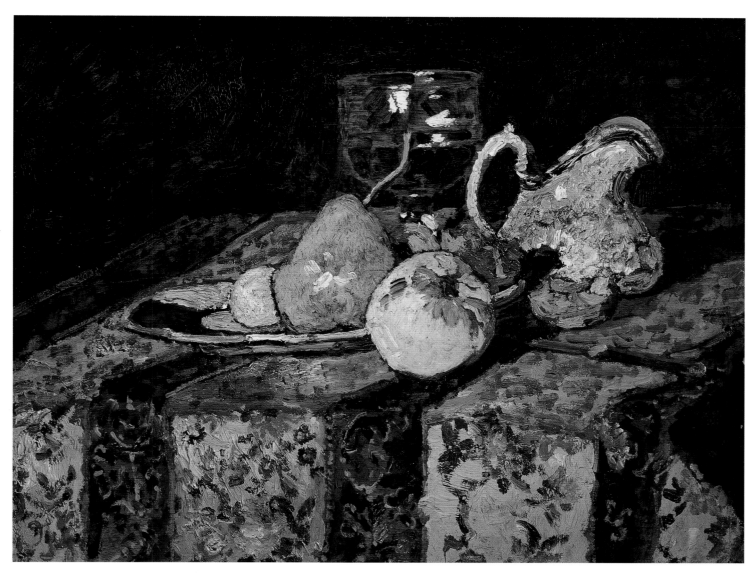

Adolphe Monticelli. *Still Life with White Jug.* c. 1878–90. Oil on canvas. 19 ¼ x 13 in. (49 x 63 cm).

Van Gogh identified strongly with Monticelli, a complex, flamboyant personality who represented to the young Dutchman one of the attractions of the Midi. In particular, Monticelli's application of intense, even pure color with thick brushstrokes inspired Van Gogh's own manner.

P. 148

Pierre Puvis de Chavannes. *Young Girls on the Edge of the Sea.* 1879. Oil on canvas. 80 ¾ x 60 ¾ in. (205 x 154.3 cm).

Where the Impressionists tended to merge figure and ground, Puvis de Chavannes created virtual color silhouettes. However refined the painting's colors—recalling Giotto's murals—the modeled, sculptural figures of the dreamy young women are vigorous, almost sturdy.

P. 149

Claude Monet. *Camille on Her Deathbed.* 1879. Oil on canvas. 35 ½ x 26 ¾ in. (90 x 68 cm).

Monet reported to a friend, as an example of his merciless obsession with color, that when he went to record the passing of the woman who had been his companion, wife, and model, he could respond only to "the proportions of light and shade in the colors that death had imposed."

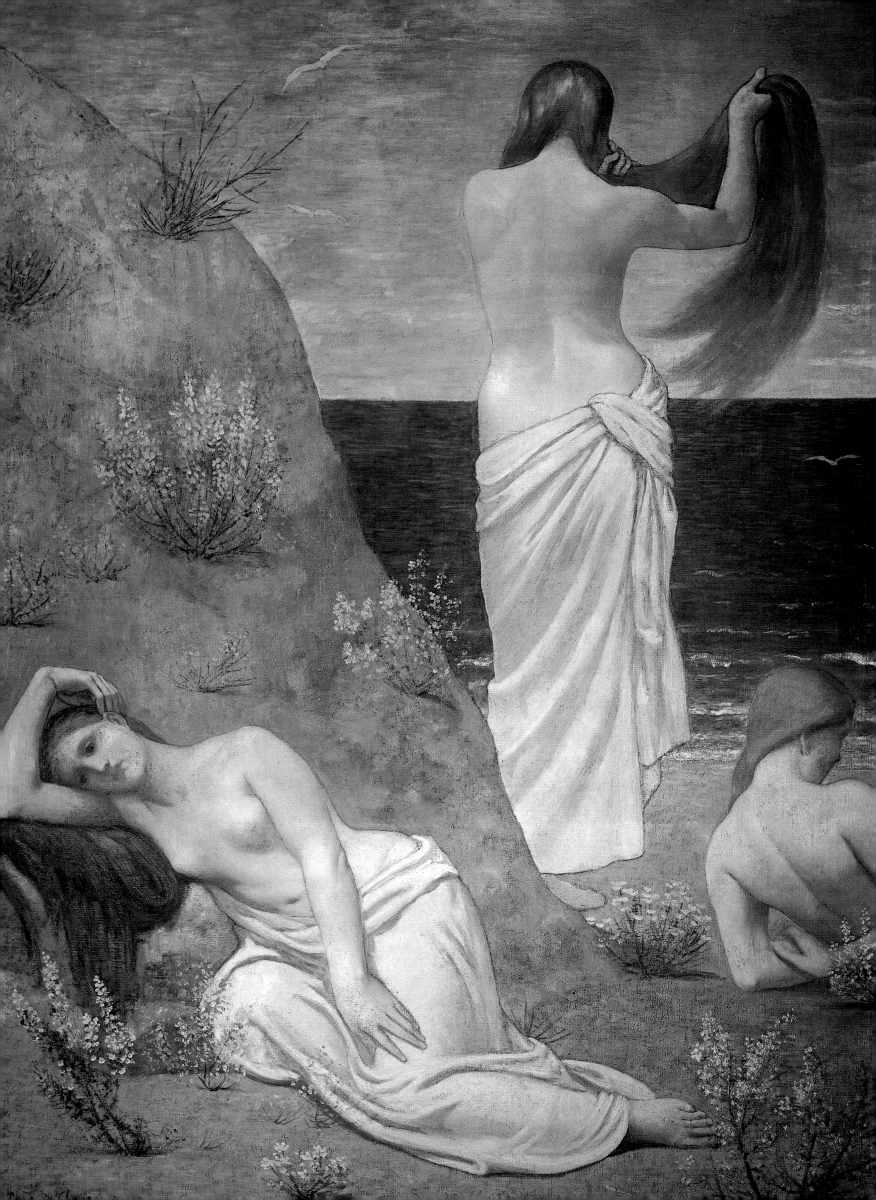

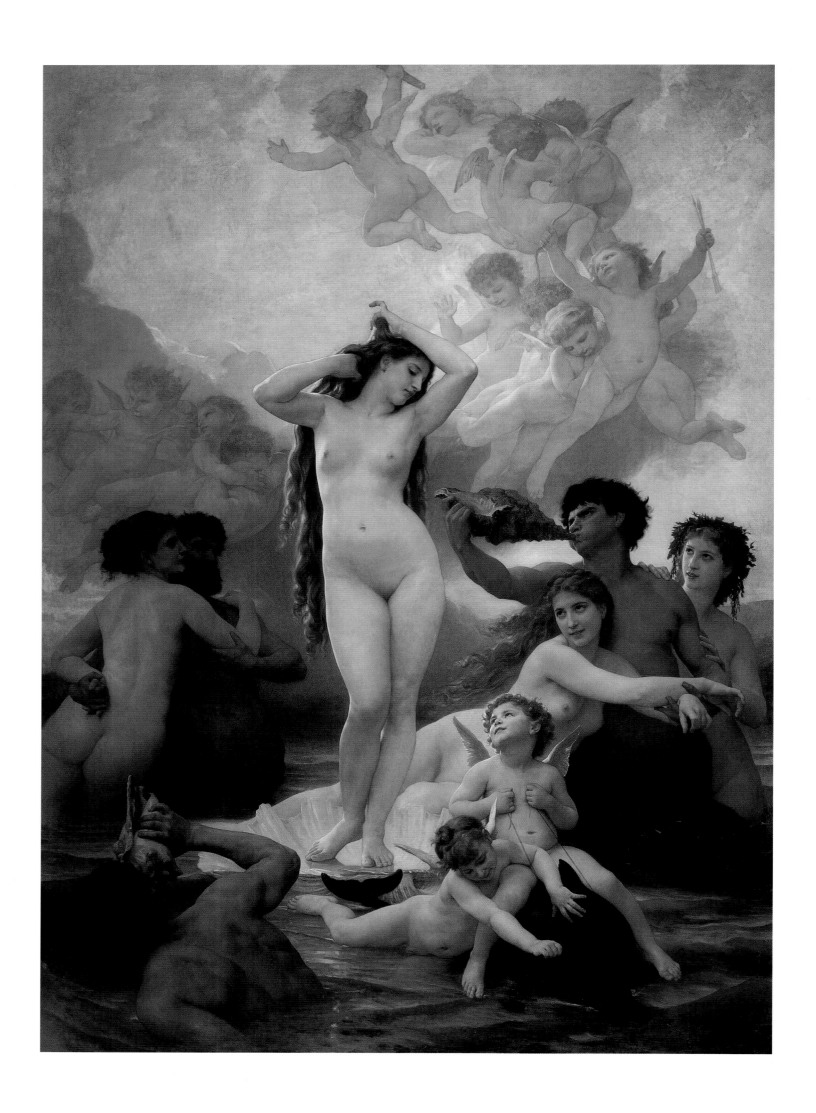

ABOVE

Fernand Cormon. *Cain.* 1880. Oil on canvas. 149 ½ x 275 ½ in. (380 x 700 cm).

Cormon, who executed landscape murals for the main hall of the Gare d'Orsay, painted each of these figures from life, and strove for the archaeological verisimilitude made possible by the century's discoveries. This was the most important painting of the last official Salon, in 1880, and immediately bought for the Musée du Luxembourg.

OPPOSITE

William Bouguereau. *The Birth of Venus.* 1879. Oil on canvas. 118 x 85 ¾ in. (300 x 218 cm).

This noisy mythological composition, one of a number of Venus-and-Cupids by this ultra-successful artist, exhibits his command of line and anatomy, classical and Renaissance allusions, and realist techniques. Venus herself is an homage to Ingres's *The Source.*

P. 152

Berthe Morisot. *Young Woman in Evening Dress.* 1879. Oil on canvas. 28 x 33 ¼ in. (46 x 39 cm).

All this woman's intelligence has retreated into solipsistic anxiety: will she be chosen? Her sexuality, ladylike but manifest, is adumbrated by a discreet curve and cleavage, while Morisot has indicated her subject's decorative destiny by merging the gown's ruffles into the background.

P. 153

James, born Jacques-Joseph, Tissot. *The Ball.* c. 1879. Oil on canvas. 35 x 19 ¾ in. (88.9 x 50.2 cm).

Tissot, who fled to London during the 1871 uprisings, was another chronicler of Paris high society, along with friends such as Degas. The fashionable young woman is all agaze: her posture and the curve of her elaborate ballgown carry her like a wave into the glittering crush.

Alphonse de Neuville. *The Saint-Provat Cemetery*. 1881. Oil on canvas. 92 ¾ x 134 ¼ in. (235.5 x 341 cm).

The Third Republic, like the regimes preceding it, sought legitimacy through the art it patronized, including images such as this one, which commemorates a pivotal moment during the Franco-Prussian war. De Neuville's huge historical painting was exhibited at the conservative Salon des Artistes Francais.

Édouard Manet. *The Escape of Rochefort.* 1880–81. Oil on canvas. 31 ½ x 28 ¾ in. (80 x 73 cm).

Henri de Rochefort, a journalist and militant critic of Napoleon III, was a hero of some of the avant-garde artists. Rochefort was banished to the penal colony of New Caledonia in the South Pacific, but escaped the following year. He returned to France and Paris following the amnesty of 1880.

Léon Lhermitte. *Harverster's Country*. 1882. Oil on canvas. 84 ¾ x 110 in. (215 x 272 cm).

L'Hermitte was one of the most popular of the State-approved artists of the Third Republic. His treatment of a traditional subject—country folk—displays a confident and insightful naturalism, along with an idealism that refers back to the Le Nain brothers.

Camille Pissarro. *Young Woman with a Stick.* 1881. Oil on canvas. 32 x 25 ½ in (81 x 64.5 cm).

Pissarro had long limited his figure paintings to his numerous portraits. In the early 1880s that changed, and he eventually produced a series of peasant girls, of which this is one of the first. The interiority of her reflective mood makes her akin to Impressionist-painted urban sisters.

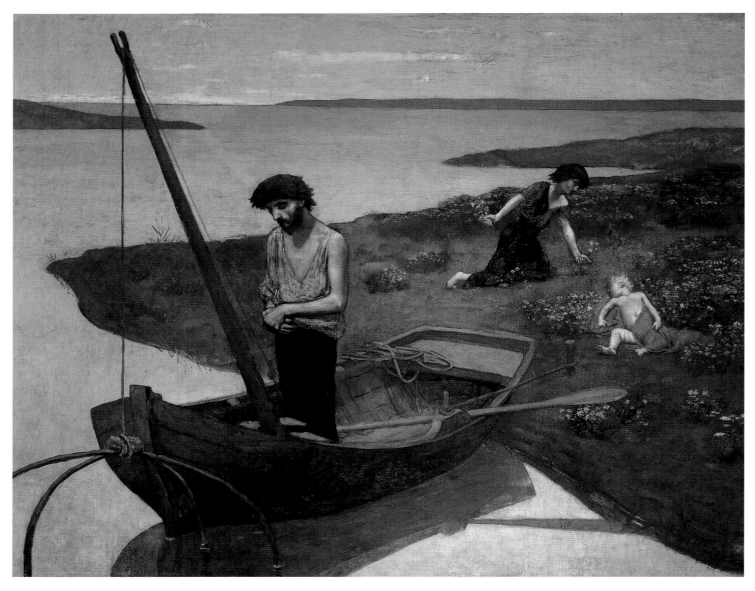

Pierre Puvis de Chavannes. *The Poor Fisherman.* 1881. Oil on canvas. 61 x 75 ¾ in. (155 x 192.5 cm).

This painting was one of the most discussed of its century, and artists as diverse as Gauguin, Seurat, and Picasso responded to its subdued, evocative poetics and flat areas of color. Critics have assigned it to various "isms," but, like the artist's work generally, it is in a class of its own.

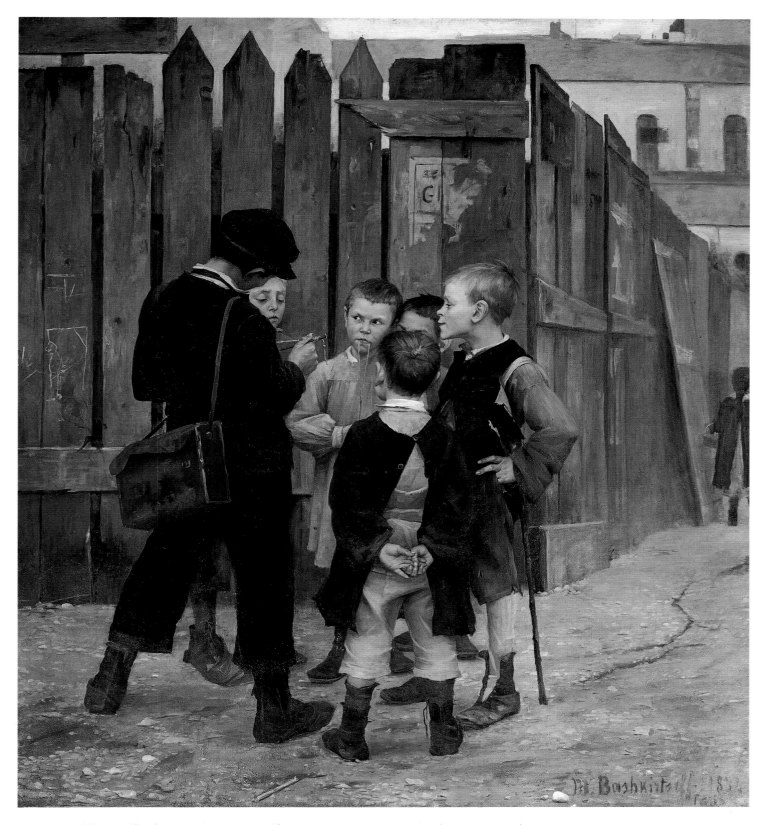

Maria Bashkirtseff. *The Meeting.* 1884. Oil on canvas. 76 x 69 ¾ in. (193 x 177 cm).

This Russian painter was drawn to Paris and the naturalism of Jules Bastien-Lepage, with whom she studied. Something of a prodigy, she first exhibited in the Salon in 1880, and was best known for informal works such as this one. She completed *The Meeting* for the 1884 Salon, but died shortly after.

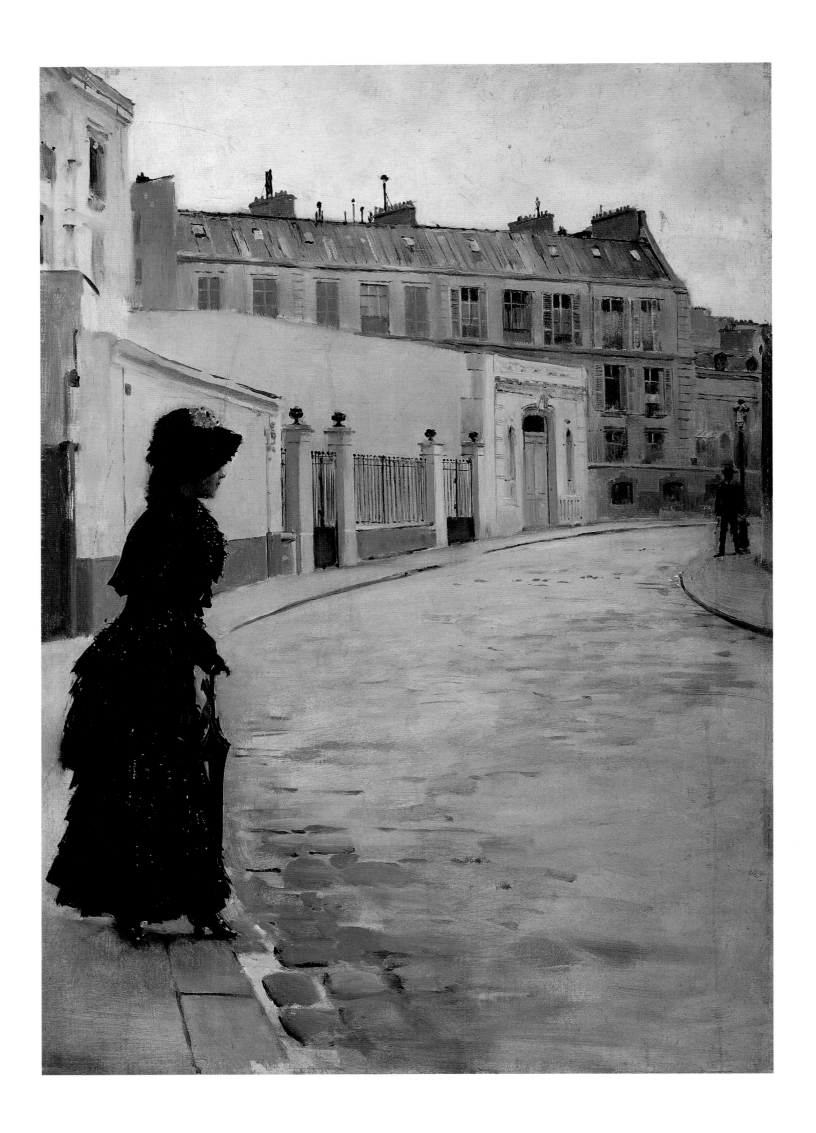

Edward Burne-Jones. *The Wheel of Fortune*. 1875–83. Oil on canvas. 78 ¾ x 39 ¼ in. (200 x 100 cm).

At mid-century, with William Morris, the Pre-Raphaelite Burne-Jones was a pioneer of the decorative Arts and Crafts movement, as well as a painter. The examples of Botticelli, Michelangelo, and medieval symbolism are evident in this panel, which was much admired by Puvis de Chavannes, among others.

Jean Béraud. *The Wait*. n.d. Oil on canvas. 22 x 15 ½ in. (56 x 39.5 cm).

Béraud was one of the naturalists who depicted the anecdotes of daily Parisian life. The striking contrast of warm tan and black and the absence of any other human presence render the tension between the two figures thrillingly acute. The pendant of this painting, at the Musée des Arts Décoratifs in Paris, is titled *The Rendez-vous*.

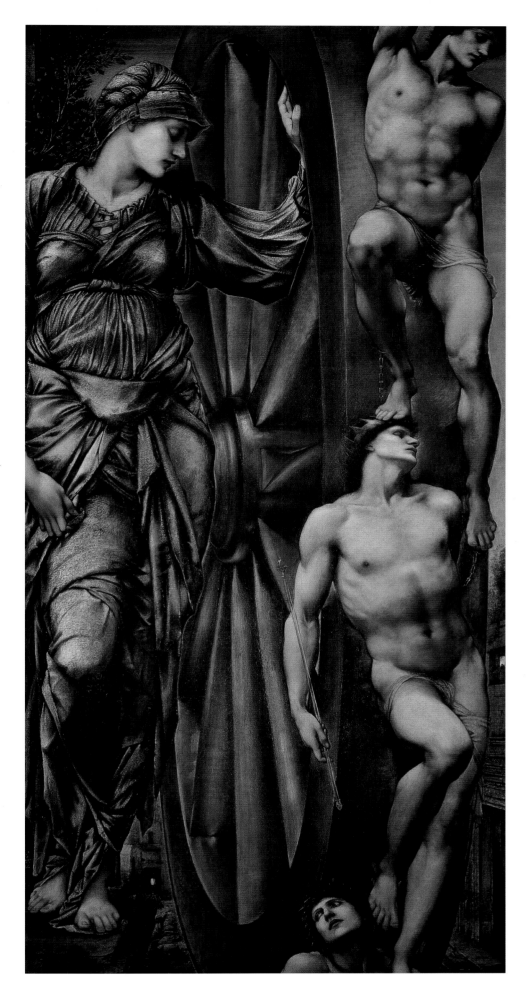

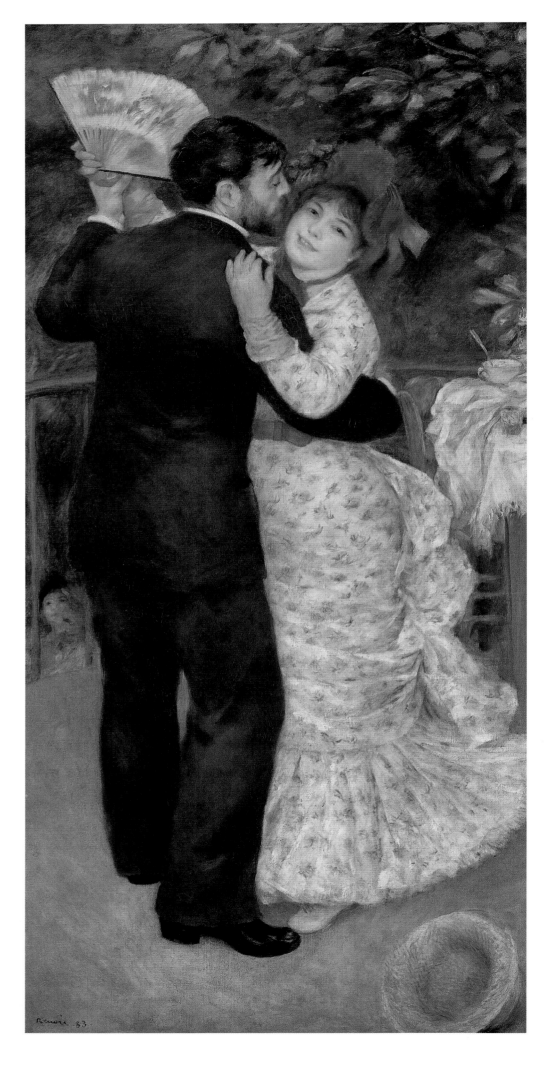

Pierre-Auguste Renoir.
Dance in the Country. 1883.
Oil on canvas. 70 ¾ x 35 ½ in.
(180 x 90 cm).

The models are Aline Charigot,
the artist's companion, and
Paul Lhôte, a journalist and
friend, who, like Charigot,
appears in several of Renoir's
paintings. In part, this is a
tribute to Renoir's future wife:
unselfconsciously provincial,
she is also outgoing,
enthusiastic, and affectionate.

Pierre-Auguste Renoir. *Dance in the City*. 1883. Oil on canvas. 70 ¾ x 35 ½ in. (180 x 90 cm).

This work and its companion piece, *Dance in the Country*, are tidier than Renoir's previous works, illustrating the more precise draftsmanship and acidulated palette that were replacing his Impressionist manner. The woman is the painter and painters' model Suzanne Valadon.

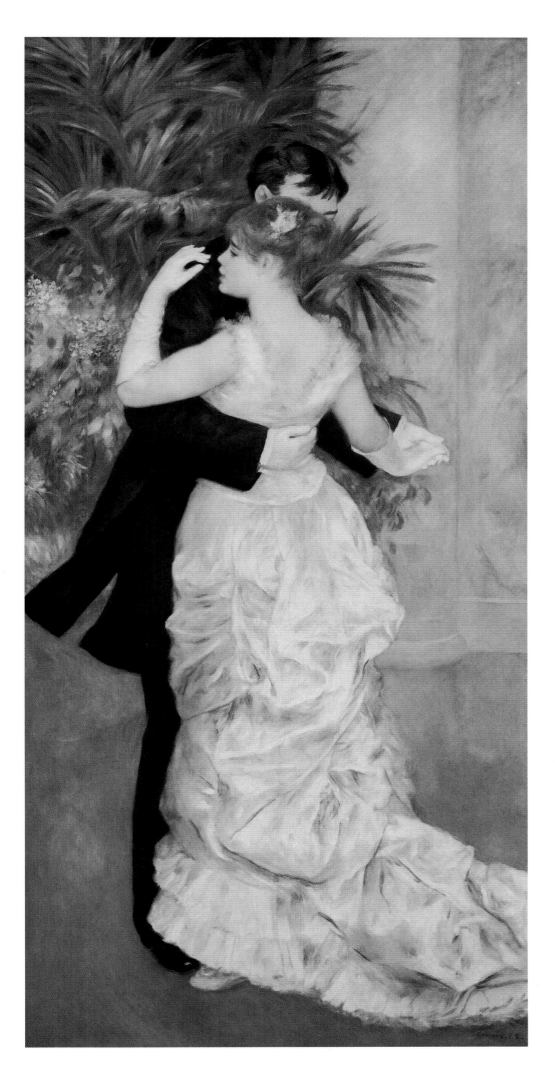

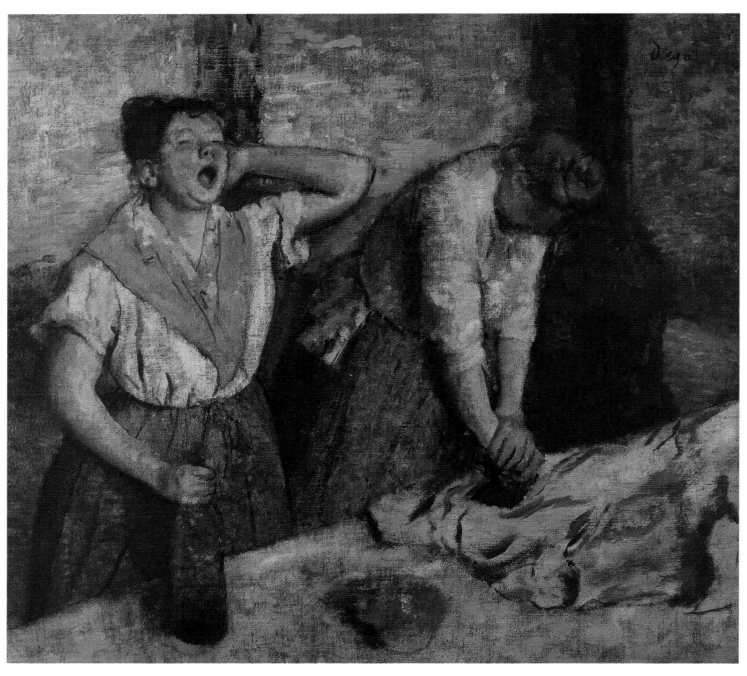

Edgar Degas. *Ironing Women (The Laundresses).* c. 1884–86. Oil on canvas. 30 x 31 ⅞ in. (76 x 81 cm).

Degas captured the postures of these uncorseted and underpaid laborers in a virtuoso display of paint on unprimed canvas. The woman on the left is well on her way through a bottle of wine. Behind the woman on the right is the stove where she heats the tools of her trade.

OPPOSITE

Mary Cassatt. *Young Woman in the Garden (Woman Sewing in the Garden).* c. 1883–86. 36 x 25 ½ in. (91.5 x 64.7 cm).

American-born Mary Cassatt, like her fellow-Impressionists, prized the details of daily life. Where Degas often selected the public sphere of the *boulevardier*, and Manet the congenial clamor of the *brasseries*, Cassatt favored the private world of domestic gestures.

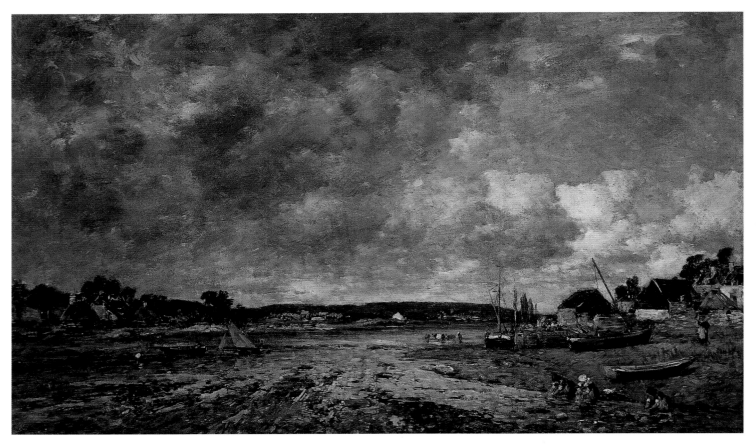

Eugène Boudin. *Norman Washerwomen on the Shore.* c. 1885–90. Oil on canvas. 14 ½ x 22 ⅞ in. (37 x 58 cm).

In the second half of the nineteenth century, the seashore attracted painters and, increasingly, those with leisure time. Like Millet, Boudin here portrays workers as essential to the reality of a place: the laundresses on the shore, the fishermen out at sea.

ABOVE

Hendrik Willem Mesdag. *Setting Sun.* c. 1887. Oil on canvas. 55 x 70 ¾ in. (140 x 180 cm).

Dutch artists, steeped in their native landscape tradition, inevitably responded to the English and French practice of direct observation of nature. The Hague School, including Mesdag, a passionate marine artist, referred deliberately to their national predecessors.

P. 168

Claude Monet. *Woman with an Umbrella Facing Right: Sketch from Life of a Figure in Open Air.* 1886.
Oil on canvas. 51 ⅝ x 34 ⅝ in. (131 x 88 cm).

In 1878, Monet stopped painting figures. He resumed again, for a while, in 1885, and it was at this point that he began detailing how light and colors change over the course of days and seasons. The model for this series of two is probably Suzanne Hoschédé, one of the daughters of Monet's lover, Alice Raingo Hoschédé, who married the artist in 1892.

P. 169

Claude Monet. *Woman with an Umbrella Facing Left: Sketch from Life of a Figure in Open Air.* 1886. Oil on canvas.
51 ⅝ x 34 ⅝ in. (131 x 88 cm).

This work and its companion painting with the figure facing right were executed some three years after the peripatetic Monet moved to his beloved Giverny. In both pictures, he attempted to translate the exact light that he saw surrounding the figure, but this is the more successful of the two.

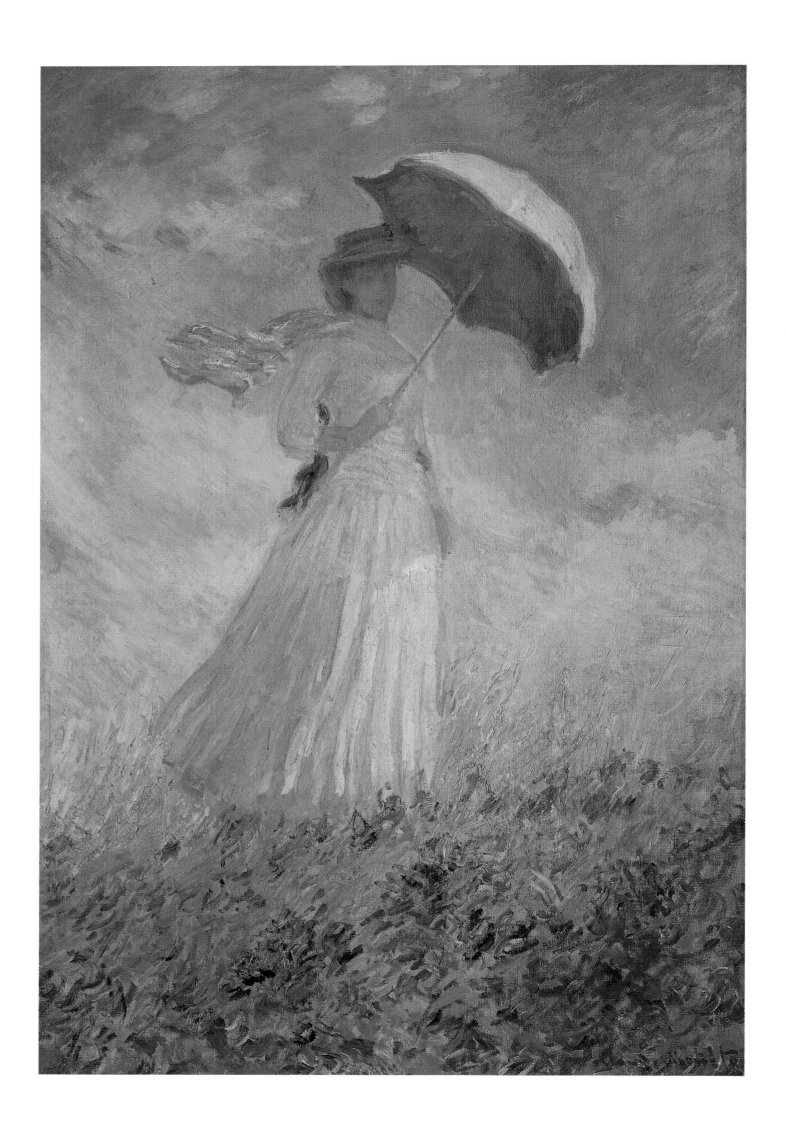

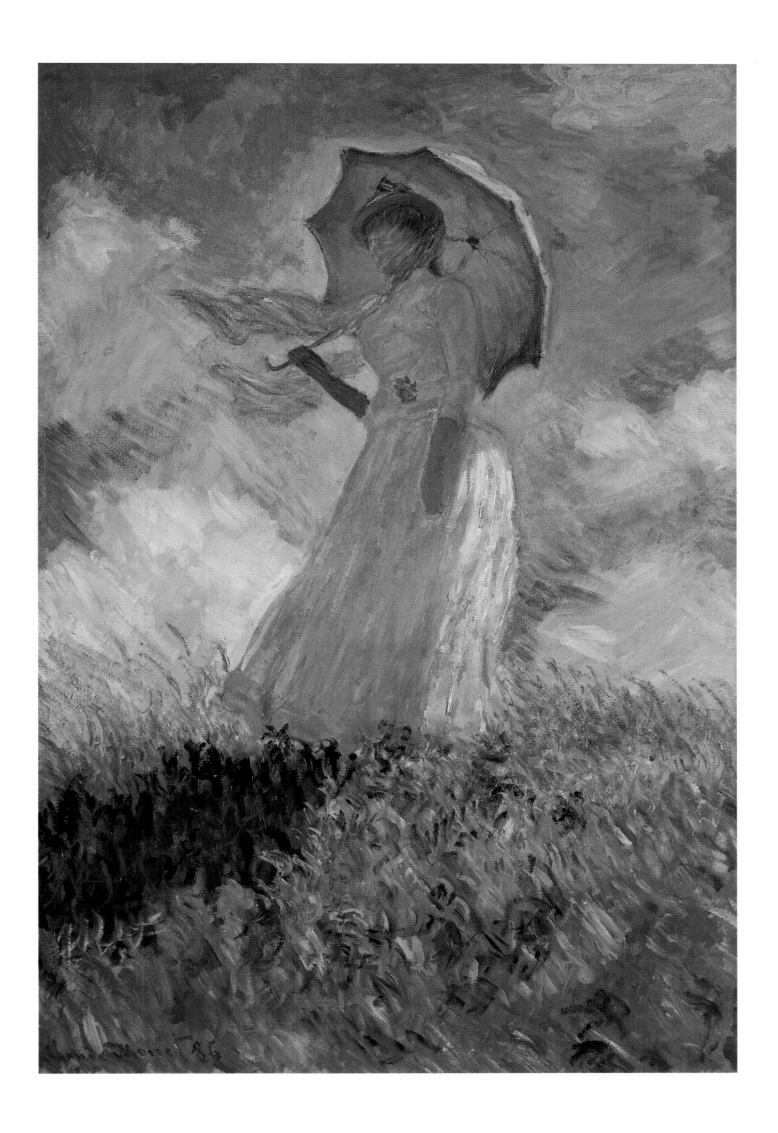

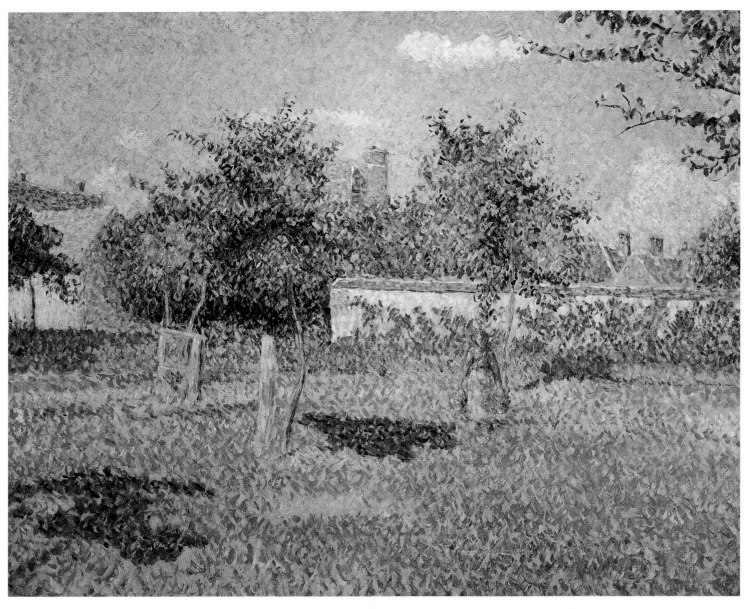

Camille Pissarro. *Woman in a Field, Spring Sunshine at Eragny.* 1887. Oil on canvas. 21 ½ x 25 ½ in. (54.5 x 65 cm).

In 1885, Pissarro met the much younger artists Paul Signac and Georges Seurat, who were juxtaposing pure color on the canvas, rather than mixing it on the palette first. This painting represents one of Pissarro's few experiments with Pointillism, and a modified one at that.

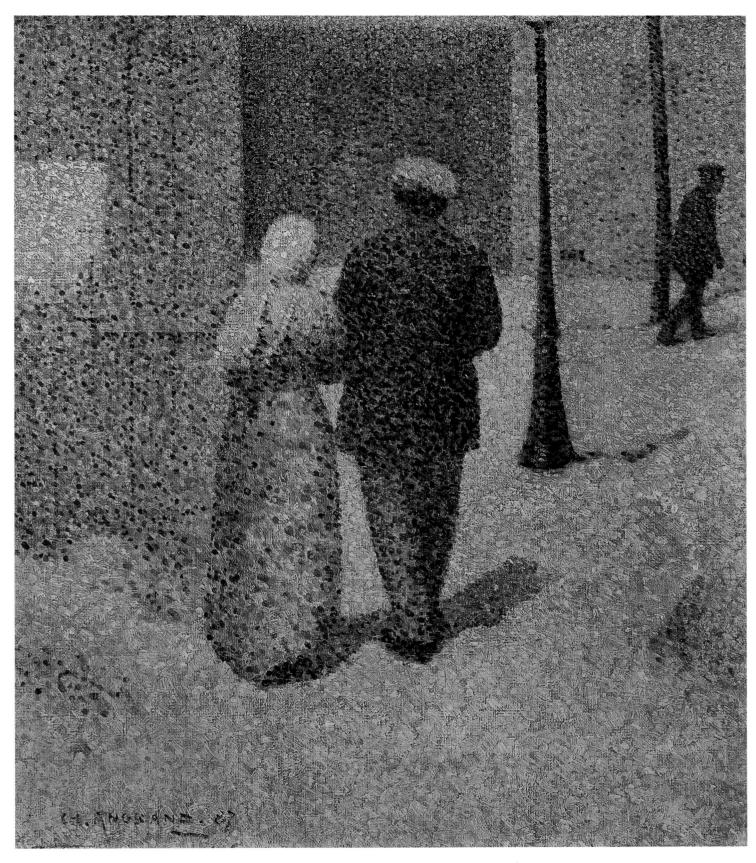

Charles Angrand. *Couple in a Street.* 1887. Oil on canvas. 15 x 13 in. (38.5 x 33 cm).

The weave of the canvas that shows through the Divisionist-constructed brushwork literally adds texture to the painting, and seems in keeping with the unpretentious quality of the title couple, walking through an almost abstract urban space.

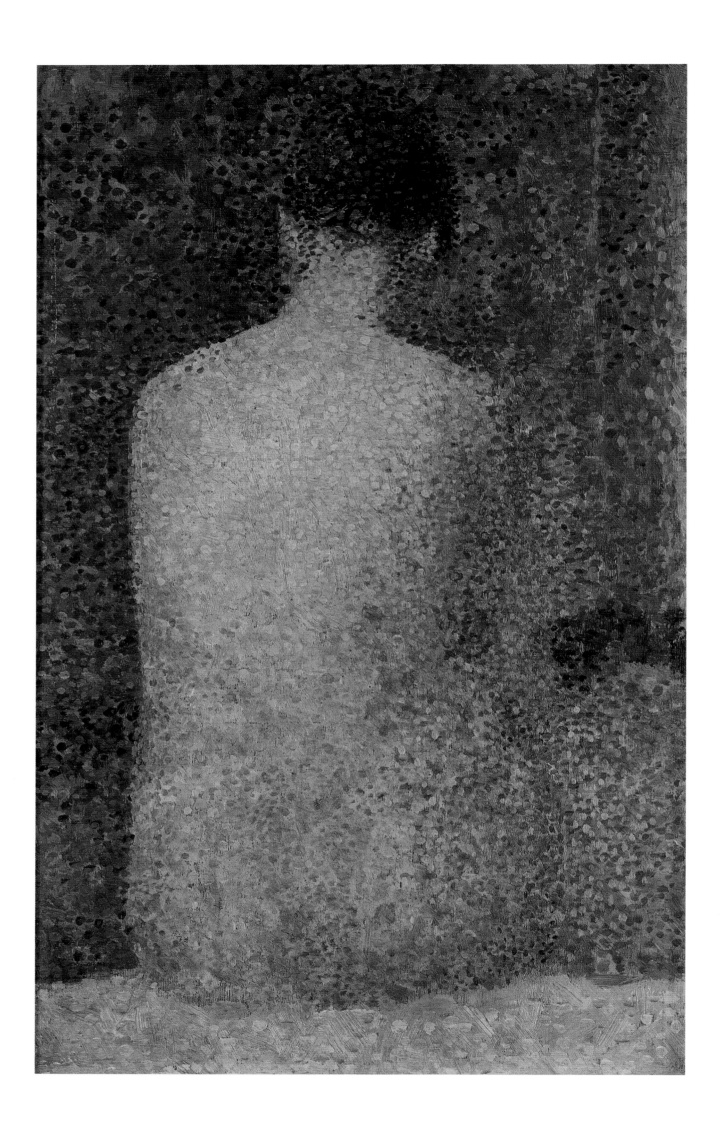

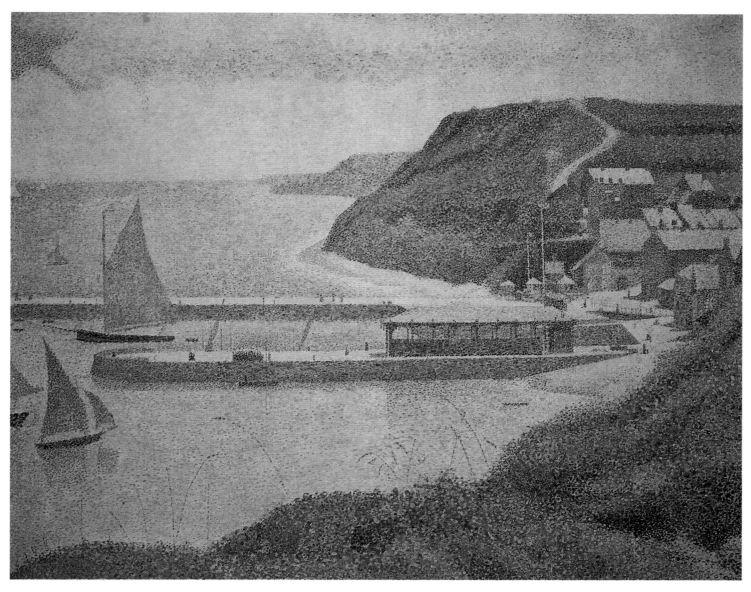

ABOVE

Georges Seurat. *Port-en-Bessin, Outer Harbor at High Tide.* 1888. Oil on canvas. 24 x 32 in. (61 x 82 cm).

The painter spent the summer of 1888 in this village on the Normandy coast, as did his friend and fellow-Divisionist, Paul Signac. Seurat's custom of painting borders on his works was intended to negotiate—and so call into question—the relationship between painting, frame, and surrounding wall.

OPPOSITE

Georges Seurat. *Model from Behind.* 1887. Oil on canvas. 9 ¹ x 6 in. (24.5 x 15 cm).

Experimenting with contemporary theories of color and physics, Seurat juxtaposed pure dots of color to achieve his remarkable results: a sort of aura follows the contours of the model's body. Color, modeling, and line are applied as suavely and expertly as in any "classical" painting.

P. 174

Vincent van Gogh. *The Italian [Woman].* 1887. Oil on canvas. 32 x 23 in. (81 x 60 cm).

In Paris, Van Gogh frequented an artists' bar known as Le Tambourin. This radiant, expressive portrait probably depicts Agostina Segatori, the bar's owner and a former model of Manet's. The juxtaposition of complementary colors and perhaps the painted frame are inspired by Seurat's work.

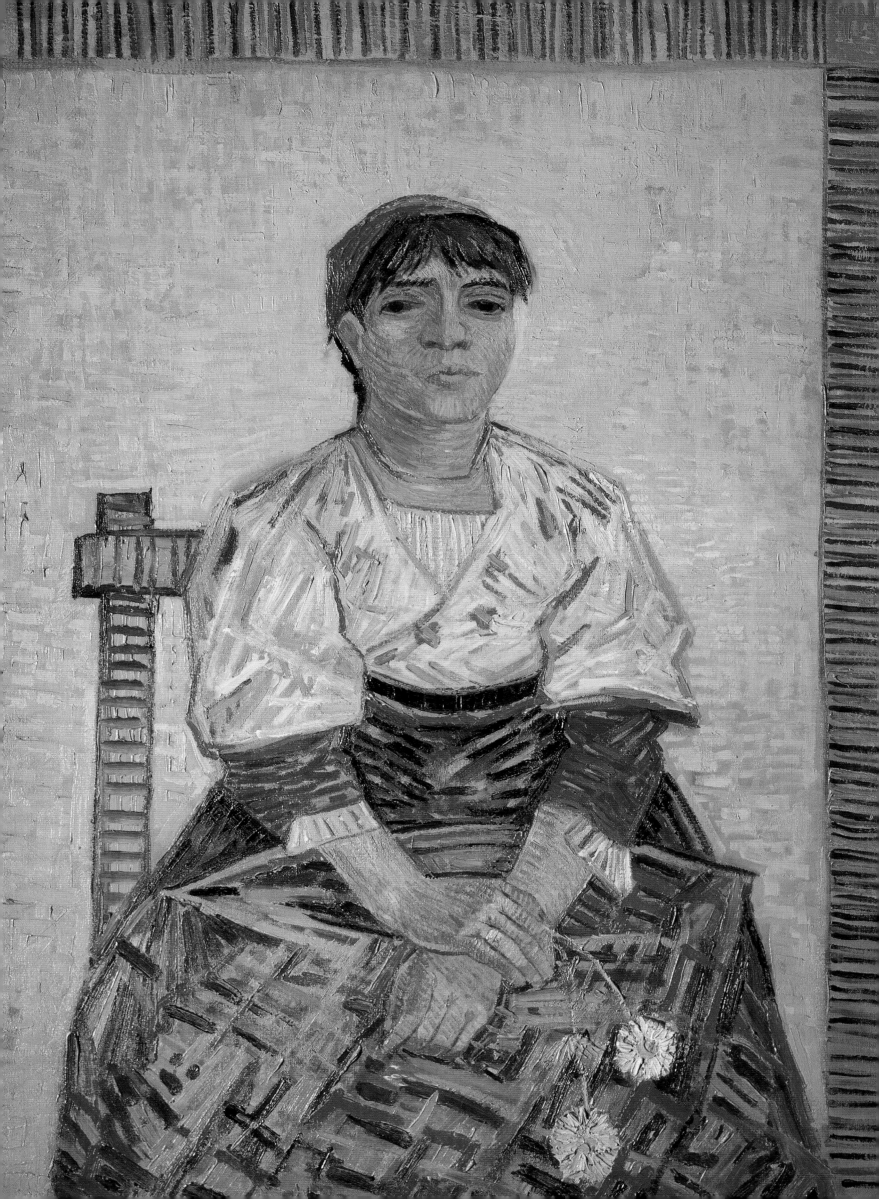

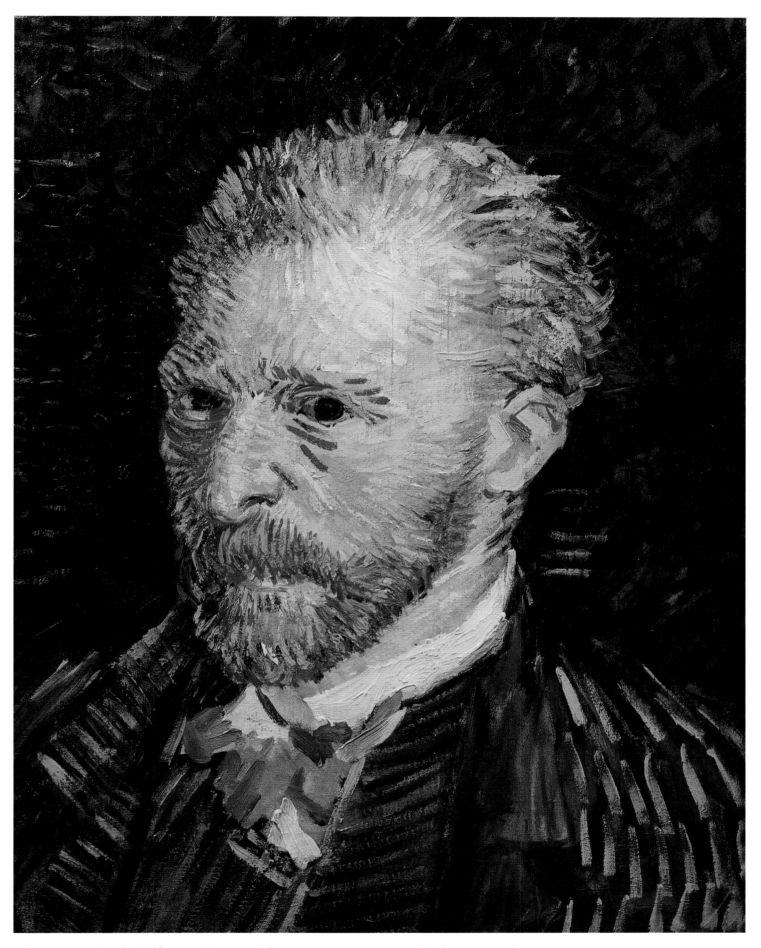

Vincent van Gogh. *Self-Portrait.* 1887. Oil on canvas. 17 ¼ x 13 ¾ in. (44 x 35 cm).

During his brief career as a pastor in Holland, Van Gogh had painted in a somber palette, with thick impasto. This remarkable portrait, assembled from brilliant, paint-laden brushstrokes, dates from the year after he moved to Paris, where initially he reveled in the artistic and social life he found there.

George-Hendrik Breitner. *Moonlight.* c. 1887–89. Oil on canvas. 39 ¾ x 28 in. (101 x 71 cm).

Breitner, a Dutch artist influenced by the commitment of Courbet, Millet, and Manet to presenting their own times, usually painted daily life in Amsterdam, where he settled in 1886. Here, he used his characteristic broad strokes to portray the billowing chiaroscuro of the sky over the plains of Holland.

Alfred Roll. *Manda Lamétrie, Farmwife.* 1887. Oil on canvas. 84 ⅜ x 63 ⅓ in. (214.5 x 161 cm).

By this time, naturalism in execution and subject matter, including such modest figures as a farmwife—who is named—and the homely rear end of a cow, was no longer shocking. On the contrary, reproduced in dictionaries and schoolbooks, this and works in this manner were well known and popular all over France.

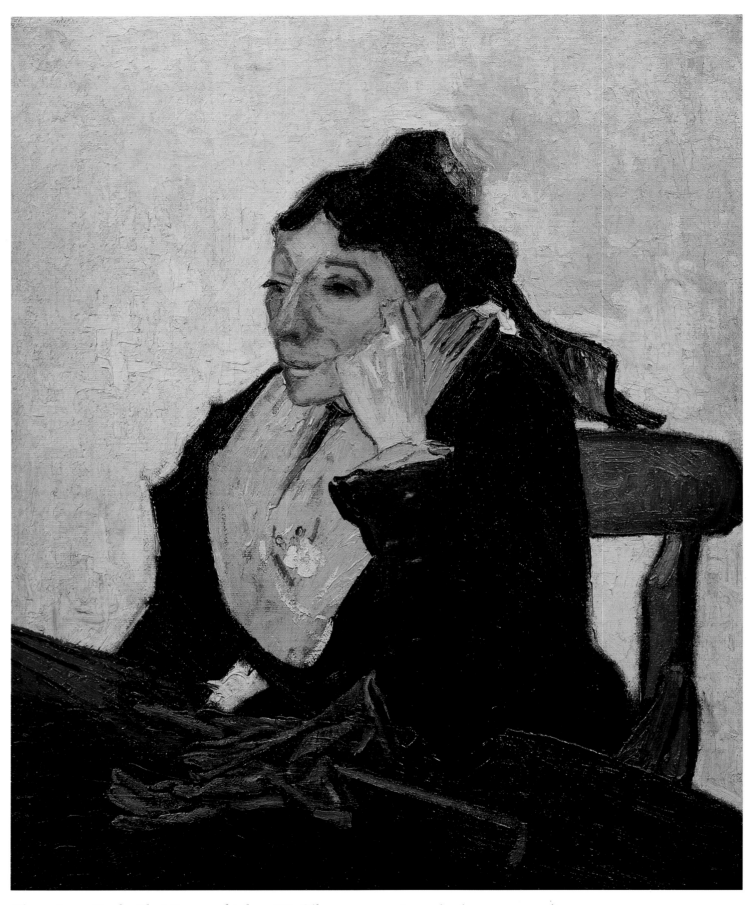

Vincent van Gogh. *The Woman of Arles.* 1888. Oil on canvas. 36 x 29 in. (92.3 x 73.5 cm).

Van Gogh painted several portraits of Marie Julien Ginoux, who with her husband ran the all-night Café de la Gare in Arles, where the artist was a regular, and above which he had lived for several months. In a letter to his brother, Theo, Van Gogh claimed to have "slashed [the figure] on in an hour."

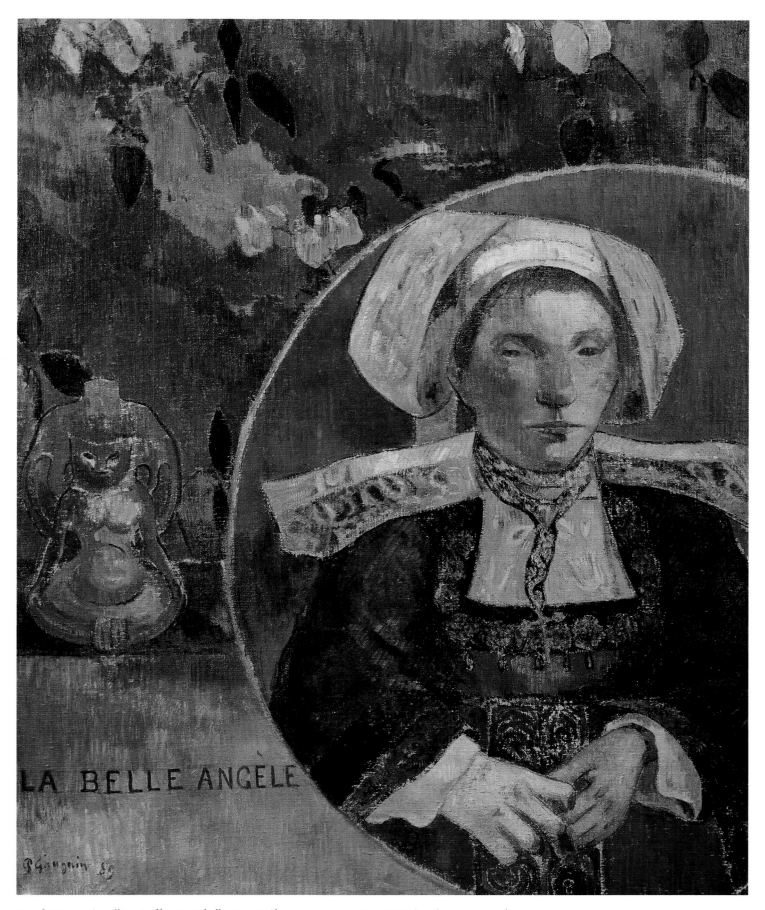

Paul Gauguin. *"La Belle Angèle."* 1889. Oil on canvas. 36 x 28 ¾ in. (92 x 73 cm).

The sitter for this unusual portrait was Mme Satre, a hotelkeeper in Pont-Aven, a town on the Brittany coast, whose traditional costume she wears. Gauguin, Émile Bernard, and others worked together there, sharing ideas of decorative, Japanese-inspired treatments of edged figures and rich hues.

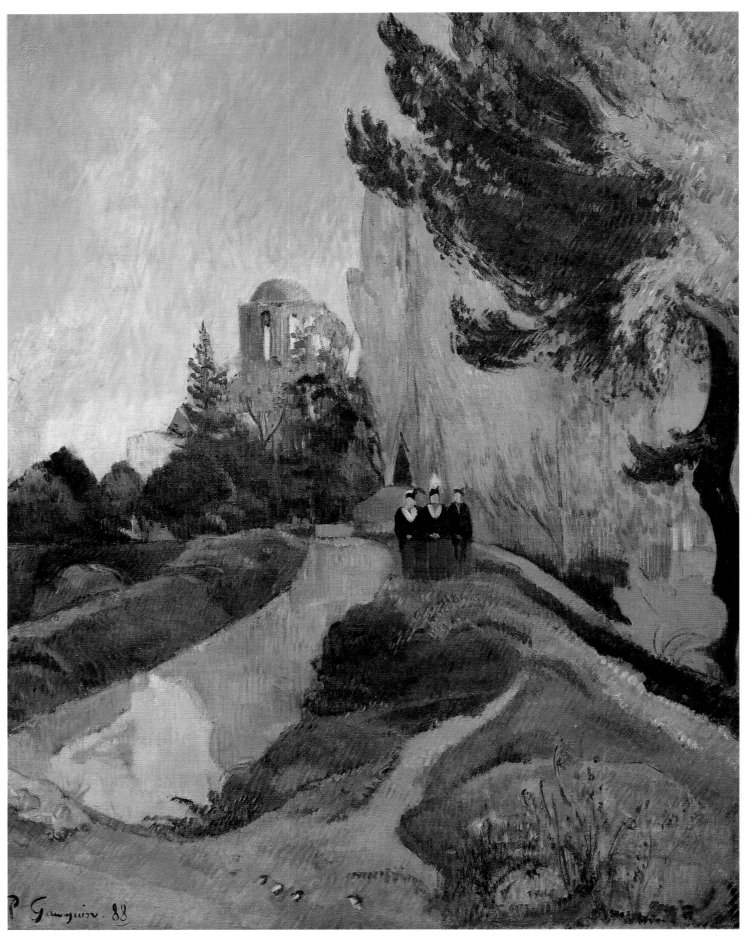

Paul Gauguin. *Les Alyscamps.* 1888. Oil on canvas. 36 ¼ x 28 ¾ in. (92 x 73 cm).

Gauguin, intrigued by his friend's excitement, joined Van Gogh in Arles, in the fall of 1888, and the two occasionally painted the same subject, as in the case of this local cemetery. This was one of the first two works by Gauguin to enter the Musée du Luxembourg, twenty years after his death.

Paul Sérusier. *The Talisman*. 1888. Oil on canvas. 10 ¾ x 8 ½ in. (27 x 21.5 cm).

The young Sérusier executed this small, vibrant work following Gauguin's instructions; its arcane reference may also be in keeping with the older artist's mystical inclinations. The painting displays discrete, flat areas of bright color, while representing a transition to the decorative, Japanese-flavored aesthetic of the Nabis, of which the artist was a founding member.

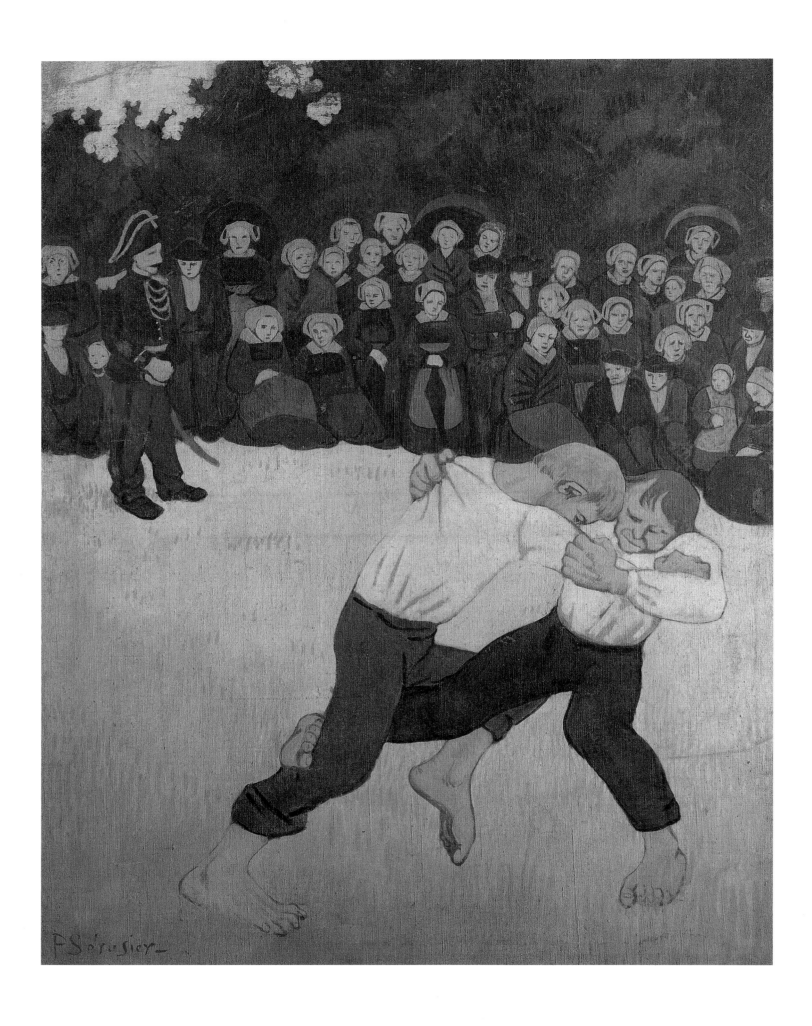

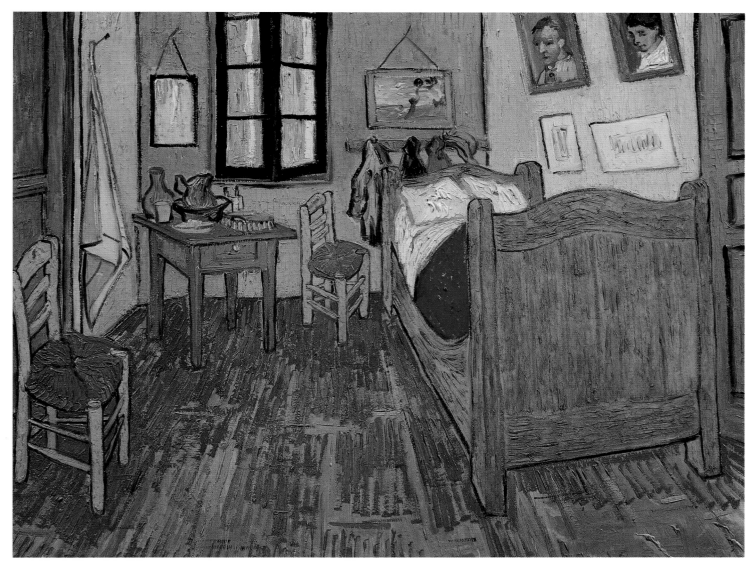

ABOVE

Vincent van Gogh. *The Bedroom.* 1889. Oil on canvas. 22 ¼ x 29 in. (56.5 x 74 cm).

In April 1889, Van Gogh voluntarily entered the sanitarium of Saint-Paul-de-Mausole in Saint-Rémy, some fifteen miles from Arles; he remained there until May 1890. During that time, he copied not only works of established masters, but his own: this is one of two replicas he made of an 1888 painting.

OPPOSITE

Paul Sérusier. *Breton Wrestlers.* 1890. Oil on canvas. 36 x 28 ¾ in. (92 x 73 cm).

The goal of the Pont-Aven painters was the opposite of the Impressionist endeavor. Where the earlier artists had pushed realism to the edge of temporality, shade, and detail, Sérusier and his colleagues sought to simplify forms to the limits of decoration.

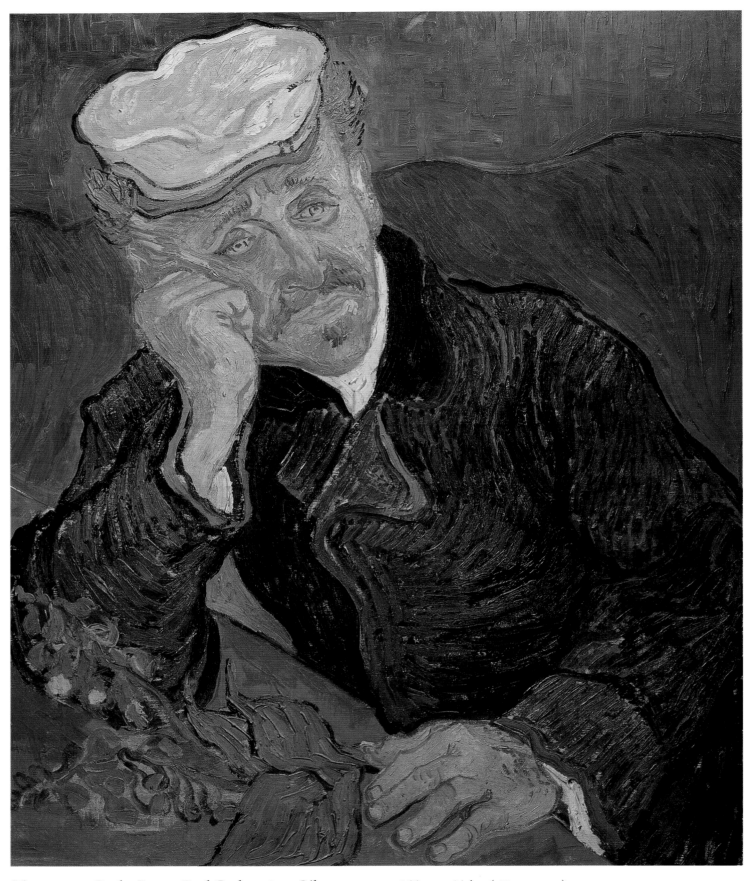

Vincent van Gogh. *Doctor Paul Gachet.* 1890. Oil on canvas. 26 ¾ x 22 ½ in. (68 x 57 cm).

Van Gogh would spend his last year in Auvers, an area long beloved of artists. Gachet, an art patron and a specialist in mental illness who had written on melancholy, took Van Gogh into his care. With this portrait, Van Gogh meant to convey "the heartbroken expression of our time."

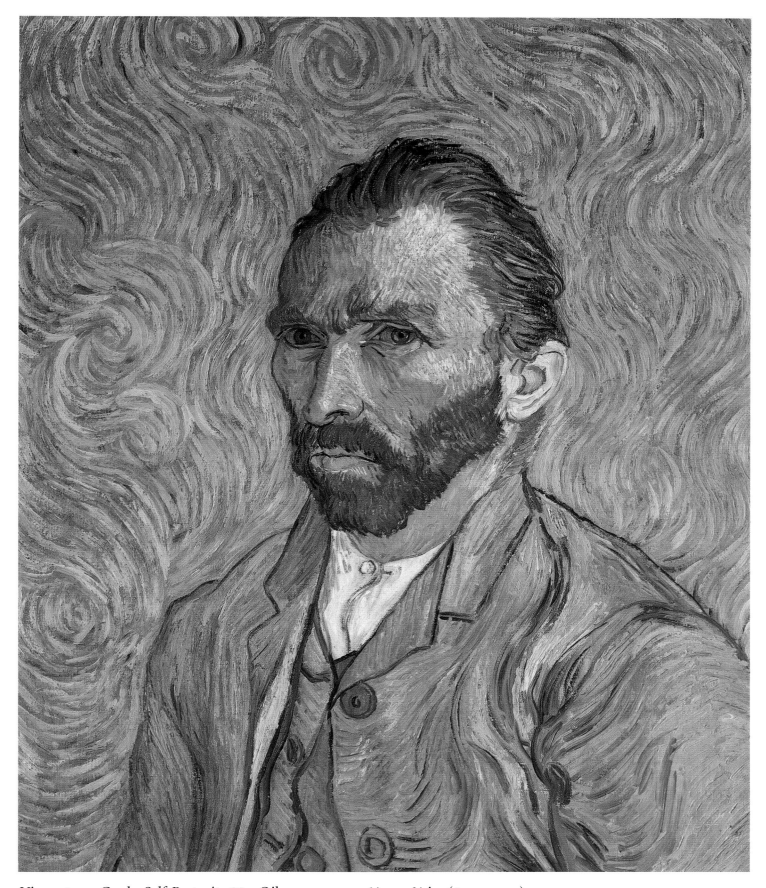

Vincent van Gogh. *Self-Portrait.* 1889. Oil on canvas. 25 ½ x 17 ¾ in. (65 x 45 cm).

The attitude in this self-portrait, painted in Saint-Rémy, is identical with that in a self-portrait Van Gogh had executed more than a year before in Paris. He wrote his brother, Theo, anxiously: "I hope my face is much calmer, though it seems to me that my gaze is cloudier than before."

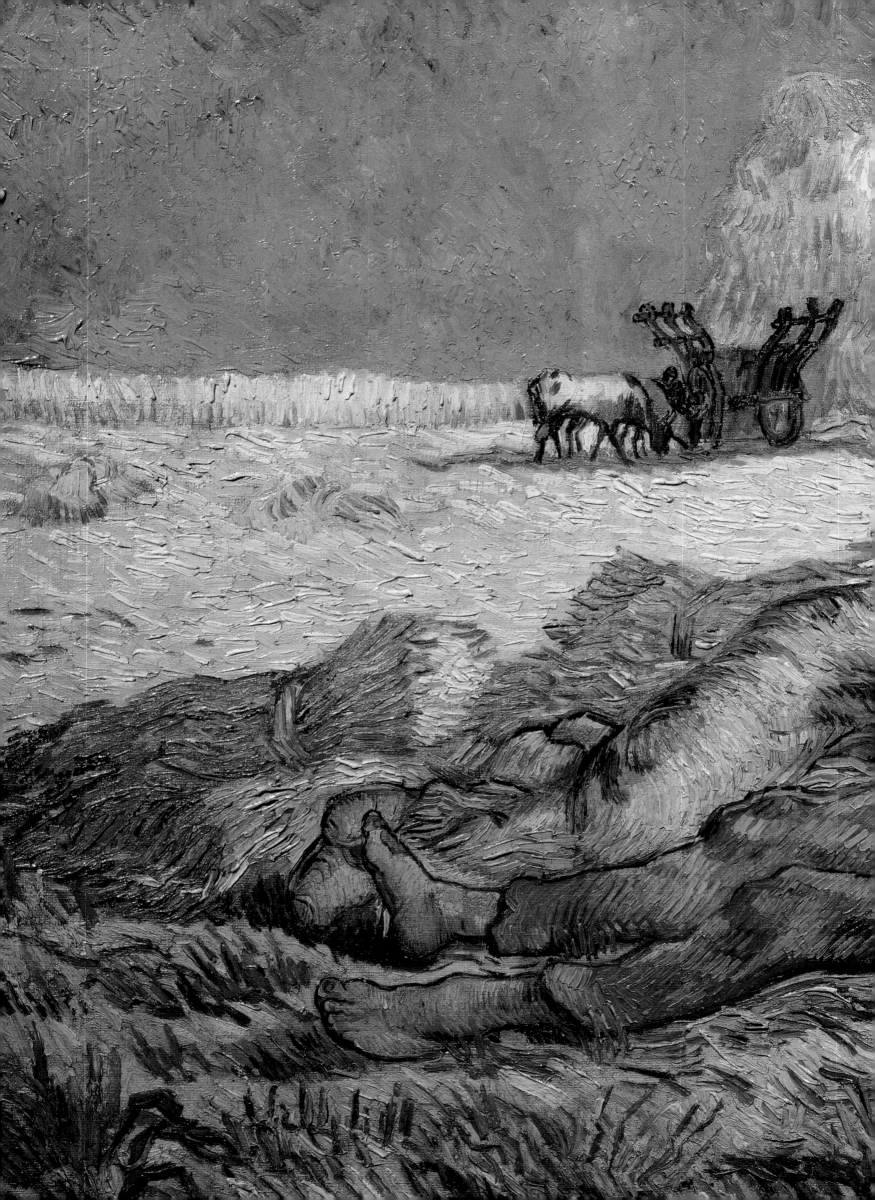

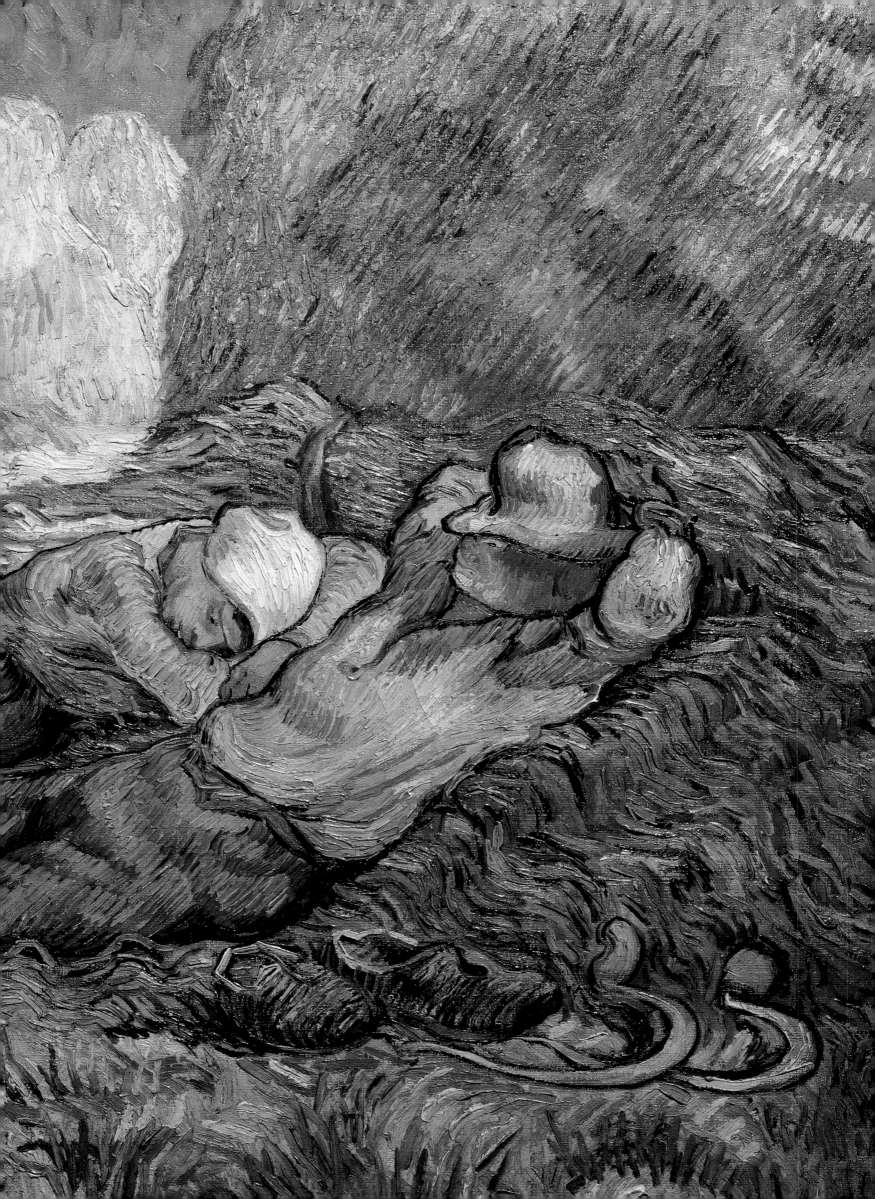

ABOVE

Édouard Vuillard. *In Bed.* 1891. Oil on canvas. 28 ¾ x 36 in. (73 x 92.5 cm).

Vuillard constructed this pleasing and expert composition very early in his career, proving himself a born Nabi. The harmonies of color and the draped and sweeping lines evoke deep early morning dozing, and, perhaps, dreaming.

OPPOSITE

Paul Cézanne. *Woman with a Coffee Pot.* c. 1890–95. Oil on canvas. 51 ½ x 38 in. (130.5 x 96.5 cm).

Preoccupied with line and volume—which would become explicitly geometric with Cubism—Cézanne treated figures and objects similarly. The difference is illustrated in this impressive work, in which he portrayed the sitter's psyche through her physical quality rather than her facial expression.

P. 186–187

Vincent van Gogh. *The Siesta.* 1889–90. Oil on canvas. 28 ¾ x 35 ¾ in. (73 x 91 cm).

In his last year, Van Gogh executed a number of copies, including this one, painted after a carved reproduction of a drawing by Millet, whom Van Gogh admired greatly. The challenge, he wrote, was to translate black-and-white into color, but it is hard not to see the subject as also a poignant fantasy.

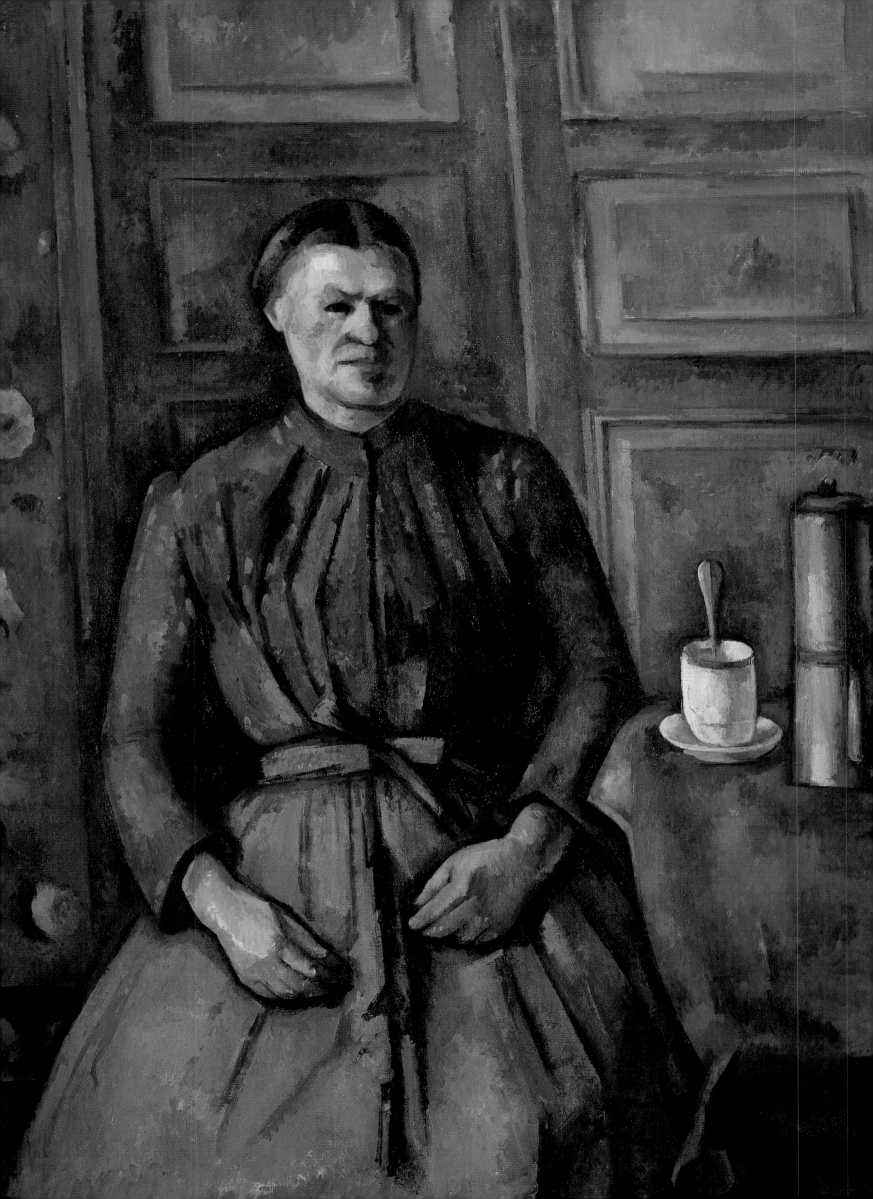

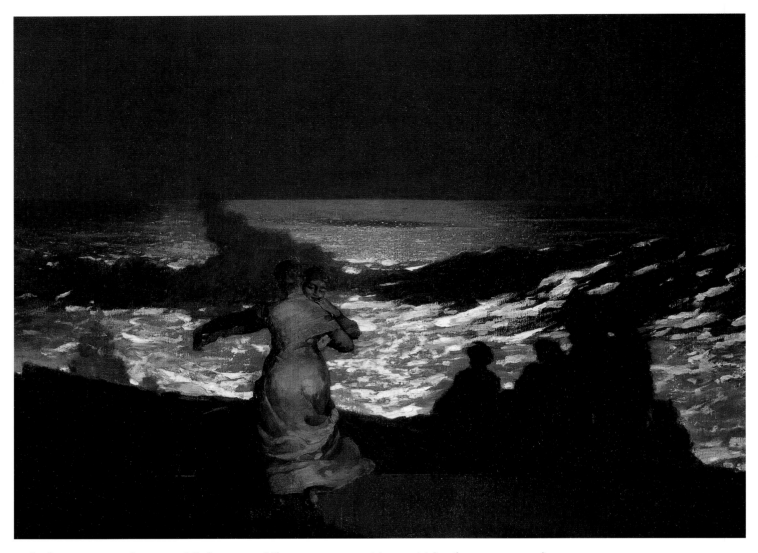

Winslow Homer. *Summer Night*. 1890. Oil on canvas. 30 ¼ x 40 ¼ in. (76.7 x 102 cm).

This was one of the first non-French works to enter the Musée du Luxembourg. Homer, an American, is best known for his watercolors, but remained independent in his choices of medium and manner. Impeccably realist, this painting nonetheless portrays the mysterious, bewitching spell of the full moon.

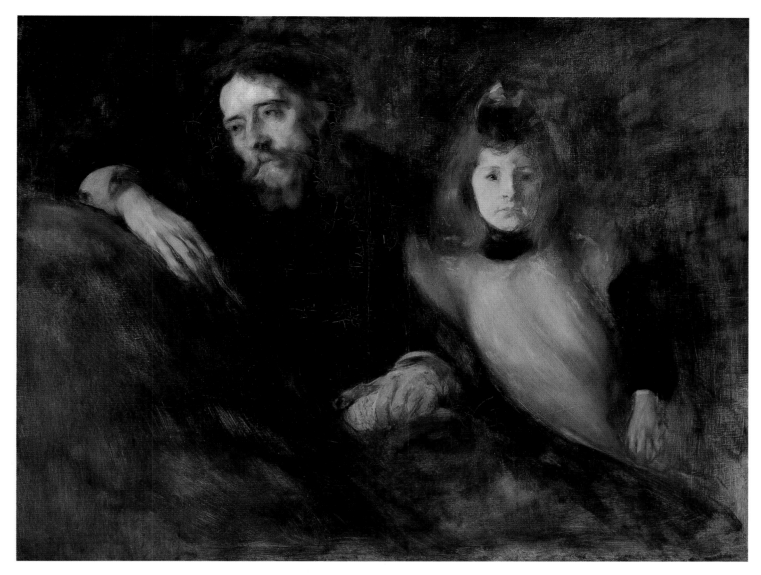

Eugène Carrière. *Portrait of Alphonse Daudet and His Daughter.* c. 1890. Oil on canvas.
35 ½ x 45 ⅞ in. (90 x 116.5 cm).

Considered a discreet Symbolist because of his use of light and shadow, Carrière turned to an all-brown palette in the 1880s. He is known for his portraits of writers; this one represents the naturalist playwright, novelist, and short-story writer Alphonse Daudet with his daughter.

OVERLEAF

Claude Monet. *Grainstacks, Late Summer, Giverny.* 1891. Oil on canvas. 23 ¼ x 39 ½ in. (60.5 x 100.3 cm).

The artist began his *Grainstacks* series in the autumn of 1888, working in the field of a neighbor at Giverny. By May 1891, he was able to show fifteen paintings on the subject at the Galerie Durand-Ruel. This work, executed a few months later, is almost redolent of the warm scent of new-mown hay.

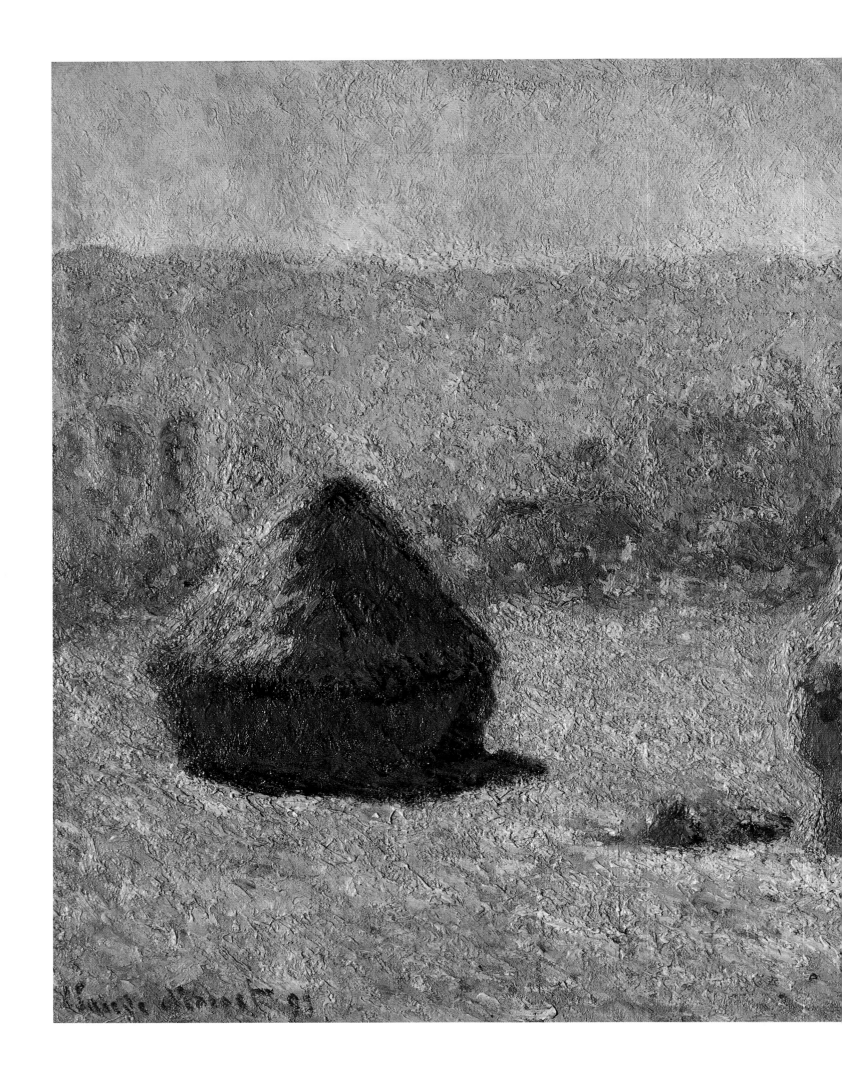

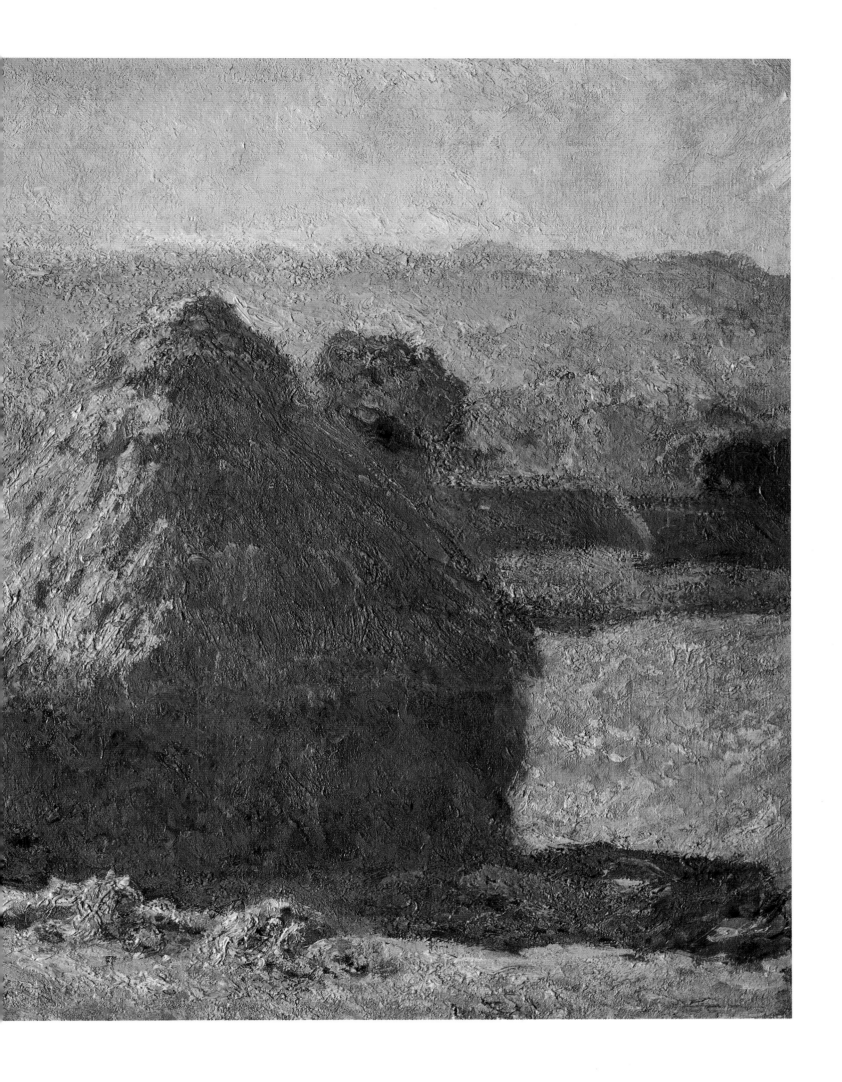

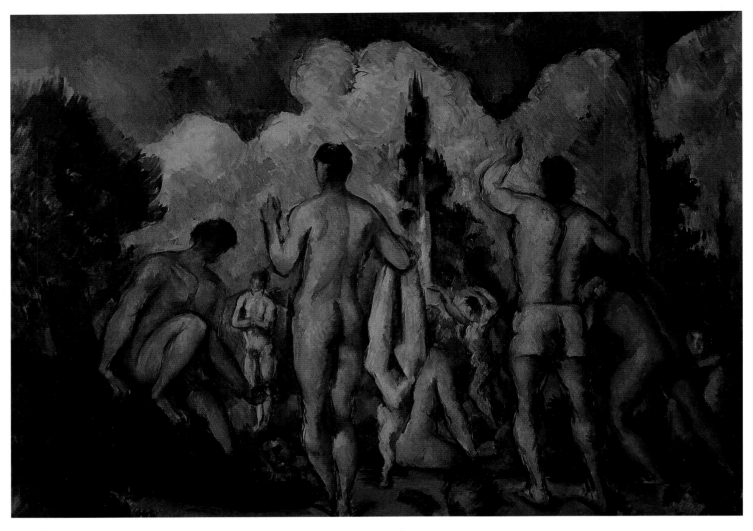

Paul Cézanne. *The Bathers.* c. 1890–1900. Oil on canvas. 8 ¾ x 14 in. (22 x 35.5 cm).

Maurice Denis, Henri Matisse, and Pablo Picasso all owned versions of this painting. Inspired by masters as diverse as Giorgione and Poussin, it is a meticulously composed series of balances and contrasts, expectations and surprises, between warm and cool colors, volumes and space, and the sexes of the bathers here and in the work's forerunners.

Georges Seurat. *Le Cirque (The Circus).* 1890–91. Oil on canvas. 73 x 60 in. (185.5 x 152.5 cm).

The people in the stands, carefully ranged by class, set off the magical grace, even physical impossibility, of the performers' movements—a product of scrupulously scientific composition. Are we (and the painter) the clown drawing (or opening) the curtain? This work was left unfinished at Seurat's death.

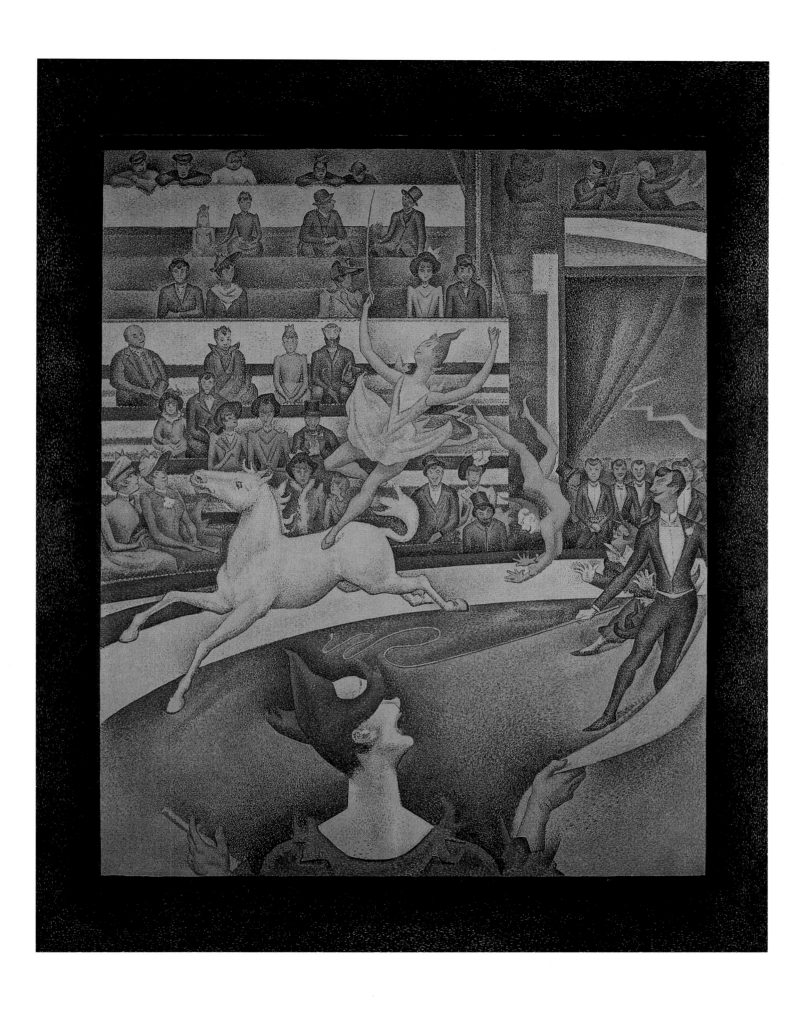

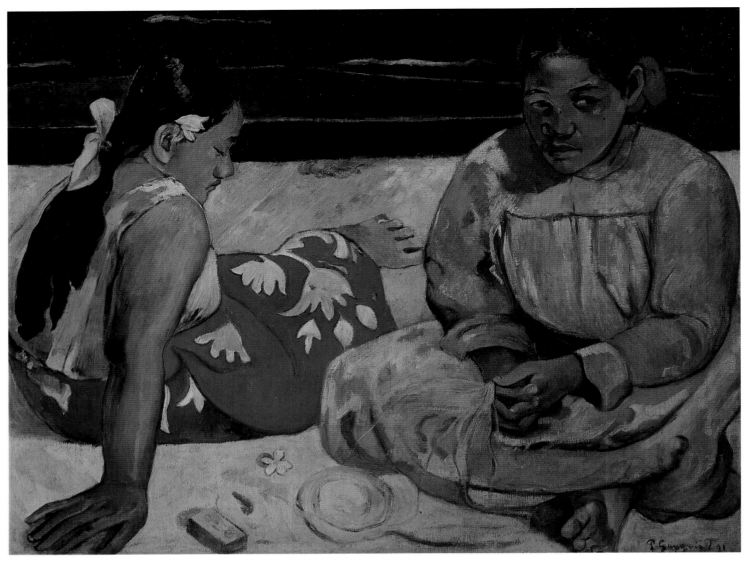

Paul Gauguin. *Women of Tahiti* or *On the Beach*. 1891. Oil on canvas. 27 ¼ x 36 in. (69 x 91.5 cm).

This painting was executed the year Gauguin first arrived in Tahiti. Nothing could have been further from the capitalist frenzy—and complex clothing—of fin de siécle Europe than the culture of these distant shores. At the same time, Gauguin easily extended the Pont-Aven manner to his new environment.

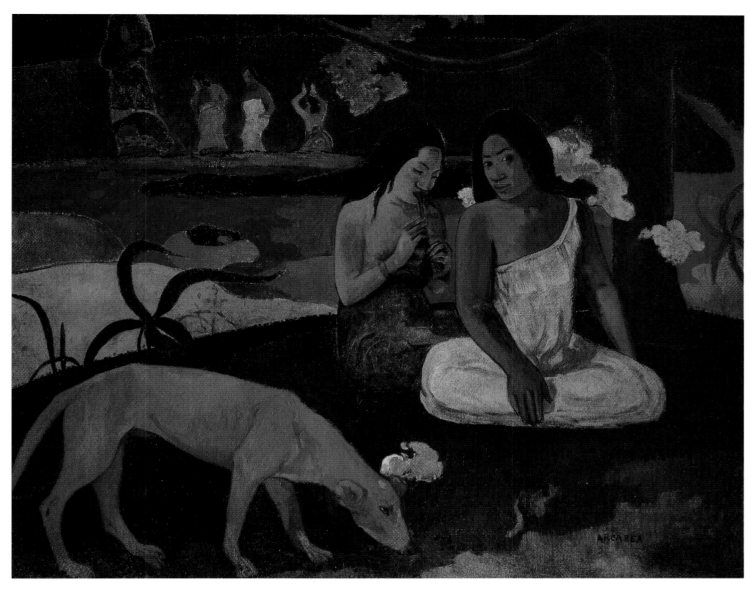

ABOVE
Paul Gauguin. *Arearea* or *Joyeuses*. 1892. Oil on canvas. 29 ½ x 37 in. (75 x 94 cm).

This painting is also known as *The Red Dog*; the Fauvists, in particular, were fascinated by its arbitrary colors. There is a feeling of great stillness: Gauguin wrote his wife, Mette, in 1891: "It's always silent. . . . I feel all this beginning to penetrate me."

P. 198
John Singer Sargent. *La Carmencita*. 1892. Oil on canvas. 91 ⅜ x 56 in. (232 x 142 cm).

Sargent's painting *Madame "X"* created a scandal at the 1884 Salon with the lady's extreme décolletage and immodest attitude; he left Paris the next year. Sargent, a friend of Monet, was close to the Impressionists: like Manet, he drew on Spanish influences and placed his figure in an ambiguous physical space.

P. 199
Henri de Toulouse-Lautrec. *Jane Avril Dancing*. 1892. Oil on cardboard. 33 ⅝ x 17 ¾ in. (85.5 x 45 cm).

Drawing was a family pastime in the artist's childhood home, and his own draftsmanship is as nimble as this dancer. Jane Avril, known as La Mélinite (Dynamite), performed at the Moulin Rouge and elsewhere; she was one of Toulouse-Lautrec's favorite subjects, and his posters for her shows were instrumental in making her a celebrity.

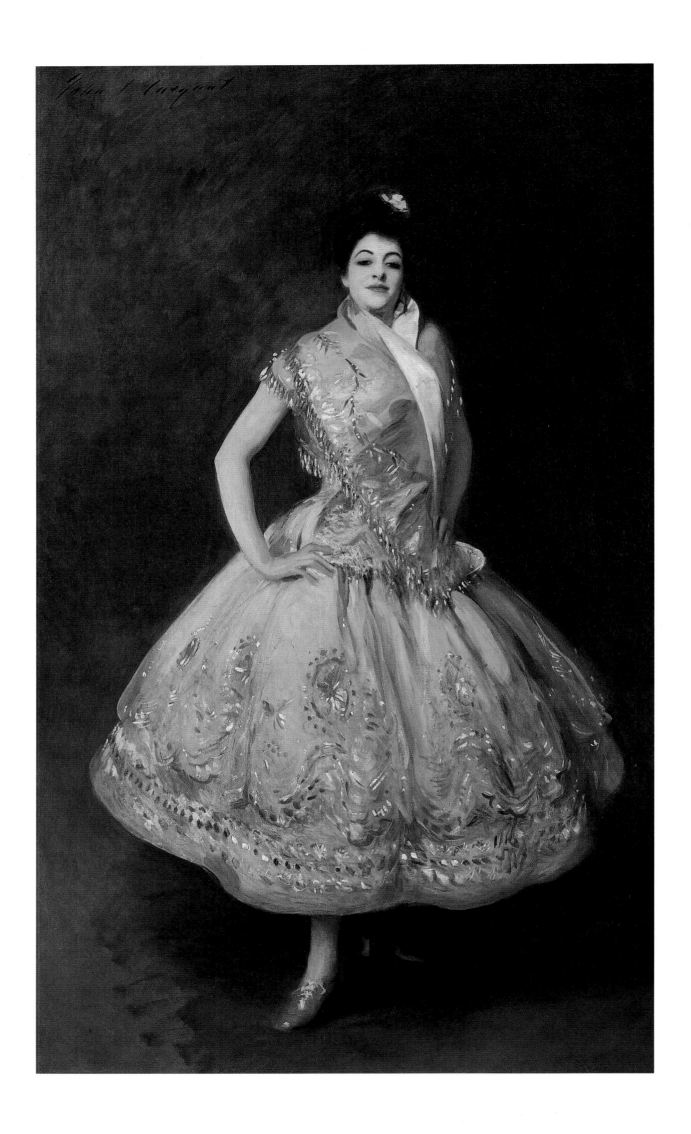

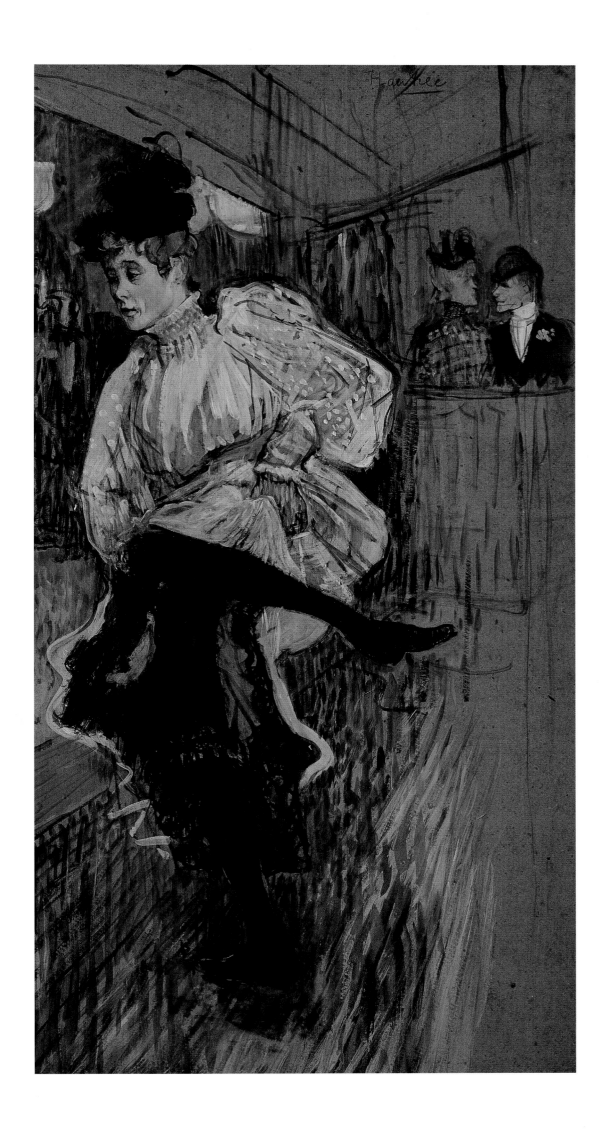

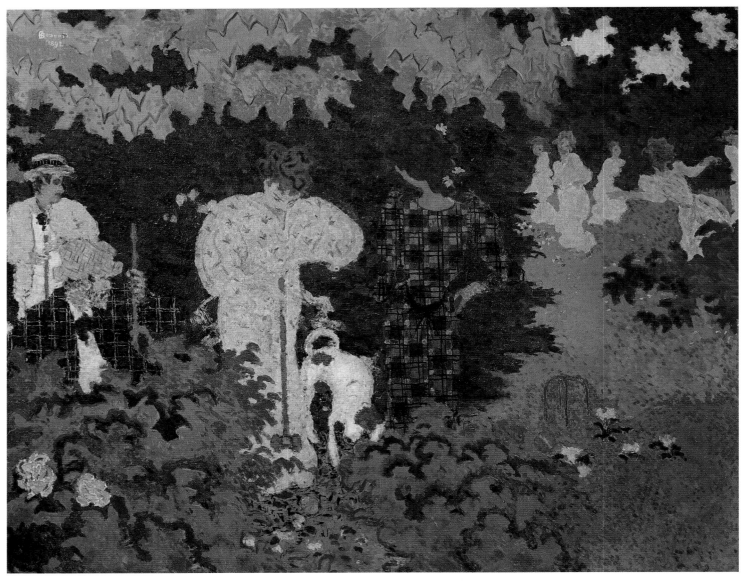

Pierre Bonnard. *The Croquet Game.* 1892. Oil on canvas. 51 ⅛ x 64 in. (130 x 162.5 cm).

Though its hard edges could not be further from Impressionism, this painting would not have come to be without that revolutionary movement. This garden, peopled with relatives of the artist, was at the artist's mother's home in the Dauphiné. The figures are reduced to lively attitudes.

Henri de Toulouse-Lautrec. *Woman with Gloves (Honorine Platzer).* 1891. Oil on cardboard.
21 ¼ x 15 ¾ in. (54 x 40 cm).

Toulouse-Lautrec, descended from the ancient counts of Toulouse, was born in that area, but moved to Paris in the early 1880s. This portrait of a fashionable bourgeois lady is unusual in the artist's body of work, and contrasts with the deliberate exposure of the homely support.

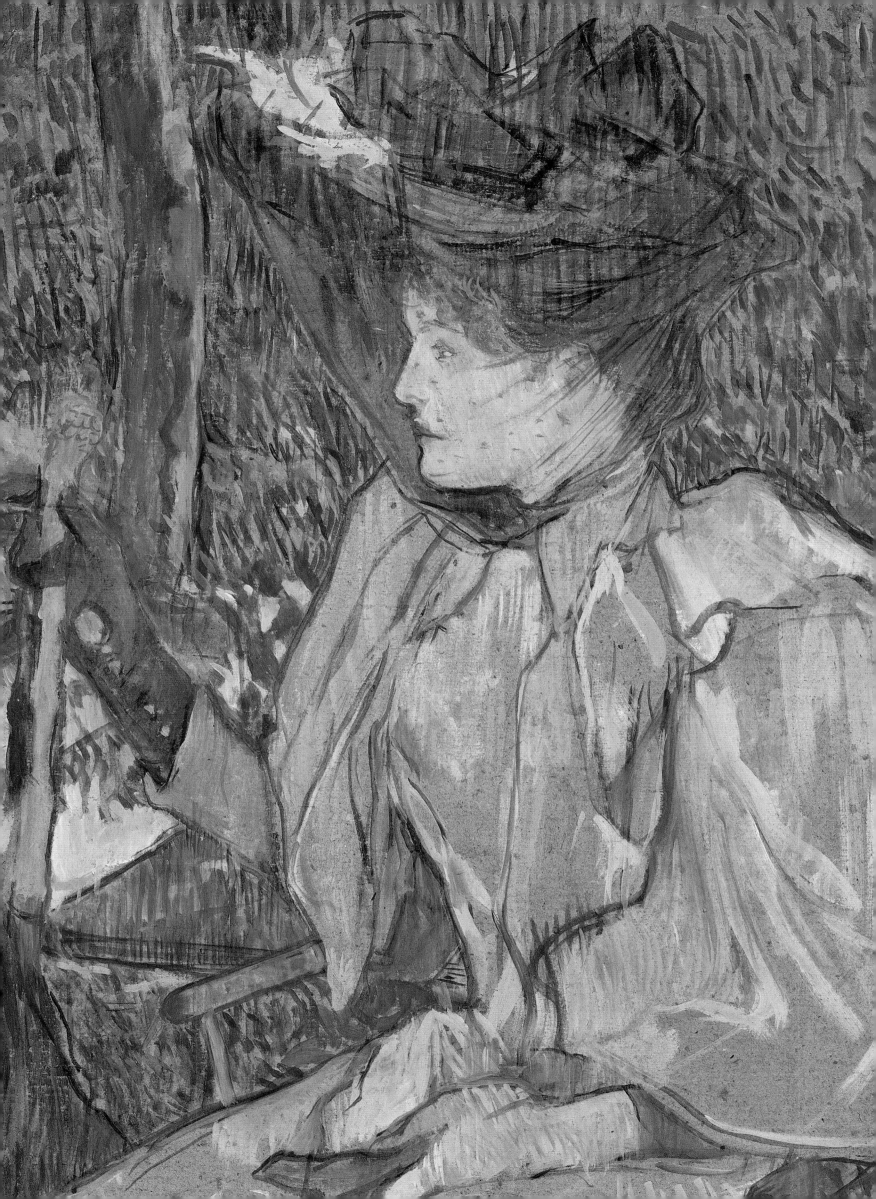

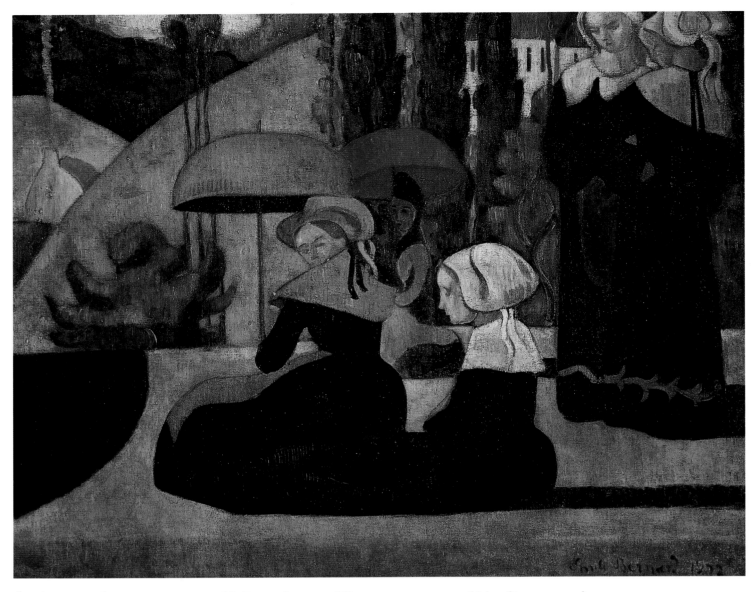

Émile Bernard. *Breton Women with Parasols*. 1892. Oil on canvas. 34 x 41 ¼ in. (81 x 105 cm).

In Pont-Aven, Bernard, Gauguin, and others were radically reinterpreting visual representation. One of the Breton women is almost violently subordinated to the painting's formal requirements: the central vertical axis, as embodied in the shaft of her parasol, obscures the woman in the middle.

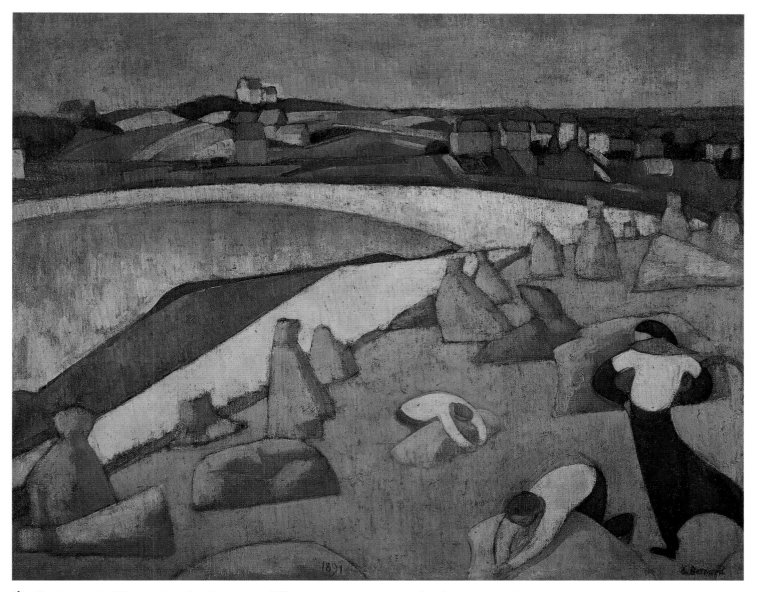

Émile Bernard. *Harvest by the Sea.* 1892. Oil on canvas. 27 ½ x 36 in. (70 x 92 cm).

This handsome, harmonious scene owes as much to Paul Cézanne as it does to Pieter Brueghel. The painters of Pont-Aven, the Nabis, and other Post-Impressionist groups were rediscovered only in the mid-twentieth century—this work was acquired by the state in 1982.

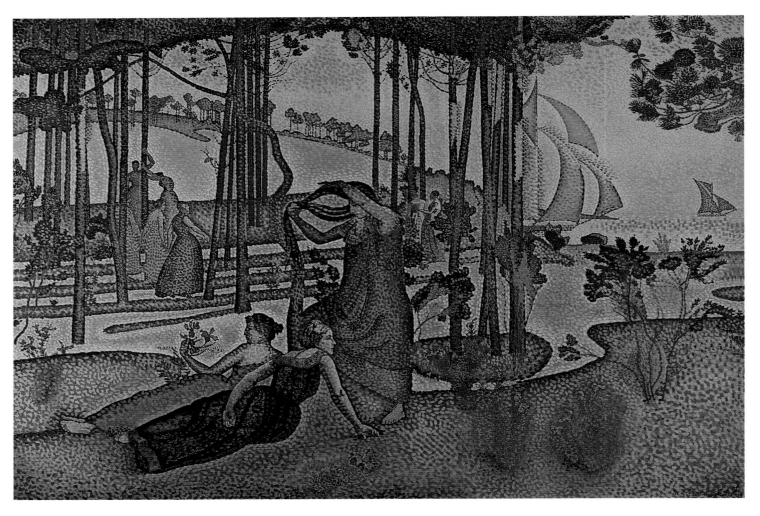

ABOVE

Henri Edmond Cross. *Evening Breeze.* 1893–94. Oil on canvas. 45 ¾ x 65 in. (116 x 165 cm).

The influence of Puvis de Chavannes is evident in the peaceful quality of this scene, with its dreamy, aimless women. The foliage overhead tell us this is a scented seaside copse of umbrella pines, while the sunset breeze fills the sails of passing boats.

OPPOSITE

Henri Edmond Cross. *Woman Combing Her Hair.* c. 1892. Oil on canvas. 24 x 18 in. (61 x 46 cm).

The Divisionist principle of juxtaposing contrasting colors produces the shine of waves in the title cascade of hair, but also a subdued quality. By emphasizing the woman's hair, which she would only have worn long and combed in a private moment, the artist further enhances the feeling of intimacy.

P. 206

Paul Signac. *Woman with Umbrella.* 1893. Oil on canvas. 31 ⅞ x 25 ½ in. (81 x 64.7 cm).

Ladies carried parasols to keep their skin fair and allow them pretty gestures, but to the artists of the avant-garde these accessories provided opportunities to study attitudes and modeling in shadow.

P. 207

Paul Signac. *Women at the Well.* 1892. Oil on canvas. 76 ¾ x 51 ½ in. (195 x 131 cm).

This painting is awash in warm yellow southern light, and joyous with its extreme color contrasts and sinuous lines. As in the works of Puvis de Chavannes, the laws of physics seem countermanded here: the women's water jugs are mysteriously weightless.

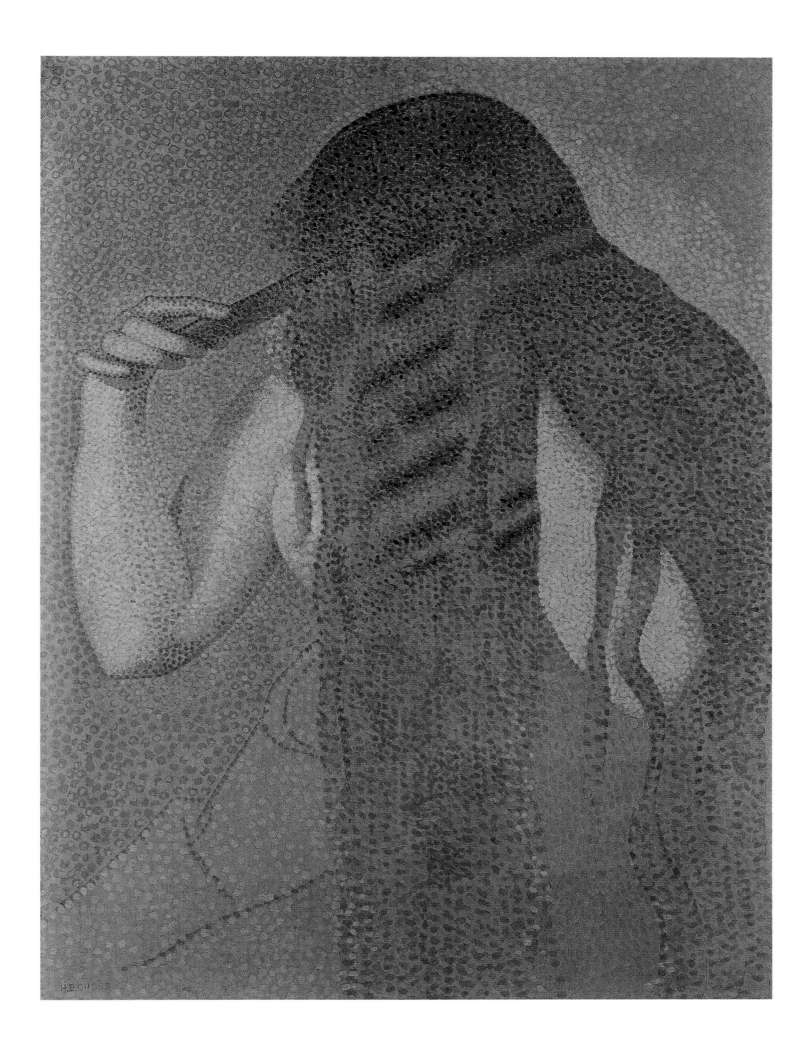

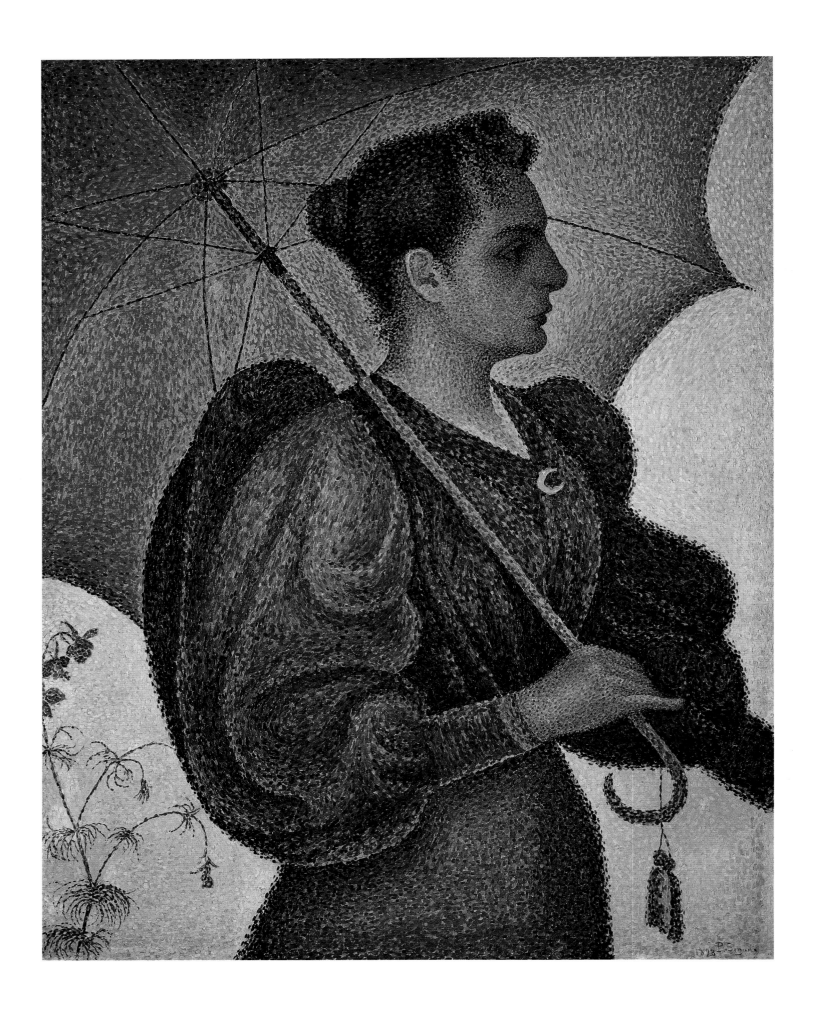

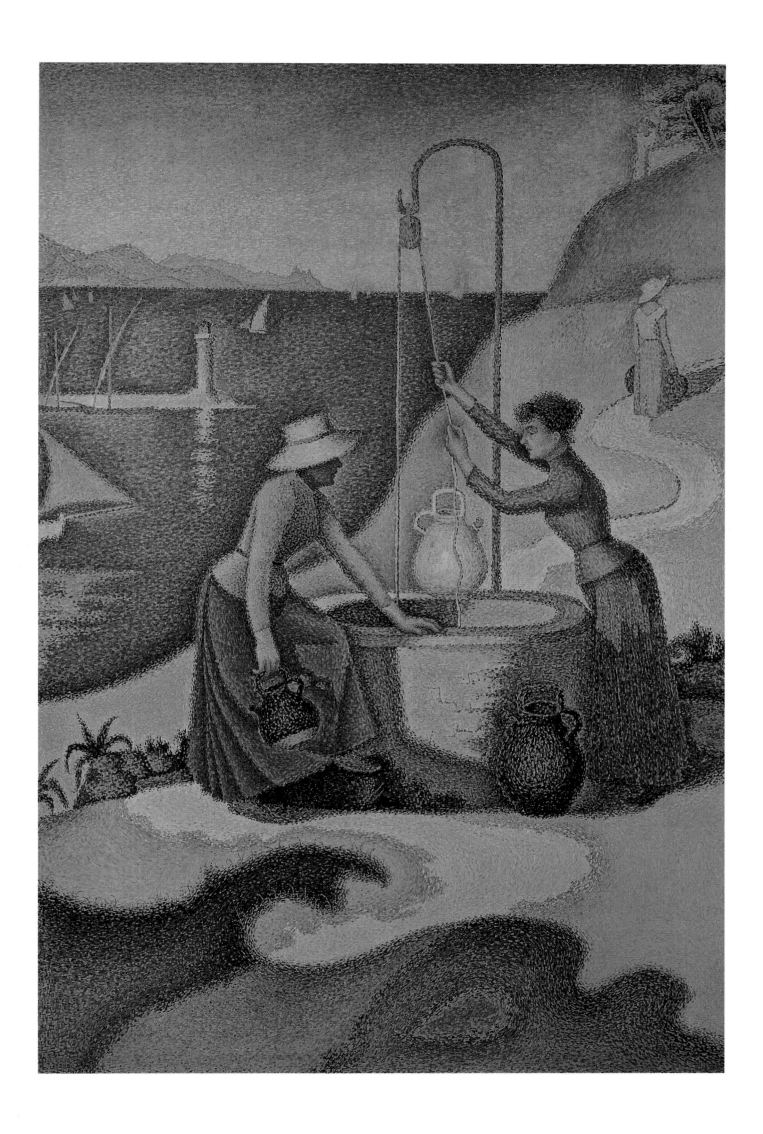

 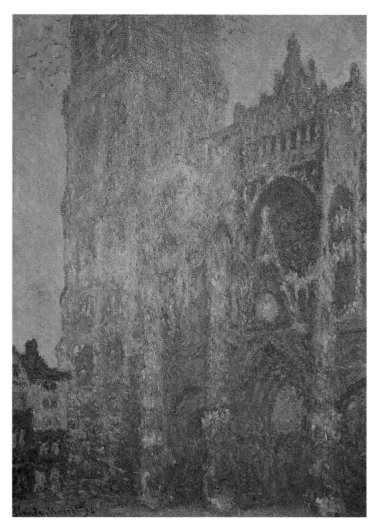

ABOVE, LEFT

Claude Monet. *Rouen Cathedral Series. Harmony in White.* 1892–93. Oil on canvas. 35 ⅞ x 24 ⅞ in. (91 x 63 cm).

In February 1892 and 1893, Monet settled himself and his canvases in a room facing the great façade of Rouen Cathedral, begun in the thirteenth century. Inspired by the serial Persian collection *The 1,001 Nights,* Monet created paintings that the critics described as "fairy-like."

ABOVE, RIGHT

Claude Monet. *Rouen Cathedral Series. Morning Sun.* 1892–93. Oil on canvas. 42 ⅛ x 28 ¾ in. (107 x 73 cm).

Georges Clemenceau, a radical politican, publisher, and author who was a friend and fan of Monet, wrote of a "fury of live atoms" in describing this series, a process of "what the eye decomposes and the hand recomposes."

OPPOSITE

Claude Monet. *Rouen Cathedral Series. Harmony in Blue and Gold.* 1892–93. Oil on canvas. 42 ⅛ x 28 ¾ in. (107 x 73 cm).

A dream at midday: massive ancient stone blocks appear as delicate as sandstone. The shadows, emphasized by the angle at which the cathedral is captured, bespeak the hands and craft of medieval artisans, although the whole is treated as unromantically as geology.

OVERLEAF

Max Liebermann. *Country Brasserie in Brannenburg.* 1893. Oil on canvas. 27 ½ x 39 ¼ in. (70 x 100 cm).

The German Liebermann combined the Impressionist effect of filtered sunlight and theme of outdoor leisure with a naturalist interest in clear edges and definition (for example, in the lines of the alehouse), and the laboring classes, whether peasantry or industrial workers.

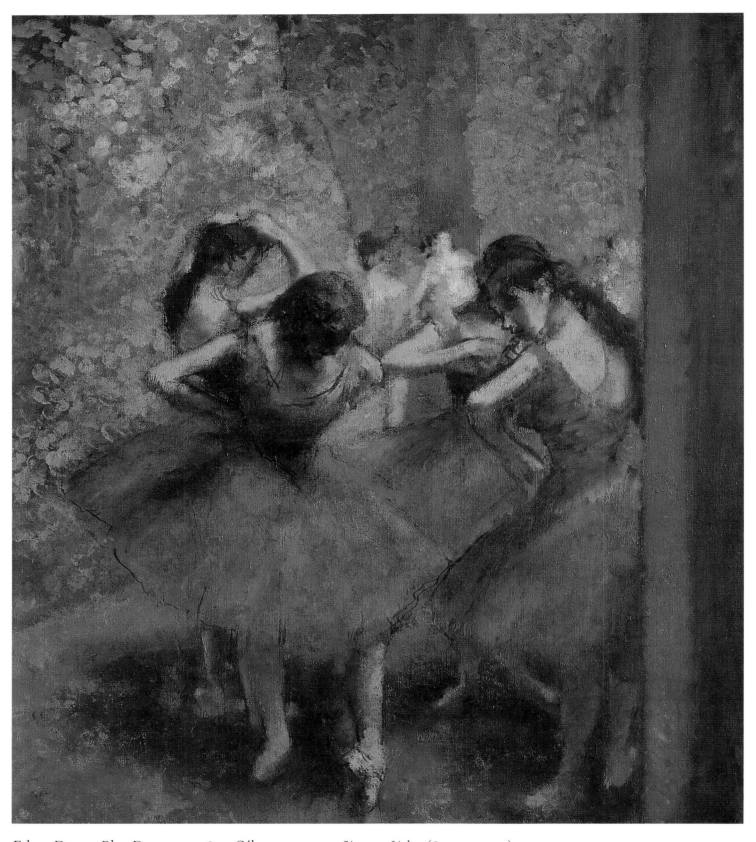

Edgar Degas. *Blue Dancers.* c. 1893. Oil on canvas. 33 ⁷⁄₁₆ x 29 ¾ in. (85 x 75.5 cm).

Like many of his avant-garde colleagues, Degas explored the boundaries of artifice. His attitude was particularly in keeping with his approach: "No art," he wrote, "could be less spontaneous than mine." Here, sketchy lines barely contain the bright, almost garish clouds of color that define shape and texture.

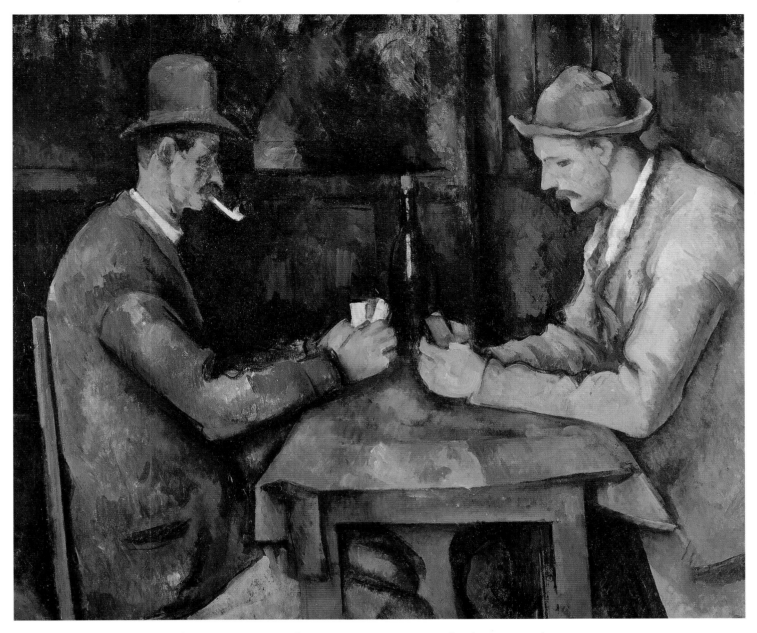

Paul Cézanne. *The Card Players.* 1892–95. Oil on canvas. 17 ¾ x 22 ½ in. (45 x 57 cm).

Cézanne once said that "nature should be rendered as a sphere, a cylinder, or a cone." The wine bottle, which defines the central axis, is in fact also the apex of a cone or pyramid. The sitters for this painting were probably local people from around Cézanne's hometown of Aix.

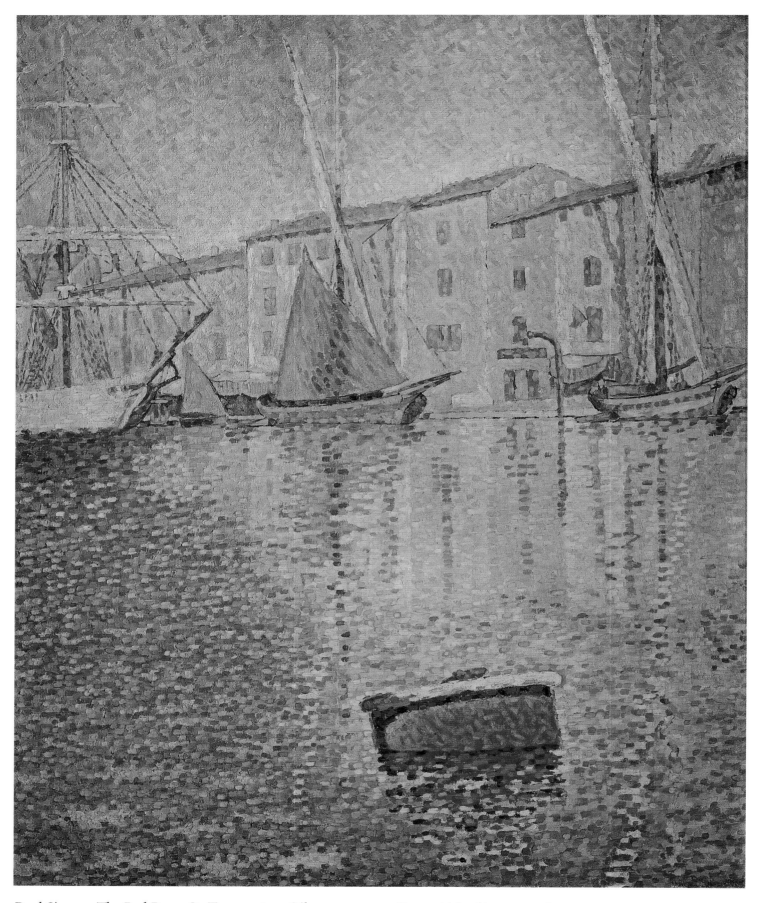

Paul Signac. *The Red Buoy, St. Tropez.* 1895. Oil on canvas. 31 ⅞ x 25 ½ in. (81 x 65 cm).

Aligned with the Impressionists before joining Seurat and the Divisionists, Signac moved to the Midi after Seurat's death. The treatment of this buoy and its reflections, though carefully constructed, is more relaxed than the artist's previous works.

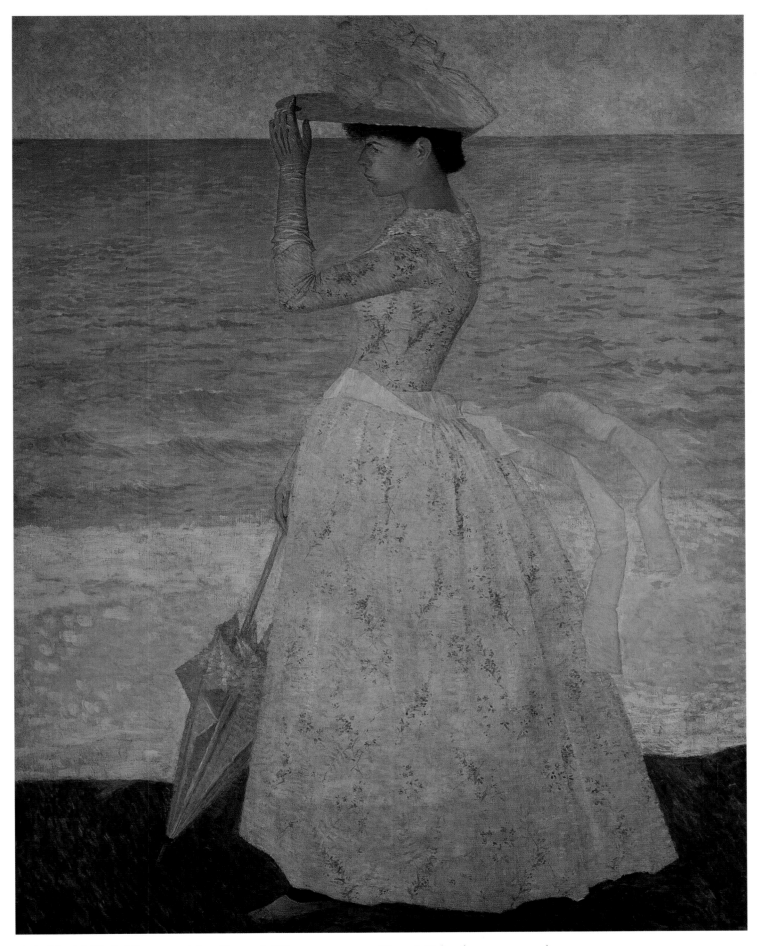

Aristide Maillol. *Woman with a Parasol*. Oil on canvas. 74 ¾ x 58 ¾ in. (190 x 149 cm).

This image could almost be a fashion plate, were it not for the expressiveness of the model and the stylized swathes of the background. Maillol was designing tapestries at the same time he was painting with the Nabis during this period. Around 1900, he would abandon painting for sculpture.

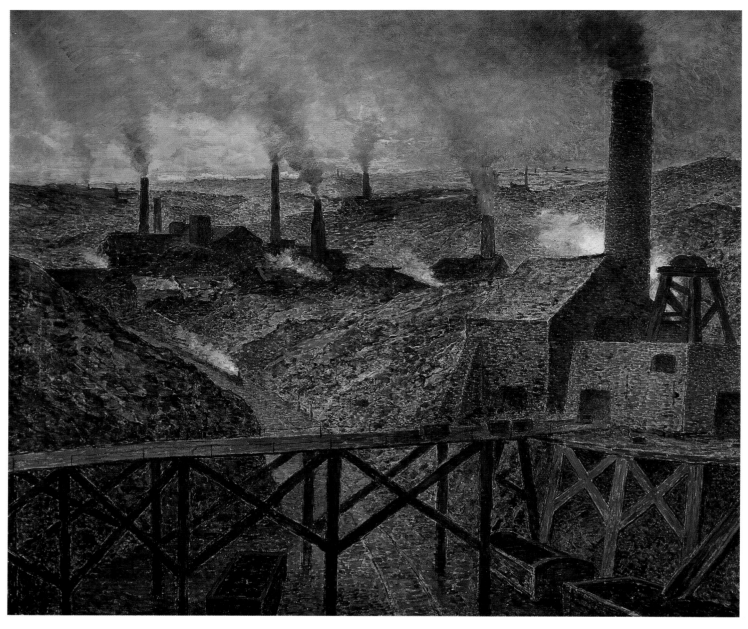

Constantin Meunier. *In the Black Country*. 1893. Oil on canvas. 32 x 37 in. (81 x 93 cm).

Meunier, a Belgian, specialized in paintings and sculpture about industrial workers. His unromanticized depictions often asserted that it was these nameless—and, in this painting, faceless—"human machines" who paid the price for the tremendous economic progress then taking place in western Europe.

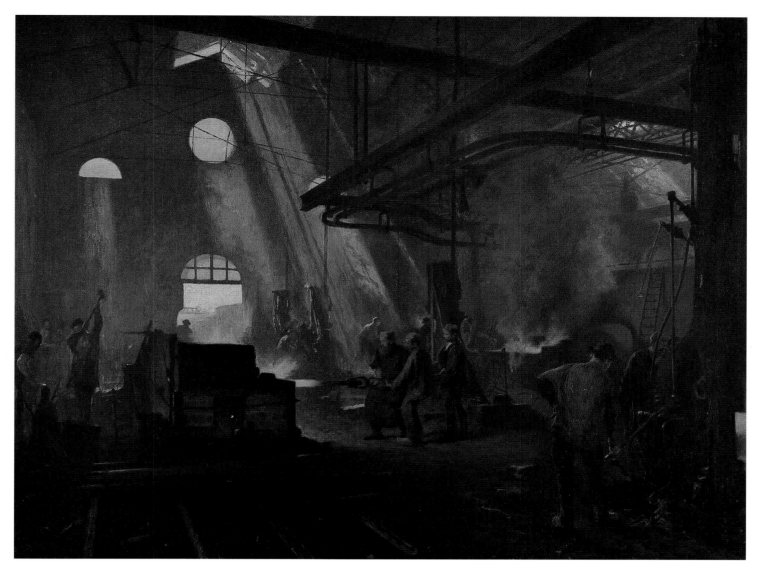

Fernand Cormon. *A Forge.* 1893. Oil on canvas. 28 ¼ x 35 ½ in. (72 x 90 cm).

The art establishment's acceptance of naturalism provoked a reaction: that the naturalist manner and subjects lacked "idealism and spirituality." Compared with other paintings, the atmosphere in this forge is peaceful—the pitch of the roof and the oculus below it even suggest a church.

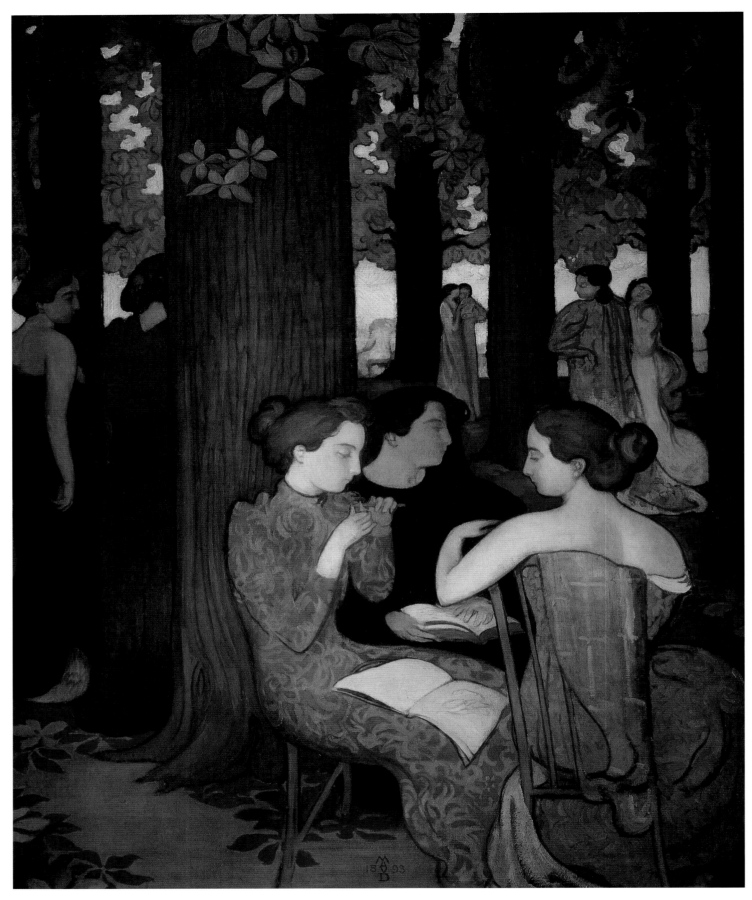

Maurice Denis. *The Muse.* 1893. Oil on canvas. 67 ½ x 56 ¼ in. (171.5 x 137.5 cm).

Denis once defined a painting as "essentially a flat surface covered in colors that have been assembled in a certain order," but there is poetry in his sophisticated composition. The classicism of the subject—the nine ancient Greek deities of the arts—is treated with an urbane, even witty hand.

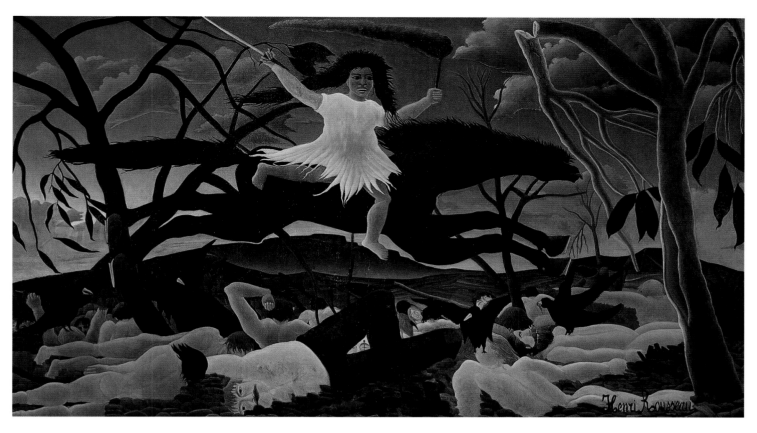

ABOVE

Henri Rousseau. *War*. 1894. Oil on canvas. 45 x 76 ¾ in. (114 x 195 cm).

Called by his modernist contemporaries *Le Douanier*—the customs officer—because of his job, Henri Rousseau, an "outsider" artist, was adopted by Signac and others of the avant-garde. He showed frequently, including at the Salon des Indépendants in 1886 and every year thereafter until his death.

P. 220

Cecilia Beaux. *Sita and Sarita*. 1893–94. Oil on canvas. 37 x 25 in. (94 x 63.5 cm).

Born in Philadelphia, Beaux, like Renoir, first earned her living painting china. After studying privately in her hometown, she traveled to Paris, and eventually became a very successful portraitist in the United States. Her work is known for subtle evocations of character—here, a dreamy sensuality.

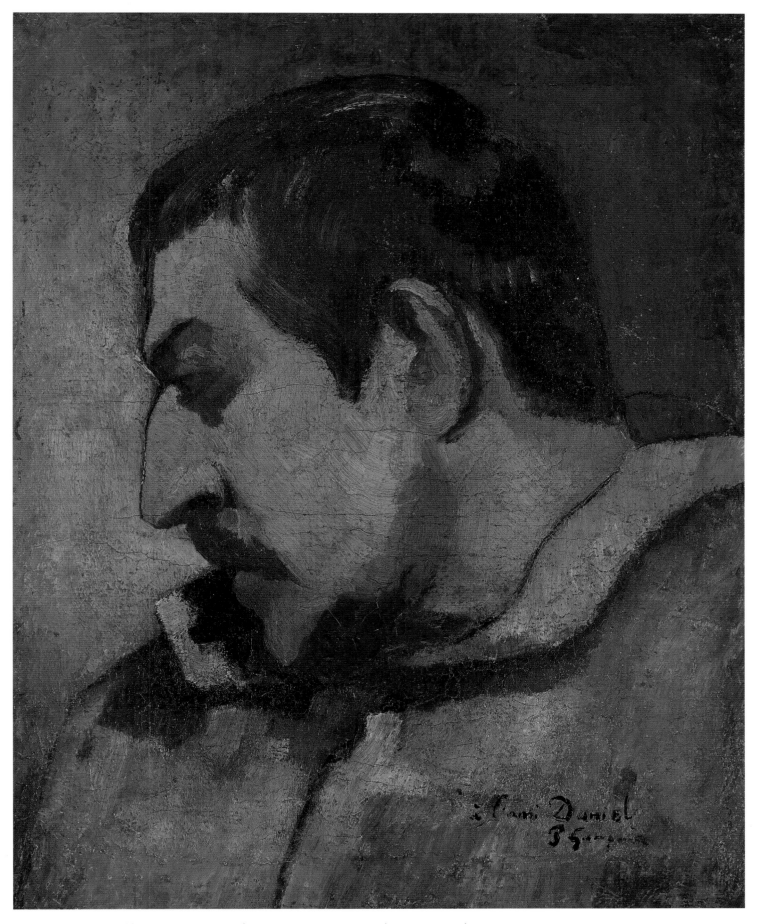

Paul Gauguin. *Self-Portrait*. 1896. Oil on canvas. 16 x 13 in. (40.5 x 32 cm).

This pensive work dates from the years immediately following the artist's final return to the South Pacific. Although he maintained ties with Europe, and with friends such as the one to whom he dedicated this painting, Gauguin was increasingly retreating from the sphere of European influence.

LEFT

Pierre Bonnard. *Mud Pies*. 1894. Oil on canvas. 65 ¾ x 19 ¾ in. (167 x 50 cm).

The materials Bonnard used for this elegant and affectionate panel are often employed for mural decoration or scene painting. Theater sets, with their stylized compositions, were, in fact, important models for the Nabis. The child is the artist's nephew, playing in the yard of Bonnard's mother's home.

OPPOSITE

Pierre Bonnard. *The White Cat*. 1894. Oil on canvas. 20 x 13 in. (51 x 33 cm).

The decorative background is very stylized, almost abstract, as is the stretching cat. Bonnard, nicknamed "the Japanese Nabi," often painted charming domestic scenes, as well as stylish panels recalling his early days as a poster painter.

P. 224
Henri de Toulouse-Lautrec.
La Toilette. 1896. Essence on
cardboard. 26 ⅔ x 21 ¼ in.
(67 x 54 cm).

By 1885, Toulouse-Lautrec was
living in Montmartre, a fixture at
the heart of bohemian Paris, and
an insider who recorded the
worlds of *déclassé* entertainments,
the demimonde, and those who
frequented them. The subject,
cool palette, and perspective
recall Degas's treatments.

P. 225
Henri de Toulouse-Lautrec.
The Lady Clown Cha-U-Kao. 1895.
Oil on canvas. 25 ¼ x 19 ¼ in.
(64 x 49 cm).

This portrait is unusual in that
we cannot see the sitter's face, only
her businesslike transition to her
fantasy role at the Moulin Rouge,
which recalls also the artist's
fondness for the circus. Like
Degas's dancers, Toulouse-Lautrec's
women earned their living, but
were also sexually available—note
the distinguished gentleman visible
in the mirror.

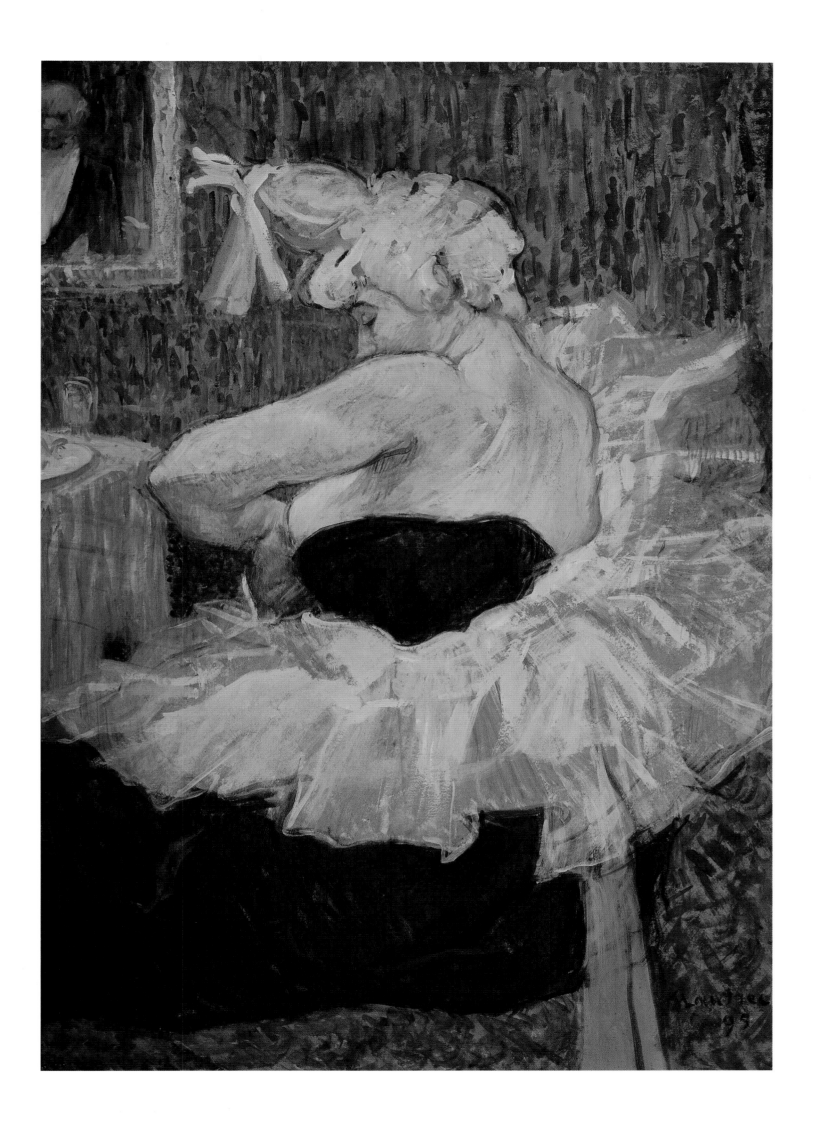

Léon Frédéric. *The Ages of the Worker.* 1895–97. Oil on canvas. Triptych. Center: 64 ¼ x 73 ½ in. (163 x 187 cm); sides, each: 64 ¼ x 28 ⅔ in. (163 x 94 cm).

This Belgian painter was one of the few foreign artists whose works were acquired for the Musée du Luxembourg. This epic, hyper-realist, but not naturalist triptych depicting a vigorous and well-fed society was exhibited at the Salon of 1898, and purchased by the State that same year.

Louis Welden Hawkins. *Sévérine*. 1895. Oil on canvas. 30 ¼ x 21 ¾ in. (77 x 55 cm).

"Sévérine" was the pseudonym of the journalist Caroline Rémy. The English Hawkins, a practitioner of the decorative arts, was attracted to Paris as one of the European centers of Art Nouveau. The frame, which bears the Latin words for "peace" and "bread," is probably by Hawkins as well.

Lucien Lévy-Dhurmer. *Woman with a Gold Medallion* or *Mystery*. 1896. Pastel on canvas. 13 ¾ x 21 ¼ in. (35 x 54 cm).

Pastels seem to lend themselves to symbolism. Here, modernity—in the unspecified background and its stylish color contrast with the woman's contemporary costume—coexists with an arcane motif. The woman's gesture resembles a medieval blessing, but what image does the title medallion reveal?

Paul Cézanne. *Apples and Oranges.* 1896–1900. Oil on canvas. 29 ⅛ x 36 ⅝ in. (74 x 93 cm).

Cézanne was notoriously shy, and this character trait may explain a relaxed fluidity in his still-lifes that contrasts with the tensions structuring his figure paintings. As in many of his works, he handled traditional elements—in this case fruit and fabrics—in anything but a conventional manner.

Henri Rousseau. *Portrait of a Woman.* c. 1897. Oil on canvas. 78 x 45 in. (198 x 114 cm).

Genuinely admired for his fresh and fearless imagination by some of his fellow artists, patronized by others, the self-taught Rousseau claimed to follow establishment stars such as Cabanel, Bouguereau, and Gérôme. Other sources were mass-produced color prints, old photographs, and the vegetation in the Paris botanical gardens.

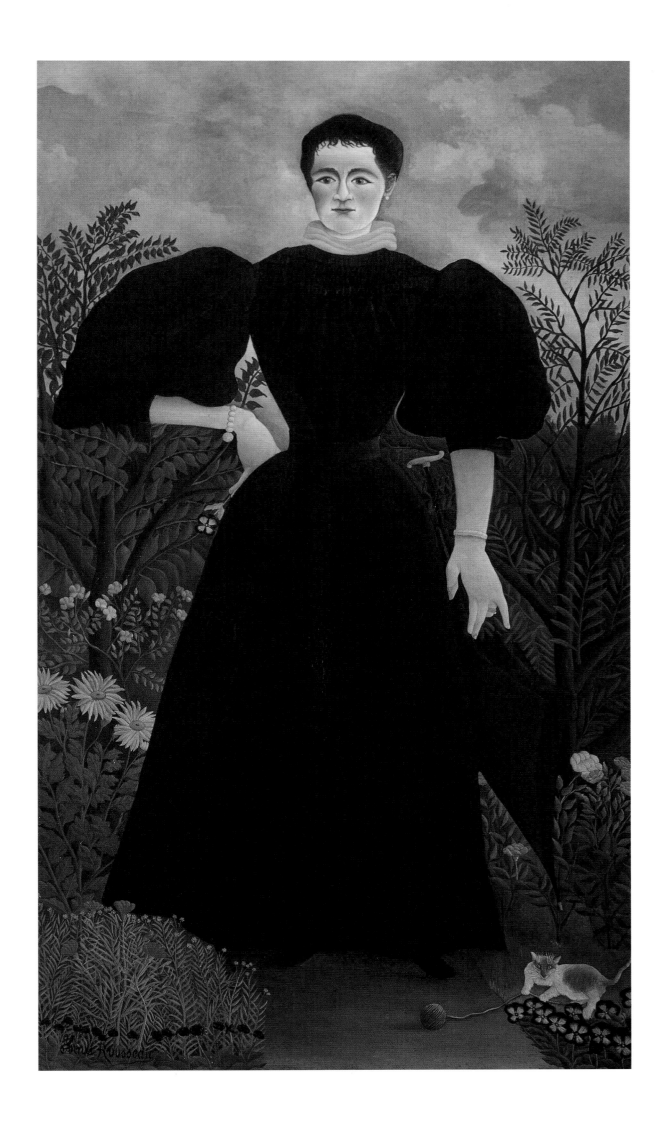

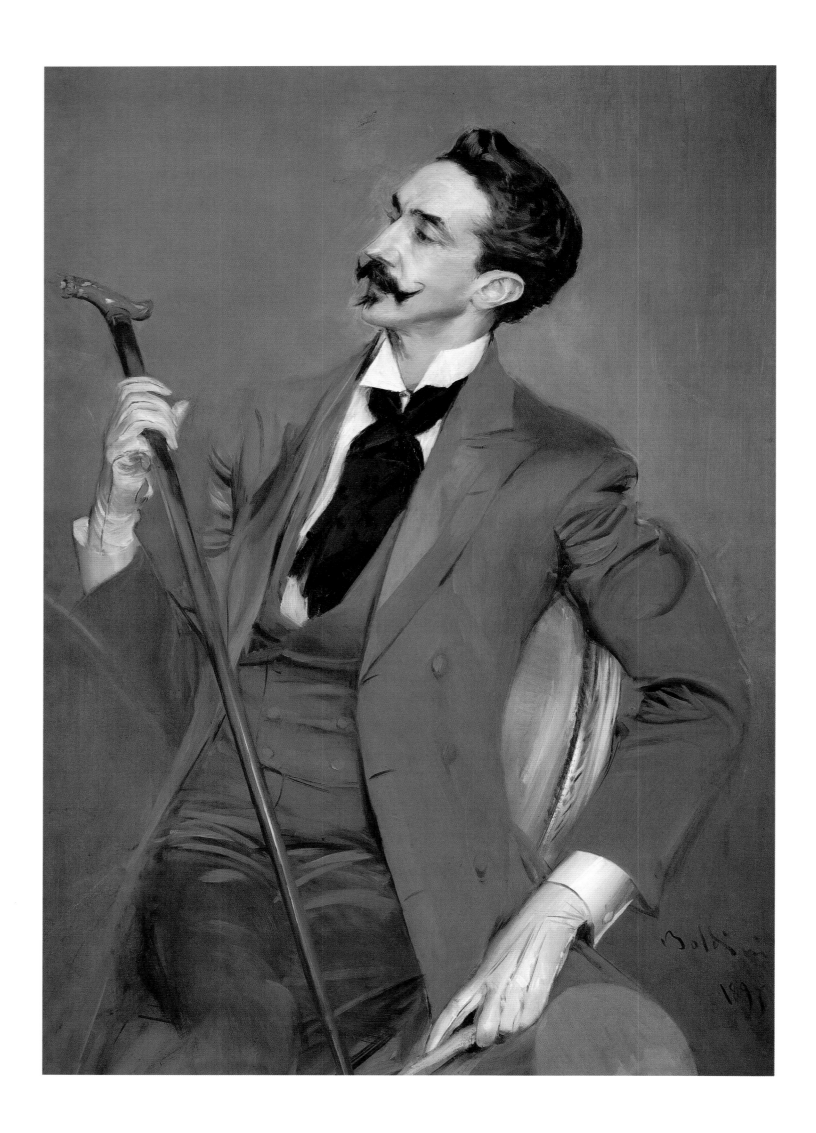

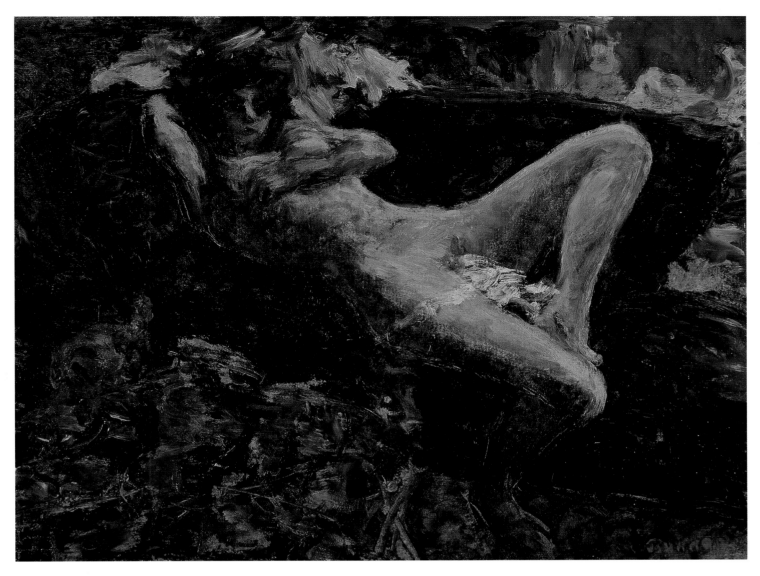

Pierre Bonnard. *Lazy Nude.* 1899. Oil on canvas. 37 ¾ x 41 ¾ in. (96 x 106 cm).

The cast shadows suggest that this woman is idly and erotically lying abed in full daylight. The model is probably Marie Boursin, known as Marthe, Signac's lover, and later his wife. He painted her all their life: over the years his depiction of her body never altered, but remained lithe and sensuous.

Giovanni Boldini. *Count Robert de Montesquiou-Fezensac.* 1897. Oil on canvas. 65 ⅜ x 32 ¼ in. (166 x 82 cm).

Boldini's rapid brushwork matched the verbal swiftness of this poet and man-about-town, renowned for his fearsome wit. The count, who provided the model for Baron Charlus in Marcel Proust's *Remembrance of Things Past*, was a famous dandy: his suit and gloves are works of art in themselves.

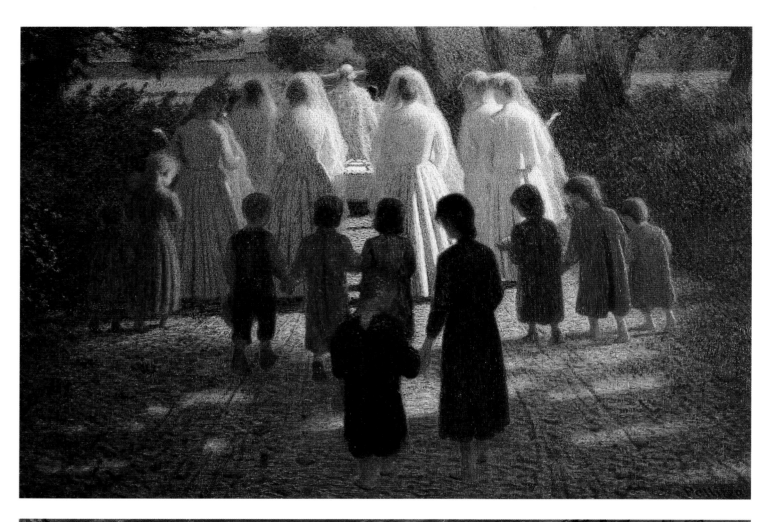

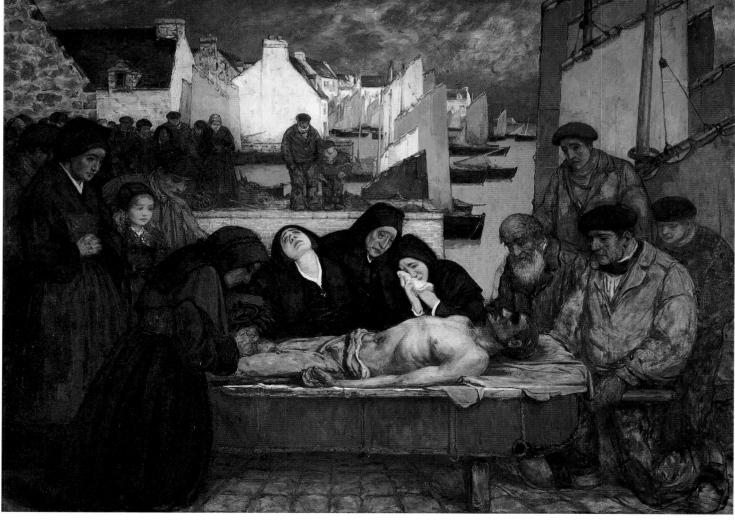

Marianne Stokes. *Death and the Maiden.* c. 1900. Oil on canvas. 37 ½ x 53 ¼ in. (95 x 135 cm).

The Austrian-born artist was inspired by Franz Peter Schubert's song of the same title, written in the early decades of the 1800s. The painting's virtually monochromatic palette (save for the bright red bed cover) enhances its lyrical, dreamlike quality, which places it in the symbolist current of the turn of the twentieth century.

Giuseppe Pellizza da Volpedo. *Broken Flower.* c. 1896–1902. Oil on canvas. 31 ¼ x 42 ⅛ in. (79.5 x 107 cm).

The Italian artist evocatively combined Divisionism, a muted color palette, and a dramatic use of light and shadow to achieve an effect of pathos: the dead girl was perhaps just confirmed, while the barefoot children behind her may be the children and descendants the deceased will never bear.

Charles Cottet. *Grief in the Land of the Sea.* 1909. Oil on canvas. 104 x 135 ⅞ in. (264 x 345 cm).

Cottet joined *la bande noire,* "the black band," a group of artists in Brittany fascinated by the region's intense melancholy and the harsh life of those who lived by the sea. This painting reaches back to the Dutch masters, and even to the themes of the Deposition and the Last Supper, but Cottet's style remains singularly his own.

Félix Vallotton. *The Ball (Corner of the Park, Child Playing with Ball).* 1899. Oil on canvas. 19 x 24 in. (48 x 61 cm).

There is an uneasy, almost sinister undertone here—perhaps no more than premonitions of adult life—with its clearly demarcated areas of dark and light, distant figures, and shadows that almost seem to pursue the child. The peculiar point of view endows the composition with an unusual third dimension—vertical depth. There are *two* balls.

Félix Vallotton. *Dinner by Lamplight.* 1899. Oil on canvas. 22 ½ x 35 ¼ in. (57 x 89.5 cm).

While still a teenager, the Swiss Vallotton moved to Paris, where he worked with the Nabis. The hard edges created by the strong light are emphasized by contrasting colors and the shiny effect of oil on wood. This group portrait of the artist's family is, like *The Ball,* particularly sensitive to the child.

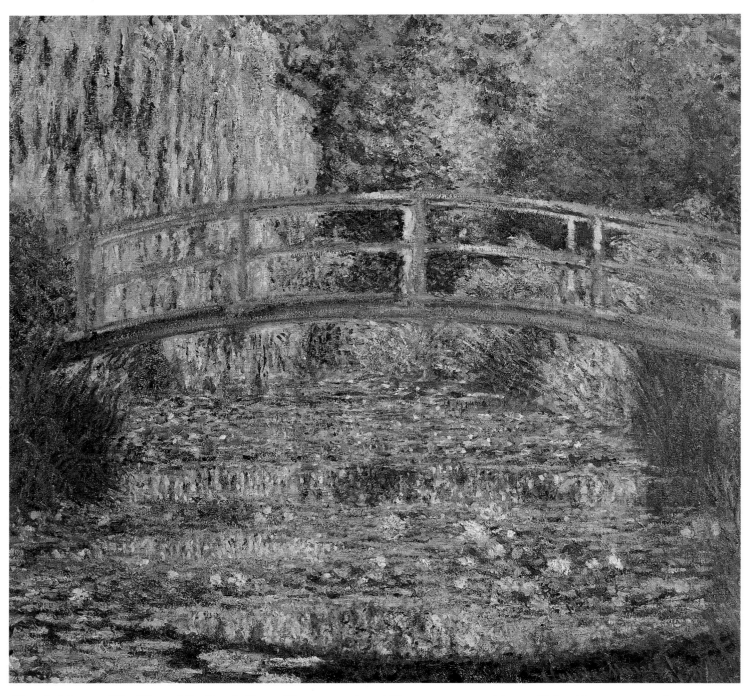

Claude Monet. *The Water Lily Pond: Green Harmony.* 1899. Oil on canvas. 34 ¼ x 39 ⅞ in. (89.5 x 100 cm).

The Japanese influence so prevalent in modern French art of the period appears straightforwardly in the little bridge that Monet had built in his beloved gardens at Giverny. This head-on view, in several treatments, would become a series.

Claude Monet. *The Artist's Garden at Giverny.* 1900. Oil on canvas. 37 ⅞ x 36 ¼ in. (81 x 92 cm).

In April 1883, Monet rented a house in Giverny; in 1890, he bought a home and property there, although he would continue to travel throughout France and to Holland for work. The painter proved an enthusiastic landscape designer, arranging plantings to provide colors and textures as motifs.

Paul Signac. *The Papal Palace at Avignon.* 1900. Oil on canvas. 29 ¾ x 36 ½ in. (75.5 x 92.5 cm).

Signac's regular, broad brushwork in this painting has been compared to mosaic work, while the delicate tints transform the massive walls of the fourteenth-century castle into something out of a fairy tale. What is left of the famous "pont d'Avignon" of song is in the lower left corner.

Maximilien Luce. *The Quai Saint-Michel and Notre-Dame.* 1901. Oil on canvas. 28 ¾ x 23 ½ in. (73 x 60 cm).

Some of the magic of Monet's Rouen cathedrals recurs here, literally balanced in the bottom half of the canvas by another Impressionist theme: the specificity of time and daily life. Luce has rendered his urban observations in a sumptuously textured Divisionist manner.

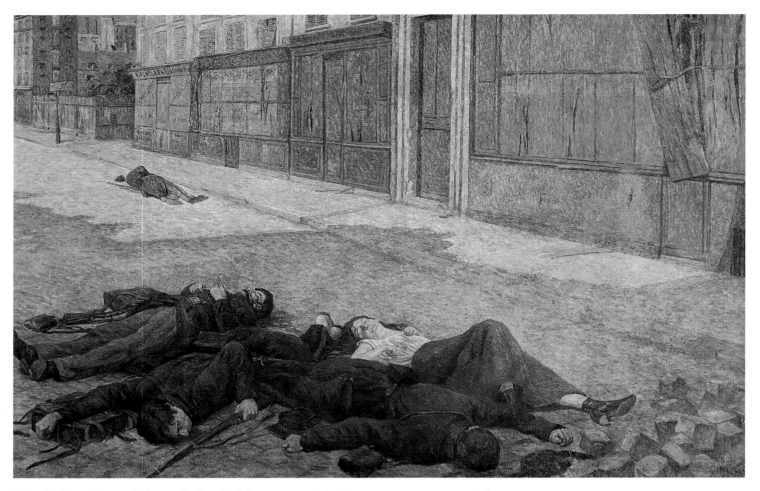

Maximilien Luce. *A Street in Paris, May 1871* or *The Commune*. 1903–05. Oil on canvas.
59 x 88 ½ in. (151 x 224.8 cm).

The suggestive poetry of Luce's brand of Divisionism and the painting's large size endow this solemn scene with grandeur. The working-class Luce, an inveterate anarchist, here features the heroes of the Commune, recalling the significant presence of women in the nation's revolutionary history.

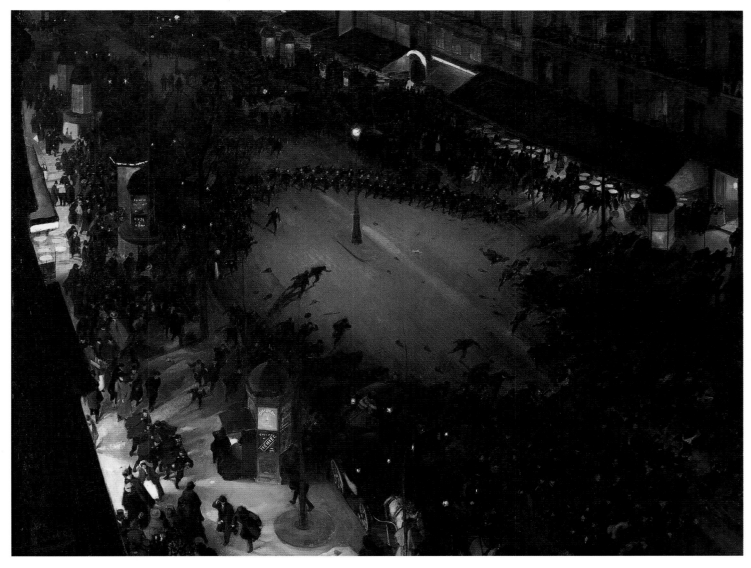

André Devambez. *The Police Charge*. 1901. Oil on canvas. 50 x 63 ¾ in. (127 x 162 cm).

The unusual aerial perspective gives the vivid immediacy of journalism to its subject, a clash between government forces and left-wing demonstrators. This painting was shown in 1902 at the conservative Salon des Artistes Français, and given as a gift in 1928 to the then police commissioner of Paris.

ABOVE

Gustav Klimt. *Rose Bushes under the Trees*. 1905. Oil on canvas. 43 ¼ x 43 ¼ in. (110 x 110 cm).

The Vienna Secessionist movement of decorative and fine arts "seceded" from the reigning academic historicism. Nevertheless, Klimt drew upon byzantine mosaics for some of his effects, as here. The overall green, by infusing every part of the picture, manifests the vital omnipresence of nature.

OPPOSITE

August Strindberg. *Wave VII*. c. 1900–01. Oil on canvas. 22 ½ x 14 ¼ in. (57 x 36 cm).

Considered Sweden's greatest modernist author, Strindberg was a naturalist best known for acidly pessimistic novels and plays. In the 1890s, following a psychological and spiritual breakthrough, a profoundly religious mysticism informed his writing and, perhaps, paintings such as this one.

Edvard Munch. *Summer Night at Asgarstrand.* 1904. Oil on canvas. 39 x 40 ¾ in. (99 x 103.5 cm).

This truncated corner of a village by the Oslo fjord is illuminated by the long, eerie half-light of northern summers. Munch handled several of the important styles of the turn of the century, while the Fauvists especially were enthusiastic about Munch's "wild precision and spiritual coloration."

Claude Monet. *The Houses of Parliament, London.* 1905. Oil on canvas. 31 ⅞ x 36 ¼ in. (81 x 92 cm).

In 1903, Monet began painting his London scenes from memory; his most recent trip to that city had been in 1901, when he had collapsed from overwork. These paintings represented the first time Monet had not worked directly from nature since his youth.

Maurice de Vlaminck. *Restaurant de la Machine à Bougival.* c. 1905. Oil on canvas. 25 ⅝ x 32 in. (60 x 81.5 cm).

The self-taught Vlaminck addressed traditional subjects, as here, but in explosive, expressionistic applications of pure color. Bougival, a suburb on the Seine west of Paris, served by the trains leaving from the Gare Saint-Lazare, had been one of the towns favored by the Impressionists in the 1870s.

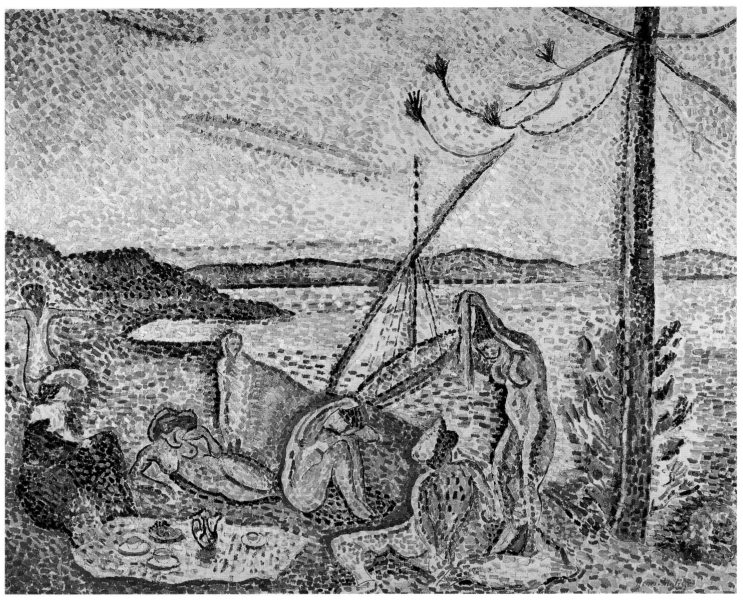

Henri Matisse. *Luxe, Calme et Volupté*. 1904. Oil on canvas. 38 ½ x 46 ½ in. (98 x 118 cm).

Matisse's beautiful masterwork of pure Fauvist color—its title is a phrase from Charles Baudelaire's poem *Invitation au voyage*—is a summary and culmination of its antecedents, and a harbinger of a new art. Signac purchased it at the 1905 Salon des Indépendants, and kept it all of his life.

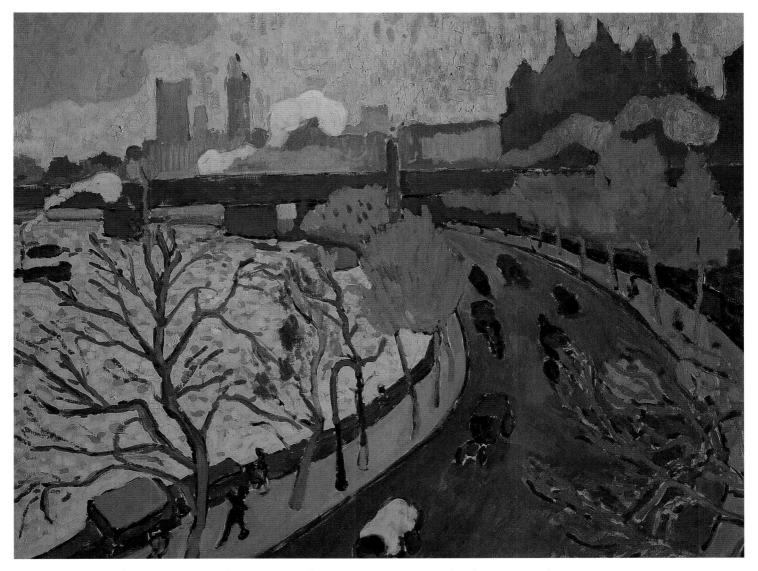

André Derain. *Charing Cross Bridge.* c. 1906. Oil on canvas. 32 x 39 ¼ in. (81 x 100 cm).

The investigations into color conducted first by the Impressionists, then by Van Gogh, Gauguin, and others, led, between 1904 and 1906, to the quantum leap represented by the Fauves, or "wild beasts." The flamboyant, arbitrary colors and dynamic curve make this one of the most striking Fauvist works.

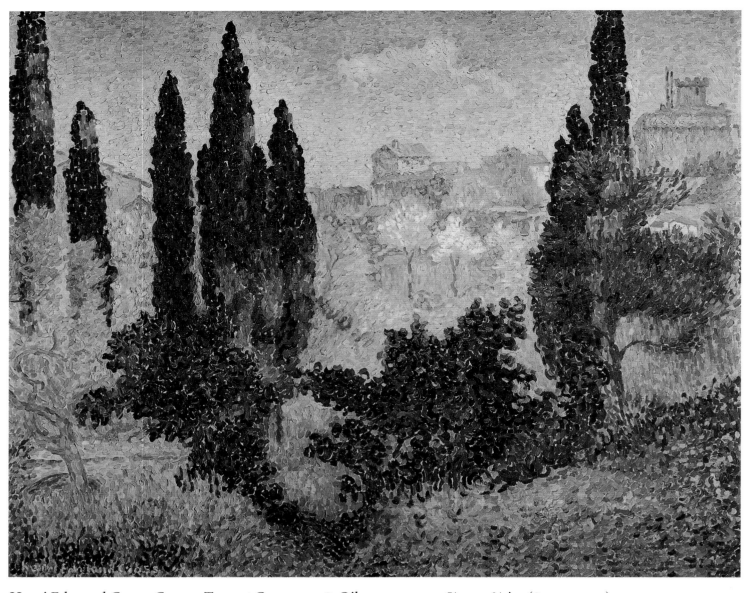

Henri Edmond Cross. *Cypress Trees at Cagnes.* 1908. Oil on canvas. 31 ⅞ x 39 ⅜ in. (81 x 100 cm).

By the turn of the century, the south of France, and especially the Riviera, was a popular area for artists, who appreciated the low cost of living and the extravagant wealth of hues. The dark green cypresses are typical of the area, as are the silver olive trees, here, translated into violet.

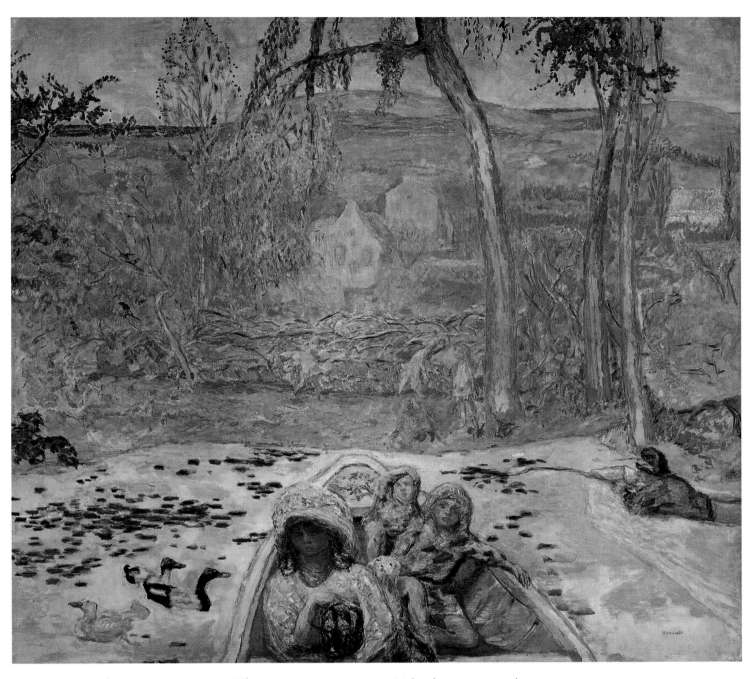

Pierre Bonnard. *In a Boat.* c. 1907. Oil on canvas. 109 ½ x 118 ½ in. (278 x 301 cm).

"All my life, I have been drifting between intimist and decorative work," Bonnard, never a theorist, once remarked to a friend. This daring work summarizes the artist's delicate application of color in the service of evocative emotional landscapes.

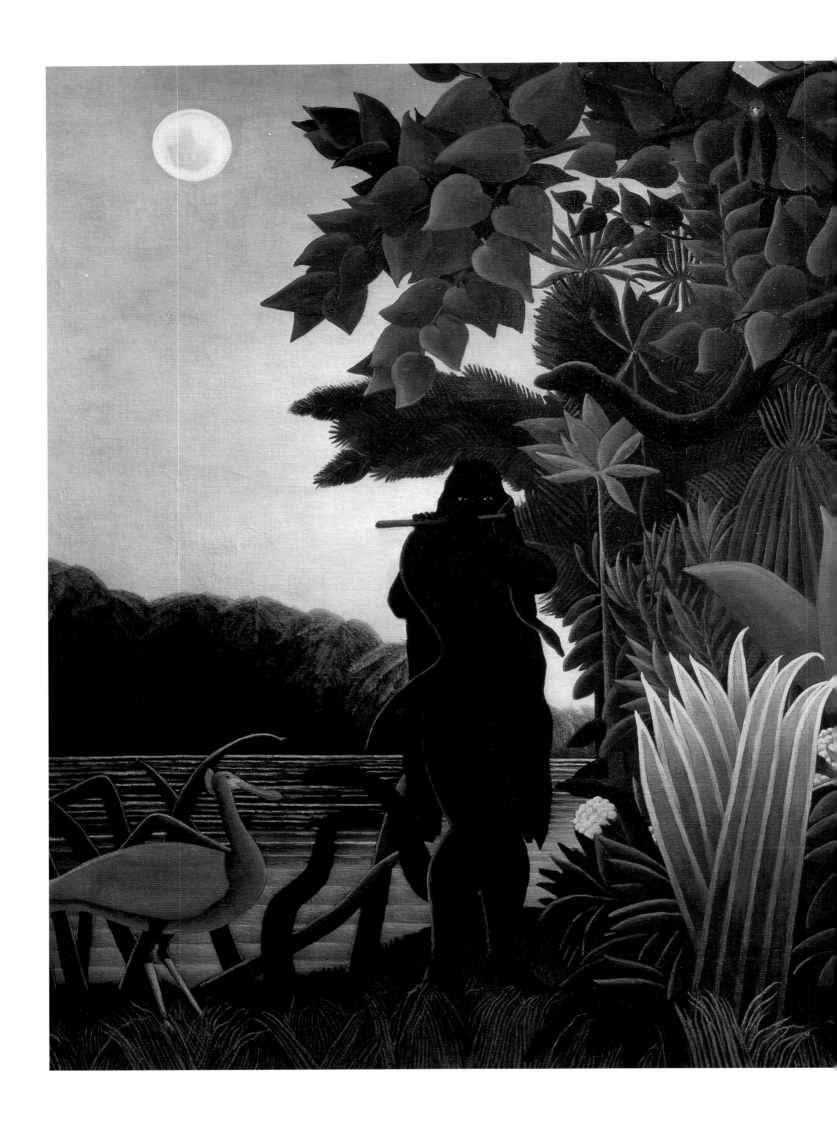

Henri Rousseau. *The Snake Charmer.* 1907. Oil on canvas. 66 ½ x 74 ½ in. (169 x 189.5 cm).

Rousseau considered this one of his most important works. It shares a feeling and even some of the execution of some of Gauguin's Tahitian subjects. Originally commissioned by Robert Delaunay's mother, today it hangs in the last room of the Musée d'Orsay, with other forerunners of the artistic revolution of the twentieth century.

Odilon Redon. *The Shell.* 1912. Pastel on canvas. 20 x 22 ¾ in. (51 x 57.8 cm).

Madame Redon was from the éle de la Réunion, and this luminous object may refer to her homeland. It was not an unusual studio prop, however—Gustave Moreau had one. Redon first attempted this subject in oil, then turned to pastel: the black outline, background hues, and mysterious light source create an otherworldly quality.

Odilon Redon. *Young Girl in a Blue Bonnet.* Pastel on canvas. 20 ⅞ x 15 ⁹⁄₁₆ in. (53 x 39.5 cm).

"In art," Redon maintained, "everything is achieved by docile submission to the unconscious." Artists reacting to the Realist movements, including Impressionism, found many ways to express subjective responses to external and internal realities. Redon's pastel portraits are masterly examples of such art.

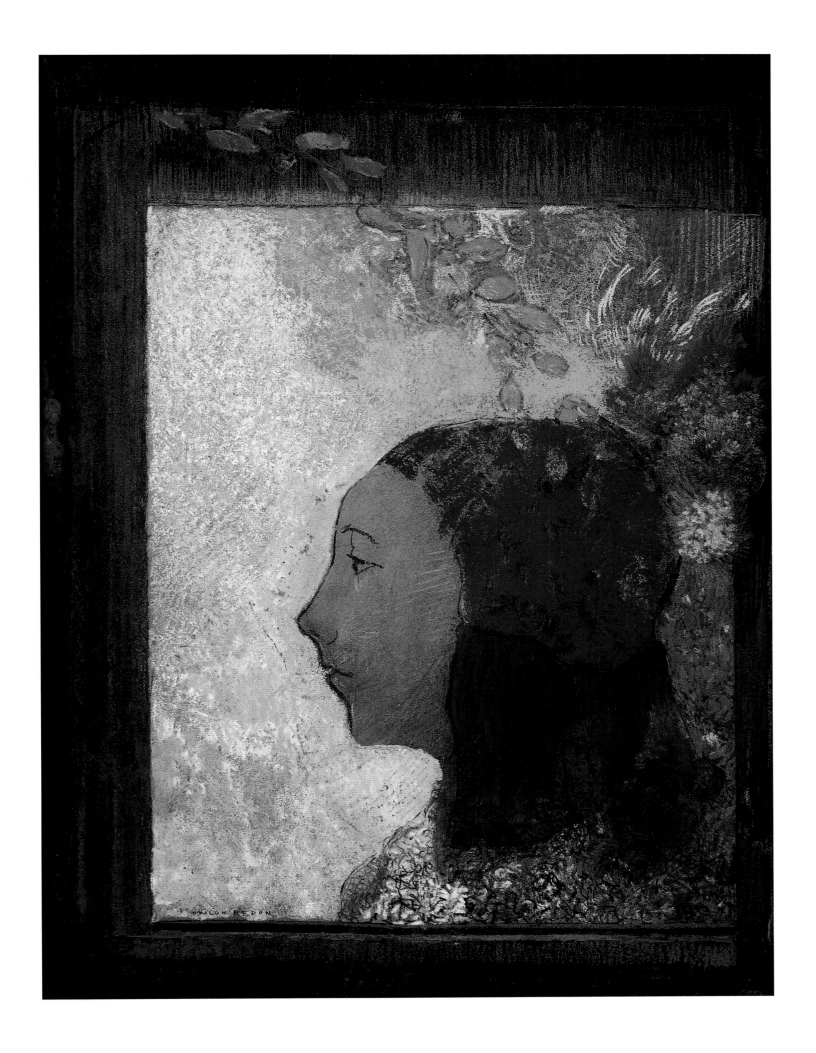

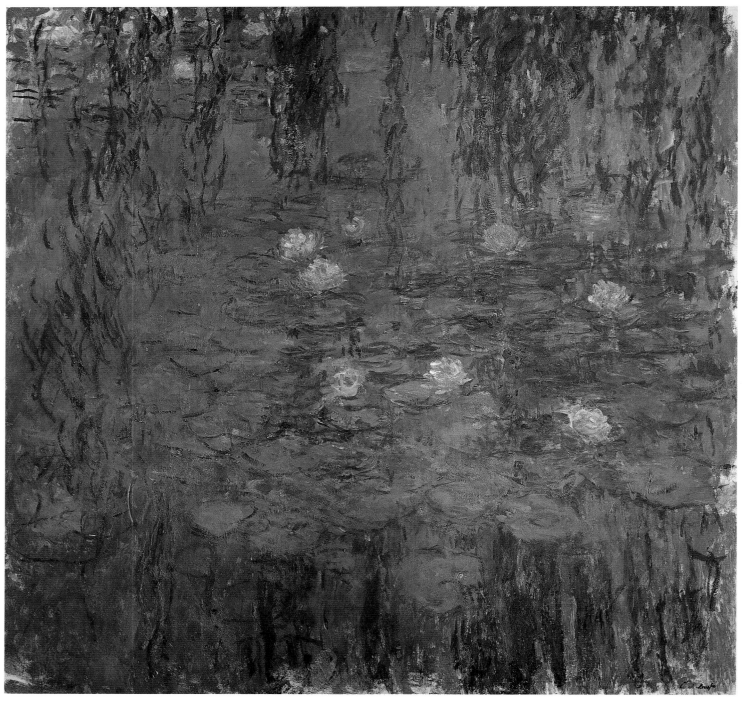

ABOVE

Claude Monet. *Blue Water Lilies.* c. 1916–19. Oil on canvas. 78 ¾ x 78 ¾ in. (200 x 200 cm).

Besides his decorative murals of the subject, Monet was working on a series of easel paintings of his water lily pond, whose waters Marcel Proust would later equally exactly describe as "a bright kingfisher blue, verging on violet, the color of Japanese cloisonné. . . "

OPPOSITE

Odilon Redon. *Apollo's Chariot.* 1905–14. Pastel on canvas. 20 ⅞ x 15 ⁹⁄₁₆ in. (53 x 39.5 cm).

During the Second Republic, Eugène Delacroix painted this classical mythological subject on the ceiling of the Louvre's restored Galerie d'Apollon. Now Redon brought his rich, saturated, often unnatural pastel hues to the evocation of an alternate reality behind the familiar image.

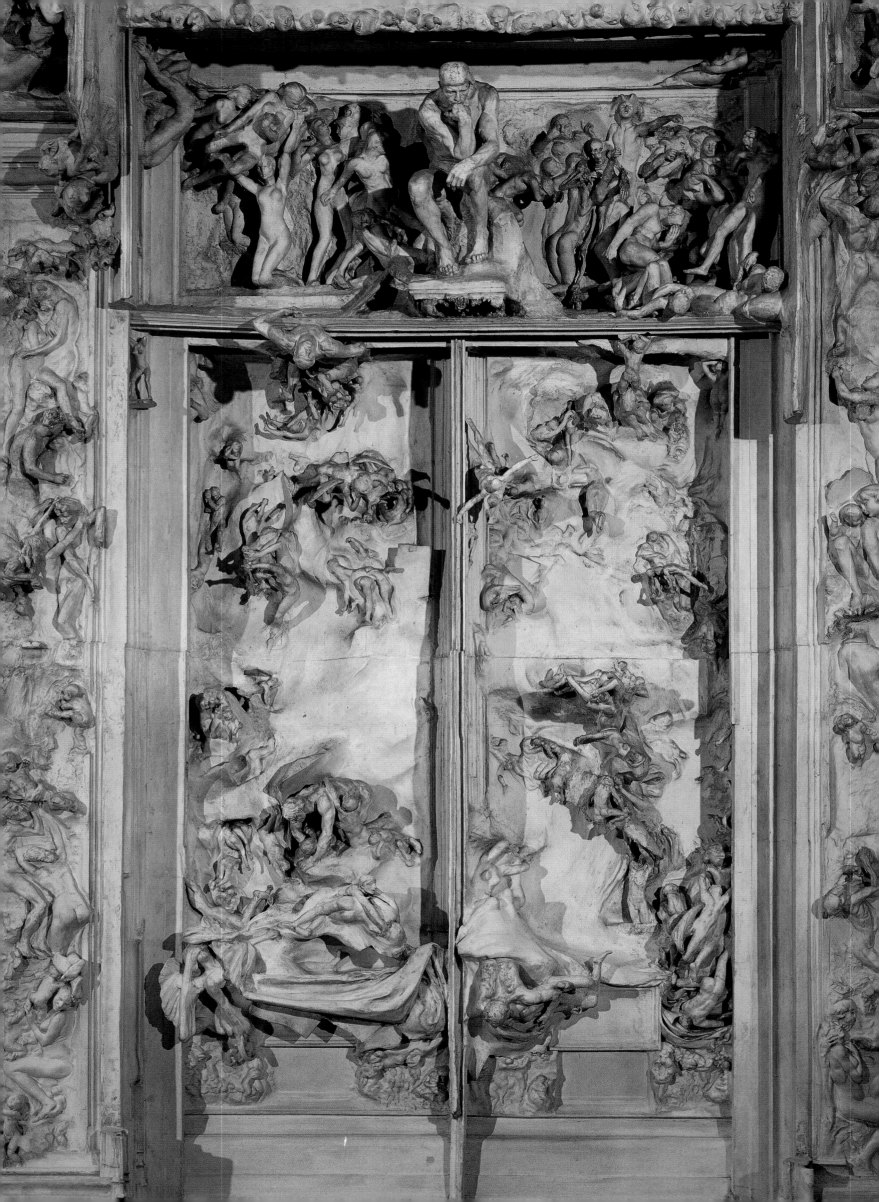

~ SCULPTURE

François Rude. *Napoleon Awakening to Immortality*. 1842. Plaster model for the bronze monument ordered by Capt. Noiset, grenadier on the island of Elba. 84 ⅝ x 76 ¾ x 37 ¾ in. (215 x 195 x 96 cm).

Romanticism made emotional effect its primary goals, and Napoleon was a larger-than-life Romantic hero. Rude's stirring vision transcends the mix of symbols, including what may be a phoenix, about to rise again. The metaphysical placement of the viewer—within immortality?—is ambiguous.

P. 260
Auguste Rodin. *The Gates of Hell* (detail). 1880–1917. Plaster.
267 ¾ x 157 ½ x 33 ½ in. (680 x 400 x 85 cm).

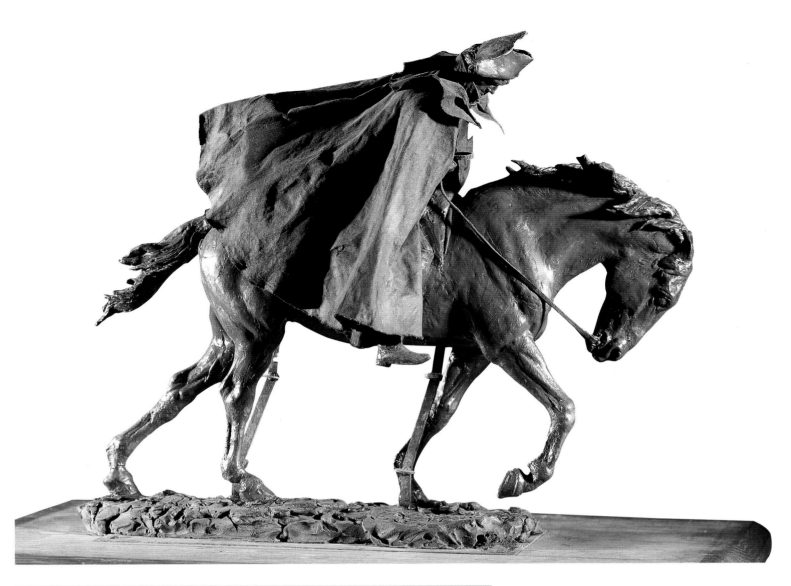

Ernest Meissonier. *Traveler*
(left profile). n.d. Wood.
20 x 29 ½ in. (52 x 75 cm).

Meissonier, known for the high
naturalism of his paintings, went
even further in three dimensions: the
artist constructed a skeleton around
which he built up the waxwork
horse. The traveler, dressed in cloth,
holds reins of leather, which lead to a
metal bit in the horse's mouth.

LEFT

Honoré Daumier. *Charles
Philippon.* c. 1831–35. Oil-glazed
potter's clay. 6 ¼ x 5 ⅛ in. (16 x 13 cm).

Charles Philippon, editor of *La
Caricature,* is one of Daumier's
twenty-six Celebrities of the
Juste-Milieu, also called The
Parliamentarians, a series he used
for lampoons drawn in the political
and satirical magazine *La Caricature.*

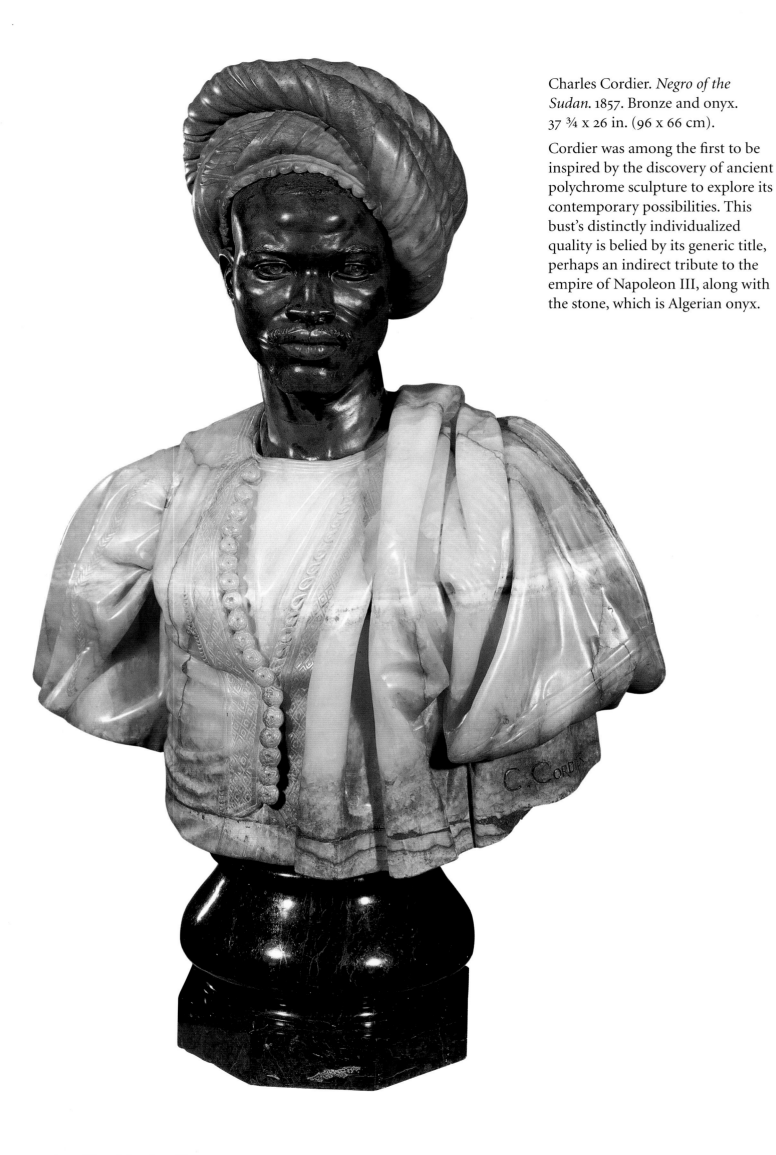

Charles Cordier. *Negro of the Sudan.* 1857. Bronze and onyx. 37 ¾ x 26 in. (96 x 66 cm).

Cordier was among the first to be inspired by the discovery of ancient polychrome sculpture to explore its contemporary possibilities. This bust's distinctly individualized quality is belied by its generic title, perhaps an indirect tribute to the empire of Napoleon III, along with the stone, which is Algerian onyx.

James Pradier. *Sappho*. 1852. Marble. 46 ½ x 27 ½ in. (118 x 70 cm).

This flawless white marble statue is in the classical vein, but the identity of the figure—a poet—and her reflective demeanor illustrate the Romantic influence. Because female figures are so often available as symbols, the woman, with her lyre as attribute, functions as an allegory of poetry as well.

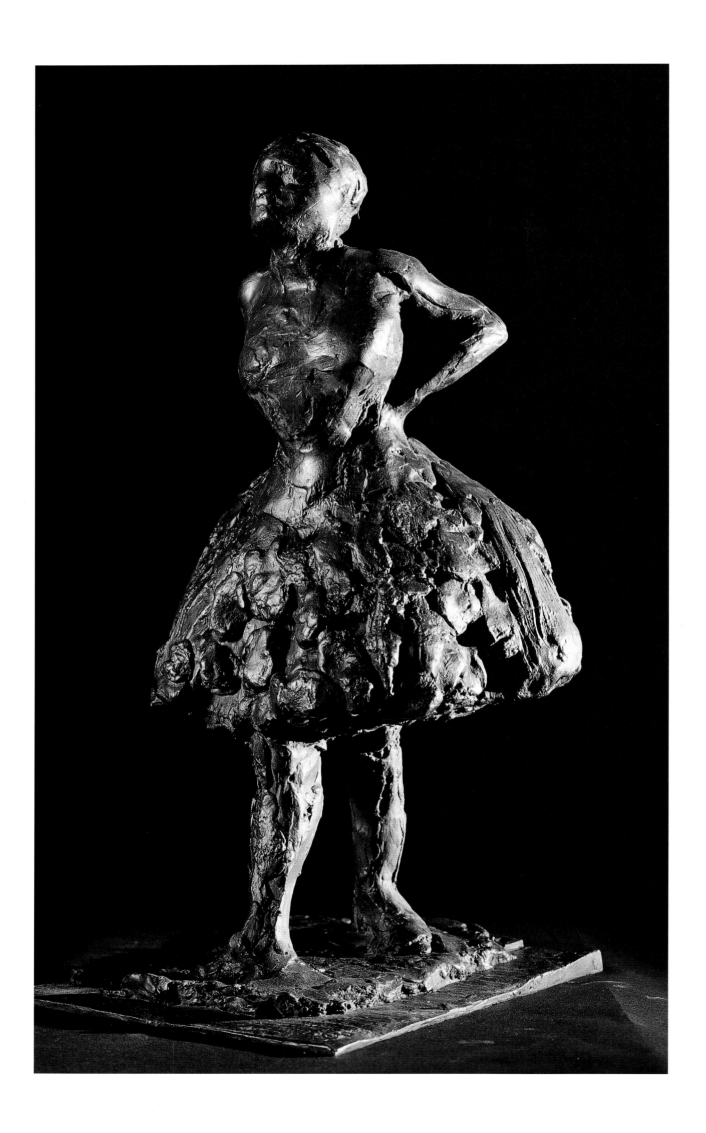

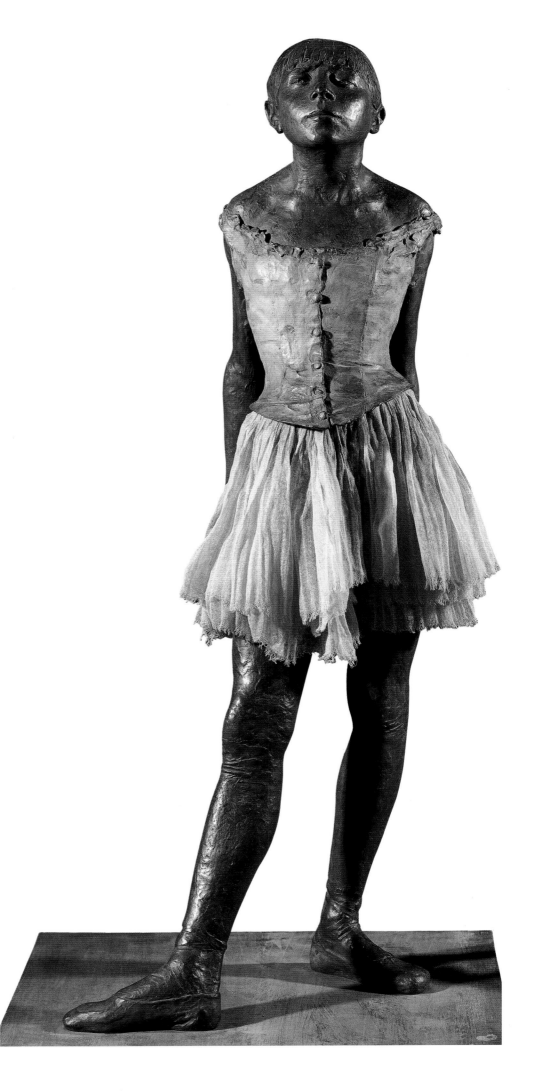

RIGHT

Edgar Degas. *Little Dancer at age Fourteen.* 1880–81. Patinated bronze, cotton skirt, and pink satin ribbon. 39 inches (99 cm) high.

Little Dancer was the only one of Degas's sculptures to have been exhibited publicly. One observer commented upon the figure's expression, with its "promises" of "vice," while the novelist and art critic Joris-Karl Huysmans admiringly noted its "terrible realism."

OPPOSITE

Edgar Degas. *Dancer, Dressed and at Rest.* 1881. Bronze. 17 ⅛ x 9 x 10 ¼ in. (43.6 x 23 x 26 cm).

Degas had been working in wax, clay, and a combination of the two since about 1865; he considered his sculptures to be mainly studies for his paintings and pastels, on a par with his numerous sketches of Marie van Goethem as an adolescent dancer. The bronze statues, cast after his death, create the eerie sensation of his figures on canvas come to life.

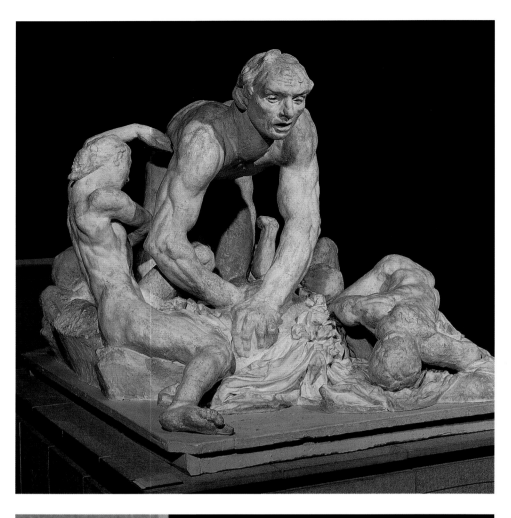

LEFT

Auguste Rodin. *Ugolino*. 1882. Plaster. 17 x 14 x 14 in. (43 x 36 x 36 cm).

One of the most terrible episodes of Dante's *Inferno* tells of Ugolino della Gherardesca of Pisa, who was overthrown by the archbishop of the city, imprisoned with two of his sons and two grandsons, and left to starve. According to tradition, Ugolino ate the dead children's flesh before dying himself.

BELOW

Auguste Rodin. *Mme Vicuña* (¾ view). 1888. Marble. 22 ½ x 127 x 14 ½ in. (57 x 50 x 37 cm).

Rodin's sculpture occupies a place and position in the Musée d'Orsay in keeping with his importance. Beside his monumental works, the sculptor also made many portraits of the artists and writers of his time, as well as society portraits: Madame Vicuña was the wife of the Chilean ambassador to Paris.

OPPOSITE

Auguste Rodin. *The Gates of Hell.* 1880–1917. Plaster. 267 ¾ x 157 ½ x 33 ½ in. (680 x 400 x 85 cm).

This singular monument was commissioned for a planned museum of the decorative arts, but the Gare d'Orsay was built on the site instead. Rodin took his theme from Dante's *Divine Comedy*, and its design from the doors of Florence's medieval Baptistery, then adding existing sculptures such as *The Thinker* and *The Kiss*.

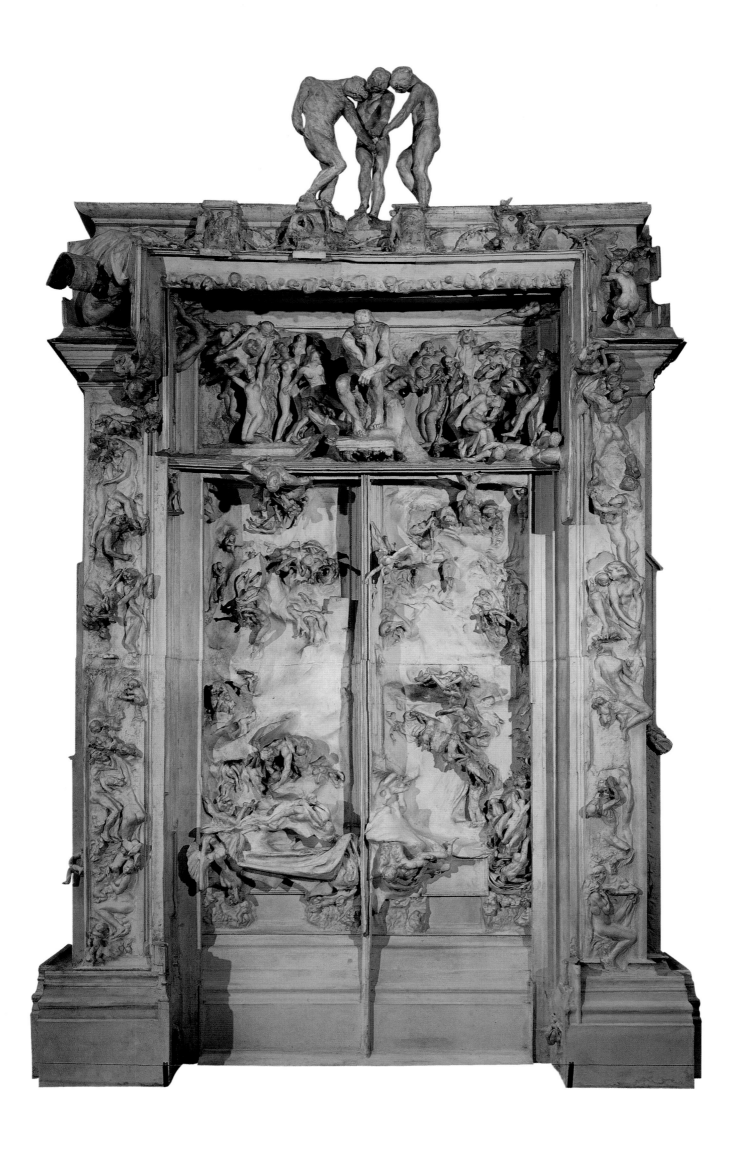

LEFT
Louis-Ernest Barrias. *Nature Unveiling Herself to Science.* 1899. Colored marble. 78 ⅝ x 33 ½ x 21 ⅝ in. (200 x 85 x 55 cm).

The nineteenth century gloried in its scientific advances. The title's overtones of sexual surrender are represented by the masterfully sensual handling of the drapery, the splendid profusion of exotic and costly stones—including onyx, lapis lazuli, and malachite—and the allegorical figure's coy nudity.

OPPOSITE, ABOVE
Camille Claudel. *Maturity.* 1893–1903. Bronze. 44 ⅞ x 64 ⅛ x 28 ⅜ in. (114 x 163 x 72 cm).

Claudel went to work with Rodin in his studio when she was twenty. His assistant on *The Gates of Hell*, among other projects, she also became his model and lover. In the late 1890s, their difficult relationship was ending. Here, Claudel attempts to hold Rodin back from what may be a former lover or old age.

Auguste Rodin. *Thought: Portrait of Camille Claudel.* 1886. Marble. 29 inches (74 cm) high.

Rodin's virtuosity in working marble is eveident here. Camille Claudel was the model for this arresting conceit; Rodin's use of a woman to embody focused thought—as opposed to musing— was quite novel. Also conceptually bold is his sculptural expression of intellect divorced from other human faculties.

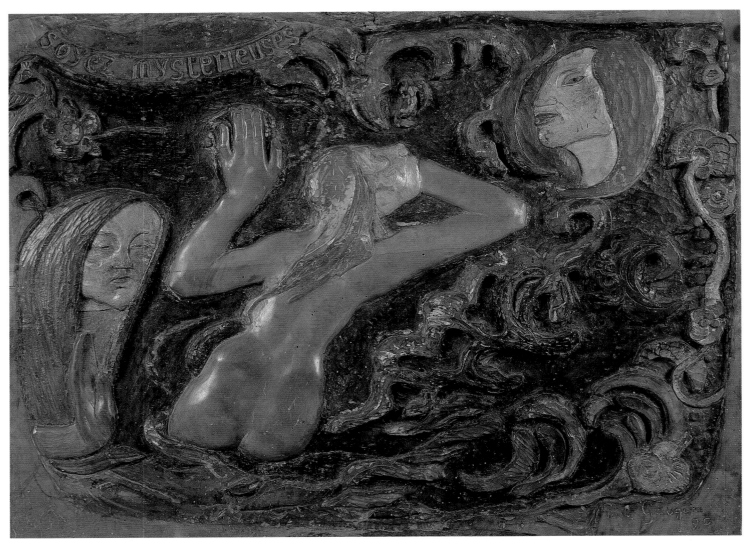

ABOVE

Paul Gauguin. *Be Mysterious*. 1890. Painted wood relief. 28 ¾ x 37 ⅜ in. (73 x 95 cm).

Gauguin's injunction to women reads as a plea from the heart: it may have been prosaic daily life with an adult French woman that drove him to a more exotic routine in the islands of the Pacific. Before he left, however, he made decorative Symbolist works such as this, intended to be a pair with *Love and You Will Be Happy* (Museum of Fine Arts, Boston).

Gauguin. *Idol with Shell.* 1893. Wood. 10 ⅔ inches (27 cm) high.

Gauguin extended his artistic vision into several mediums, and, as here, into mixed mediums. Since 1886, he had been working with ceramics and with Symbolist effects in wood, but the Marquesan tikis and mythology of Tahiti inspired what he referred to as "barbaric knickknacks."

OPPOSITE, BELOW

Aristide Maillol. *Female Dancer.* 1895. Wood relief. 8 ⅔ x 9 ½ in. (22 x 24 cm).

Maillol was still painting when he carved this intricate, furiously energetic figure, recalling ancient bas-reliefs in the Louvre, while reflecting Art Nouveau lines. His background as a ceramist and glazer may have influenced this work, whose antecedents in antiquity would have been of terra-cotta.

OVERLEAF

Jean-Léon Gérôme. *Sarah Bernhardt.* c. 1895. Colored marble. 27 ¼ x 16 ⅛ x 11 ⅜ in. (69 x 41 x 29 cm).

Gérôme's partly polychrome sculpture *Tanagra*, a reference to the ancient practice of painting statues, shocked many visitors to the Salon of 1890. Gérôme's painterly instincts recur in this portrait bust of the intense, popular, and successful actress, here portrayed in tranquility.

Aristide Maillol. *Mediterranean* or *Thought*. 1905–1923. Marble. 43 ¼ x 46 ⅛ x 26 ¾ in. (109.8 x 117 x 68 cm).

"Art does not consist in merely copying nature." A scale model of this sculpture that Maillol developed in 1902 was more naturalist than this one, which is the result of progressive simplification, a reinterpretation of Classicism. What Maillol sought was a perfect harmony, in which passion had no place.

Joseph Bernard. *Effort Towards Nature*. 1906–07. Stone. 12 ½ x 9 in. (32 x 23 cm).

The formalism of academic and other idealist art provoked a thirst for sincerity in Bernard and other sculptors. Working with wood as well as stone, and committed to "freeing the imprisoned nymph within," Bernard was one of the first to retain the material's texture, even as he carved an image out of it.

Medardo Rosso. *Ecce Puer: A Portrait of Alfred Mond at the Age of Six*. 1906–7. Bronze. 17 inches (43.2 cm) high.

The Italian Rosso was one of the originators of Impressionist sculpture (an 1883–84 work is titled *Impression of an Omnibus*). Here, he achieved a suggestion of blurring between the figure and its surroundings, and a depiction of light that is as much a part of the portrait as the child's own features.

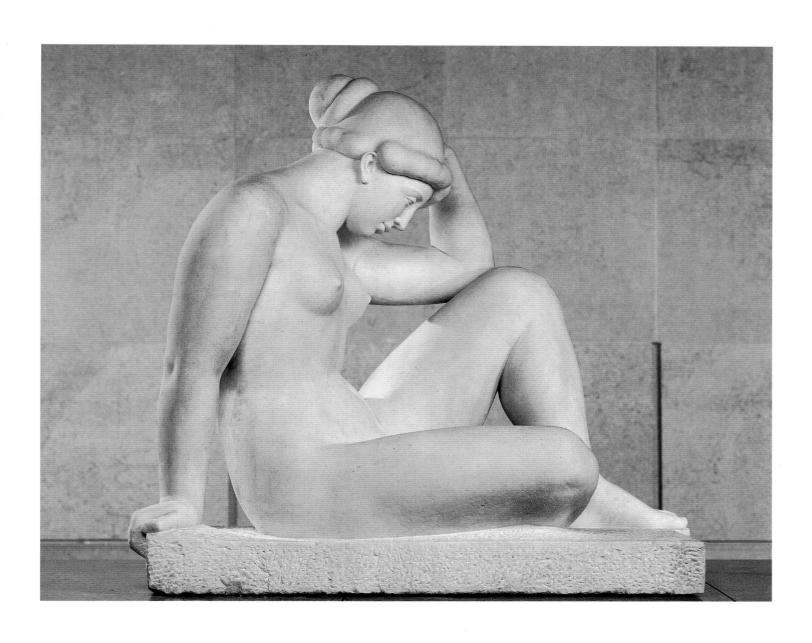

~ GRAPHIC ARTS

ABOVE

Gustave Courbet. *Portrait of Juliette Courbet as a Sleeping Child.* 1841. Pencil on paper. 7 ⅞ x 10 ¼ in. (20 x 26 cm).

A notorious nonconformist, Courbet nevertheless remained close to his family; much of his voluminous correspondence is with and about them and their extended network of relations. He made this affectionate portrait of one of his sisters, drawn with simple lines, the year he moved to Paris.

OPPOSITE, ABOVE

Paul Cézanne. *Portrait of Pissarro.* c. 1872–76. Pencil on paper. 8 ⅝ x 4 ½ in. (22 x 11.4 cm).

Pissarro is in his Impressionist kit, prepared to hike to an outdoor site, set up easel and canvas, and, with brush and palette knife, carve art out of pigments. A political artist, Pissarro always placed working human beings in his natural scenes, just as Cézanne placed Pissarro against a sketched landscape.

OPPOSITE, BELOW

Jean-François Millet. *Fishermen.* 1857–60. Black crayon on paper. 12 ⅝ x 19 ⅜ in. (32 x 49 cm).

Millet was admired and reviled for his images of modest working people. Although his most widely reproduced pictures are of the peasantry, he here sketched the sleepy, silent figures of fishermen. The huddled postures of the two seated men speak of the late night or early morning chill.

P. 276

Berthe Morisot. *Portrait of Mme Pontillon.* 1871. Pastel on paper. 31 ⅞ x 25 ⅜ in. (81 x 64.5 cm).

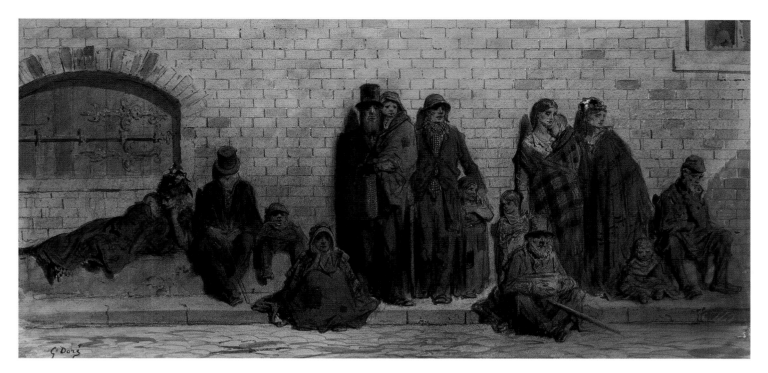

Eva Gonzalès. *Pink Morning.*
1874. Pastel on paper. 35 ½ x 28 ⅜ in.
(90 x 72 cm).

Gonzalès applied pastel to a study
of shades and textures in the falls of
pink and white. While puppies
were a popular sentimental detail,
the woman's thoughtful gaze is in
keeping with Impressionist themes.
The pale pink and soft gray is a
color combination Gonzalès shared
with her teacher, Manet, who used
it in his still lifes of peonies.

Gustave Doré. *Scene on a London
Street.* c. 1868–72. Gouache on
paper. 12 ½ x 25 ⅛ in. (32 x 64 cm).

Best-known as an illustrator of the
Bible and of great European
literature, Gustave Doré also made
a collection of documentary
drawings, *London: A Pilgrimage.*
Parisian observers of the period,
inured to the poverty of the French
capital, were horrified by the
squalor they saw in London.

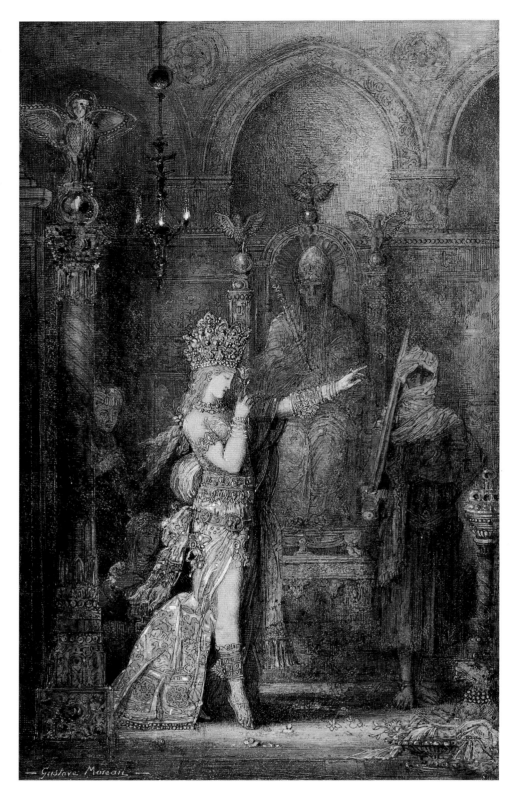

Gustave Moreau. *Salomé Dancing*. 1876.

Gustave Moreau. *Salomé Dancing*. 1876. Black ink, pencil, heightened with gold. 12 ⅔ x 7 ½ in. (31.3 x 18.9 cm).

Moreau's decorative Orientalism represented an attempt at authenticity, in an era when colonialism, archaeology, and newspapers were bringing the exotic out of the imagination and into the public eye. Herod's young stepdaughter was a Victorian-era emblem of the women's perversion of power.

OPPOSITE

Edgar Degas. *The Star*. 1878. Pastel on paper. 23 ⅝ x 17 ⅜ in. (60 x 44 cm).

Beginning in 1875, Degas more and more often used pastels, on canvas, cardboard, or paper, as here. He created an air of peril in this image with the harsh shadows created by the artificial lighting, the headless male figure in the wings, and the title figure's precarious, one-legged stance.

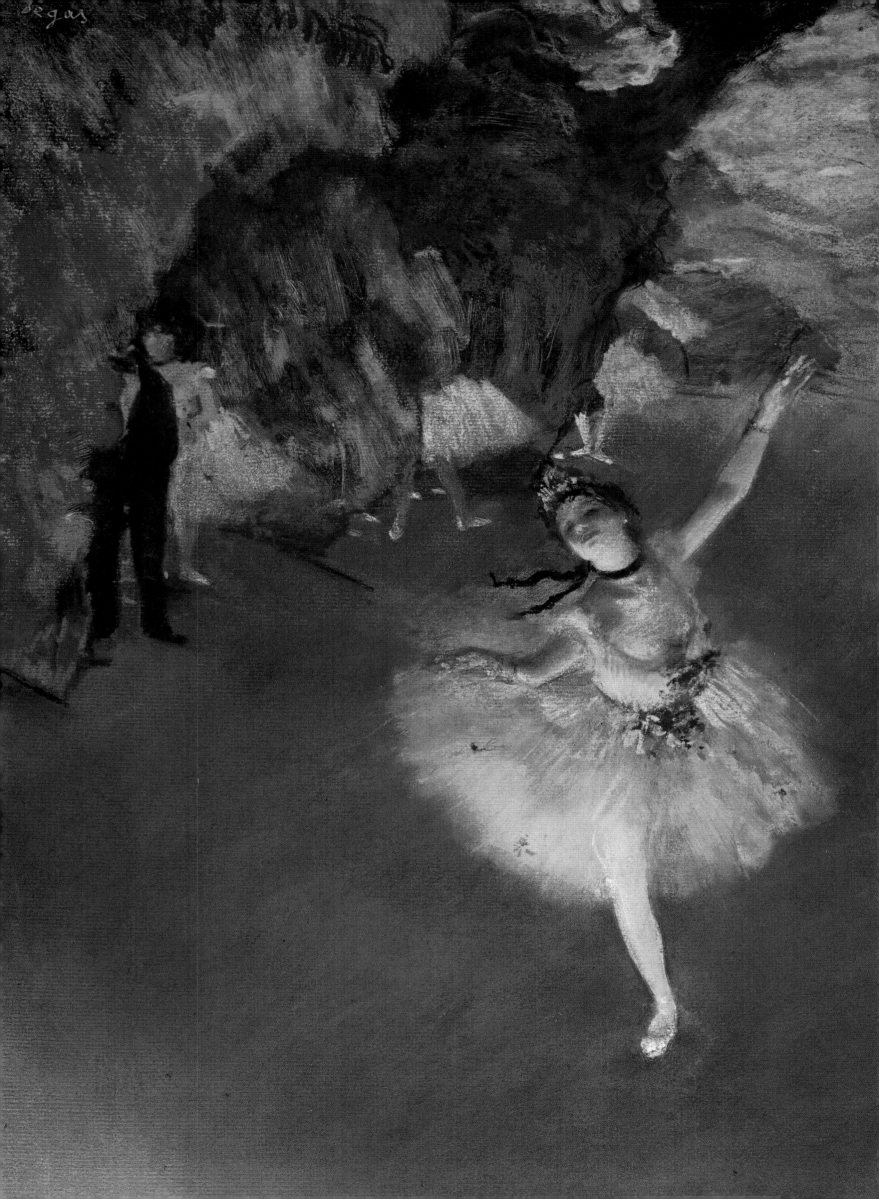

Georges Seurat. *The Black Knot.* c. 1881. Conté crayon. 12 ¼ x 9 ⅛ in. (31 x 23 cm).

This compellingly private image achieves a poised tension between eroticism and a cerebral study of shadows. The mysterious light sources do not account for the cast shadows at the figure's feet, for example, nor for the shocking, unmodulated black of the knot.

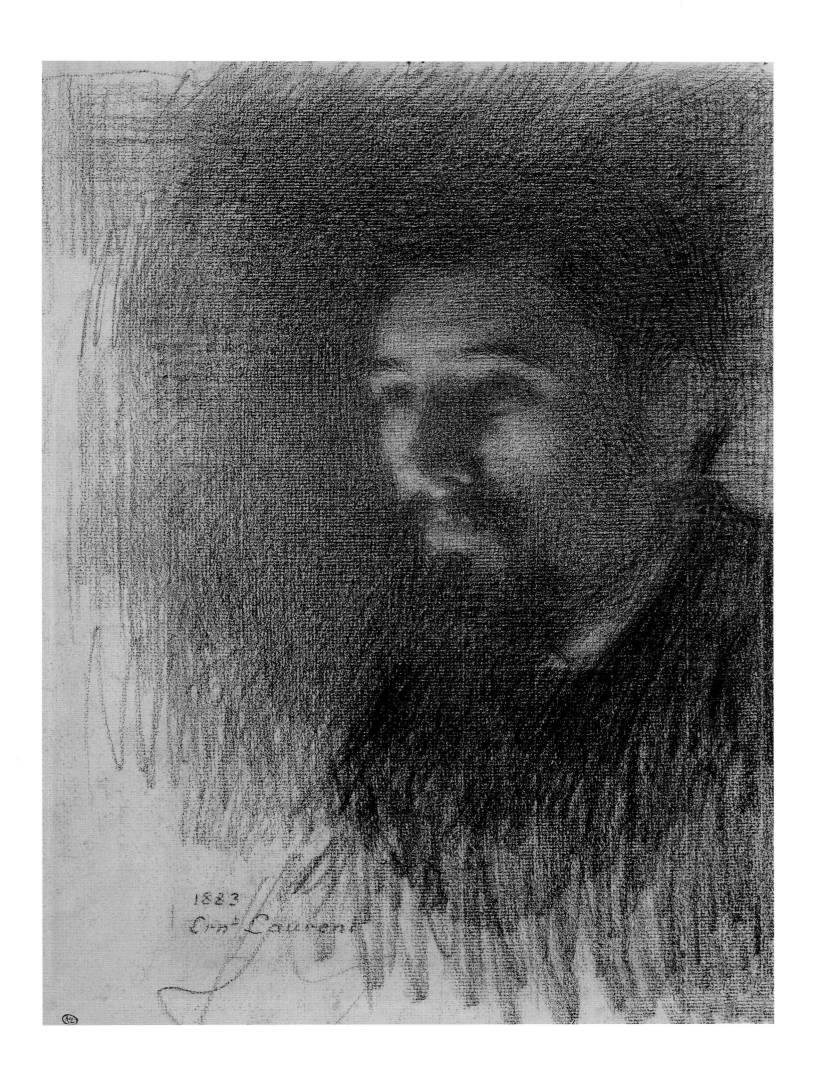

1883
Orn Laurent

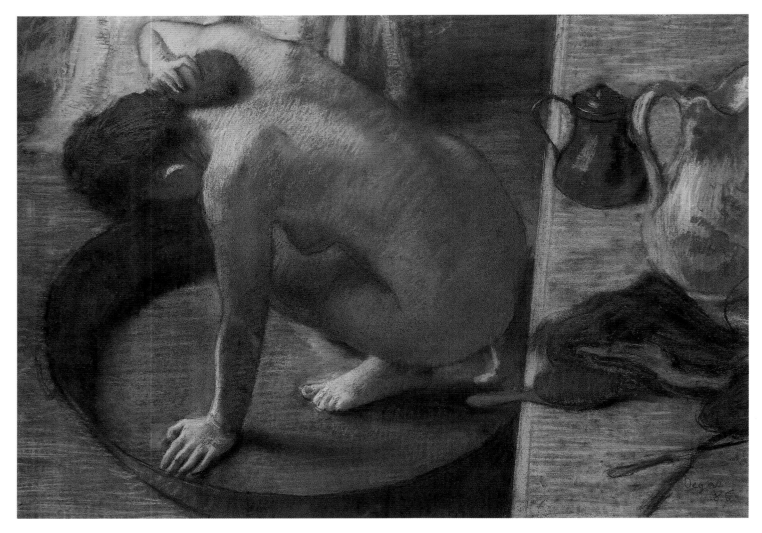

ABOVE
Edgar Degas. *The Tub*. 1886. Pastel on paper. 26 x 23 ⅝ in. (60 x 83 cm).

This is one of a series of images of women grooming themselves: —the human animal concerned with herself, like a cat licking itself—, as the artist said. There are enigmas here: the bather holds what is left of her hair, calling our attention to the scissors and tresses behind her.

P. 285
Ernest Laurent. *Portrait of the Painter Georges Seurat*. 1883. Black crayon. 15 ⅜ x 11 ⅜ in. (39 x 29 cm).

Laurent used charcoal, a soft medium, to create a portrait of inwardness, deriving from the inscrutable eyes. For this subject, in this image, looking and thinking are one. A mysterious illumination highlights the planes of Seurat's face, as his gaze reaches toward something we cannot see.

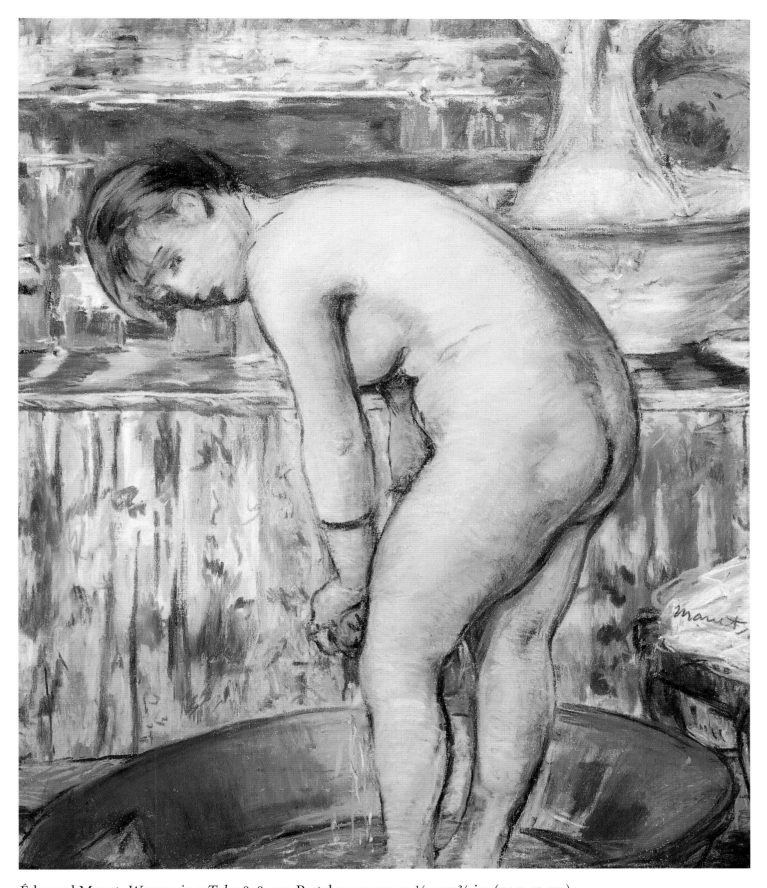

Édouard Manet. *Woman in a Tub.* 1878–79. Pastel on paper. 21 ¼ x 17 ¾ in. (54 x 45 cm).

The observer's point of view, below the model's eye level, brings a touch of irony to the scene. Manet's characteristic outline here acts almost as a caress along the woman's body, which is neither conventionally nor ideally beautiful. The proportions are odd: the figure would be hard-pressed to lift the enormous ewer on the dressing table.

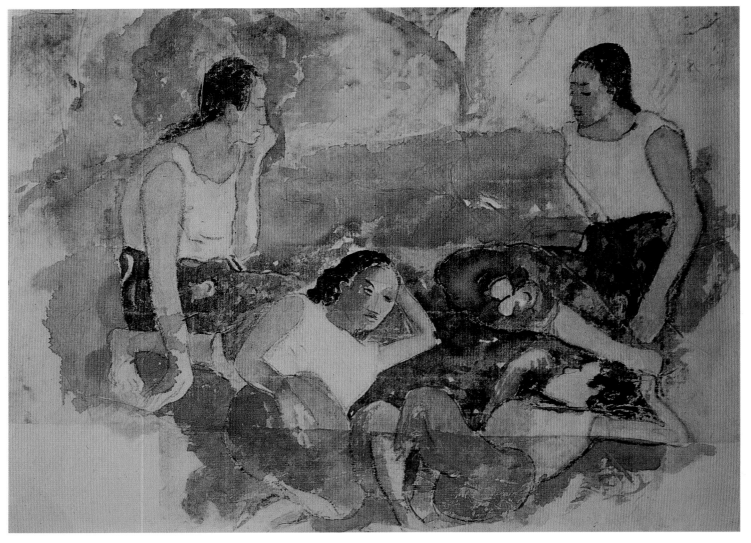

Paul Gauguin. *Three Women* from the *Noa Noa Album*. 1893–97. Watercolor, pen and black ink, and woodcut with watercolor on paper. 11 ¾ x 11 in. (30 x 28 cm).

As early as the mid-1880s, Gauguin had rejected the notion of boundaries between art forms. In 1893, during his first sojourn in Tahiti, Gauguin began *Noa Noa,* an illustrated manuscript in which the artist recorded tales of the gods, "faithfully set down."

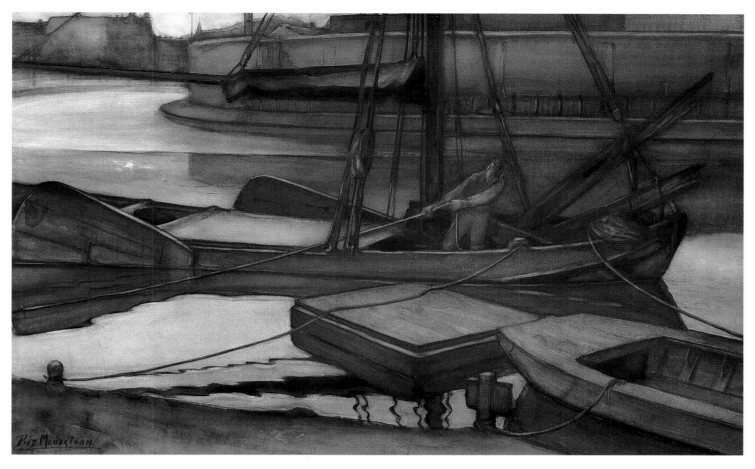

ABOVE

Piet Mondrian. *Going Fishing (Zuider Zee)*. c. 1898–1900. Pastel, charcoal, watercolor on paper. 24 ⅜ x 39⅜ in. (62 x 100 cm).

The artist combined charcoal and watercolor—two seemingly antithetical textures—to produce this handsome water scene. Mondrian, who would later declare the art object to be a thing in itself, employed lines and planes to rhythmically construct this composition.

P. 290

Odilon Redon. *Buddha*. c. 1906–7. Pastel on paper. 35 ½ x 28 ¾ in. (90 x 73 cm).

Redon's gorgeously modulated palette and control of detail are evident in his depiction of the Buddha and the banyan tree beneath which the Buddha attained enlightenment—represented by the gold cloud above his head. The resolution of the picture occurs in the "empty" space between Buddha and the banyan.

P. 291

William Degouve de Nunques. *Nocturne at the Royal Park, Brussels*. n.d. Pastel on paper. 17 ⅔ x 13 ½ in. (58 x 44 cm).

Pastel's capacity for subtle effect is exploited powerfully in this delicately cadenced Symbolist work. The streetlights hang like magic fruit from the branches of trees carefully but randomly ordered. The central avenue leads into an undefined distance, beckoned by a single globe—or moon.

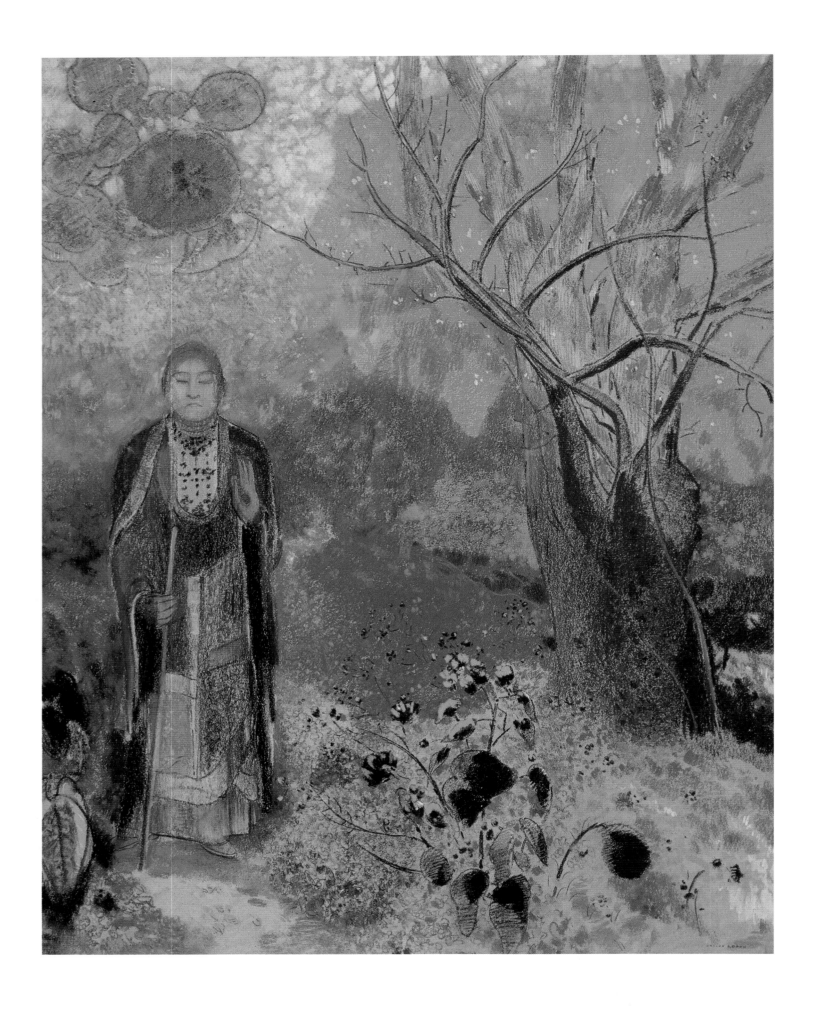

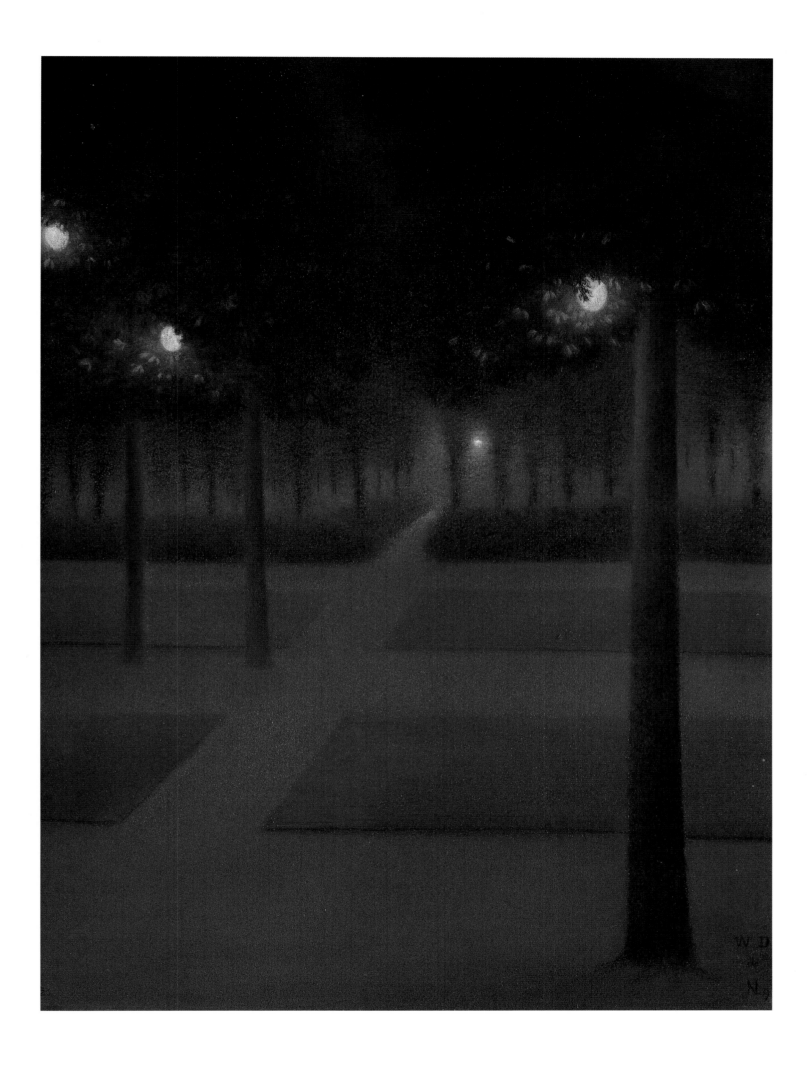

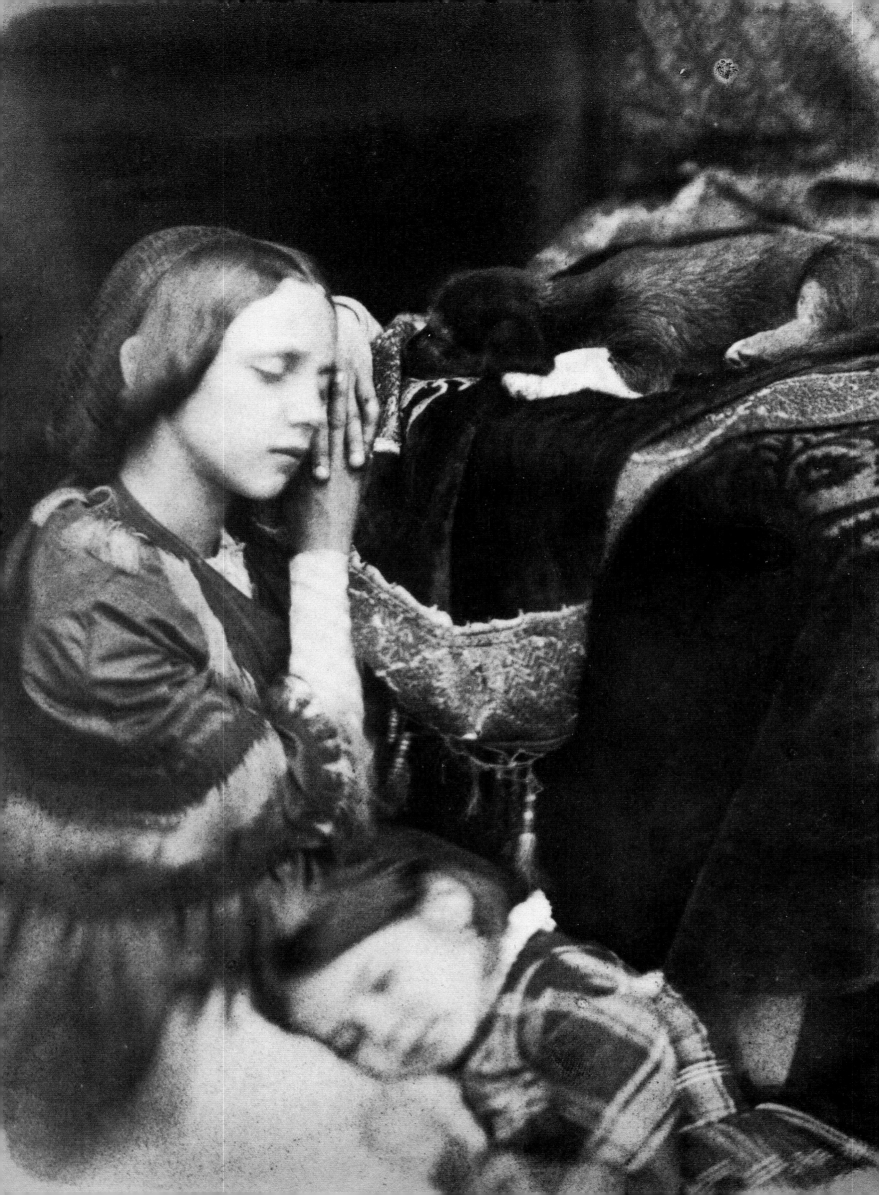

~ PHOTOGRAPHY

ABOVE
Louis-Adolphe Humbert de Molard. *Louis Dodier (Humbert de Molard's Butler) as a Prisoner.* c. 1847.
Daguerrotype. 4 ½ x 6 ⅛ in. (11.5 x 15.5 cm).

In the early days of photography, its often well-off practitioners looked to the arts for their models, and found that the artistic mainstream favored historical, or at least narrative subjects. This work of photographic fiction displays a curious side of the master-servant relationship.

OPPOSITE
Félix Tournachon, called Nadar. *Charles Baudelaire Seated on a Louis XIII Chair.* Before 1855. Salt paper print from a wet collodium glass negative. 8 ⅜ x 6 ½ in. (21.2 x 16.4 cm).

Nadar, a writer, caricaturist, and photographer, opened his first photographic studio in 1853, and was soon at the heart of the new art world at mid-century. Nadar made several portraits of the scandalous poet and critic Baudelaire. The theorist and defender of the avant-garde, he is shown here with an appositely regal prop.

P. 292
David Octavius Hill and Robert Adamson. *The Three Sleepers: Sophie Finlay, Annie Farney and Brownie the Dog.* c. 1845. Salt paper print from a paper negative. 7 ⅝ x 7 ¼ in. (19.5 x 18.2 cm).

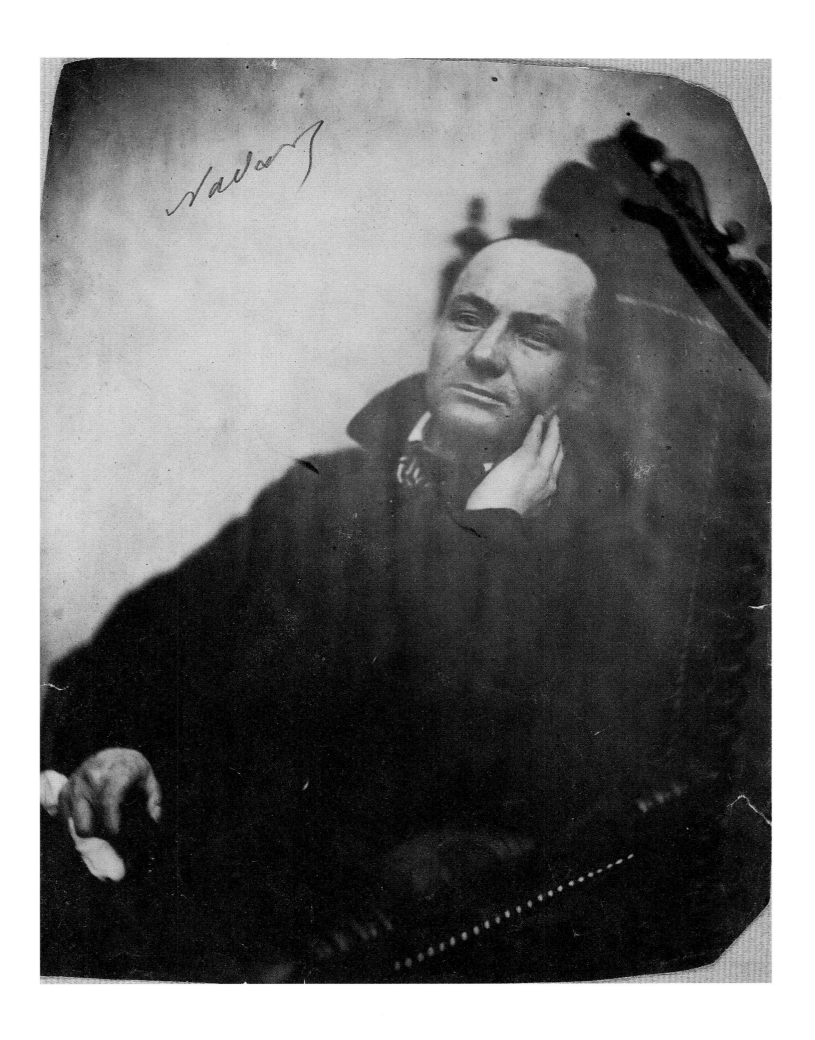

Charles-Victor Hugo [and Auguste Vacquerie]. *The Breakwaters at Jersey (with the Silhouette of Victor Hugo)*. 1853–55. Salt paper print from an albumen glass negative. 6 ⅜ x 7 ¾ in. (16 x 19.8 cm).

Napoleon III banished Victor Hugo from France in 1851. This print is one of a series made when Victor's sons Charles and François, along with Auguste Vacquerie, a poet and amateur photographer, joined him on Jersey. In the style of Hugo pére, the posts might stand for the forces barring the writer from his homeland.

Paul Burty Haviland. *Landscape of Crozant in the Snow*. n.d. Cyanotype. 2 ⅝ x 3 ⅝ in. (7 x 9.5 cm).

Haviland was a New York photographer in the Photo-Secession group that Alfred Stieglitz founded in 1902, and in the circle of American and European painters, sculptors, and photographers around the magazine *Camera Work* and the 291 Gallery. Here, Haviland achieved an evocative Impressionist effect.

Gertrude Käsebier. *The Manger*. 1903. Photograph. 11 ½ x 8 in. (29.2 x 20.2 cm).

The fashion for dreamy *tableaux vivants,* or "living paintings," found a natural medium in photography (the setting is a genuine, though impeccably clean stable). Another of Käsebier's photographs with a religious theme is much closer in style to the straight photography the artist would later be known for.

ABOVE

Charles Dodgson, called Lewis Carroll. *Xie Kitchin Sleeping.* 1873. Albumen print from collodion glass negative. 4 ⅝ x 5 ⅝ in. (12 x 14.5 cm).

Carroll was one of many writers who were attracted to photography: he took this photograph the year after *Through the Looking Glass* was published. The shadows in the corners create a sort of tunnel vision that calls the viewer's attention to the figure's face, in sharp focus and deep in dreams.

LEFT

Julia Margaret Cameron. *Little Girl in Prayer.* 1871. Photograph.

The arched frame adds a solemn, church-like, and slightly composed note to this portrait "d'aprés nature"—"from life"—as the artist emphatically specified.

Julia Margaret Cameron. *Profile: (Maud.)* c. 1867. Photograph. 12 ⅝ x 10 ⅜ in. (32.3 x 26.5 cm).

The heavy expressiveness and Pre-Raphaelite influence visible in this art photograph, an illustration for Tennyson's *Idylls of the King*, shows how flexible the medium had already become. Cameron's portrait photographs of friends such as Alfred, Lord Tennyson are, by contrast, incisive and crisp.

ABOVE

Eadweard Muybridge. *A Flying Falcon, from the album "Animal Locomotion."* 1872–85. Photograph. 7 x 16 ¾ in. (18 x 14.5 cm).

In 1872, Leland Stanford, then director of the Central Pacific Railroad, asked Muybridge to use photography to prove that at some point a running horse has all four legs off the ground. Thenceforth, Muybridge specialized in motion photography, inventing an early moving picture projection device, the "zoopraxiscope."

LEFT

Eugène Atget. *Prostitute: Nude in an Interior.* 1921. Gelatin print. 8 ⅞ x 6 ⅞ in. (22.5 x 17.5 cm).

The ambiguity of the title—documentary or artwork, sleaze or aesthetics?—and of the bourgeois setting, with its bookshelf and framed pictures, reflects the ambiguity inherent in the medium itself. Today a celebrity in the history of photography, Atget never showed in a Salon, and died virtually unknown.

Anonymous. *Young Polish Jewish Girl Leaning Against a Wall.* 1914–19. Albumen silver print. 5 ½ x 3 ½ in. (13.9 x 8.7 cm).

In its early days, the fact that photography depicted reality often confused viewers, who sought clues to help them interpret what they saw. By the time this picture was taken, in the Jewish quarter of Warsaw, documentary photography was established as a category; the portrait's expressiveness brought it into an art museum.

~ Decorative Arts and Architecture

P. 302

Louis Comfort Tiffany and Henri de Toulouse-Lautrec. *Au nouveau cirque. Papa Crysanthème* 1894–95. "American glass," marbled and chenillé, cabochons. 47 ¼ x 33 ½ in. (120 x 85 cm).

BELOW

Maison Poussielgue-Rusand, after a design by Édouard-Jules Corroyer. *Monstrance.* Before 1865. 27 ½ inches (70 cm) high.

Art and industry converged at mid-century, often meeting in eclecticism. Like other design objects by this firm, which specialized in precious metalwork and religious furnishings, this ostensory, intended to display the consecrated Host in a Roman Catholic church, was designed by an architect.

ABOVE

Édouard Lièvre and Édouard Détaille. *Furniture Composed of Two Parts: Cabinet Mounted on Bracket Table.* 1877. 83 x 43 ¾ x 22 ½ in. (211 x 111 x 57 cm).

The line between decorative and fine arts has traditionally been movable; the effect on both of the Japanese arts section of the 1867 Paris World's Fair was revolutionary. Famous for his depictions of European soldiers, Détaille painted a Japanese warrior for this one-of-a-kind cabinet.

ABOVE

Louis-Ernest Lheureux. *Monument to the Glory of the French Revolution.* c. 1886–89. Drawing in pen, wash, and watercolor, heightened with gold. 18 ⅞ x 34 in. (48 x 86.5 cm).

Lheureux's 1876–78 library for the Paris Law School was much admired for the harmony of its eclectic elements. The same could be said for this aerial plan for an elaborate pyramid in the Louvre complex, intended to replace Napoleon I's Arc de Triomphe du Carrousel. The project was never built.

OPPOSITE, ABOVE

Pierre Puvis de Chavanne. *Saint Geneviève Feeding Paris.* Triptych. Oil sketch. 25 ¼ x 55 ⅛ in. (64 x 140 cm).

In fulfillment of a vow, Louis XV rebuilt the old Church of Sainte-Geneviève, the patron saint of Paris. Later dedicated as a secular monument, its windows were walled in, and the new surfaces frescoed. Puvis de Chavanne's panels of a fifth-century siege of Paris memorialized the siege of 1870, and the birth of the Third Republic.

OPPOSITE, BELOW

Morris and Company, after William Morris. *Wall Decoration* (detail). 1880. Painted wood panels.

The Arts and Crafts movement wove several philosophical and artistic strands, including a belief that every aspect of life ought to be beautiful, and, thanks to industrial processes, affordable. These painted panels display typical Morris and Co. plant motifs.

P. 305

Gabriel-Auguste Ancelet. *Reconstruction of a Decoration on the Portico of Macellum, Pompeii.* 1853. Pencil, pen and black ink, india ink wash, watercolor, and gouache on paper. 18 ½ x 11 in. (47 x 28 cm).

The archaeological expeditions of the nineteenth century added authenticity to the reigning classical style of the period. Perhaps because it had been an elegant resort suburb of Rome, the newly suburbanized and leisured Parisians found the stylish decorations of Pompeii particularly to their taste.

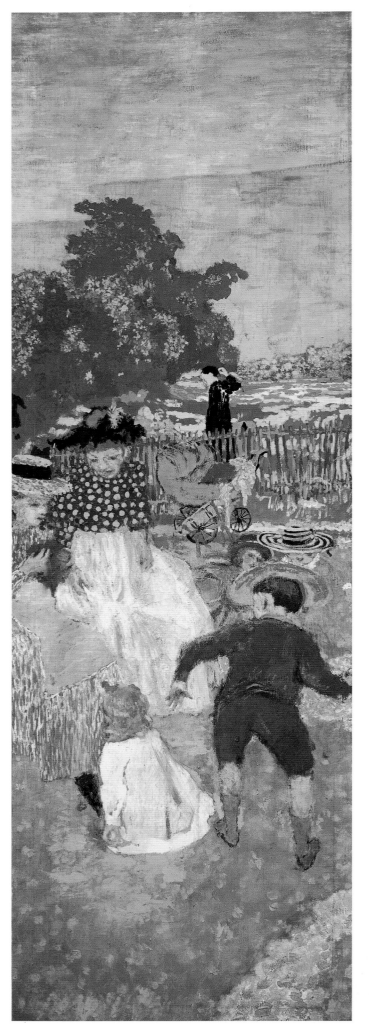
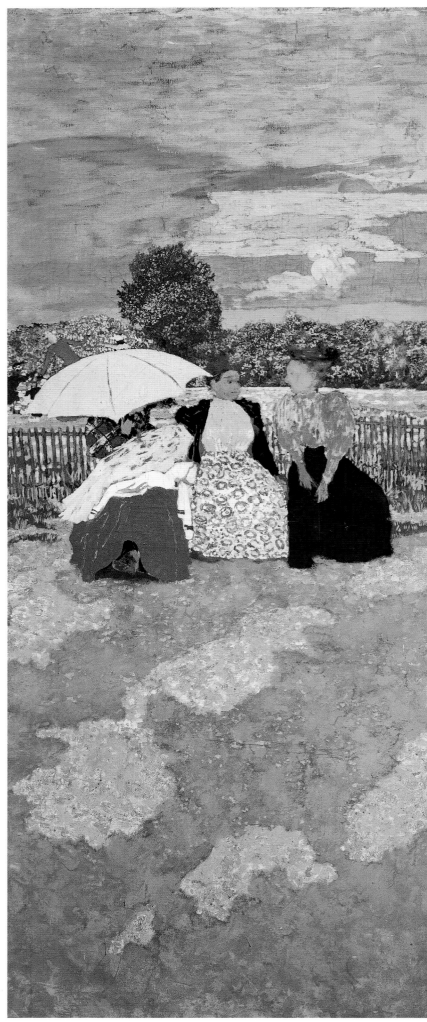

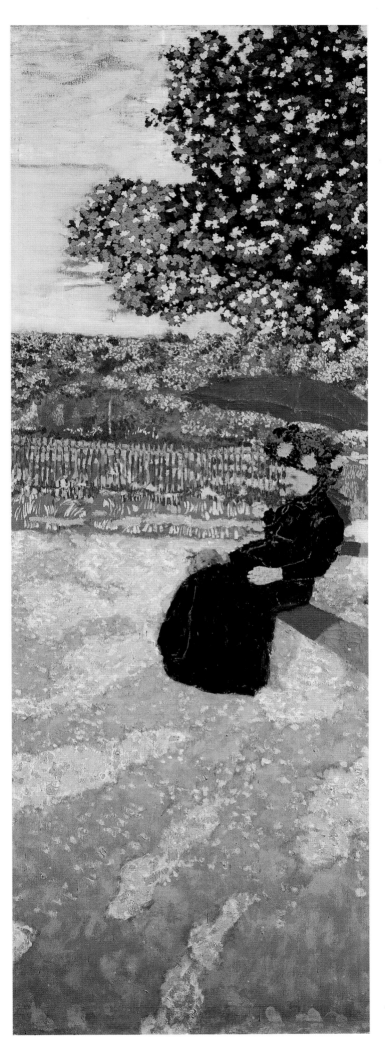

Jean-Benjamin Constant. *First Sketch for the Ceiling of the Opéra-Comique (Glorification of Music).* 1898. Paper on cardboard. 22 inches (56 cm) diameter.

Constant looked to Baroque allegory—and to a symbolic but un-Baroque empty space—for his ceiling decoration for the rebuilt Opéra-Comique. Two years later, Constant would be one of the artists selected to decorate the Hôtel du Palais d'Orsay, also more prosaically called the Hôtel Terminus.

PP. 308-309

Édouard Vuillard. *Three Panels from "Jardins Publics:" Public Gardens; The Nursemaid; The Red Parasol.*
Oil on canvas. 1894. Panel 1: 84 x 28 ¾ in. (217.5 x 73 cm). Panel 2: 84 x 61 in. (213 x 154 cm). Panel 3: 84 x 32 in. (214 x 81 cm).

Alexandre Natanson and his magazine, *Revue Blanche*, energetically supported the Nabis. These are three of the nine panels Vuillard painted for Natanson's dining room; meant to be seen from a distance, they deftly balance darker masses, lighter expanses, and patterns of shadow.

Maurice Denis. *Decoration for the chapel of the College Sainte-Croix du Vésinet. Right hand panel with angels and altarboys.* 1899. Oil on canvas. 98 ½ x 45 ¼ in. (250 x 115 cm).

Even though, like a theater set, this panel is composed of massy shapes, the figures' relationships to one another create a feeling of intmacy. The overall work is in a classical cast, but the decorative shadows of the columnar drapery no doubt harmonized with the architectural surroundings.

Eugène Feuillatre. *Candy bowl with dragonflies.* c. 1901. Enamel. 3 ¼ x 5 ¾ in. (8.2 x 14.7 cm).

Art Nouveau, inspired by sinuous natural forms and colors, offered visual relief after the Victorian era's often dark, massive aesthetic. In airy pieces such as this, artisans employed negative spaces to add lightness, and looked to unusual models: the dragonfly, with its translucent, iridescent wings, is a classic Art Nouveau theme.

RIGHT

Émile Gallé. *Hand with Seaweed and Shells.* 1904. Engraved crystal with additions and applications. 13 x 5 ⅛ in. (33 x 13 cm).

Gallé was one of the decorative arists who made the city of Nancy the original capital of Art Nouveau. An astonishingly inventive glass- and furnituremaker, expert botanist, and Symbolist-influenced designer, Gallé viewed nature as the inexhaustible source of decoration.

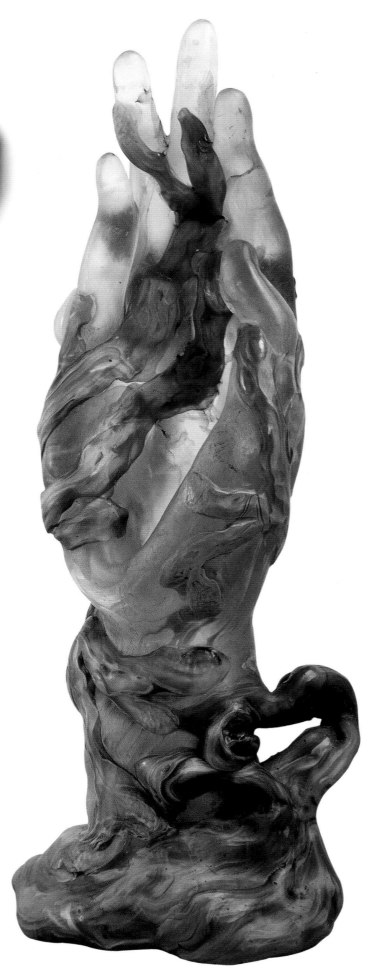

René Lalique. *Pendant and Chain.*
c. 1903–05. Gold, enamel,
diamonds, aquamarine.
2 ¾ x 2 ¼ in. (6.9 x 5.7 cm).

Lalique produced often one-of-
a-kind pieces that translated Art
Nouveau's natural forms into
jewelry and glass-making. His
radical innovation was the
introduction of luxury jewelry that,
unlike traditional pieces, either
used relatively few precious stones,
or subordinated them to the
design, as here.

Hector Guimard. *Central Section of
Large Balcony.* 1905–07. Cast iron.
31 ⅞ x 61 ⅛ in. (81 x 173 cm).

Guimard's best-known ironwork is
a series of entrances to the Paris
Métro. This piece is from a line of
architectural items that were mass-
produced in the early 1900s. The
experiment was a commercial
failure, because Guimard's singular
style proved incompatible with
virtually all other architecture.

LEFT AND OPPOSITE
Jean Dampt. *Boiseries from the Salle du Chevalier, Mansion of the Comtesse René de Béarn.* 1900–06. Wood panels.

Beginning in 1891, industrial design was accepted at the Salon of the Société Nationale des Beaux-Arts. Dampt, a sculptor, turned his talents to making furniture ensembles; his boiseries for the drawing room of the *comtesse* were relatively unadorned, featuring instead the grain and knots of the wood.

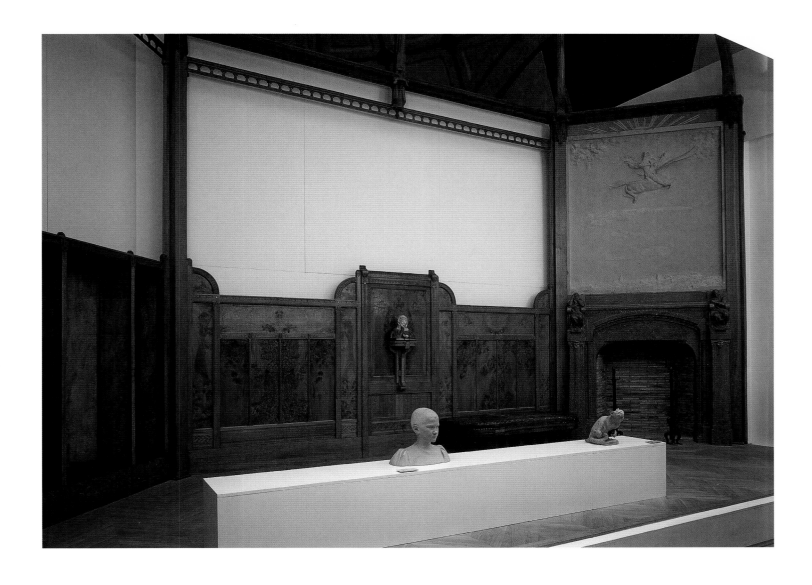

RIGHT

Josef Hoffmann. Manufactured by Wiener Werkstätte. *Jardinière*. 1903–04. Plated silver. 15 ½ x 4 ¾ x 4 ⅜ in. (39.2 x 12.2 x 11 cm).

In 1903, Hoffmann, an Austrian architect, was one of the organizers of the Wiener Werkstätte, an updated guild dedicated to luxury craft objects as antidotes to poor mass-produced design. This hammered *jardinière*, or plant stand, is an example of the workshop's handsome and costly aesthetic.

DECORATIVE ARTS AND ARCHITECTURE

BIBLIOGRAPHY

Bonnie S. Anderson and Judith P. Zinsser. *A History of Their Own.* Vol. 2. New York: Perennial Library/HarperCollins, 1988.

Margaret Barlow. *Women Artists.* Southport, CT: Hugh Lauter Levin Associates, Inc., 1999.

Robert Boardingham. *Impressionist Masterpieces in American Museums.* Southport, CT: Hugh Lauter Levin Associates, Inc., 1996.

Françoise Cachin and Xavier Carrère. *Treasures of the Musée d'Orsay.* New York: Abbeville Press, 1994.

Petra ten-Doesschate Chu, ed. and trans. *Letters of Gustave Courbet.* Chicago and London: University of Chicago Press, 1992.

"Construire le musée d'Orsay," *Carnet Parcours du Musée d'Orsay* 9. Paris: Éditions de la Réunion des musées nationaux, 1987.

J.-M. D'Hoop and R. Hubac. *Histoire Contemporaine (1848–1914).* N.p.: Librairie Delagrave, 1964.

Nancy Forgione. "'The Shadow Only': Shadow and Silhouette in Late Nineteenth-Century Paris." *The Art Bulletin*, 81, 3 (September 1999): 490–512.

Peter Galassi. *Before Photography: Painting and the Invention of Photography.* New York: The Museum of Modern Art, 1981.

Alison Gallup, Gerhard Gruitrooy, and Elizabeth M. Weisberg. *Great Paintings of the Western World.* Southport, CT: Hugh Lauter Levin Associates, Inc., 1998.

Tamar Garb. *Women Impressionists.* New York: Rizzoli, 1986.

"La gare et l'hôtel d'Orsay" *Carnet Parcours du Musée d'Orsay* 4. Paris: Éditions de la Réunion des musées nationaux, 1986.

Guide to the Musée d'Orsay. Paris: Éditions de la Réunion des musées nationaux, 1987.

Robert L. Herbert. *Impressionism: Art, Leisure, and Parisian Society.* New Haven and London: Yale, 1988.

Jules Isaac et al. *De la Révolution de 1789 à la Révolution de 1848.* Paris: Classiques Hachette, 1960.

Marni R. Kessler. "Unmasking Manet's Morisot." *The Art Bulletin*, 81, 3 (September 1999): 473–89.

Knopf Guides: Paris. New York: Borzoi/Knopf, 1995.

Michel Laclotte et al. *Paintings in the Musée d'Orsay.* Paris: Éditions Scala and Éditions de la Réunion des Musées, 1986.

Bertrand Lemoine. *Architecture in France 1800–1900.* New York: Harry N. Abrams, 1998.

Nancy Mowll Mathews, ed. *Cassatt: A Retrospective.* Southport, CT: Hugh Lauter Levin Associates, Inc., 1996.

Caroline Mathieu. *Orsay: L'esprit du lieu.* Paris: Éditions Scala, 1999.

Musée d'Orsay: Impressionist and Post-Impressionist Masterpieces. Paris and London: La Réunion des musées nationaux and Thames and Hudson, 1990.

The Museum of Modern Art, New York: The History and the Collection. Introduction by Sam Hunter. New York: Harry N. Abrams, in association with The Museum of Modern Art, New York, 1993.

Beaumont Newhall. *The History of Photography.* London: Secker & Warburg, 1972.

Jean Starobinski. *Largesse.* Chicago and London: University of Chicago Press, 1997.

Charles F. Stuckey, ed. *Monet: A Retrospective.* New York: Hugh Lauter Levin Associates, Inc., 1985.

Jane Turner, ed., *The Dictionary of Art.* New York: Grove's Dictionaries, 1996.

PHOTO CREDITS

INDEX